Nomad

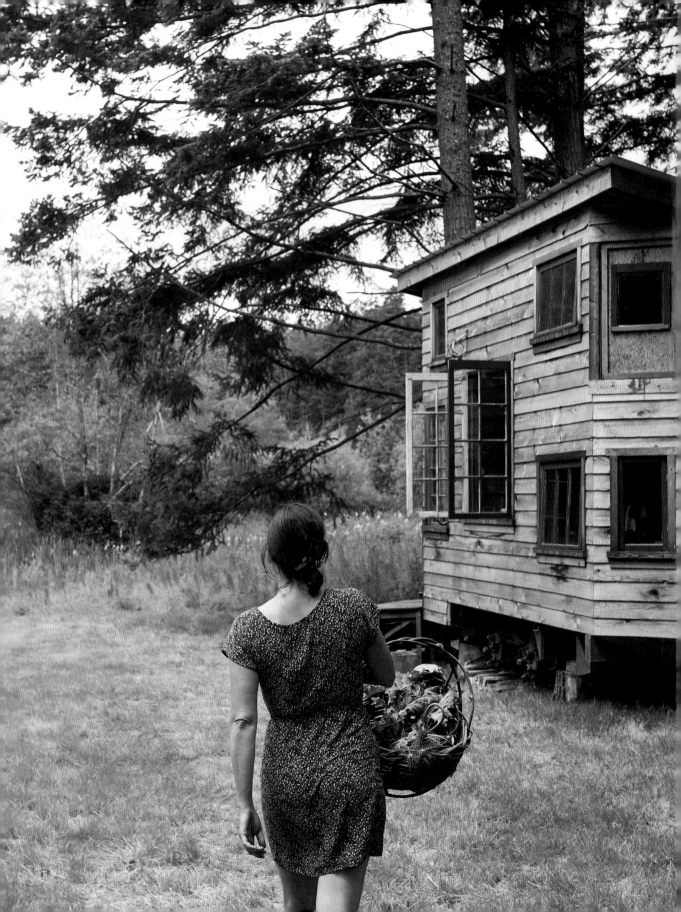

Nomad

**DESIGNING A HOME FOR
ESCAPE AND ADVENTURE**

EMMA REDDINGTON

PHOTOGRAPHS BY SIAN RICHARDS

ARTISAN | NEW YORK

Library of Congress Cataloging-in-Publication Data
Names: Reddington, Emma, author.
Title: Nomad / Emma Reddington ; photographs by Sian Richards.
Description: New York : Artisan, a division of Workman Publishing Co., Inc.
 [2019] | Includes an index.
Identifiers: LCCN 2019017699 | ISBN 9781579658137 (hardcover : alk. paper
Subjects: LCSH: Recreational vehicle living.
Classification: LCC TX1110 .R43 2019 | DDC 388.3/46—dc23
LC record available at https://lccn.loc.gov/2019017699

Design by Jennifer K. Beal Davis
Cover lettering by Kirby Salvador
Front cover photograph copyright © Nash and Kim Finley

Artisan books are available at special discounts when purchased in bulk
for premiums and sales promotions as well as for fund-raising or educational
use. Special editions or book excerpts also can be created to specification.
For details, contact the Special Sales Director at the address below, or send
an e-mail to specialmarkets@workman.com.

For speaking engagements, contact speakersbureau@workman.com.

Published by Artisan
A division of Workman Publishing Co., Inc.
225 Varick Street
New York, NY 10014-4381
artisanbooks.com

Artisan is a registered trademark of Workman Publishing Co., Inc.

Published simultaneously in Canada by Thomas Allen & Son, Limited

Printed in China
First printing, September 2019

10 9 8 7 6 5 4 3 2 1

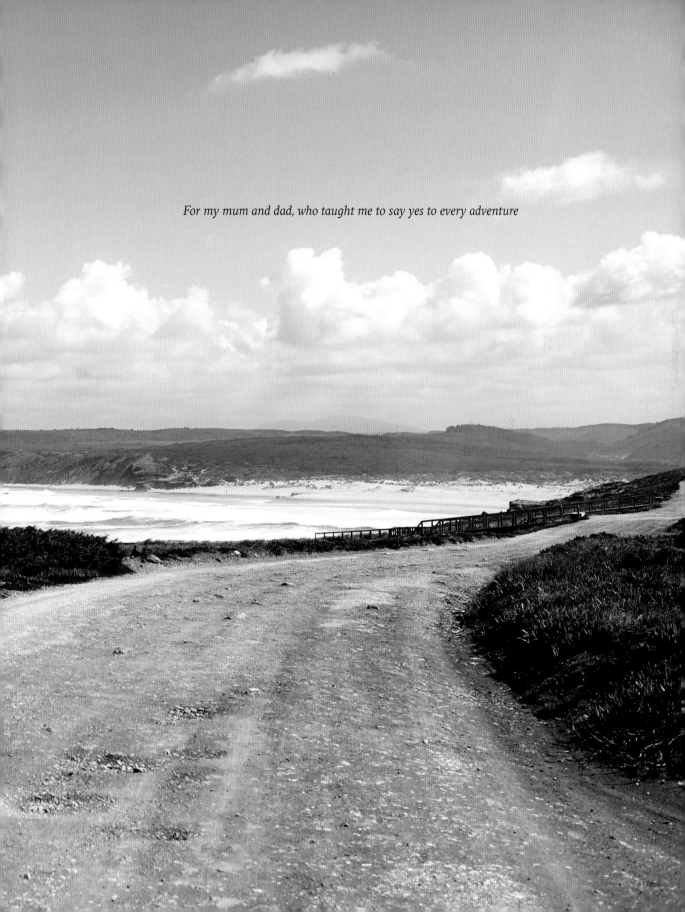

For my mum and dad, who taught me to say yes to every adventure

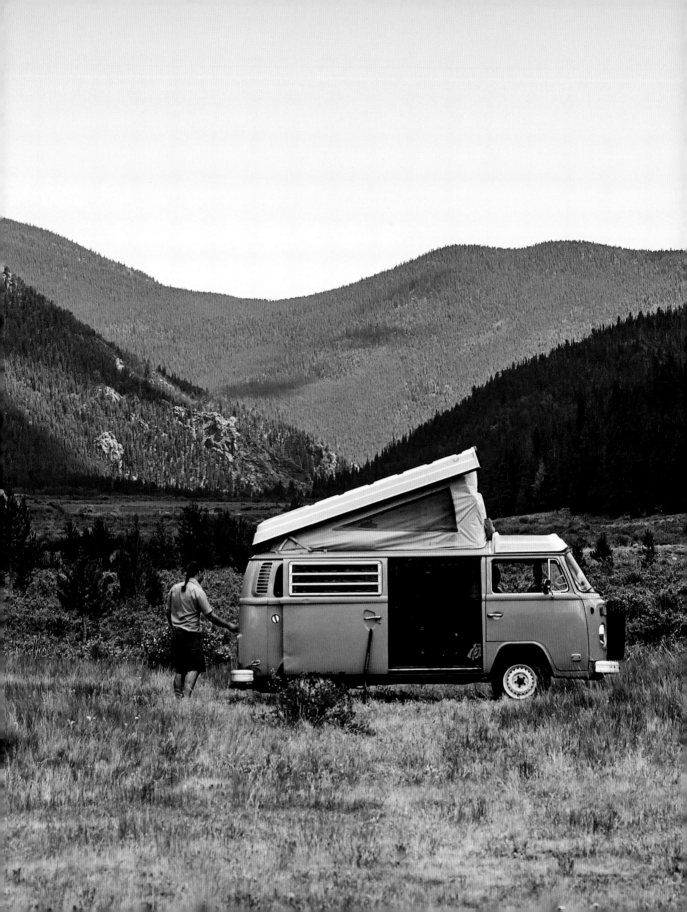

Contents

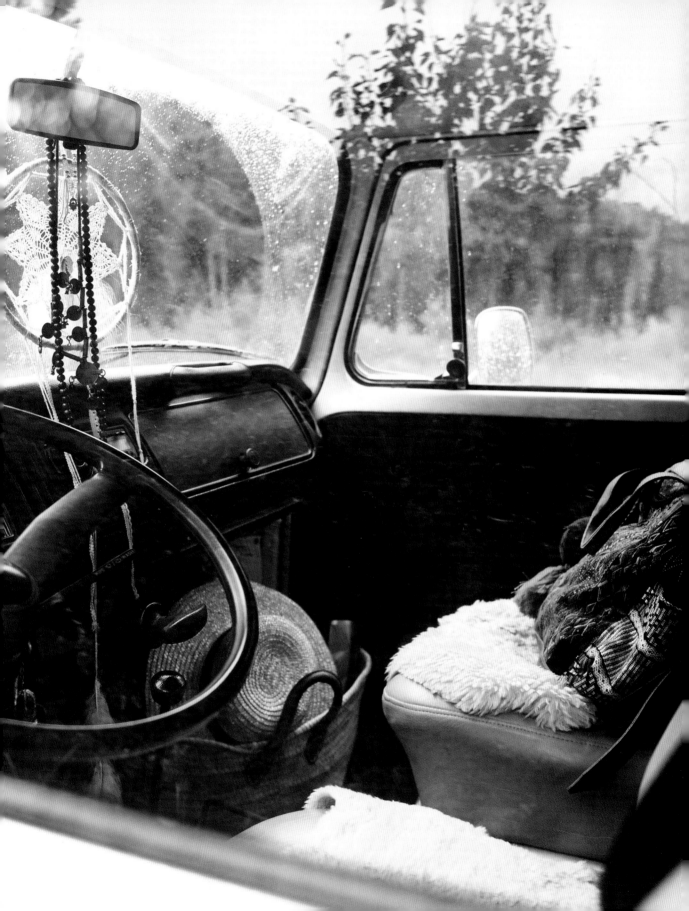

Introduction

When I was growing up, my family was always on the move. We switched houses so many times and took off on road trips and overseas adventures so frequently that I remember my mum remarking on numerous occasions, "Home is wherever we are all together."

I often joke that I lived out my childhood in the back of a car, but it's not entirely untrue. Weekends were consumed by open houses—we moved six or seven times before I turned fourteen—and school breaks were spent driving through the Canadian Rockies or farther afield to the warm lakes of British Columbia. That's when the "training" started for my two sisters and me. Twelve-hour car rides with only one scheduled stop were de rigueur, so by the time we took off on longer treks, along the Eastern Seaboard of the United States, from Madrid down to Morocco, and all over Europe, we were expert travelers learning to love the road as much as our parents seemed to.

And then I stopped. I stationed myself in Toronto, settled into my career, bought a narrow Victorian house in an up-and-coming neighborhood, and had two children. Life was busy, but it was rooted in one spot. So maybe it isn't surprising that when I read about a family living on the road full-time out of a converted Airstream, I was fascinated. Their life was so different from my own, filled with the magic of the never-ending holiday (or so I

thought), but in many ways it was also the same. They had pets, family dinners, satisfying careers, and a beautiful place to call their own. These people looked relaxed and happy, and they were free.

I soon began to find these stories everywhere. The accountant who gave up his well-paying job to surf out his days living in a van; the young couple saddled with student debt who chose to reside in an RV rather than add a mortgage to their financial obligations; the family of five who decided to simplify their lives by moving onto a bus, selling most of their possessions in the process. It seemed that the Great Recession, epidemic student loan debt, climate change, excessive consumerism, and the growing precariousness of the traditional workplace had forced many people to reevaluate how and where they lived their lives, and I wanted to know more.

Just four months after coming across the Airstream family, I embarked on the first of nine road trips that would eventually take me and my photographer, Sian Richards, to six countries, eleven US states, and more off-the-beaten-track side roads and turnouts than I ever visited as a child. What I quickly learned was that I knew nothing about life on the road. While my peripatetic childhood might have given me some common ground with these people when it came to commiserating about seven-hour car rides, bringing myself up to speed on off-the-grid basics like composting

toilets, solar cells, and DC power was like picking up where my high school science classes left off. Thankfully, I wasn't the only one who felt like a newbie.

The fact is, there is no guidebook for alternative living. In speaking with vanlifers, skoolies, liveaboards, Airstreamers, RVers, and tiny house dwellers, I heard again and again that it takes work to establish a home like this, and as much work to stay in one. None of them entered into this type of life knowing all the answers, but they all had a purposeful ambition to find a means out of a conventional existence that was no longer working for them. Whether it was discovering a way to enjoy a more meaningful life that valued experiences over things, finally taking the leap in starting their own business, or looking for a temporary reprieve from the staggering rents in big cities, these freedom seekers were willing to put in the work to forge a new path for themselves.

This life isn't without its trade-offs. While it may appear as if it is one epic Joshua Tree sunset after another, it's also just everyday life—with a few curveballs. The simple gesture of turning on the tap to make a pot of coffee isn't always easy (or even possible), nor is turning up the thermostat when you're cold. Having a big group of friends over for dinner doesn't happen when they're a hundred miles away, and the ability to bake a sheet of cookies is reserved for the lucky few. Even flushing a toilet can feel like a luxury.

Maybe this is why members of this community spend so much time making their homes into places of refuge. When the world is zooming past your window and the days are filled with the unknown, having a bed made with your own sheets or a kitchen where you can cook your favorite comfort meal offers some solace. Likewise, when your home is limited to a few hundred square feet, you need every inch of it to feel like a place where you belong. The mantra "live only with what you love" couldn't ring more true for these nomads. Their homes are the purest representation of authentic living because they don't have the luxury to be anything but.

Put aside any biases you might have about who chooses to live in a school bus or spend their time in RV parks. On these pages, you'll meet a Fulbright Scholar currently editing *The American Journal of Bioethics* at Stanford University, as well as an architect, a software engineer manager, an interior designer, and a nurse. There are skateboard designers and tech entrepreneurs—even a quilt maker. Gone are the days when only retirees and back-to-the-land hippies occupied these spaces. The ubiquity of the internet has ushered in a new era of connectivity that makes working from an Airstream beside a roaring river or running a photography business from a mountaintop a reality. It's now possible to do whatever you want from wherever you want and still have a toehold in the world.

Not everyone adopts this lifestyle for the same reasons. Some are in it for the adventure, while others are looking to downsize. There are those who are following their dreams, and some who are looking for a way to escape the status quo. To that end, I've divided the book into four sections. Many people fall into more than one category, but I've placed them in the one that best suits their intentions. And since I know you may have questions about the fundamentals—where you park, how much it will cost, how to stash your stuff, and yes, even where you go to the bathroom—I have dedicated individual chapters to both bathrooms and storage and created what I'm calling a "Road Map to Freedom": a comprehensive guide to finding the right home, the cost of renovation, handy products for small spaces, and indispensable resources for a life on the road.

The homes and homeowners profiled in the pages that follow are not all alike. Some are mobile and others are stationary. Many people are doing this temporarily, as a stepping-stone to a different life, while others are fully committed. However, they all share one common thread: each of their homes represents a solution to a problem that could not be solved by a conventional life. By embracing the unknown, this new generation of nomads has found a way to pursue what matters most to them.

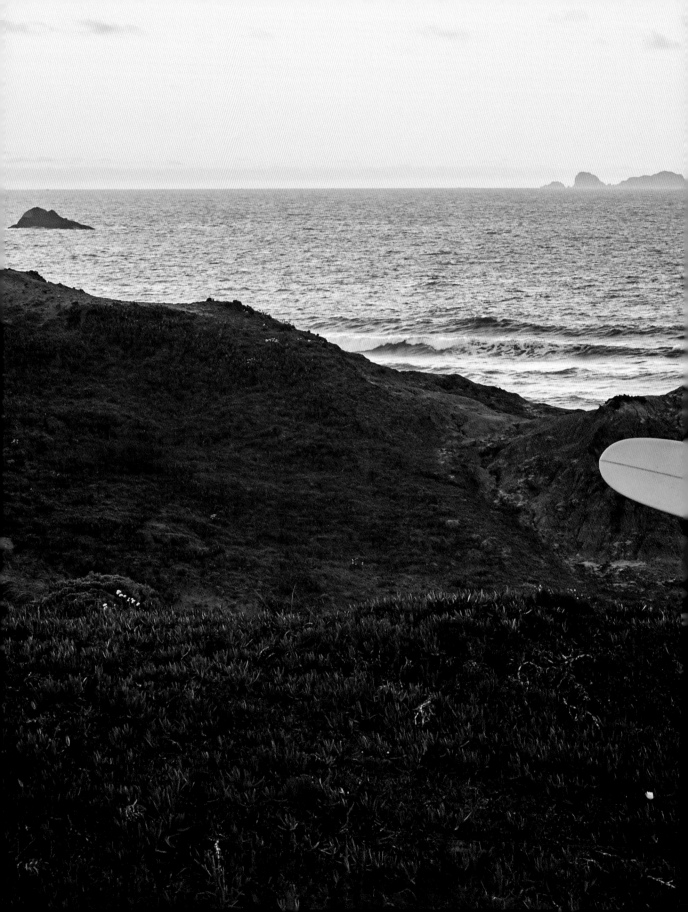

The
Adventure
Seekers

LIVING LIFE FULLY, WITH NO REGRETS,
CHASING THE THRILL OF THE UNKNOWN

The Swell Life

For a lucky few, surfing comes naturally, but for most, it's a struggle. Katharina Körfgen falls into the latter camp—but she wasn't going to spend a lifetime trying to figure it out. After seven years of hitting the break in Biarritz, France, with no improvement, she gave herself an ultimatum: move to Australia for one year and learn to surf, or give it up forever. She parked herself in Byron Bay, an area known for its gentle rolling waves, and practiced regularly. Soon, she was getting up on the board consistently, and her love affair with the sport began.

Fast-forward three years to a small parking lot in Baleal, Portugal, a surfing village about an hour north of Lisbon where Katharina has parked her home on wheels. Dozens of vans of various shapes and sizes—some with full-body wet suits hung out to dry—fill the parking lot, but on the day I visit, no one is in the water. "It's way too windy," says Katharina. "The waves are totally unpredictable. We'll try again tomorrow." Heading to a well-known boondocking area (a place where vans and campers park but without amenities or hookups), she pays no attention

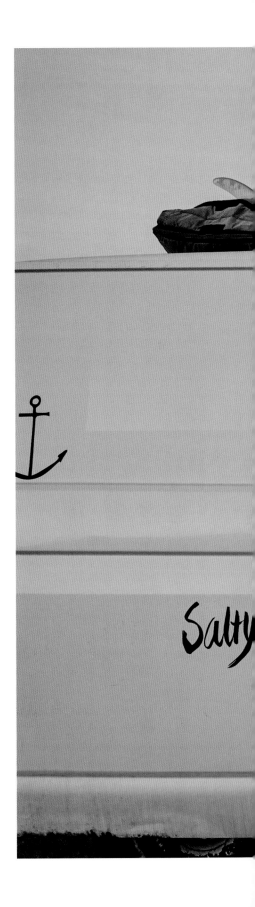

Katharina, a Cologne native, runs her online magazine dedicated to landlocked German surf lovers, *Salty Souls*, out of her van.

Souls

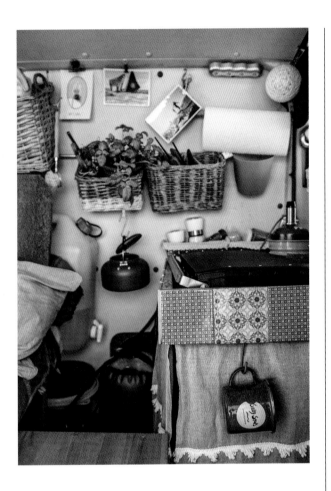

⌃ A PRETTY COOKTOP

A tiled surface and homemade linen skirt form the base for Katharina's two-burner propane cooktop. "I love cooking. I'm not missing out on anything. I make porridge for breakfast most days and then usually pasta, curry, or potatoes for dinner. I'm not a vegetarian, but I don't like meat too much," Katharina says. A lightweight enamel mug with a *Salty Souls* sticker hangs from an S-hook.

⌐ ONE THING IN, ONE THING OUT

Katharina does not convert the back of the van between a living space and a sleeping space; her bed, which measures over 6 feet, is always pulled out. To keep clutter under control, she follows the general rule of donating or throwing out an item for every new thing she brings in.

to a sign that depicts a surfer with a red line slashed through it and carefully winds her way down a dirt path cratered with muddy holes, stationing her dirty white van on the edge of a cliff. While the view is beautiful, parking close to the surf has its hazards. "When it's windy, the car really shakes. I don't know how many times I've googled 'Can a van flip over in the wind?' The answer is usually no, but I don't totally trust it," Katharina says. As she gets herself ready for the evening—she likes to change into her warmer sleeping clothes and prepare a hot water bottle before the sun dips below the horizon—other vans begin to appear across the dramatic coastline, spacing themselves out like beads along a thread.

During her time in Byron Bay, Katharina supported herself by waiting tables. But with a geography degree from the University of Cologne and a passion for writing, she aspired to something more. She opted to return to Europe, but not before stopping off in Indonesia, where she bumped into an old surf buddy. The pair talked about their ambitions to make surfing a more permanent part of their lives and decided to create *Salty Souls*, an 'online magazine for landlocked German surf aficionados.' Katharina would handle the writing, and her friend would provide the photographs and graphic design expertise. They agreed to dedicate themselves to their new endeavor for one year, to gauge its viability. In the meantime, Katharina took her writing more seriously and enrolled in some journalism courses. However, she couldn't get

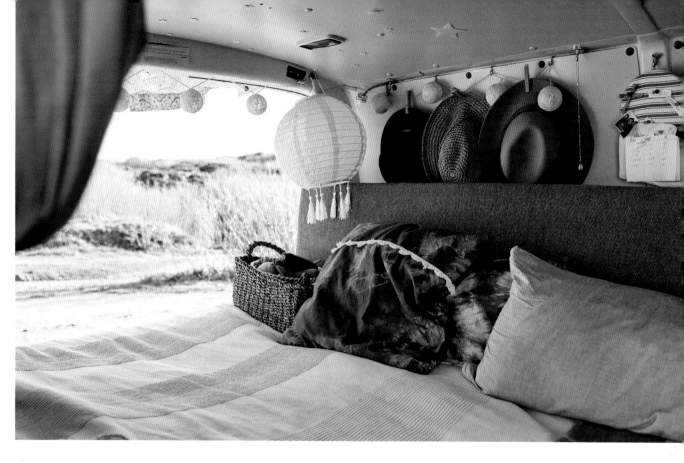

Byron Bay out of her head; she missed riding the waves daily, and she knew this was the time in her life to do it. The only thing stopping her was the bay's remoteness. As a consolation, she figured that she could make the most of the waves in Europe by living out of a van and traveling to the best swells.

She picked out a Volkswagen T5 van and enlisted her dad to help with the conversion. "We were both clueless. We had no idea how to start. Neither of us had ever done anything like this before," she says. They assumed that the custom bed, which measures over 6 feet, would take up the most room, so they began there. In order to maintain the integrity of the vehicle and avoid rust, they stayed away from attaching the bed frame to the bodywork. "My dad is a perfectionist—he likes to have things a hundred percent right—so it was kind of a struggle. We had a lot of . . . *discussions*," says Katharina.

After they built the bed frame, Katharina decided to take on the rest of the conversion herself, to preserve their father/daughter relationship. Aware that her construction skills weren't the strongest, she opted for an easy system of hooks and hanging wicker baskets that hold everything from her toothbrush to a pot of fresh basil and even a panic alarm—a safety device her dad insisted upon—instead of sophisticated built-ins.

Stored behind the driver's seat is a basic two-burner stove, which she heats with camper-size

propane canisters. "It's a nightmare to get big tanks of propane filled in Portugal," Katharina says. "They have them, but it's hard to get someone to sell one to you. At some point, I did get my hands on a tank, but then you need an adapter. Once you've found that adapter, you need to find another adapter to make it work with your particular stove. In the end, I made the decision to stick with the small, camper-size cartridges. It's more expensive, but it also frees up a lot of storage space."

She has no fridge—not even a cooler—but seems to get by just fine. "I don't need it," she says. "I eat milk, yogurt, and cheese, and it lasts for about ten days. I smell it and have a little taste each morning, and it's usually fine." Her most recent purchase is a battery-operated hand blender, which she loves. She makes soups in the cooler months and smoothies and iced coffees (with borrowed ice) in the summer.

To power her phone, computer, and camera, she has a second battery that she recharges by driving. "After a day of surfing, I'll go to the supermarket in the next village, seemingly to buy water but really to charge my battery," she admits. Katharina is also a pro at "borrowing" power wherever she goes—Laundromats, cafés, even the four-star golf resort in the next bay. "I'll pull out my expensive camera, put on some sunglasses and my nicest outfit, and go have a coffee in the restaurant. I bring along my big bag, with all the things I need to charge inside, and I hook them to a power bar. Then I just have the one cord to plug in."

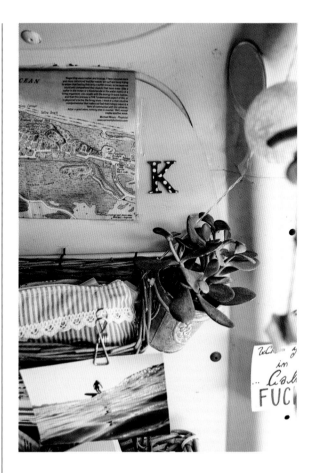

^ STICK IT TO THE WALL

Baskets and even a potted succulent are cable-tied to a metal utensil bar in the back of the van. Bulldog clips, both the regular and magnetic kind, are an easy way for Katharina to switch out photographs and motivational sayings.

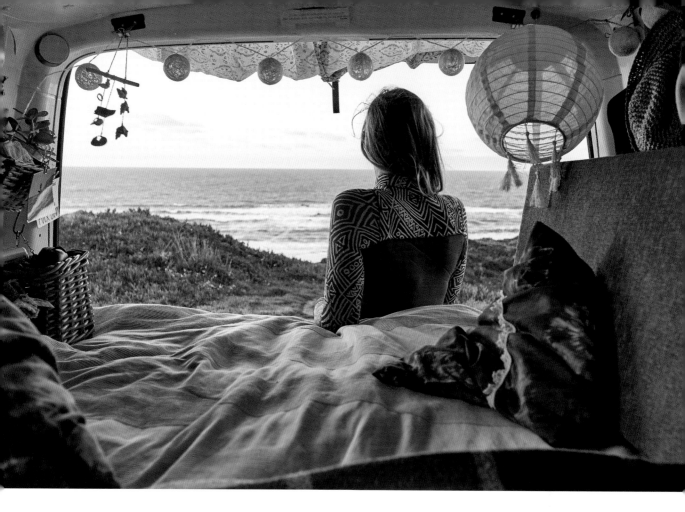

⌃ PARK WHERE YOU LIKE

"In France, parking is a problem; the local authorities knock on your door and you have to move on and pay fines. Spain is the same," says Katharina. "Portugal is a country where you can park wherever you like. But there are rumblings in the surf community that it is going to change." For now, Katharina moves between a few favorite spots near Baleal, never outstaying her welcome.

❯ CONSTANT COMPANIONS

"The hula girl is called Riccarda. I picked her up in San Sebastián. The dinosaur is Tony. I found him in a bar in Byron Bay. They're always with me on the dash," says Katharina. "My van's name is Bruno. I don't know where the name came from. No clue."

She'll also sometimes make use of the showers and sauna at the resort, which can be accessed by paying a fee—about ten euros. Otherwise, she finds a swim in the ocean followed by a quick, cool rinse in the parking lot showers surrounding the beaches perfectly adequate. "When you're surfing, you need a proper shower only once a week. You don't smell, and your hair looks perfect; it doesn't get greasy. But when you don't surf, you need to shower more often," she says.

Her toilet is a lined bucket that is stored underneath her bed. It might sound gross, but human waste is an issue around popular surf spots. With so many people free-camping at the same oceanside strips, the surrounding environment has become a bit of a wasteland. "It's a big problem. People don't like it when you go where you're not supposed to. If you have to, then put it in a bag, like you would for a dog, and just throw it away. It's better for everyone."

Last year, Katharina took a break from van life and moved back to Cologne to make some money over the winter months. It wasn't something she wanted to do, but she was struggling to get by on the few gigs she was picking up through *Salty Souls*. She landed at a start-up writing product descriptions for companies like Amazon. As the summer approached and the waves started calling her name, she felt bad about quitting but hoped the young team would understand. "They totally surprised me. They were so open-minded and forward-thinking,"

says Katharina. Instead of showing her the door, the founders suggested she work for them as a freelancer and write descriptions from the road. She took them up on the offer and hasn't looked back. "Between *Salty Souls* and my new job, I'm working more or less every day. I'm so happy I can do this and be here in this beautiful place," she says.

As a single woman, she struggled to convince her parents that she was serious about living in her van full-time. Katharina's father is still not totally on board. "My dad doesn't really like that I'm by myself in the van. My mom is okay with it, but they're not fans," laments Katharina. "It's been hard to get them to let me go and live the way that I want to live. I don't want to work in an office every day and be in a normal house and just get stuck there. It took me years to really do this. It's still a bit of a journey, I guess."

As the paper lantern and string lights hung in the back of her van flap in the wind, Katharina thinks back on the night she decided to buy the van. "I now know I made the right decision," she says. "As a kid, I was pretty shy—I didn't have much courage. No one thought I would ever do something like this on my own. But then something changed," she says. "Now I'm living my dream."

❯ SURFER'S RETREAT

A pretty patterned-fabric curtain attached to the back window keeps the van dark and private at nighttime.

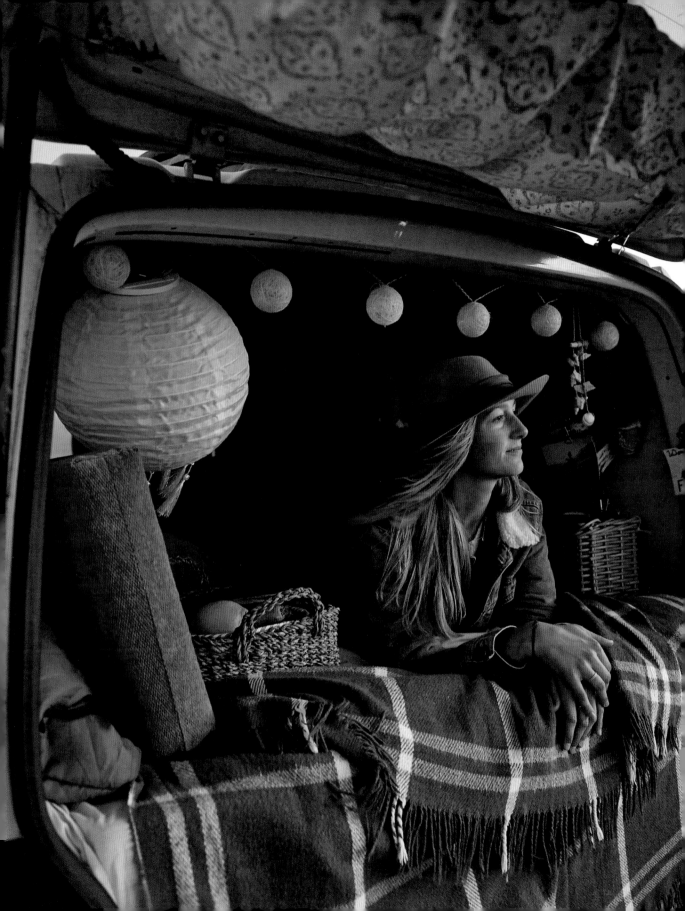

Roving Community Center

"Hi. I follow you on Instagram," says a stocky twenty-something kid in a blue hoodie as he jumps out of his late-'80s Jeep Cherokee, a little embarrassed at how giddy with excitement he is. "I caught a green bus out of the corner of my eye when I was driving by and I was like, 'There aren't that many green buses in the world. I wonder . . . ?' I'm Jacob. I'm always looking through your feed to see where you're at."

"Well, I'm here. I'm right here," answers Michael Fuehrer, seemingly unfazed by the stranger who has pulled off a steep mountain road deep in the Chattahoochee-Oconee National Forests in Georgia to meet him. "That's awesome you stopped. I'm just looking for a place to boondock for the night and thought I might give this spot a try. Do you want to come in for a tour?"

Pushing open the narrow bifold doors of the 2004 Thomas Freightliner, Michael, dressed in a pair of duck boots and a fleece-lined buffalo-check shirt, starts in on a speech he has probably given hundreds of times since he moved into the school bus eleven months ago. As Jacob climbs aboard, still starry-eyed about his chance meeting, he hurries to catch up with Michael, who is already halfway down the 35-foot vehicle.

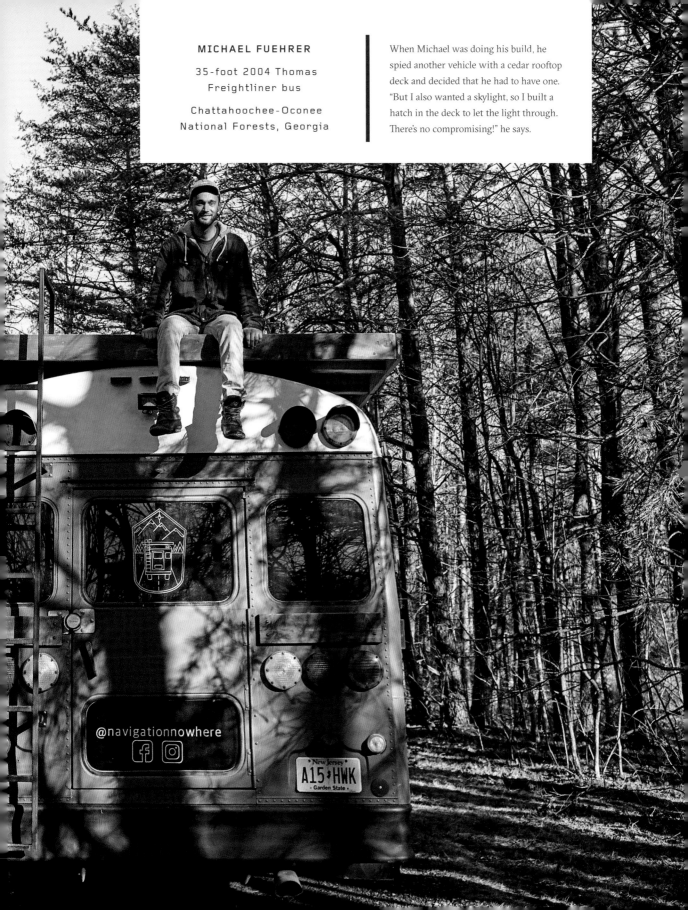

MICHAEL FUEHRER

35-foot 2004 Thomas
Freightliner bus

Chattahoochee-Oconee
National Forests, Georgia

When Michael was doing his build, he spied another vehicle with a cedar rooftop deck and decided that he had to have one. "But I also wanted a skylight, so I built a hatch in the deck to let the light through. There's no compromising!" he says.

@navigationnowhere

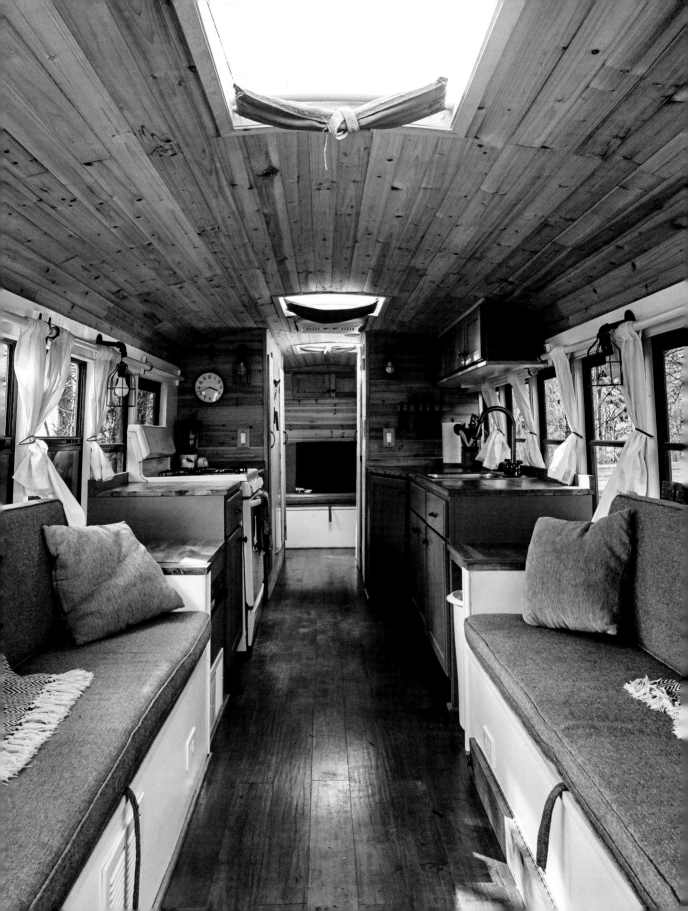

"I made a turkey in this oven for Thanksgiving last year. I put in the full-size stove because it was only a hundred and twenty-five dollars. I sometimes have six to eight people in here, and I need to feed them. The counters are all reclaimed maple, and behind this door is my bathroom," he says, revealing a hip white-subway-tiled wet room with dark grout that looks like it belongs in an Ace Hotel somewhere.

"This is a composting toilet, so I don't have to worry about a black-water tank," he continues, describing the holding receptacle typically used on RVs where the waste from the toilet is stored and has to be manually emptied. "I have room to carry a hundred and thirty gallons of water on one side and a hundred gallons on the other. I also have twenty-nine gallons of propane in the back of the bus, plus a hundred-gallon diesel tank and seven feet of storage boxes. I built this bus to go completely off-grid. Back here is my bedroom and office, but the front seats also convert to a forty-four-square-foot bed."

You can't help but wonder why a single guy has such a big bus, but Michael didn't build the bus to escape modern society or to get away from it all—he made it to bring people together. "For me, there's no point in being on the road

❮ SPRUCED-UP SPACE

The interior of the bus is divided into four zones: the living and dining area, followed by the kitchen, then the bathroom and storage corridor, and finally Michael's bedroom and office. The bus is wired with a Yamaha RX-V379BL stereo system and has surround sound throughout.

if I don't have space for people to join and be a part of what I'm doing," he says.

Before Michael started roaming the country, he was a master's student in theological and cultural anthropology at Eastern University, focusing on homelessness—he even lived on the streets in downtown Philadelphia for three weeks as part of his research. He was wrapping up the last six weeks of his courses, applying to doctorate programs, and putting the finishing touches on his thesis when he had a moment of clarity—he needed a break. He called up two friends, and they all piled into a sedan and headed west to Montana. "After living on the streets, I realized that I just needed to go and engage with life. I was studying people in cultures, and I needed to get out there and experience more things."

He returned in time to hand in his thesis and, after another brief spell traveling and sleeping out of an SUV, he moved into the basement of his parents' house in New Jersey. Michael told his parents one night that he was thinking of buying a tiny home, and his dad suggested he look into decommissioned school buses as an alternative. He mulled it over for a day, then asked his father if he would help with the conversion if he bought one. Neither of them had a background in construction, but they were familiar enough with what tools to use and decided that they had just enough knowledge to figure it out. Three days later, Michael had a bus (which he bought in a private sale for $3,200) in the driveway, and the build commenced.

The first order of business was to remove the rows upon rows of bench seats where years of lost lunch money had collected—a time-consuming procedure that took longer than expected. When the bus was finally stripped down to its shell, Michael began to imagine the possibilities. Unlike Airstreams or RVs, which are designed with living in mind, school buses offer a blank slate. An academic at heart, Michael turned to the purpose of his travels—creating a sense of community—to inform his design. He built two large flannel-covered benches/sofas at the front of the bus that could easily seat eight or more. He chose all his upholstery with spilled red wine in mind and bulked up the construction of his built-in furnishings knowing that people might prop themselves up on ledges, corners, and counter-tops. (These design details came in handy when he recently hosted forty-five people and a potbellied pig on the bus at the end of a tiny house festival he was participating in.) In the rear, he carved out a small private room for himself with just enough space for a bed and a couple of drop-leaf workstations. Influenced by a Craftsman-style house he saw on a trip to Seattle, he painted the cabinets on the bus an earthy moss green and paired them with lots of knotty cedar. On the exterior of the bus, he opted for a more outdoorsy army-green shade, applying the paint by hand so he could easily do touch-ups on the road without making the surface look patchy.

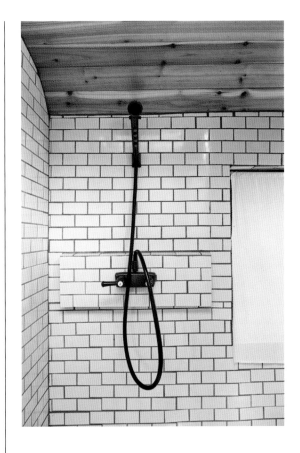

⌃ RIGHT ON TREND

Hip glossy white subway tiles with dark grout line the walls of Michael's ample shower room. He chose a faucet and showerhead made by Dura specifically for RVs and mobile homes that is lightweight and durable. The window to the right provides ventilation. (See page 265 for more on this bathroom setup.)

❯ BUILT TO ENTERTAIN

"When I'm cooking for a crowd, it's great to have this much counter space," says Michael. The moss-green cabinets are a combination of custom-built and refurbished units, while the countertops are made from reclaimed maple that was cut to size, cleaned, and oiled. A narrow pantry and a full-size fridge are situated farther down the hallway.

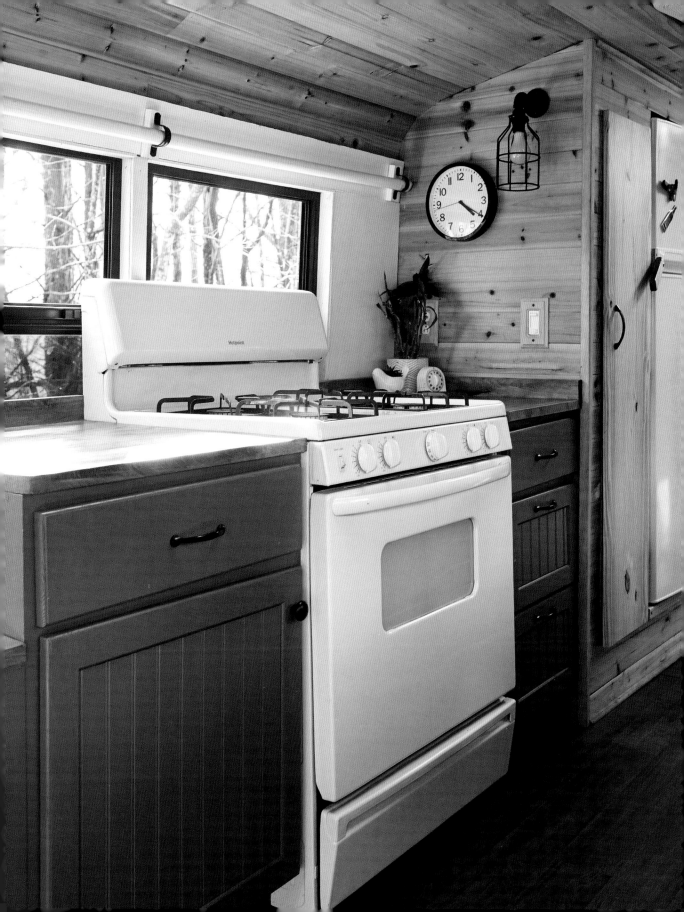

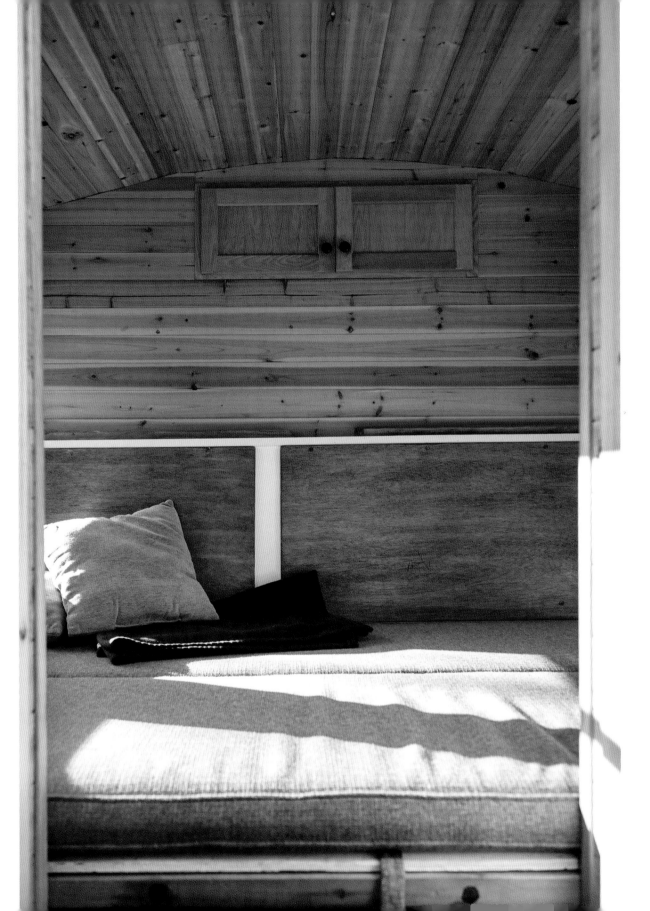

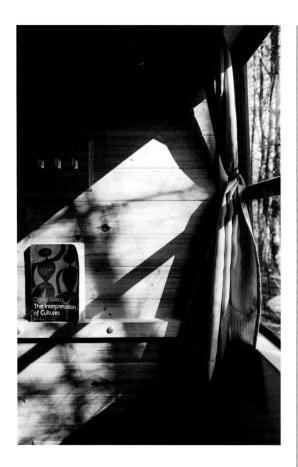

∧ CAUGHT IN THE LIGHT

The Interpretation of Cultures, by anthropologist Clifford Geertz, is one of Michael's favorite books and one of the few he brought with him. Simple pocket-rod curtains in an opaque green fabric provide privacy in the bedroom and help block out early morning sunshine or the bright lights of a Walmart parking lot. Elsewhere on the bus, Michael opted for gauzy see-through panels.

⟨ A TIGHTLY CONFIGURED MASTER BEDROOM

In the minuscule bedroom tucked into the back of the bus, a sofa folds out to make a full-size bed with storage underneath. Everything Michael owns is on the bus. He sold his car, his motorcycle, and anything he couldn't fit before he hit the road.

Nine months after the build commenced, the bus was ready for its inaugural trip. Michael invited his parents and some other family members to join him on the first leg to Yellowstone National Park and then up to Glacier National Park in Montana. From there he traveled with a few friends across the border into Canada through Banff, Alberta, and then over to British Columbia before arriving in Alaska, where he spent ten weeks. Since that first journey, he has meandered around the United States, picking up people—friends and strangers—along the way and dropping many at their destinations.

Through his social media channels and website, Navigation Nowhere, Michael communicates frequently with other skoolies (a term for people who currently own or dream of converting a school bus) who are inspired by his adventure. Fielding upward of a hundred direct messages and emails a day is not uncommon. He makes a point of responding to each one personally and is happy to offer his advice and assistance as needed. In fact, he's turned this demand for information into a way to support himself on the road. Sixty percent of his current income comes from promoting affiliate links on his channels. "I've kind of made it a point that if someone needs my help building a school bus, I don't want to charge them for my time. Instead, I suggest products I've used and direct them to links I've provided. That way, it doesn't take anything out of the pocket of the person I'm helping. My fee is

coming solely from the companies I suggest. Most are happy to help me out."

Currently, Michael spends about eight hundred dollars a month to live comfortably, which includes funds to pay off his student loan debt. Without his loans, he thinks he could survive on two hundred dollars a month. "I give myself only one tank of gas a month," he says. "When I run low on gas, I stop. It forces me to slow down and makes me live within a community for a while."

With the bus tour over and several selfies taken, Jacob begins to make his exit. Before he leaves, the conversation turns to Michael's future plans—for both himself and the bus.

"I've strongly considered going smaller or building another bus. This year's goal was community. Maybe next year's goal will be something different. I'm not sure what yet, but I'm not going to sell the bus," says Michael. "I might rent it out as an Airbnb or keep it in the family and let my parents use it when they retire. I've also thought of donating it to a nonprofit or even renting it out to people who are curious about building one."

"Dibs on first!" says Jacob.

⌃ EXTRA COUNTER SPACE

A fold-down cedar table on chains, directly beside the front door of the bus, is used for everything from outdoor cooking prep to folding laundry. "I can't go to any parking lot without getting stopped," says Michael about his eye-catching bus. "I'm okay with that. I told myself when I started this whole adventure that that was a part of it. The day I say, 'No, you can't come in,' is the day I need to move out of the bus."

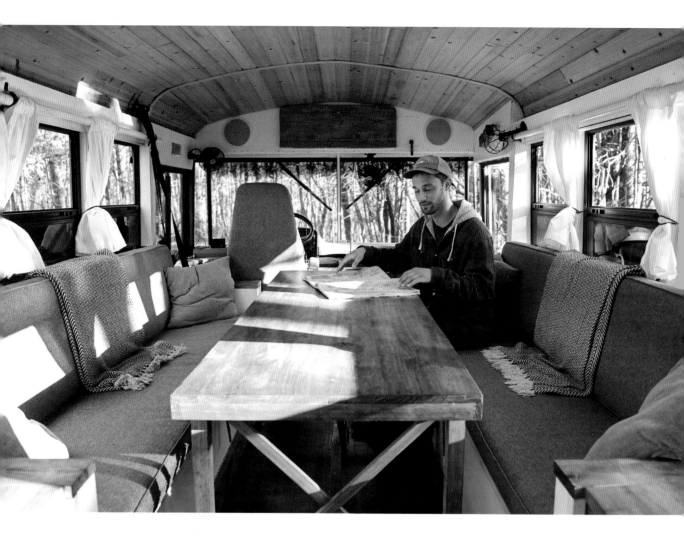

∧ ROOM FOR A CROWD

Michael sits at the 6-foot-long collapsible pine trestle table he designed, which is stored under one of the sofas when not in use. "I really like having clean designs but then also surprising people with things that are hidden away and pop out of nowhere," he says.

‹ WARNING SIGNS

Michael's brother is a volunteer firefighter, and he was adamant that Michael label all the flammables (like gasoline) on the outside of his bus. "He said, 'If you're ever in an accident, you're going to put a first responder in danger if you don't do it.' So I did it."

Home
on the Range

Leaving the town of Moab, Utah, along the Dinosaur Diamond Prehistoric Highway, a lengthy lineup of vehicles plastered with extreme-sport stickers and outfitted with Thule roof racks slowly inch their way over the Colorado River, waiting to take a left into Arches National Park. But if you want to get to Castle Valley, a town of fewer than four hundred people, you'll need to go right and follow the river until you get to a nondescript turnoff. Down that winding road, past local schools and churches, a lush fertile valley resplendent with green vegetation comes into view, standing in stark contrast to the towering terra-cotta-red sandstone formations that surround it on all sides. Most sports enthusiasts don't make it out this way, but if they did, they would find a small community working away as hobby farmers on small 4- to 5-acre lots.

"We had two fresh baby goats about an hour ago," calls out Marcella Garofalo, straightening out her black tank top while she walks toward a blue plastic storage box shaded under a tree.

Standing over the makeshift nursery like a proud mother, Tannaz Darian, Cella's partner of five years, points out the latest addition to the Castle Valley Creamery herd—two black and tawny baby goats (called kids) curled up like a yin-yang symbol.

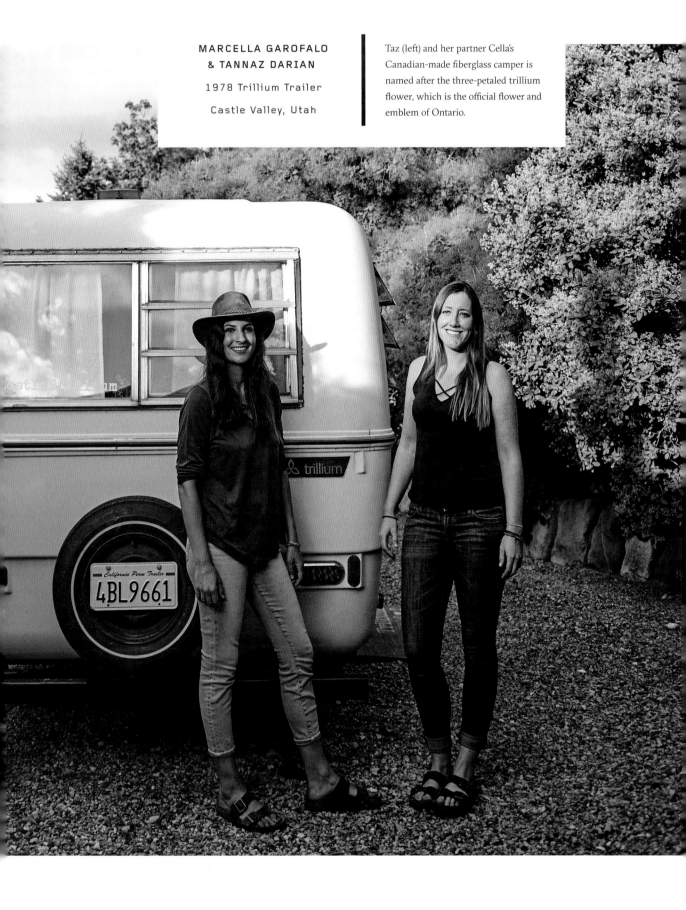

MARCELLA GAROFALO
& TANNAZ DARIAN

1978 Trillium Trailer

Castle Valley, Utah

Taz (left) and her partner Cella's Canadian-made fiberglass camper is named after the three-petaled trillium flower, which is the official flower and emblem of Ontario.

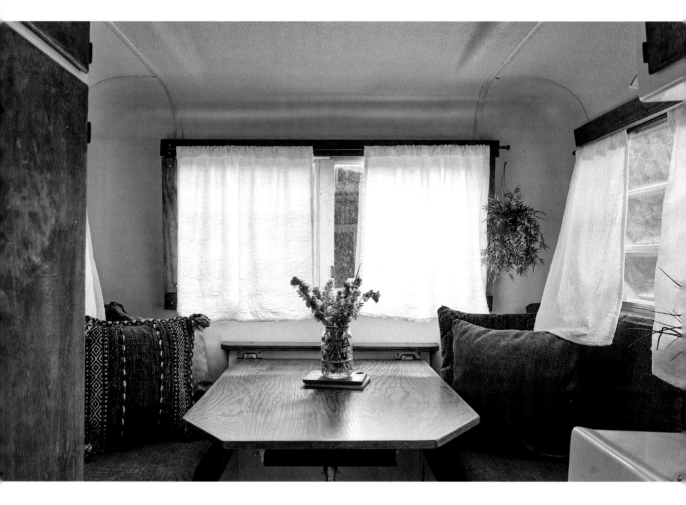

"These two, along with most of the rest," she says, gesturing to the enclosure behind her jumping with over a dozen kids, "will eventually be sold as pack goats to be used for hiking. They'll spend their days going up and down mountains like sherpas, foraging along the way. They're living the dream."

The couple, former city slickers from San Diego (Cella was in construction marketing, and Taz worked at a physical therapy clinic), returned to this farm less than two months ago to assist with the goat birthing season after helping out the owners earlier in the year. They have been on hand for thirteen births, sometimes sleeping in the barn while waiting for the moms to go into labor. Cella and Taz are WWOOFers—volunteer workers for World Wide Opportunities on Organic Farms—and spend about half of each day helping out on a host farm learning about organic farming and sustainable agriculture in exchange for room and board (if needed). WWOOF was founded in 1971 in the UK and has locations in every US state, as well as in many countries around the world. Cella first heard about the organization when she was in college and filed it away as something she'd like to tick off her bucket list.

"I was hustling and commuting every day," says Cella, bottle-feeding one of the small kids. "I'd been doing it for almost five years, and it was taking a toll. San Diego is beautiful, but the cost of living is outrageous. Taz and I were starting to wonder whether we would ever be able to afford a house there. It just seemed so far out of reach for us."

The couple decided to set out on an adventure across the western half of the United States, in part to take a step back from their grueling jobs and also to see whether there were any other places they could eventually settle down. Knowing they wanted to take at least a year off if not longer, they planned to buy a camper and WWOOF part-time along the way. They figured that it would push them way out of their comfort zones and also allow them to sink deeper into the communities they were visiting.

"We've always been campers," says Taz. "We knew we wanted something small with character that we could drive into national parks when we weren't WWOOFing. It took us six months to find the perfect camper, but when we saw her, we knew she was it." "She" is a 13-foot, butter-colored, 1978 Trillium towing trailer with a distinctive bubble shape. The camper was in tip-top condition, with all its original features in place due to having had only one owner—a ninety-eight-year-old woman who stored it inside for the majority of its life. "She traveled with her husband and their three kids in this. Can you imagine?" says Cella.

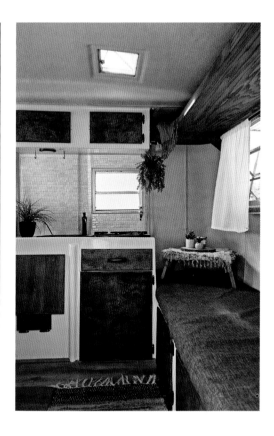

⌃ TRAILER FOR TWO

Cella and Taz removed the second bunk bed on one side of the trailer and made it into a high upper shelf, creating the illusion of more space. The bottom bunk is the couple's sofa. The small portable table comes in handy as a place to chop vegetables or as a tray when they want to eat on their laps or in bed.

⌐ SMALL-SPACE REALITY

Living in this Lilliputian space has had its ups and downs. Native Californians Cella and Taz left home in the fall and headed up to the Pacific Northwest. "By November, the weather had gotten pretty brutal. We were freezing. Plus it was raining all the time and we were confined in this teensy little space," says Cella. The couple has a portable heater, but it only works so well. "There's also no toilet if it's raining out," says Taz with a sigh, referring to the fact that the trailer doesn't have one.

The well-preserved interior included an orangey-brown carpet, plaid yellow upholstery, and rusted-out kitchen appliances. "Plus it smelled like Grandma," adds Cella. Digging the '70s vibe, they kept the gold and burnt sienna color scheme and left the layout of the trailer alone but resolved to replace everything else—cabinets, upholstery, appliances, flooring. Out came the carpet and in went a walnut-looking laminate floor; old cabinet fronts were replaced with new ones; and itchy plaid upholstery was updated with a soft, chocolate-brown linen.

In the kitchen, they switched out the two fixtures the trailer came with—a medium sink and a two-burner cooktop—and put up lightweight, peel-and-stick faux marble tile. They contemplated installing a 12-volt Dometic fridge but decided that it would be too expensive and opted to use a portable cooler instead. "We have only the necessities—the trailer doesn't come with any hookups," says Cella. "We're basically camping on wheels." To bring in some texture and color, the pair added a few houseplants but chose artificial ones so they wouldn't have to worry about upkeep or dirt spilling when they were on the road. The final touch was a selection of pillows in woven indigo and rust-colored velvets. The finished product respects the history of the vintage trailer but is clean and comfortable.

"It was a huge adjustment going from a full-time job—the constant rat race—to slowing down completely," says Taz. "In the beginning, I was going a little crazy because I was so used to having that structure in my life."

"At one point, we were like, what is our purpose? Why are we doing this?" adds Cella. "During some of the lows, we would really have to lift each other up and say, 'It's going to pass.'" The couple, who have been together for five years, turned to Mother Nature—spending time outdoors, going for hikes—to help get them through the rough patches; they were determined not to fail. The pair is impressed with how they've coped with the stresses that come with constant traveling and living small. They've met people along the way who couldn't hack living in such a tight space, broke up, and aborted their trips. "If you're thinking about marriage," says Taz, "I recommend doing a renovation together and then living in ninety-six square feet. See how you do!"

Traveling through small towns and working on farms, Cella and Taz exposed themselves to experiences they never could have imagined back home—slaughtering lambs, growing their own food, delivering breech goats. "It's been very emotional to see the amount of hard work and patience that goes into farming," says Taz, who has since become a vegetarian. "One of the mom goats didn't make it last week and we were

> A QUICK KITCHEN FIX

Cella and Taz chose a peel-and-stick backsplash for the kitchen to keep from adding too much weight to the trailer. The Islamic prayer beads, known as *tasbih*, that hang from the curtain rod were a gift from Taz's uncle. "I personally don't practice," says Taz, whose parents were born in Iran. "But Persians tend to be on the superstitious side, so I like having them around."

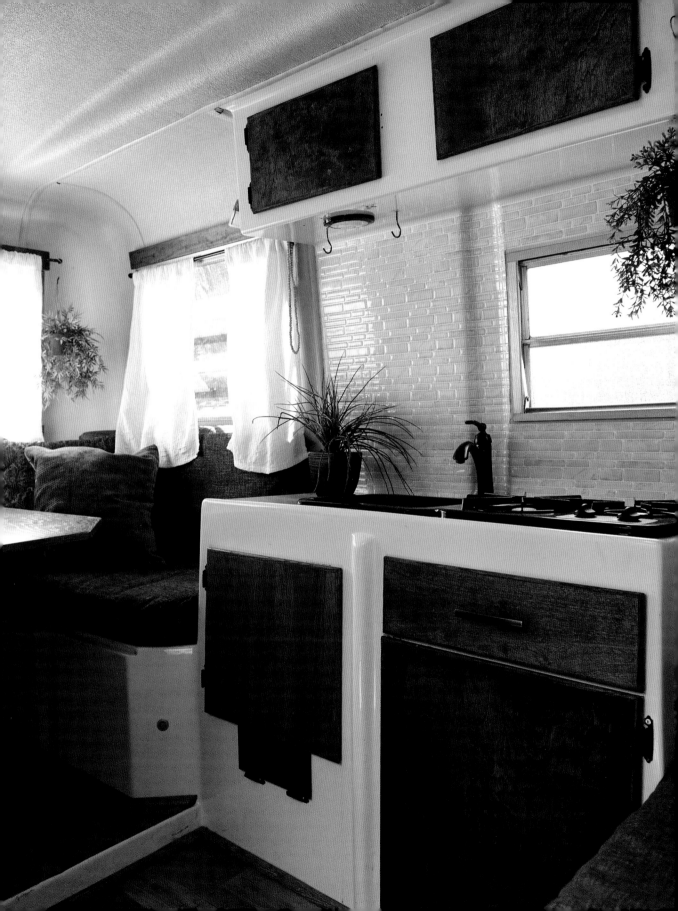

just devastated, but it's part of life—you're going to lose animals, and crops are going to fail."

With almost a year behind them, the couple is still searching for that elusive spot to call home. To date, they have WWOOFed in Oregon, Washington, Arizona, and New Mexico. They're thinking of returning to San Diego, where a secondary investment property—a downtown condo purchased by Taz's parents—awaits them if they want it. It would allow them to save some money for a few years until they get their own place. But the question remains: Where?

"There are a lot of things we're looking for—a decent cost of living, job opportunities, a moderate-size city, and a community that is welcoming to gay people," says Cella. The couple is careful about showing their affection for each other in public while they are traveling, knowing that their sexual orientation may put them at risk for discrimination. "We've felt uncomfortable a couple of times," says Taz. "On those occasions, we leave. If we don't get that cozy feeling, we just book it."

"It's good to get out of our bubble and see all these new places, but I still haven't found a place that touches my heart the way San Diego does," adds Taz.

"There's still Colorado," pipes up Cella. "That's a huge candidate for us."

"Or we could buy airplane tickets and do this internationally," adds Taz.

"Sell the trailer and just go?" asks Cella. "We'll see how we feel."

Their journey may just have begun.

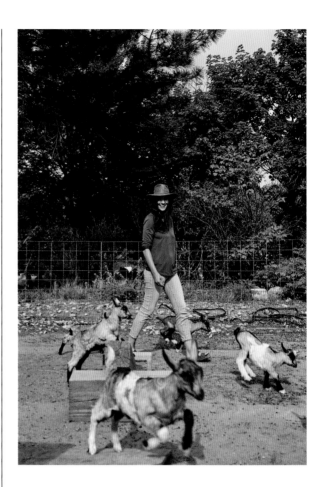

⌃ FARMHANDS

Taz and Cella's main responsibility at their current WWOOF farm is to help deliver and feed baby goats, which are immediately weaned from their mother. Farming is a big change for these former city girls. "You really see a whole different way of living when you travel and work like this," says Cella. "I think you see Americana—that old American style—the farmers and other laborers who built this country, essentially."

❯ A BREATH OF FRESH AIR

Taz's favorite feature of the trailer is the original louvered, or jalousie, windows. Their unique design allows for natural ventilation, as air can come in through the whole window (though they can be a bit drafty).

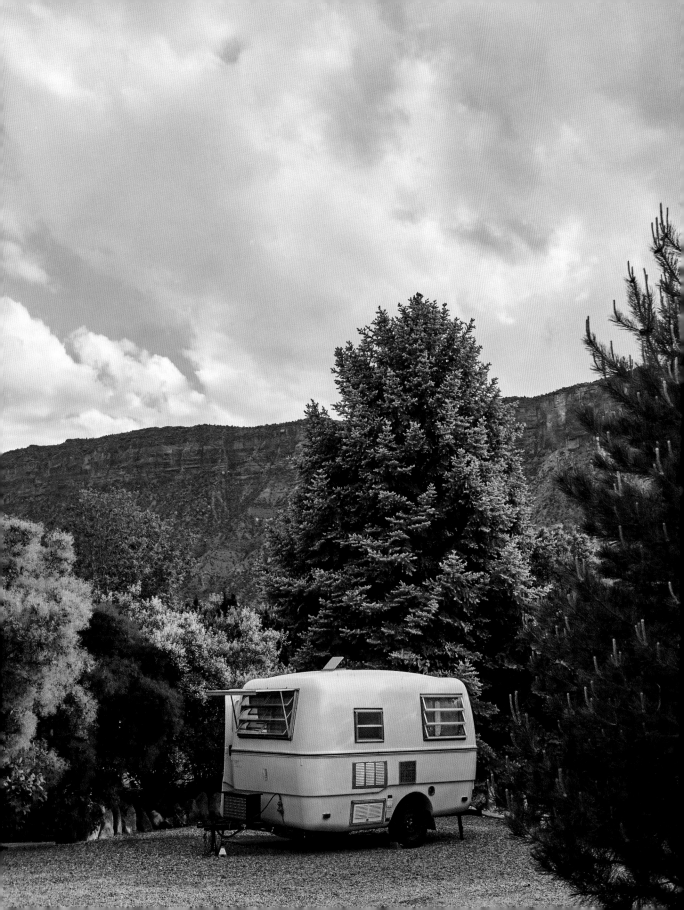

Surf Nomads

In a sleepy Spanish village, far off the track of any tourist itinerary, a ramshackle pale-blue motor home with surfboards strapped to the top rattles into the parking lot of a natural hot spring where locals are unabashedly wriggling into swimsuits. Matt H-B, a charming Brit with sunbleached curly locks, jumps out of the right-hand-drive van and starts to do the same, revealing a tribal half-shield tattoo that extends across the top of his shoulder blades and over his chest. Rummaging in the back for some towels, he calls out to his English girlfriend, Steph Rhodes, and asks her if she has seen the robe they recently picked up in Dakaar in the Western Sahara. With the robe found and another towel dug out of the depths of the vehicle, the pair heads off to the small pool, rubbing their arms for warmth against the encroaching mist.

"It's busier here today than usual," Matt quips. "That's one of the reasons we're careful not to share all our favorite places. It's packed with people everywhere these days."

"We never outstay our welcome. One to two nights tops, because we don't want to piss off the locals," says Steph, conscious of the other swimmers around her. "When we first got this van three years ago, we traveled the coasts of Portugal and Spain without really knowing where to go, but that was the fun of it—exploring places and wondering what was going to be at the end. Would we have to reverse all the way out? Would we get stuck?"

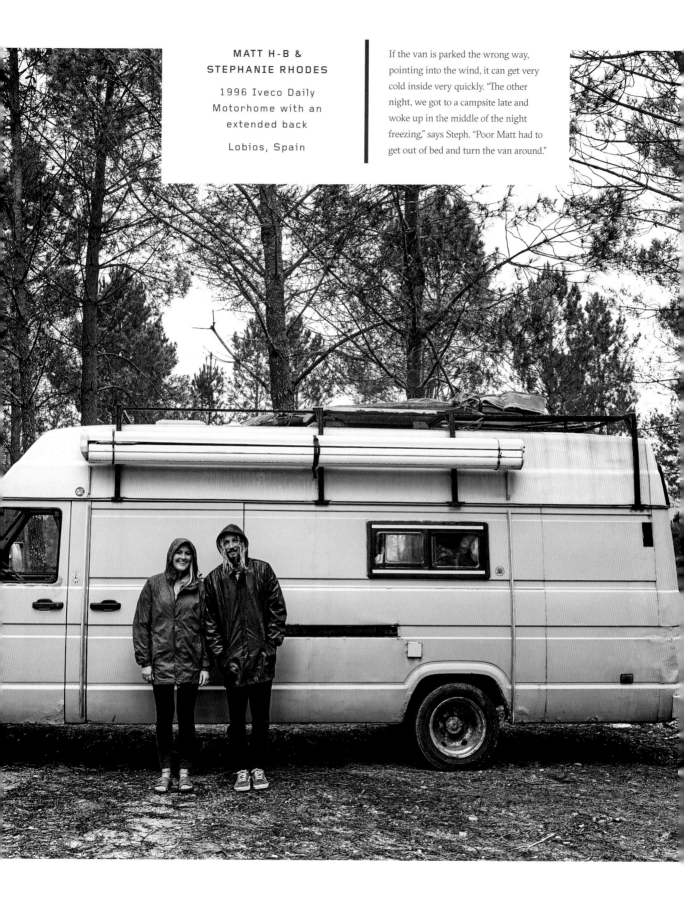

**MATT H-B &
STEPHANIE RHODES**

1996 Iveco Daily
Motorhome with an
extended back

Lobios, Spain

If the van is parked the wrong way, pointing into the wind, it can get very cold inside very quickly. "The other night, we got to a campsite late and woke up in the middle of the night freezing," says Steph. "Poor Matt had to get out of bed and turn the van around."

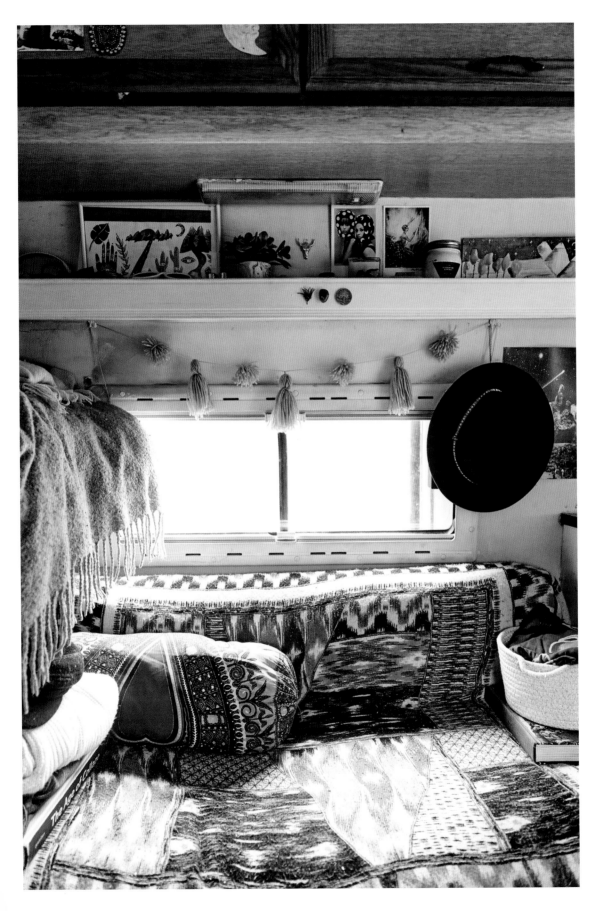

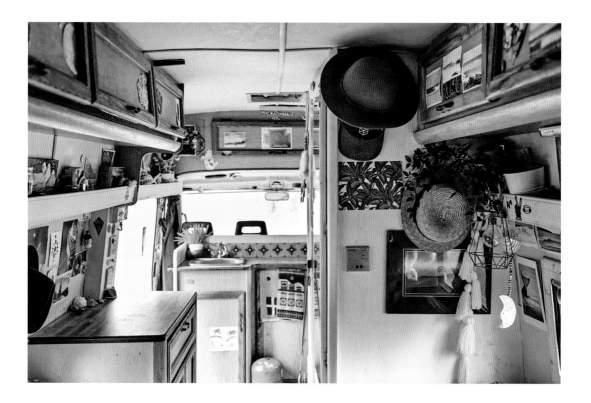

⌃ FORWARD-FACING KITCHEN

The L-shaped kitchen is located directly behind the cab, dividing the living space from the driving space. Matt and Steph love the layout and would go with a similar design if they were to convert a van in the future. "We have so much room," says Steph. "It's sectioned into different areas, so when someone is in the kitchen, they feel very far apart from someone on the benches or bed." An intricately detailed Spanish-looking tile found on Etsy was installed by Steph to create a backsplash.

⌃ BOHO BENCH

The textile on the living room bench is from Canada and was given to Steph by her mom, who recently traveled there. Steph loves hats and displays them throughout the van, along with anything else she finds interesting or pretty, including postcards, bunting, and tiny pieces of artwork.

"You don't get the same satisfaction if you're told where to go, do you? That's the fun of living in a van and traveling," says Matt.

These two would know. Matt, a talented and accomplished surfer with a fine-arts degree in photography, and Steph, a dedicated surf enthusiast with an illustration degree, have been living full-time on the road for almost four years now. They began their foray into small-space living after knowing each other for only three months, on a yearlong surf holiday in Australia where staying in a compact Ford Econoline was a cheap alternative to hotel rooms. Lately, their home base has been a 1996 Iveco Daily Motorhome, affectionately referred to as Ivy. Their protective attitude toward their self-discovered hangouts is one shared by many vanlifers, especially those

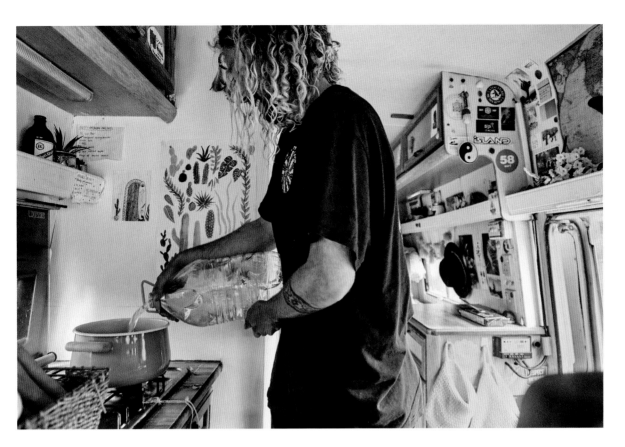

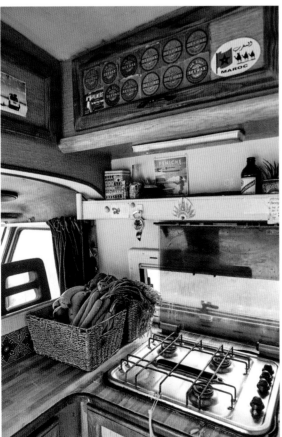

⌃ WATER WAYS

The motor home has freshwater tanks, but the couple doesn't always fill them because doing so adds weight—something they are very conscious of since they travel with multiple surfboards (five at last count, plus a body board) and all their worldly possessions. It also gives them less clearance on dirt roads. When they are close to towns, they will simply fill up portable water bottles instead.

❮ EATING ON A DIME

Matt and Steph make all their own meals and are careful to live within their means. They like to shop in local markets and pick up fresh produce along their route. The van has a fridge, but the pair uses it only when they have access to hookups. A piece of string tied to the cooktop keeps the drawer from sliding open when they are driving.

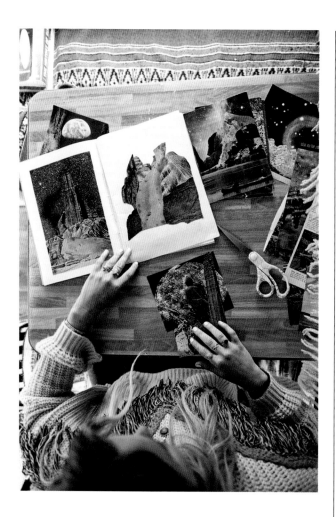

∧ PUTTING IT ALL TOGETHER

Steph uses old *National Geographic* magazines to make collages, which she sells on Society6.com. She's also working on an illustrated children's book about van adventures. "Ivy is our moving art studio–cum–surf shack," says Steph. "I like collaging and layering and collecting, so traveling around and picking up things wherever we go is perfect."

who have been on the scene for a few years. It's not unlike the surf tradition of localism, where native surfers claim the territory around coveted waves and deter outsiders from even entering the water. It was a lesson Matt and Steph learned firsthand when they left Australia to join a new business venture that some friends of Matt's were getting off the ground in Portugal.

The idea was to run a couple of mobile surf trucks up and down the Atlantic coasts, showing wannabe surfers the best surf breaks and offering them lessons. For eight months, they gave it a shot, but it became apparent that the idea wasn't going to work. "The thing with surfing is that you're in other people's territory, so if you turn up with a bus full of strangers, you're not very welcome," says Steph.

"The locals were not happy," adds Matt with a sigh.

The couple said good-bye to their partners and returned home to England, where they had originally met during their university days. Back on their own soil, they settled in surf-friendly Cornwall and found jobs working at a beachside surf shack giving lessons to happy amateurs (Matt) and running the day-to-day operations (Steph).

With their 140-square-foot rig now their bona fide permanent home, they got to work making it into a charming surf shack on wheels. The first order of business was to lower the bed platform, which had been built quite high by the original owners to accommodate their motorcycles in the rear. Once the mattress was

at a more agreeable height, Matt and Steph layered folkloric pillows atop basic white sheets and illuminated the sleeping nook with a row of pretty battery-powered Edison-bulb lights. Instead of replacing the dated wood cabinetry throughout, they covered the surfaces with favorite photographs, surf stickers, and Steph's own otherworldly drawings and collages, bringing a laid-back, devil-may-care vibe to the whole interior. Below the bed, a pair of facing built-in benches were draped in boho ethnic tapestries collected on the couple's travels and made more useful with the addition of a tabletop that can be pulled out for meals or whenever they need to work on their laptops.

They squirreled away as much money as they could that summer in England, and when winter came, they were flush enough to take off down to France, Portugal, Spain, and Morocco to do nothing more than surf for six months. It's a pattern they have repeated for almost four years now. "We wouldn't be able to rent in Cornwall and then afford to take off. Living in the van lets us do the things we love—surf and travel," says Matt.

The bed, which has a memory foam mattress topper, is not quite long enough to allow both Matt and Steph to fully stretch out, so they tend to sleep diagonally. The couple swears by hot water bottles, which they pop into their bed before they get in. "They're our saviors," says Steph. "So simple, but it works."

There are a few compromises, of course. "We don't use our fridge when we travel," adds Steph. "We have hookups when we are stationed

⌃ CUT AND PASTE

The van's walls provide space for photographs, Steph's collages, surf stickers, and other bits and bobs that remind the couple of their journeys.

❯ ROAD MEALS

Matt and Steph tend toward vegetarian meals out of convenience. "Steph's a bit more experimental," says Matt, "whereas I'm more slapdash. I'll make lots of stuff with sauces—pasta, rice dishes, curries—but Steph will make things like chicken dumplings or a cake. For her birthday, she wants this stovetop cake baker called a Wonder Pot that you can put on top of the gas stove, because we don't have an oven."

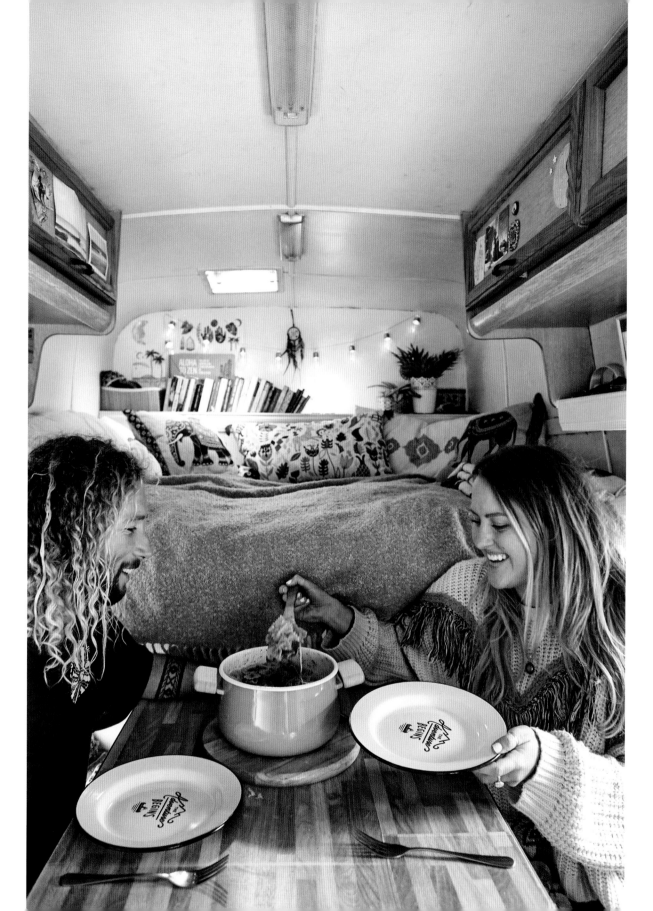

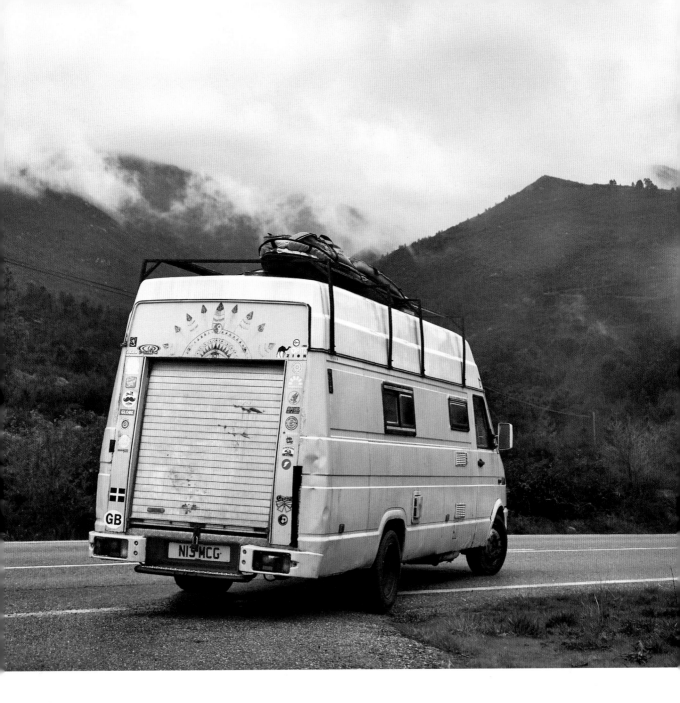

⌃ NO SURFACE LEFT UNTOUCHED

Matt and Steph paint the van themselves every six months or so with a Tekaloid paint commonly used on motor coaches. "The ocean breeze just eats away at the paint," says Steph. "It's definitely showing its adventure," adds Matt.

⌐ OLD-SCHOOL NAVIGATION

Trusty old paper maps come in handy when you're trying to save the battery on your smartphone.

in Cornwall, but out on the road it's too much of a hassle. Having a cold beer would be nice sometimes, or cold milk, but—"

"Cold milk on cereal is a dream," pipes in Matt.

While none of their family members or friends have come forward and explicitly said it, Steph and Matt get the feeling that most people just don't understand their choice to live in a van. "They think it's a phase," says Matt, but for both him and Steph, this is a

conscious decision. "I can't imagine working a nine-to-five job," says Steph. "I have friends who have design jobs in London and sometimes I think they've got their stuff together, but they never have any money. London is so expensive. They're just working to pay for everything." She and Matt are aware, however, that their choice to live in the moment and do what they love comes with its own costs.

"You have to make a sacrifice somewhere, don't you?" continues Matt. "And I'd say we've sacrificed the stability and security that come with following a traditional career path and settling down." The couple knows that their way of life isn't a conventional one, but they feel that their experiences on the road have prepared them for the future in ways that will serve them well. "Risk is second nature to us," says Matt.

"We are constantly dealing with the unknown," continues Steph. "We're addicted to that unpredictability, and as a result, you become adaptable—super adaptable."

As Matt and Steph wind their way through the local bathers to the far end of the hot spring, Matt comments, "We often stop in here on the way back up to Cornwall. You want to remember this heat for all those times when you're freezing cold, coming out of the sea dripping wet. My dad has this saying, 'Grab a piece and put it in your pocket,' and we always keep that in mind. That's what we are doing out here. Putting lots of memories in our pockets."

Take the Wheel

"We get in fewer fights if I drive," says Danielle Boucek, backing the converted RV she shares with her boyfriend, Tommy Krawczewicz, into a camp spot just outside of the Appalachian Mountains in Northern Georgia. "I'm a terrible backseat driver, and I'm a really, really bad *hey-you're-driving-my-home* kind of backseat driver. So I drive a lot now. I'm a control freak."

Tommy nods in agreement and then breaks into laughter, adding, "It's kind of funny considering that driving is all we do now."

Danielle and Tommy, both in their mid-twenties, have just spent the past three days at a tiny house festival in Atlanta, Georgia, a gathering for curious onlookers and would-be joiners of the burgeoning small-space movement, answering questions about their newly renovated 1992 Toyota Odyssey motor home and speaking the truth about what it's like to share fewer than 150 square feet with each other and two dogs. They're exhausted and happy to have found a spot with no other campers around.

"When people ask us what kind of vehicle they should get, I tell them to be super realistic about what they need," says Danielle, a California-born beauty with African American, Filipino, Irish, and Czech roots.

"Tommy wanted a sofa because he hates to feel like he's just lying around in bed all day. We also wanted a full

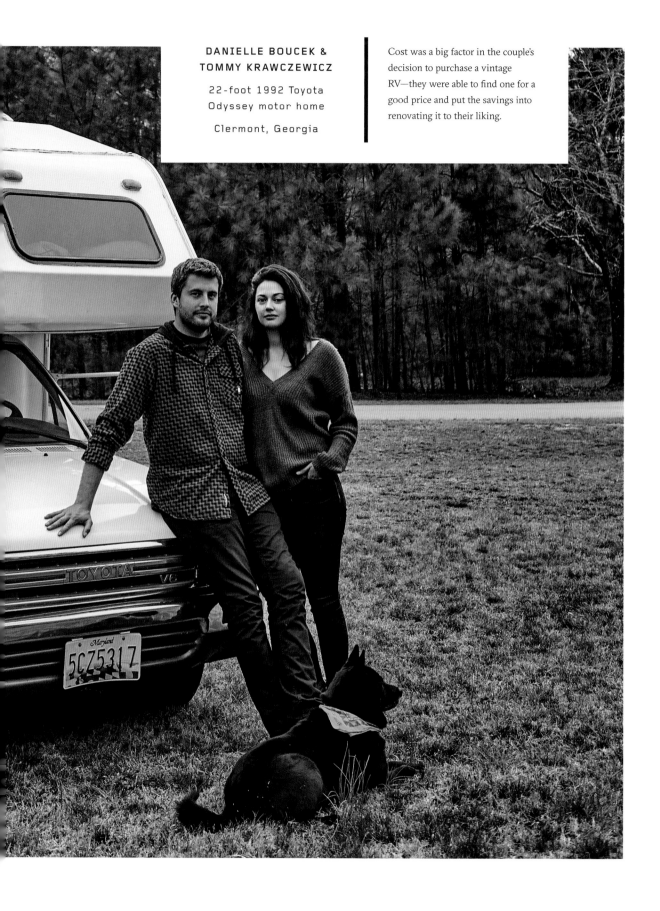

**DANIELLE BOUCEK &
TOMMY KRAWCZEWICZ**

22-foot 1992 Toyota
Odyssey motor home

Clermont, Georgia

Cost was a big factor in the couple's decision to purchase a vintage RV—they were able to find one for a good price and put the savings into renovating it to their liking.

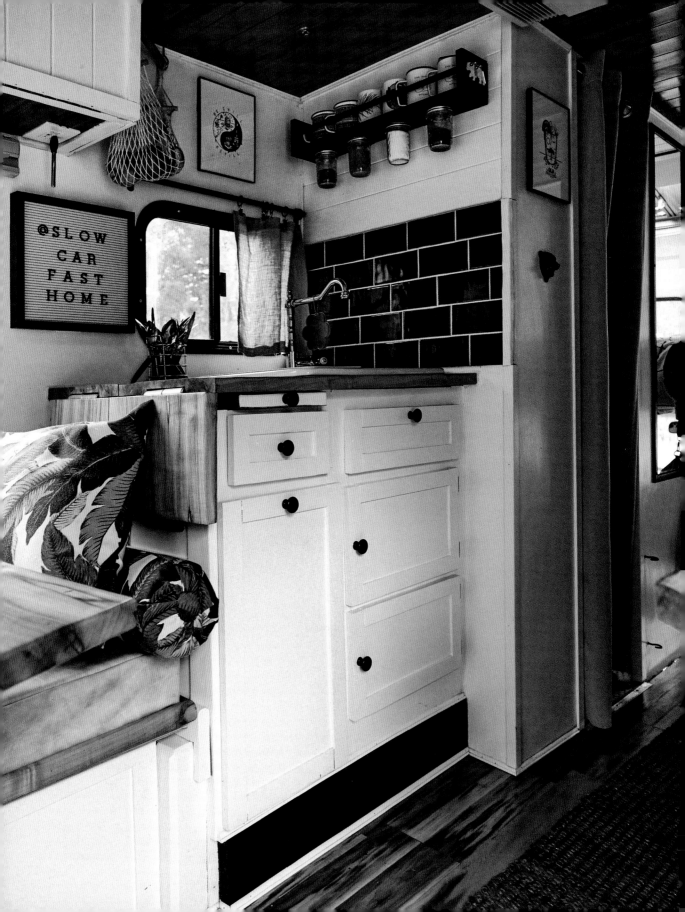

@SLOW
CAR
FAST
HOME

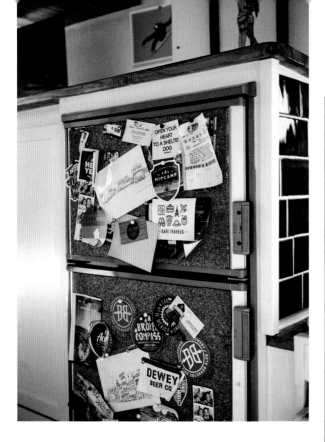

▲ DIY CORKBOARD

Instead of replacing the original Dometic fridge, which was in good working order but looked a little dingy, the couple glued panels of cork to it using construction adhesive. "My biggest problem is finding tacks that are short enough, because it's not very deep," says Danielle. "They stick out pretty far."

❮ BEACH BUNGALOW ON WHEELS

In a small space, the key to a cohesive look is sticking with a limited palette. Danielle and Tommy chose a color scheme of white accented with hits of black and emerald green and finished it off with natural wood, which they repeated on the floor, countertops, and ceiling. The countertops are made of ambrosia maple finished with multiple layers of Interlux Compass Clear varnish; the Havsen sink and Glittran faucet are by Ikea. A flip-up countertop extension as well as a pull-out cutting surface above the top drawer extend their prep space in the kitchen. The banana hammock is by Prodyne.

bathroom (see page 271), an area to run our businesses, a place for our dogs, and enough headspace for Tommy to stand up—he's six foot two," says Danielle.

Tommy and Danielle, who met in eighth grade and have been a couple since their senior year of high school in Annapolis, Maryland, first experimented with close-quarter living on an epic seventeen-hour road trip to California one summer. They pit-stopped in the parking lot of a Las Vegas casino and slept with their two dogs in the back of their small car. Not long after that, one of Tommy's dad's neighbors was trying to get rid of an old Ford Econoline conversion van that was taking up space in his driveway. Thinking it might be useful to his son, Tommy's dad took it off the neighbor's hands. He replaced the battery, put in some new carpet, and drove it out to Denver, Colorado, where the couple was living at the time.

"Suddenly, we were in business," Tommy says. He and Danielle, who both dropped out of college after a year, had been working in the service industry while experimenting with their own craft-based companies—designing T-shirts and art, making marijuana rolling trays, and customizing longboards. At first, they sold these items to their friends; but as the positive reviews kept pouring in, they expanded their businesses online and started selling their wares at pop-up shops and markets, using the van as a portable booth.

All the money they made from their part-time vending went into a jar—a savings method

Danielle swears by. "If I can't see it, it's not real," she says. Tommy, who was starting to tire of their lifestyle ("We were just working to live—it didn't make sense"), had spotted a few retro Toyota RVs around the city and was thinking that their savings, which at this point was topping $10,000, should be put toward buying a new vehicle, something that could take them farther afield than their current conversion van.

Danielle indulged his fantasy and even went as far as to test-drive a few different RVs. "I think I was banking on him not being able to find the perfect one. But then after about four months of searching, he called me at work," she says. Tommy had found a 1992 Toyota Odyssey in original condition with a V6 engine in Seattle for $11,500 that looked really good on paper. He contacted his dad and asked him if he wanted to fly out to the West Coast to take a look at it. Just in case, they purchased one-way tickets. "The next thing I knew, Tommy and his dad were driving back to Denver with our new RV," laughs Danielle.

She and Tommy parked the vehicle, which they ended up paying only $7,500 for after some persuasive bartering, outside their apartment in Denver for four months. Every night, they would look at inspiration photos Danielle had pinned to her secret RV Pinterest board. ("So nobody would see how weird I was," she says.) When their lease was up, they sold off most of their possessions, including the conversion van, and headed home to Maryland,

where they could easily renovate the rig with the help of their parents and community.

They began by stripping the motor home of its retro styling, including bumper-to-bumper blue shag carpet, frilly curtain valances, and pale-wood-veneer cabinetry. With everything removed, they noticed that the RV had weak spots throughout the floor from previous water damage, something not uncommon for this year and make of vehicle, so they shored up the floorboards and improved the insulation throughout. With those things out of the way, they got to work on their "beach bungalow on wheels," creating a huge L-shaped sofa topped with easy-to-clean, marine-grade vinyl fabric (a necessity with the couple's two dogs, Missy and Trip). When it came to the kitchen, Danielle was at first reluctant to choose white cabinets, knowing that keeping them clean would be a chore, but in the end, she decided that it was the only way to achieve the "light, airy, awesome" look she was after. To get that laid-back, tropical vibe, she and Tommy added palm-leaf-printed pillows and glossy green subway tile. With the interior complete, they repainted the exterior in the same palette, applying a single gallon of white glossy polyurethane paint to the exterior with a spray gun and then hand-painting green and tan stripes.

To fund their travels, the couple made sure there was room in their RV for their businesses. A stand-up office with a computer screen that can be swiveled toward the bed and used as a TV screen to stream Netflix or Hulu was placed

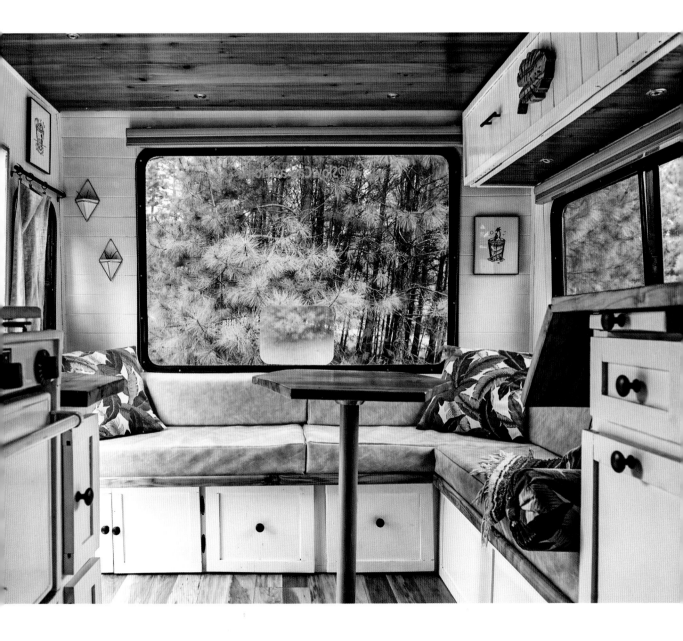

∧ PROTECTION FROM THE ELEMENTS

The most recent addition to the RV is motorized, insulated blackout shades. "We still have some of the natural linen curtains that I made," says Danielle. "But on the road, you can see right in here at nighttime." The copper and ceramic plant holders are by Lanmu and can be purchased on Amazon. The couple mounted them with screws but then added Command Strips to keep them from rattling around when the RV is in motion.

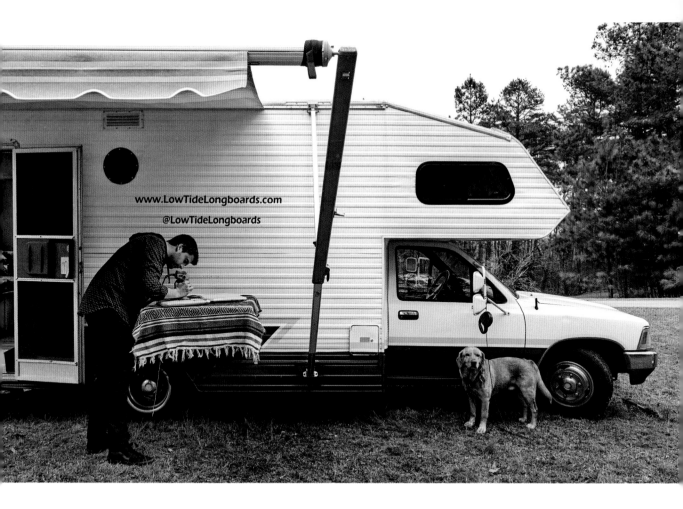

www.LowTideLongboards.com
@LowTideLongboards

just beyond the kitchen. A small portable printer is hidden away in a closet and brought out only when needed. Elsewhere, an overhead cabinet outfitted with pegs is used as a drying rack for recently painted longboards, and a rectangular toolbox installed on the back of the RV is filled with routers, sanders, and spray guns.

After eight months and $7,000 spent on renovations, Danielle and Tommy were finally ready to hit the road and start their new nomadic life. They assumed it would be smooth sailing. They had been in the RV practically every day since they bought it and were used to the close confines of the space—or so they thought.

∧ MOBILE WORKSTATION

Danielle and Tommy collaborate on everything they make—longboards, rolling trays, art—with Tommy doing most of the cutout work and Danielle doing the painting. They have a generator they can plug all their power tools into no matter their location and have recently hooked up their rig with Humless foldable 130-watt solar panels. The motorized canopy provides shade when they need it.

"We had a bad first two weeks," says Danielle. "It was pretty difficult to adjust. You think because you're in it all the time during the build that it will be the same, but it's not. We were bumping into each other, we were bumping into the dogs, and then we also had to figure out all the practical things, like how much water would last us a week and whether we were going to poop in the toilet."

"All the big questions," says Tommy, with a smirk.

To keep themselves from going crazy in the 8-foot-wide space, they developed a set of rules. Danielle would take care of cleaning the bathroom, while Tommy would be responsible for the black-water disposal at dump stations. They would share the cooking, but only one person and one dog would be allowed in the kitchen at any time. They would attempt to use as little water as possible cleaning dishes so they could save it for showers. Finally, only one person would be allowed to get changed at any time in the tight area in front of the bathroom where their closets are located.

To their surprise, running their businesses from national parks and parking lots across America has proven fairly easy. With their two dogs in mind, they tend to travel north in the summer and south in the winter so they are not exposing the animals to extreme temperatures, but otherwise they roam freely. They carry a limited amount of supplies on board, and when they run out, they get more delivered to either UPS stores, which hold products

for up to a month, or Amazon lockers, which have a shorter, one- to two-day window. They have separate Instagram accounts for each of their businesses, and they can see a direct correlation between sales and the number of posts they put up. When things get slow, they know it is often because they have neglected one of their feeds. They've experimented with revealing their nomadic lifestyle on one of the accounts, sprinkling in stunning landscape and RV photos among product shots, and have found those customers much more tolerant of longer delivery times. "I recently told a customer that we had some travel days coming up and that her package would be delayed by about a week, and she was like, 'No problem. Take your time,'" says Danielle. If sales slow, the couple just stays put for a few days and works on the businesses; not only does it get them refocused on their work but it also cuts their living costs dramatically when they don't have to pay for daily tanks of gas.

As Danielle pulls out her phone to plot their next trip—they're headed down to Florida to celebrate her grandma's birthday—she remarks, "This probably sounds crazy, but the hardest thing for us is finding time for ourselves. We both come from big families, and now that we're mobile, we get requests like, 'Can you be in Virginia on this day for this birthday?' They never expected it of us when we were in Denver, but now they think we can be anywhere at any time."

"As long as she's behind the wheel, though," says Tommy, poking fun at Danielle. "It's all cool."

Wandering
the World

"I thought I was going to die," says Kim Finley, stirring some miso and kale into simmering water on her two-burner propane stove. "The Malaysian doctors had me on an intravenous drip, and I was lying there thinking, 'I'm not going to make it. I've done everything I wanted to—I've traveled to almost two dozen different countries—but I put my relationship on the back burner.' I told Nash that if I did make it through, I wanted to return to the United States, get married, and live in a van."

Nash Finley, a soft-spoken Arizonan with a laid-back, skateboarder attitude, blushes as he recalls the time in Southeast Asia when Kim, suffering from dengue fever, pivoted their life in a whole new direction. He had just joined her for a few weeks of road-tripping through Thailand, Malaysia, and Nepal while she finished up a six-month internship for her hospitality degree when the fever struck. Luckily, she made a full recovery, and without wasting any time, the couple made good on Kim's request—they flew home to America, bought a VW van, and got married two months into their life on the road.

Parked at the foot of the Clark Fork River just outside of Missoula, Montana, their beat-up 1978 blue Volkswagen camper van with New Mexico license plates and prayer beads visible through the windshield stands apart from the hulking pickup trucks off-loading fly fishermen in

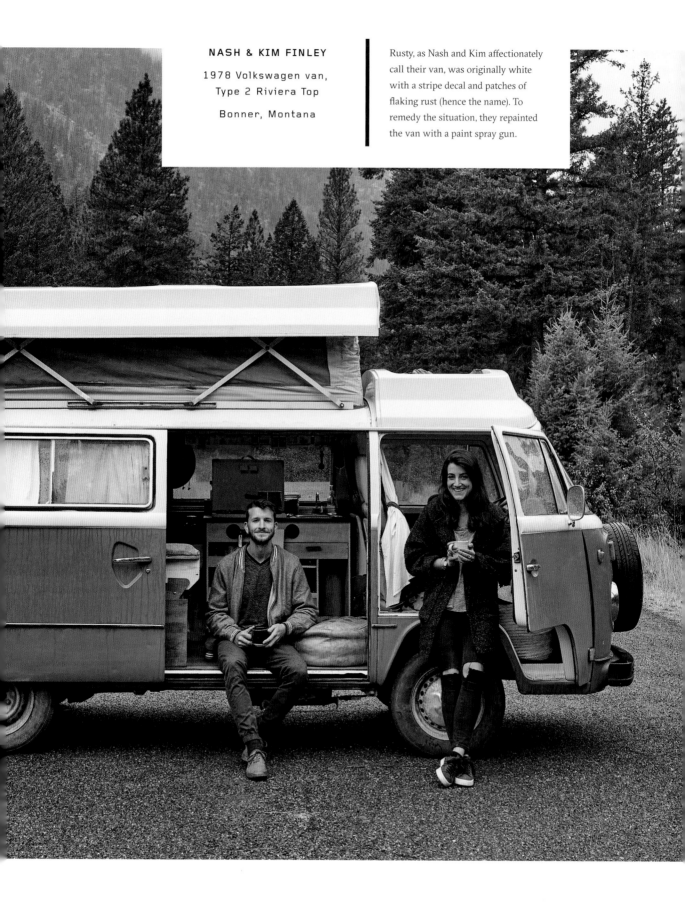

NASH & KIM FINLEY

1978 Volkswagen van,
Type 2 Riviera Top

Bonner, Montana

Rusty, as Nash and Kim affectionately call their van, was originally white with a stripe decal and patches of flaking rust (hence the name). To remedy the situation, they repainted the van with a paint spray gun.

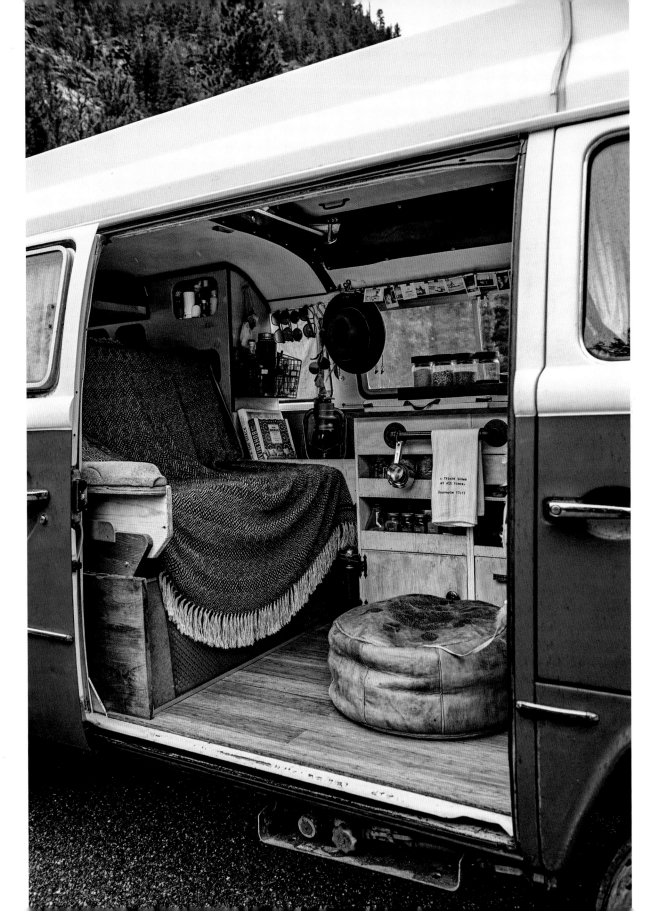

∧ TRIP TRINKETS

Talismans from the couple's travels hang from the rearview mirror. The small macramé dream catcher was picked up in Thailand, one of their favorite destinations. The beads come from India, while the silver necklace is courtesy of a small company they work with. Ikat-patterned fabric disguises the sun visors and adds to the boho vibe.

❮ EASY SLIPCOVER

The double seat in the back, draped with an alpaca and wool Peruvian blanket by the company Sackcloth & Ashes, folds down to create the bed. Kim wanted to clean up the panel beneath the seat, so she found some decorative perforated brass panels at a hardware store. "I just stapled them on," she says. The leather pouf was picked up on a trip to Morocco. "Sometimes we have people over, and you want to be able to offer them a seat," says Nash.

green waders. Nowadays, they're used to curious stares from anglers, vacationers, and hikers who can't help but peek inside at the caramel leather Moroccan ottoman and fluttering ribboned dream catcher inside their VW. Even with these homey touches, their van conceals the fact that they live in it full-time. There's no bed in sight, the minuscule kitchen with its neatly arranged spices and matching jars looks like it's rarely cooked in, and there's no evidence of other daily necessities like a refrigerator (there isn't one) or even water jugs. It could just as easily be a weekend warrior's getaway vehicle. But looks can be deceiving.

The couple has lived in their van on and off since 2015. Their original plan was to drive through the United States for one year, looking for a place to settle down; but those plans were tested early on, when their engine had a complete breakdown at the seven-month mark. A new one was going to cost them four thousand dollars. They could take that money and put it toward first and last month's rent and forget their nomadic life, or they could invest it back into the van and carry on. Still hungry for adventure, they decided to rebuild the engine and get back on the road. With that psychological crossroad behind them, the need to put an end date on their van life faded away. They've been driving ever since.

But for all their time on the road, the two still craved the exhilaration of going on big trips to far-flung places like they had before they committed to van life in America—something

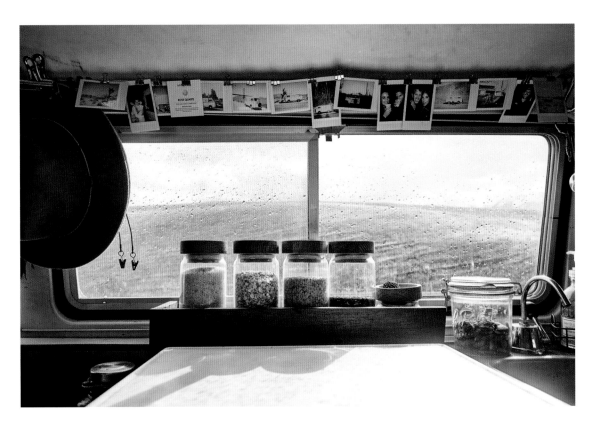

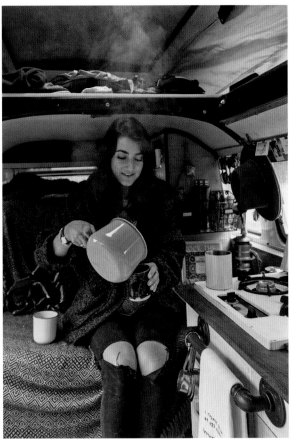

⌄ BEAN COUNTER

Nash and Kim eat a mainly vegetarian diet,
relying on favorites like pasta, Thai curries, and
rice-and-bean dishes that can be made quickly
with spice mixtures and canned sauces. Without
a fridge, fresh vegetables and meat go bad quickly,
especially in warm locations. "I think we've
learned what lasts the longest and what foods
are easiest to make," says Nash. "Tofurky! Tofurky
lasts a long time. And kale. We gave up making
salads because the lettuce wouldn't keep, but kale
lasts a long time."

⟨ ENVIRONMENTAL AWAKENING

With only a five-gallon jug of water on board,
each drop is appreciated and used wisely. "It's
really opened our eyes to how we consume
water," says Nash. The yellow pop-up top gives
the couple a few extra inches of standing room,
which makes navigating the small space a little
easier. While they could opt to sleep on the top
bunk, they tend to prefer the bottom mattress.

not particularly easy to do when you're getting by on measly freelancer contracts (Nash has a degree from the Art Academy in San Francisco and picks up work doing brand identity and website design) and seasonal employment. So the two hatched a plan; they'd offer their services as photographers to hotels and adventure travel outfitters around the world in exchange for free accommodations. The couple was raised in the digital age and already had an established portfolio of exceptional professional-quality shots and videos—think thousands of hot air balloons taking off at sunrise over Bagan in Myanmar—on their own Instagram feeds, which helped flesh out their proposal. To their astonishment, businesses started to say yes: with the rise in social media, travel companies were looking for new ways to promote their properties to a younger, more tech-savvy generation.

To make their on-the-go lifestyle work, the couple books their flights out of cities where they have friends or family so they can leave Rusty, as their van is affectionately known, with them. "When we went to Africa, we left it at my cousin's house in Salt Lake City, and we're going to leave it at my parents' house in Los Angeles when we fly off to India soon," says Nash. They don't mind if people drive the van when they're gone, but most prefer not to. "It's a stick shift, and we let them know that it can have its moments," laughs Kim.

Neither Nash nor Kim is handy when it comes to repairs, but with every breakdown, they learn a few new tricks. "We're getting better," says Kim. "Especially with the small things. We have a book that we reference, and then we go through all the things that have worked in the past to get it going again." They've also found that ex-hippies and former VW van owners will often pull over and offer their help. "They say, 'Mine used to always do something like this,' and they rattle around with the engine, and the van usually drives well enough to get us to a shop," Kim says. "They like to tell us stories about what it was like back in the day."

When she and Nash set out on this journey, they didn't intend for it to be long-term, so they didn't spend much time overhauling the interior of the van, with the exception of a new floor and the kitchen. "I designed it mainly around the items we had already picked up, like our metal water container and this little green pot. I wanted to make sure everything fit," he says. In retrospect, he wishes he had thought it through a bit more thoroughly. "I would make the spice container shelves the same size. I made the small one just a wee bit too small. It's wasted space," says Nash. The hardest thing to keep in check is all the beautiful treasures they find on their trips—pillows from Laos, a pouf from Morocco, and a dream catcher from Thailand. "We always buy stuff and then when we bring it home to the van, we don't know where to put it," laments Kim.

"Storage is especially challenging," agrees Nash. Luckily, his parents don't seem to mind holding on to things for them, whether it's

accepting shipments of rugs from Morocco or providing an address they can get a new driver's license or car registration mailed to. "They're our mail mules for everything. We get stuff sent in their direction and then we just let them know that we are coming their way." Cooperative parents aside, the life Nash and Kim have chosen for themselves isn't an easy one. With no toilet or shower, they rely on truck stops, cafés, and Mother Nature to get them through the day.

As their reputation as hotel and lifestyle photographers begins to solidify, the couple has been able to slowly start charging for their services. In the meantime, Nash continues to pick up freelance graphic design jobs, and Kim has put her hospitality degree to work with an upscale glamping company that sets up temporary seasonal safari-style tents in places like Moab, Yellowstone, Grand Canyon, and Zion. Their search for a "forever home" is always at the back of their minds, but they're pretty happy to keep roaming for now. "We're young," says Nash. "We don't really have anything tying us down. The feeling associated with having no set itinerary is so intoxicating."

> **PASS ON THE RIGHT**

The van tops out at around fifty-five miles per hour. Navigating the foothills and mountainous areas of Montana can be slow-going, but these two don't mind. "You just have to go around us," says Nash with a smile.

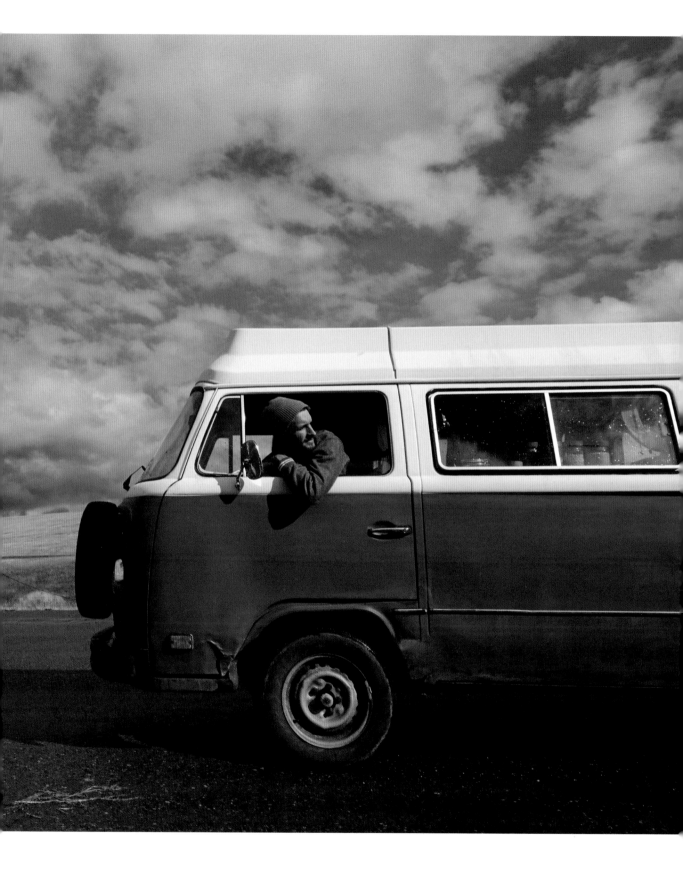

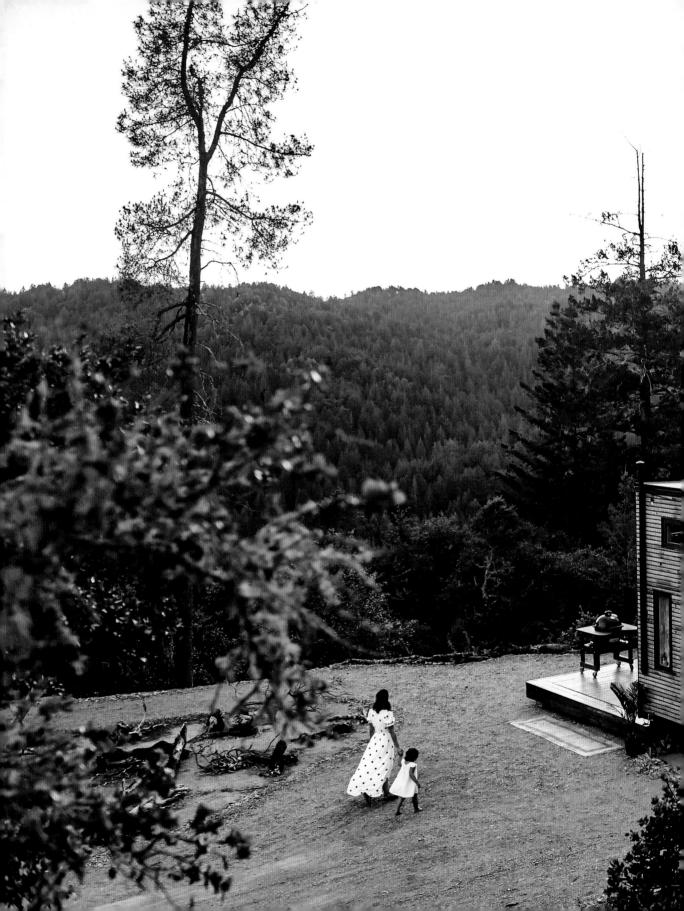

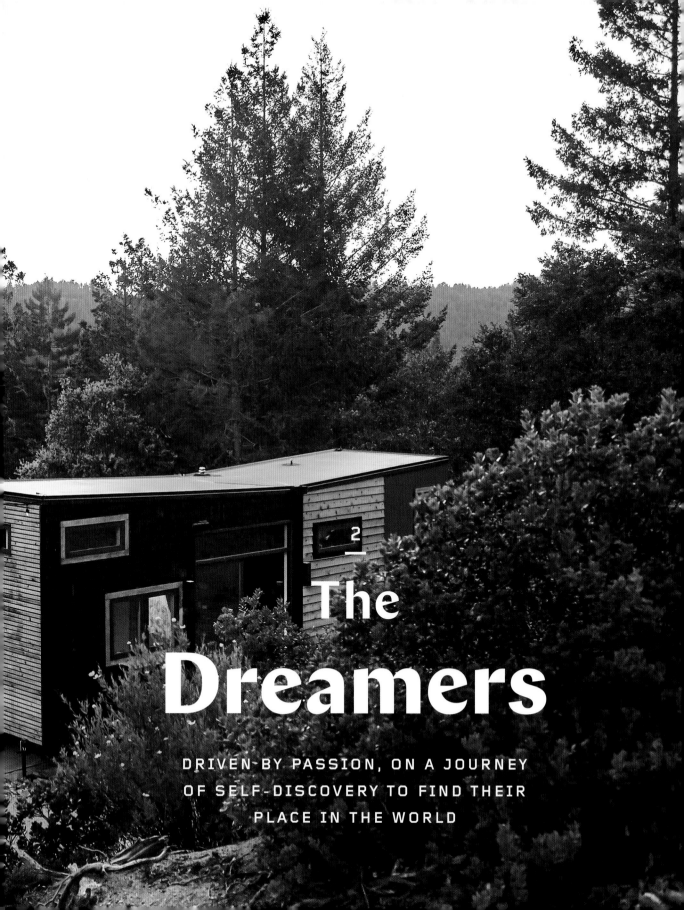

The Dreamers

DRIVEN-BY PASSION, ON A JOURNEY
OF SELF-DISCOVERY TO FIND THEIR
PLACE IN THE WORLD

License to Wander

You have to trust your instincts to get to Bela Fishbeyn and Spencer Wright's tiny house. Five minutes outside of sunny Boulder Creek, California, ribbons of switchback roads lead you deep into a towering old-growth forest. A turn of the wheel takes you off the main road onto a winding, single-track dirt trail that you're sure must be going in the wrong direction. When the house number appears at last, tacked to a wood board, you heave a sigh of relief and remember Bela's instructions to keep left when you hit the fork. Seconds later, you find yourself perched over a decline so steep you can't see the road below. Inching your way forward, you hang in midair for longer than feels comfortable before your front wheels finally hit the road below and all at once, the tiny house marooned on a sandy outcrop comes into view.

"We had agreed to film the reveal of our home for an episode of *Tiny House, Big Living*," says Spencer. "When the guy who was delivering the house from Nashville got here, he was like, 'Nope. No way am I bringin' it through

❮ BIRD'S-EYE VIEW

The secluded location, with a view of Big Basin Redwood State Park, comes with a few compromises—but Bela and Spencer will gladly take them. "You end up with a bit of a commute, but I'd rather have a mountain-view drive a couple of times a week than a bumper-to-bumper one every day, which is what was happening before when we lived in Oakland," says Bela.

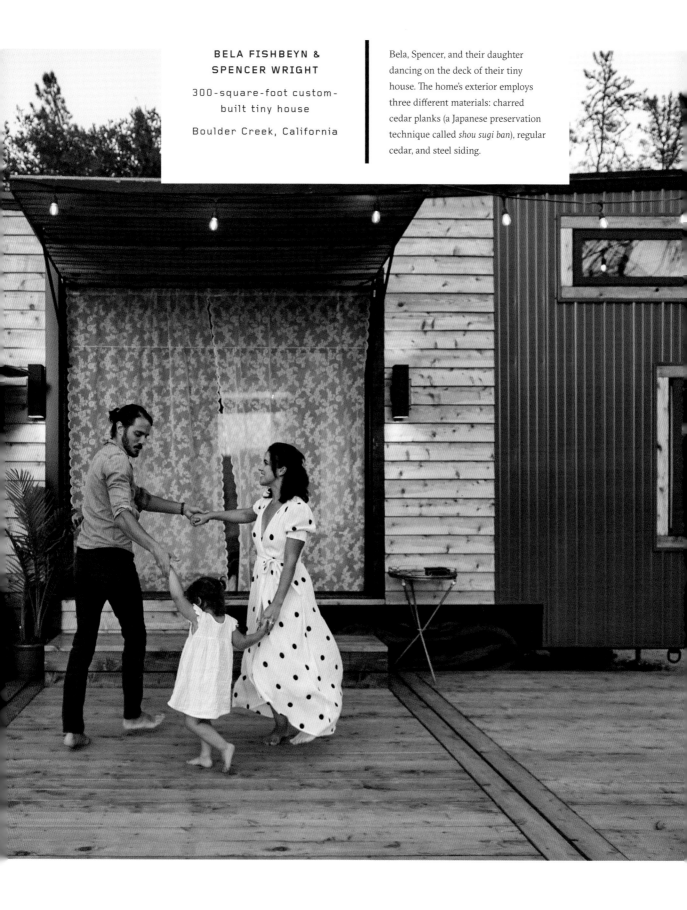

**BELA FISHBEYN &
SPENCER WRIGHT**

300-square-foot custom-
built tiny house

Boulder Creek, California

Bela, Spencer, and their daughter dancing on the deck of their tiny house. The home's exterior employs three different materials: charred cedar planks (a Japanese preservation technique called *shou sugi ban*), regular cedar, and steel siding.

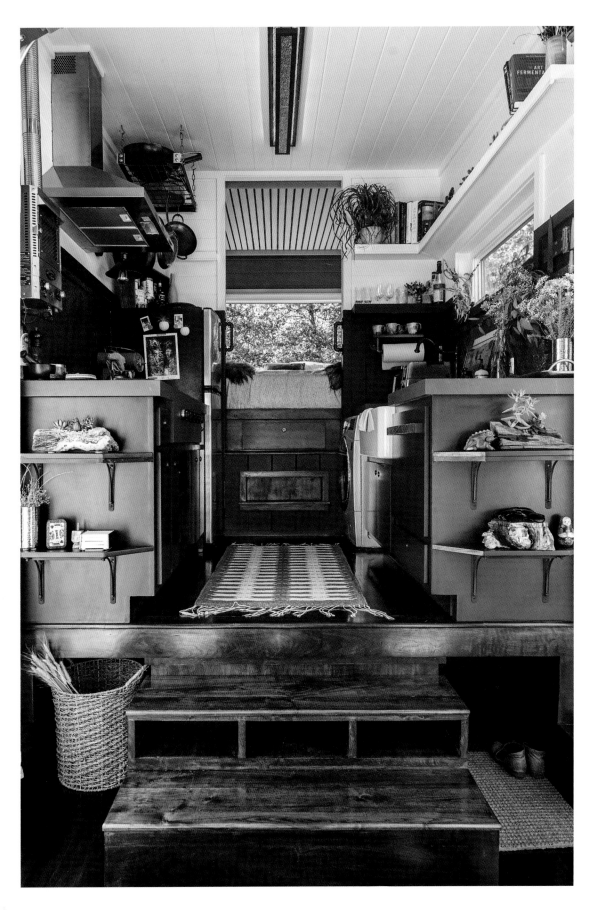

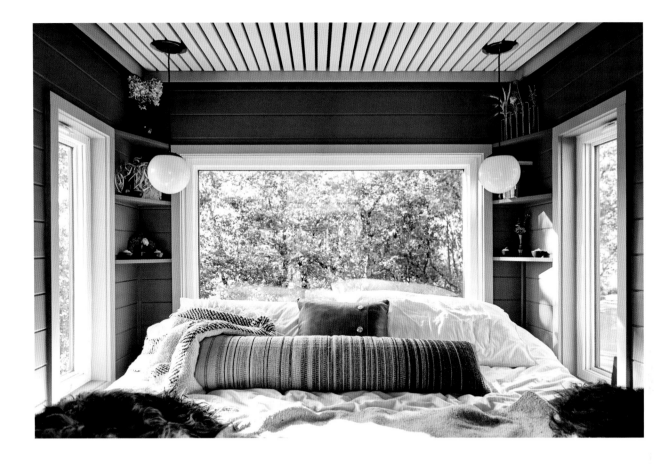

⌃ A HANDSOME HIDEOUT

The couple's builder, David Latimer, encouraged them to buy a fifth-wheel trailer, an extended design with an additional split-level space over the hitch that allowed them to position their bedroom off the back of the kitchen. Without it, they would've had to sleep in a loft above the cooking space. "It's amazing," says Bela. "With the dark walls and big picture windows, you feel like you're floating. The only thing that can be a little awkward is making the bed!" The blanket is by Connected Goods, and the striped lumbar pillow is from the Citizenry.

❰ THE NEXT LEVEL

Steps lead from the small living room into the galley kitchen and then back into the raised master bedroom. The multiple levels serve two functions: they allow for ample storage (both underneath the kitchen and under the bed, which lifts on hydraulics), and they help delineate the space into separate rooms, creating the feeling of a larger house.

these hills. I'm not takin' that risk.' So we had twenty-four hours and no plan to move it three miles."

"We eventually found this local guy who digs cars out of ravines to do it for us," says Bela. "Our designer and builder was on the roof of the house with a chain saw, chopping down branches. They got it here just in time for the reveal. We weren't allowed to see the house throughout this whole ordeal, so we were really very little help."

Six months prior to setting eyes on their home for the first time, Bela, a Fulbright Scholar and managing editor of the *American Journal of Bioethics* at Stanford University, and Spencer, a former chef and current stay-at-home dad to

the couple's daughter, Escher, had experimented with a year of living lease-to-lease in furnished apartments to offset the high cost of residing in the Bay Area. This allowed them to take off on vacations or stay with family for a few weeks at a time without having to pay double for a place back in the city. "We were spending almost thirty thousand dollars a year on rent, so we were trying to find ways to combat throwing away all that money," says Spencer.

Around the same time, they decided to start a family, thinking it would take a couple of months. "It basically happened instantaneously," smirks Spencer. They bounced around to a few more places and made a plan to spend their parental leave in Mexico, where they could rent a home for half the price. With a baby on the way, they vowed that during their tropical sojourn, they would find a more permanent solution to their housing crisis.

Spencer, who at one time had thought pulling a trailer behind their Mazda sedan could be a solution to their housing woes, had come across some tiny houses on wheels. He wondered if maybe that was the answer to their problem. "I found out pretty quickly that I needed to connect with people in the community and work with a builder," he explains. "It's completely overwhelming. Not just the design, which can go in a million different directions, but all the legal gray areas—how do you get insurance, where can you park it, how do you finance it, and so on."

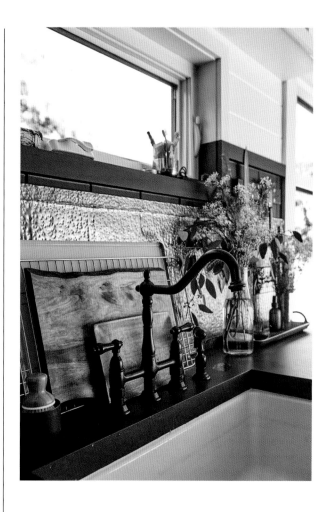

∧ USE EVERY INCH

A baking sheet, a cooling rack, and cutting boards are tucked behind the faucet in a savvy bit of space-saving. The hammered copper backsplash adds character to the kitchen while also protecting the walls from cooking spills and splashes. "Having so little stuff is very liberating," says Spencer. "It's really surprisingly easy once you get used to it." The majority of the tiny house is sheathed in painted shiplap, a design detail that speaks to the craftsmanship of the home.

The couple set a budget of approximately ninety thousand dollars and made a short list of all the features they hoped to include. "We didn't want to build another studio on wheels," says Bela, referring to the typical layout of many tiny houses, which features one big room with one or two overhead lofts. "We wanted something that had more division of space," continues Spencer. "That could sustain big gatherings, give us two separate bedrooms and a nice kitchen and bathroom." They quickly discovered that banks were not going to finance their tiny house, so they turned to personal loans—which meant a higher interest rate and worse terms than a conventional mortgage. Knowing that a reality TV show would aid in the process (by getting them discounts on products in exchange for on-air credit), Spencer submitted a casting application to HGTV. To his surprise, they got in touch with him right away.

The couple fired off an email to David Latimer, a tiny house craftsman in Nashville, Tennessee, who had built a model known as the Alpha that incorporated many of the features they liked. He agreed to work with the couple remotely and promised he would have the house ready in six months—the timeline the producers insisted upon.

The threesome came up with a floor plan that divided the house into five distinct zones—a separate master bedroom for Bela and Spencer with massive picture windows, a gourmet cook's kitchen with top-of-the-line appliances, a breezy living space with an operable garage-door window, an L-shaped bathroom with a generous steam shower, and a half-size upper loft and play nook for two-year-old Escher.

They approached the project with mindfulness and attention to detail, knowing that every inch counted. "We figured that since we were only paying for three hundred square feet, we could splurge a little bit on the finishes and appliances," says Bela. Throughout, the walls and ceiling are treated with different materials—burnished copper, shiplapped wood, even an intricate pattern of reclaimed wood strips. Modular furniture was custom-designed by David to allow for multiple uses of the main living space, with pieces that could be tucked away beneath the kitchen stairs when not in use. Spencer wanted a galley kitchen where he could still practice his craft. As a result, the kitchen has a five-burner cooktop, ceramic countertops, open shelving, and a hanging pot rack the couple found on Houzz. But the pièce de résistance is the master bedroom. Cantilevered off the end of the trailer, the king-size sleeping nook, with views on three sides, is like a luxurious grown-up bunk bed. A space-saving marine heater, the kind usually found on sailboats, is all the couple needs to warm their Northern California home.

With the design in good hands, the last thing Bela and Spencer had to figure out was where to park their new home. They couldn't afford to buy land in the Bay Area, so they

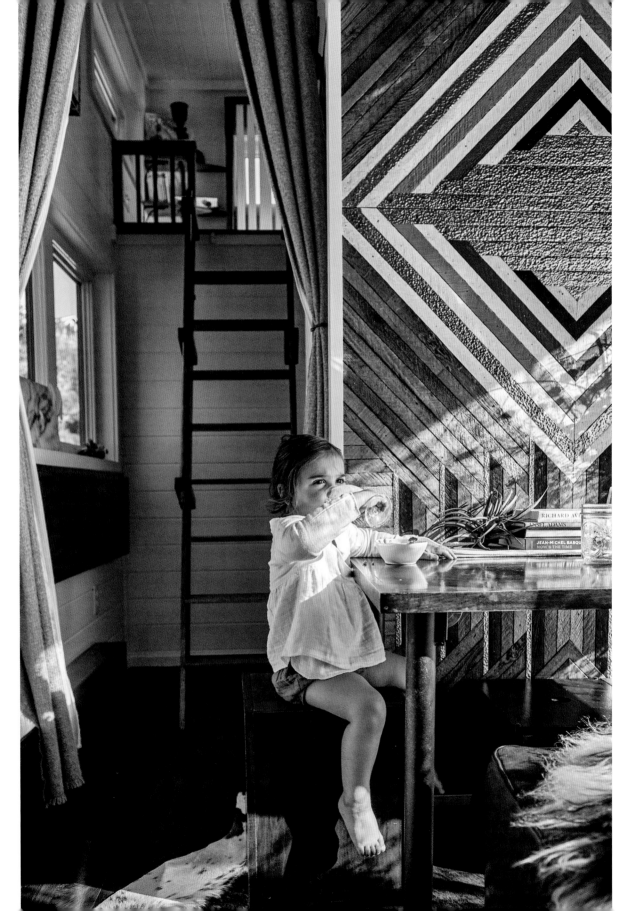

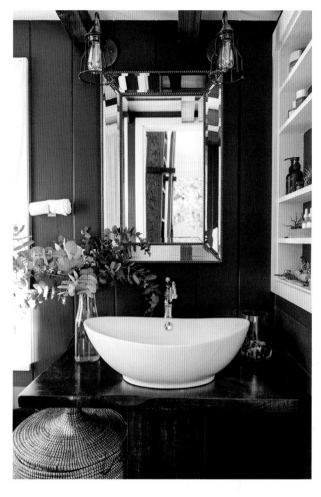

⌃ A ROOM OF ONE'S OWN

The doll-size upstairs loft where Escher's bedroom is located is painted in a pale shade of blue to set it apart from the rest of the house. The couple finds that spending time with Escher in her own space brings them down to her size, which allows for more intimate playtime. Having a separate room for her was high on their wish list. "We wanted to be able to have things going on in the evening and have her in her own bed," says Spencer with a wink.

⌐ NO COMPROMISES

The roomy bathroom has a composting toilet, a shower stall, and a generous vanity with a vessel-mounted sink. A lidded hamper keeps the room looking tidy, while an open shelf that was built into the wall cavity provides ample room for toiletries. The mirror and light fixtures are from Restoration Hardware.

⟨ WALL ART

Nashville studio 1767 Designs layered strips of reclaimed wood and copper—materials used elsewhere in the house—to create this graphic quilted pattern. The table can be completely folded away and tucked under the kitchen stairs when not in use, or a second table can be added for entertaining groups of eight people or more. Escher's loft bedroom and a flip-up table that Bela uses as a standing desk are directly behind this setup.

approached individuals they found on Airbnb who already had rentals on their properties. They cold emailed everyone within the vicinity and waited for a response. Only one person got back to them, but it would prove to be enough. The respondent mentioned that he was also building a tiny house and was open to the idea of renting a piece of his property to them.

"I sent him a photo of our place under construction in Nashville to give him an idea of what to expect," says Spencer. "And in the background of the photo, unbeknownst to me,

was their tiny house also being built. It was a total, utter coincidence." It sealed the deal.

A short six months after starting their journey, Bela and Spencer were the proud owners of a custom tiny house. With the stress of getting their home up the mountain roads behind them and the cameras off, they have settled into their life up in the Santa Cruz Mountains. To extend their living space, they recently added an expansive cedar deck and a canvas bell tent that they plan to keep up year-round. This summer the couple will open up their home to renters while they take off on a three-month road trip, having finally realized their dream of not being financially tied to one place. "We wanted to push what was possible and eliminate all compromises," says Spencer. "I think we've done that. I think anyone who steps in here will feel like we haven't lost anything in the process of going small."

⌃ DOUBLE YOUR LIVING SPACE

The cedar deck, built by Spencer, is almost the same size as the house. The couple love to entertain and will often set up their expandable dining room table on the extension when they host parties.

⟨ A PORTABLE HANGOUT

A spacious canvas bell tent, made by Stout, is located about 800 yards from Bela and Spencer's tiny house. It gives them an additional space to lounge in—especially when they want to play with their daughter or spend time with a large group of friends. It also provides an extra sleeping spot when guests stay overnight. The couple is experimenting with keeping the tent up year-round; ten months in, they have found the waxed cotton exterior strong enough to stand up to Northern California weather.

Addicted to Road Life

Sitting shoulder to shoulder with their backs facing the kitchen of their newly renovated Airstream, Laura Preston and John Ellis couldn't look more different. Laura, wearing a simple white T-shirt and high-waisted mustard-yellow pants, bends over her sewing machine, finishing up the top for one of her earth-toned quilts; her husband, John, dressed in black, punches computer code into one monitor while checking his emails on a second. Yet the combination seems to work. Since 2013, John and Laura have been living in less than 200 square feet—and they don't intend to stop now.

"Our first Airstream had lots of traditional oak wood cabinets, warm walls, and a leopard-print sofa, so it was very cozy, but it was also dark," says Laura, revealing a Lauren Hutton–esque gap between her two front teeth.

"And the lights were very dim," continues John. "It felt cave-like."

"We're still not a hundred percent finished with this new one," says Laura, glancing around at the bare white walls of the spotless Airstream. "We thought we would fix things right after the wedding, but we haven't lifted a finger."

"Now that we have our evenings back to ourselves, we're like, 'Let's just have some cocktails,'" says John with a grin.

Who can blame them? The couple put eighteen months into their latest renovation, finishing it just in time for its

**JOHN ELLIS &
LAURA PRESTON**

34-foot 1990 Airstream
Excella

Long Beach, California

When it came time to upgrade to a
second Airstream, John and Laura
opted to buy the same extended model
they had previously, which has ample
room for their two dogs and cat.

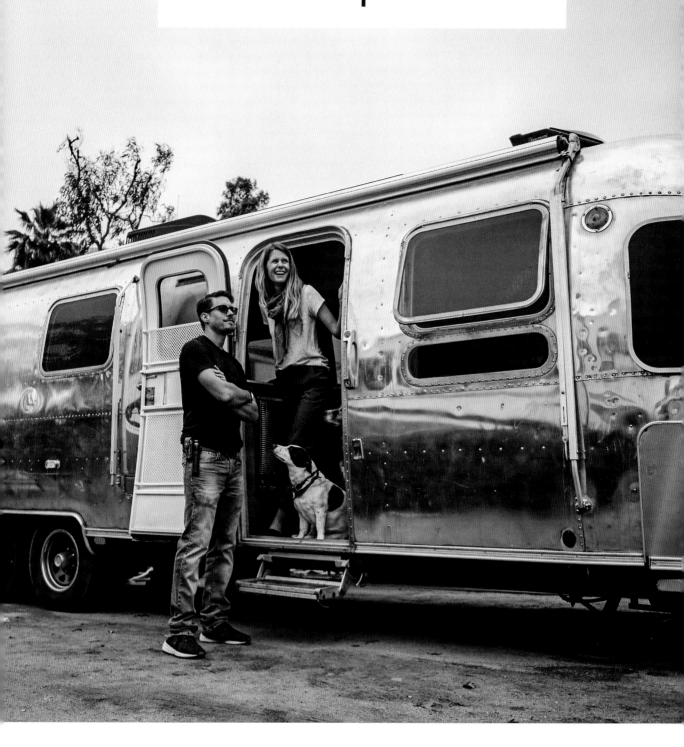

inaugural drive up to Joshua Tree for their wedding. With those two big projects behind them, they're slowly starting to ease back into day-to-day life, figuring out the quirks of their new home and settling into a regular work schedule—something that can be hard for the other people staying in the same holiday RV park in Long Beach, California, to understand. "This isn't a vacation for us," says Laura. "This is our life."

To understand how Laura and John came to live full-time on the road, it helps to go back to the early days of their relationship. In 2011, when John was twenty-six, his father passed away suddenly. "I went through a grieving process and decided that I needed to do something with my life. My mom had this Airstream that she never used and I thought maybe I could borrow it for a year and do the whole 'find myself' thing," says John. He and Laura had been dating for about four months, and John asked her to join him. She said yes. The couple headed down to Florida to meet John's mom and, more important, to ask if they could borrow the Airstream. "She answered with, 'I'm not saying no, but I'm not saying yes, either,'" says John. "I was like, 'Okay, so that's a yes.'"

It took John and Laura some time to prepare the 34-foot Airstream for full-time travel and to finish up their leases in New York City, but by February 2013 they were ready to hit the road. As they began to tell people about their expedition, they were inundated with suggestions for places they should go and things they should see. This gave John an idea: Why not

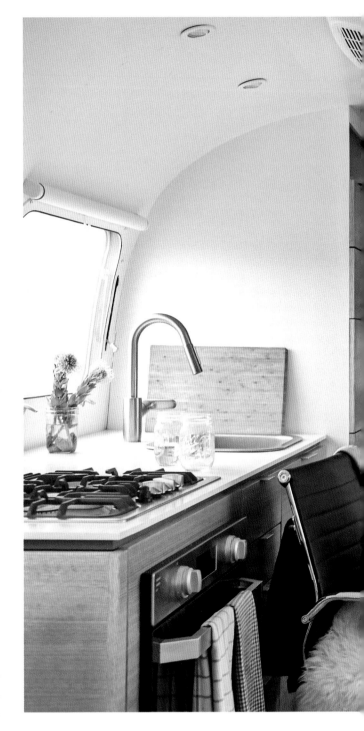

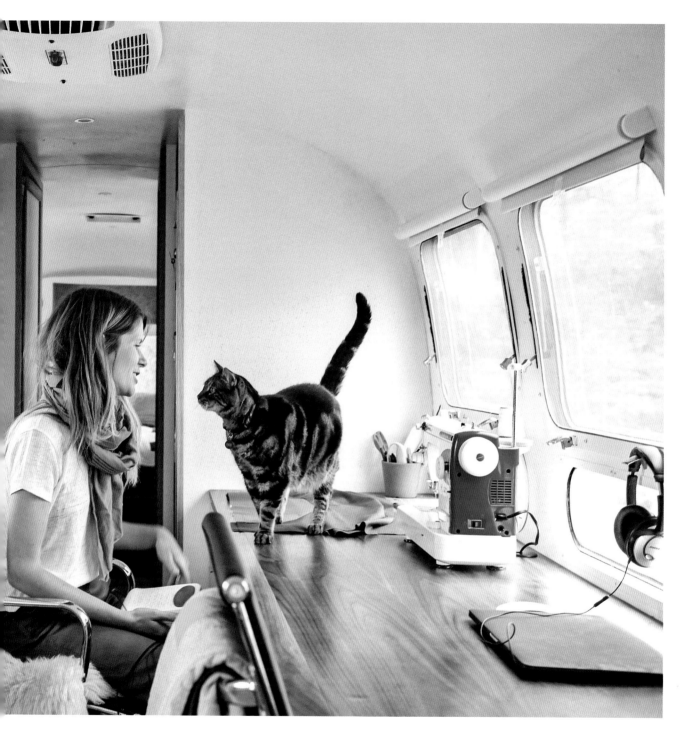

︿ A PLACE FOR EVERYTHING

The cabinetry throughout the Airstream, custom made by John and Laura, is finished in red oak veneer that they edge-banded. Laura made the desk herself. "It's a piece of walnut veneer that I oiled to bring out the wood grain," she says. "It's the sexiest desk I've ever seen."

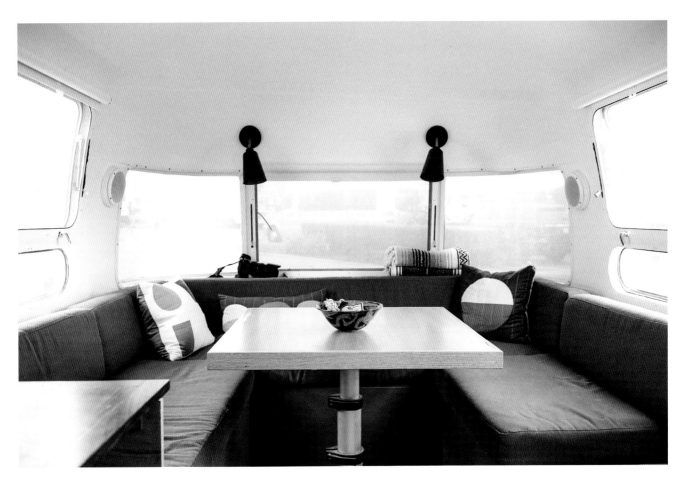

⌃ AROUND THE TABLE

With two dogs and a cat, this banquette often gets a little crowded. At first, John and Laura thought they would choose a sensible charcoal-gray fabric for the banquette cushions, but at the last minute they opted for this earthy terra-cotta red, which Laura often uses in her quilts and throw pillows (like the ones seen here). The table drops down so the entire front of the Airstream can be turned into a second bed. The black and brass sconces throughout are by AllModern.

❯ MADE BY HAND

In their old Airstream, Laura made her quilts at the dinette table, which measured 30 by 36 inches. It was also where she and John ate dinner. "I had to cut all my fabric and then move it out of the way, then pull up my sewing machine, and then move that out of the way, and then bring out my iron. It's so nice to have a dedicated work space now," says Laura.

set up a website where anybody could leave a recommendation? And so the Democratic Traveler was born. Before long, Laura and John were weaving their way through the 518 crowd-sourced suggestions, which ranged from "Eat Sonoran hot dogs at El Guero Canelo in Tucson, Arizona" (completed) to "Experience the Lumberjack Saloon with sloping bar floor at the Kettle Falls Hotel in Kabetogama, Minnesota" (not completed—yet). The site caught the attention of the editors at *National Geographic*, who nominated Laura and John as 2013 Travelers of the Year along with ten other hopefuls. (They eventually lost out to Benny Lewis, a globe-trotting Irishman who had learned more than seven languages through travel immersion.)

They continued to roam for the next two years, returning to New York City to pick up Laura's cat, Papa, and adopting two dogs, Bulleit and Marlow, from shelters along the way while supporting themselves remotely as online assistants and programmers. Laura began quilting around this time to fulfill a creative urge; in college, she had done oil painting, but that was not compatible with Airstream living. Eventually, the constant movement took its toll on both their wallets and the Airstream, and they decided to stay put for a few months to make some cash. John found work as a software engineering manager for a start-up in San Francisco, while Laura pushed ahead with her quilt-making, which she was then doing full-time. They parked their Airstream in an RV lot

and accustomed themselves to city life, dreaming of the day they could get back on the road.

A few months turned into a year. At his annual review, John asked the company if he could work remotely. They agreed, and he and Laura said good-bye to their friends and made their way to Dallas, Texas, to visit Laura's family for Christmas. "It was on that trip that we discovered that the Airstream's frame was completely rusted, that there was mold in the walls, and that we had floor rot," says John.

"At that point, our options were to settle down somewhere permanently, buy a ready-to-travel trailer, or rebuild a vintage Airstream from scratch," says Laura. "Of course, we chose the hardest, most time-consuming one."

In January 2017, John hopped on Craigslist and within four days found a gutted 34-foot triple-axle Airstream Excella nearly identical to their first. During time away from their full-time jobs, he and Laura worked on the trailer, which they parked on a property just outside of Dallas. They started with the shell, which they polished to a high shine—a tedious process in the hot Texas sun. (Airstream exteriors are made of aluminum, and over time, an oxidation process dulls them. It's a point of pride among members of the Airstream community to keep their trailers polished, but it can take weeks of tedious work.) Next, they moved onto the interior, where they modernized the holding tanks, relocated vents, replaced valves, upgraded the gauge sensors, and plugged a toilet hole. They then sprayed the entire skeleton with a

slow-rising foam insulation, which bonded to the walls and got into every nook and cranny, before closing up the walls. After ten months of working weekends, they completed the shell of the trailer; it had a polished exterior, a finished linoleum floor, and painted interior skins (a term for the aluminum panels of an Airstream). Now all that remained was the interior design.

In order to make this last step go faster, Laura and John decided to move out of the 400-square-foot studio they had been renting in Dallas and into their old trailer, which was parked on the lot beside their new one. The couple got to work constructing cabinetry, installing a kitchen and a bathroom, and adding solar panels. For a complete contrast to their old Airstream, which was dark and cozy, for this one they opened everything up, painting the interior skins a bright white; installing flat-fronted, red-oak-veneer cabinetry; and adding shapely black and brass sconces throughout. They avoided overhead cabinetry and instead opted for a streamlined, full-height pantry in the corridor that connects the living area to the bedroom. It efficiently contains slide-out drawers for foodstuffs, a fridge/freezer combo, and the pets' food supplies. In a creative stroke of genius, the couple devised a solution for the notoriously small bathrooms on Airstreams: they positioned the sink and toilet in one small room and the shower in a separate nook across the hall. When the doors of the two rooms are opened, they effectively shut off the hallway, acting as walls and creating one big, long bathroom.

The thing that makes John and Laura's Airstream most unique is the addition of Laura's handmade throw pillows and quilts. Inspired by the landscapes she sees on their travels, the muted, desert-like colors and strong graphic shapes of her designs bring the modern space to life.

"We went way over budget. We ended up splurging on high-end wood and appliances, but when we figured out how much sweat equity we'd put into this thing, it didn't make sense to put anything cheap in here," says John. "For the amount of work we'd done, we thought we might as well spend a little extra so the whole thing would last for a long time."

And last for a long time it better. John and Laura see their new Airstream as their permanent home for the coming years. They fell in love with being on the road during their last venture, and they have no plans to stop.

As the couple puts away their work for the day, Laura reflects on the name she gave her quilt company, Vacilando, back in February 2015—two years to the day after they set out on their inaugural road trip. "It's a Spanish word that was in John Steinbeck's *Travels with Charley*, which recounts his road trip across America in the 1960s. The word doesn't have a direct English translation, but it means that the journey is greater than the destination," says Laura. "It stuck with me." For a couple who has no final destination but wishes to live out their days wandering the roads with their three pets, it's a sentiment that fits in more ways than one.

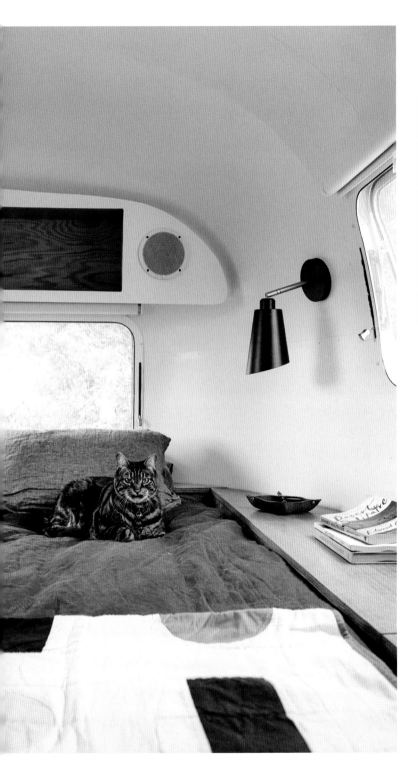

∧ WHERE THE LIVING IS EASY

Bulleit, named after the whiskey, finds a cool spot on the floor underneath the dinette table. The three animals get along just fine in the small space.

❮ AT LAST

One of Laura's quilts rests at the bottom of the queen-size bed in the couple's bedroom. "This is the first time we've had my quilts in our own space," marvels Laura. "John was always asking me when I was going to make us a quilt, so I finally caved in." The built-in shelves around the bed have flip-up lids to provide extra storage; one is dedicated to dirty laundry.

Foraging with the Seasons

Just outside of Squamish, Canada, a small community between Vancouver and Whistler on the Sea to Sky Highway, Mark Coelho swings open the double doors of a white storage trailer, the kind you'd expect to see hauling recreational ATVs or a contractor's tools. Flicking on the lights, he reveals a fully outfitted work space with a classic octagonal-tiled floor, two countertops, an apron-front sink, and a wall of neatly stacked wood crates—each branded with the name Boreal Folk.

"I had actually heard about Raph years before I met her," says Mark, referring to his partner, Raphaëlle Gagnon, who has just stepped into the trailer from a side door. "She was literally folklore around a campfire—a tall tale. This mysterious woman who would run through tree-planting camps and baffle everyone with her capabilities."

Raph bows her head slightly under her earthy green outback hat and then continues the story. "I was a very quick tree planter, and I just learned how to maximize every single movement. The average tree planter would plant between twenty-five hundred and three thousand trees a day, and my average was seven thousand. From the start, I saw the opportunity—the harder I work right now, the more money

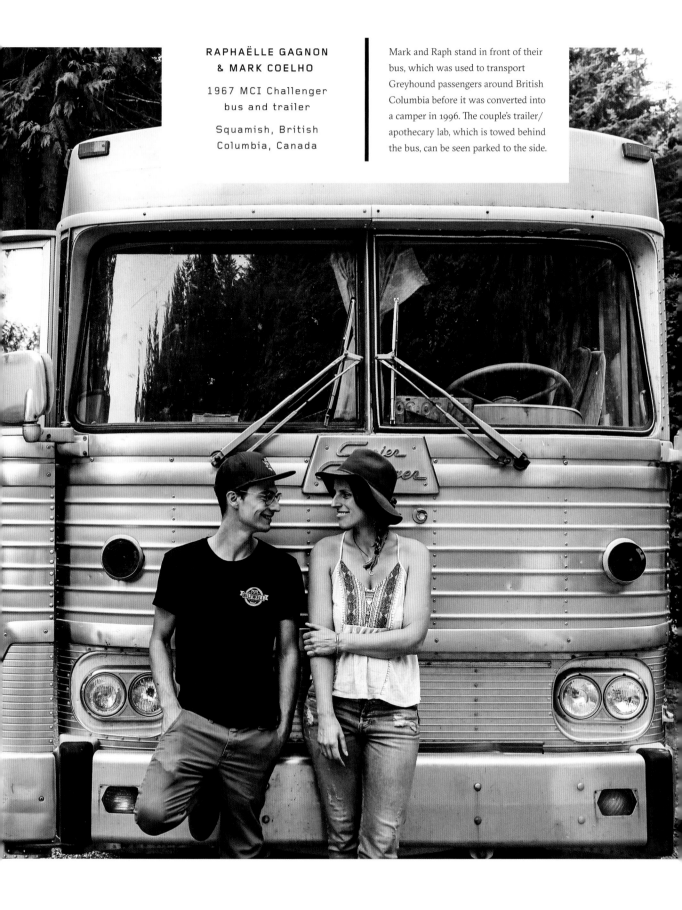

RAPHAËLLE GAGNON & MARK COELHO

1967 MCI Challenger
bus and trailer

Squamish, British
Columbia, Canada

Mark and Raph stand in front of their bus, which was used to transport Greyhound passengers around British Columbia before it was converted into a camper in 1996. The couple's trailer/apothecary lab, which is towed behind the bus, can be seen parked to the side.

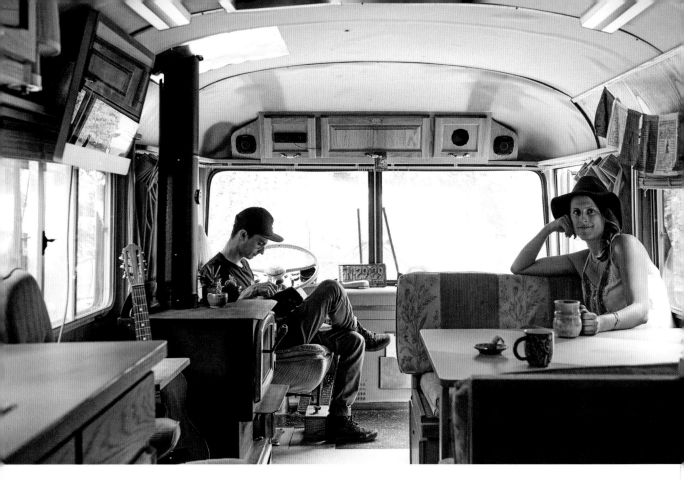

I'm going to make and the more I can pursue my dreams."

Tree planting, the grueling summer job and rite of passage for many Canadian university students, involves sowing tiny saplings into rough and craggy clear-cut forest land in remote northern wildernesses across the country. The conditions are basic at best: a tent set upon the earth's floor is considered shelter, daily battles with mosquitos and flesh-eating black flies are de rigueur, and clothing encrusted with mud or worse, still damp from the day before, is just the way it is. And yet thousands of students do it each summer in the hopes of earning enough to cover their school expenses for the following year. Or in Raph's case, financing her dream of making organic skin-care products. "This entire business," Mark says, waving his hand around the trailer turned mobile apothecary lab, "is funded by planting trees at ten cents a pop."

It all started on September 1, 2015, when Mark invited Raph to move into his 1999 Ford E350 delivery van. Mark, a former office space designer and trained mechanic, had put together the rig as a sleeping pad and mobile work-shop for his summer months out in the bush, where he worked as both a planter and a machinist. A mutual friend had introduced the two, and Raph had already spent many of her weekends off traveling with Mark through the

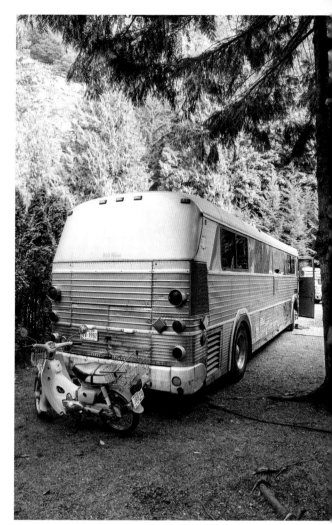

⌃ ONE PAGE AT A TIME

"Even though that book was written in the forties, it's actually very useful to me," says Mark about the *Audels New Automobile Guide* he found at an American Legion book sale. "It's funny because people think it's decoration, but that's reading material for me."

⌐ HOME SWEET HOME

The wood-burning stove, an essential for Canadian winters, and a wall-mounted computer screen are the only additions the pair has made to the bus to date. In the future, they'd like to upgrade the bathroom by switching out their black-water toilet for a composting one and converting the tub to a shower. Mark also hopes to make the bed (which is located at the back of the bus) more comfortable.

⌃ WHEELS TO GO

The blue scooter is transported in the lab. "We use that to scout when we're out exploring or foraging," says Mark. "We've taken it up mountains on billy goat trails, but we can also use it in towns to pick up groceries, mail out products, or run errands when we're urban camping."

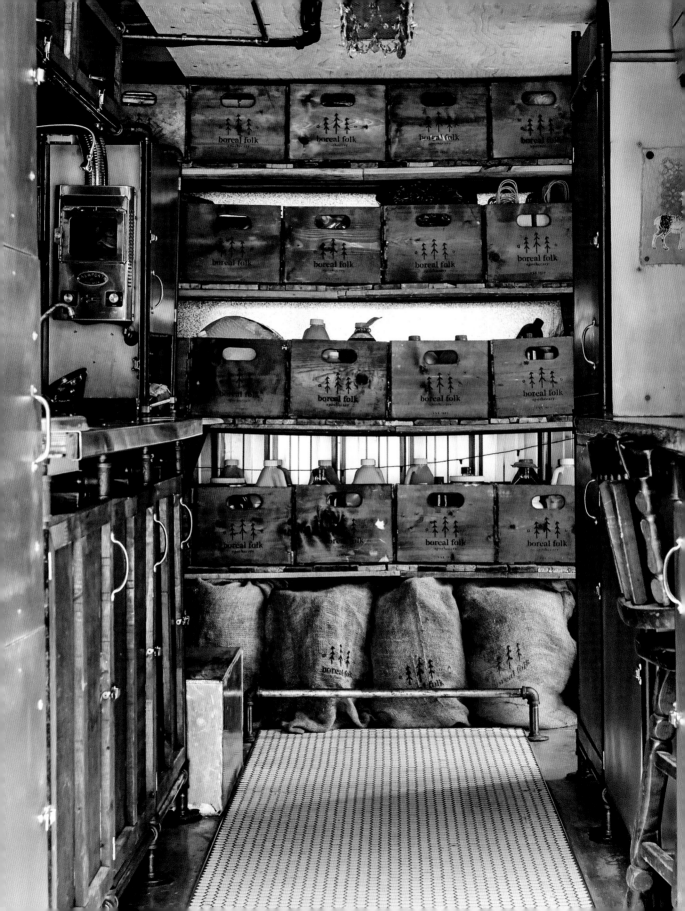

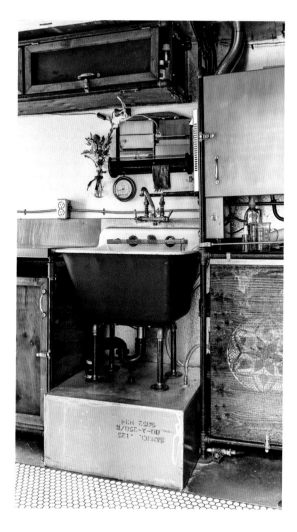

︿ ADD SOME PLANTS

The octagonal mosaic floor tile is repeated as a small backsplash. Clip-on lights provide extra illumination where it's needed and are used throughout the trailer. Raph loves plants and keeps a few in the trailer even though they don't get much natural light. "Every now and then, I let them out into the sunshine," she laughs. The moose textile was traded for Boreal Folk products with a friend at a craft show.

︿ CRAFTED OUT OF VINTAGE FINDS

Both Mark and Raph like to shop at antiques stores and salvage yards for one-of-a-kind treasures like this sink. The brass instrument is a "moistometer" they found at a thrift store. It measures relative humidity and the temperature.

❮ APOTHECARY ON WHEELS

The lab is zoned into three sections: the left side is primarily for making products and includes a soap-curing rack that holds about twelve hundred bars of soap; the right side is for packaging; and the rear of the trailer is lined with crates and burlap sacks filled with raw goods such as coconut oil, mineral salts, clay, and lye.

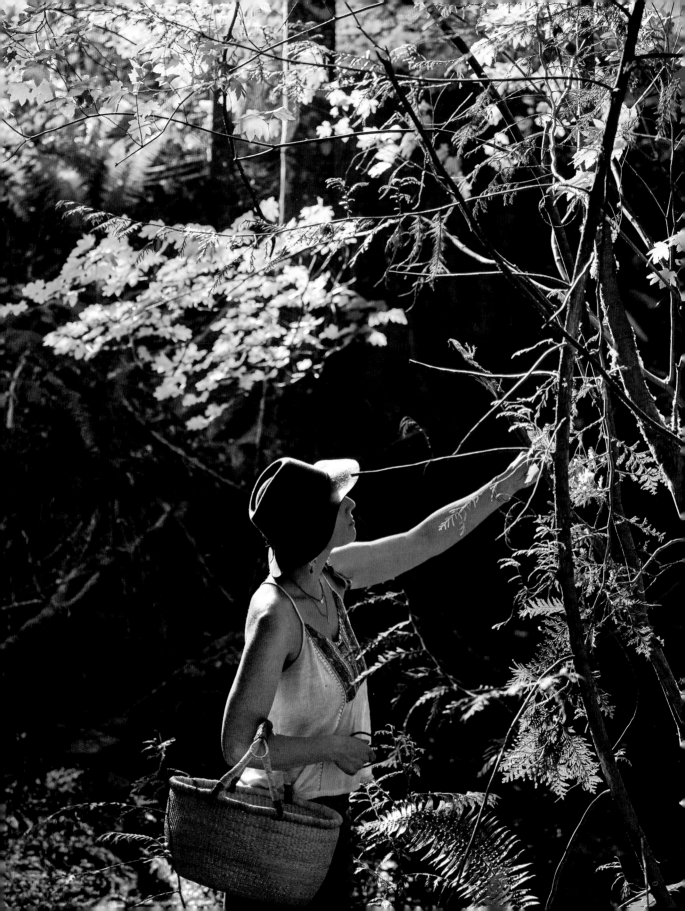

boreal forests of British Columbia, Alberta, and the Northwest Territories foraging for wild botanicals—yarrow, horsetail, mint, sagebrush, chickweed, and fireweed—and making them into wild-crafted skin-care products. Coming off her ninth summer of tree planting (a true nomad, she spent the winter months traveling the world with only a backpack), she decided that she was ready for a change and said yes. Mark proposed that they convert the van into their full-time living space and add a workshop for their growing business.

They kept it up for about a year. "Then, one day, Mark asked me if I wanted to convert a ninety-nine-foot storage trailer into a soap lab," says Raph. By that point, the pair could see that not only were they a copacetic couple but also that life on the road, creating products in the wilderness, really worked for them. They knew that if they were going to commit to the lifestyle for the long term, they needed an upgrade. "We didn't even think about it twice. We're not diddly-doodlers who make a list of pros and cons and what-ifs. We just went for it," says Raph.

Mark, with his years of experience as an ergonomic office designer and his deft ability to weld, forge, and otherwise fabricate magic

❮ OUT IN THE FIELD

Raph's interest in plants started back in her tree-planting days. She would often pick different specimens and then come back to her tent, dry or infuse them, and play around with making skin-care products. These days she tries to forage one or two days a week, depending on her vending schedule.

from off-casts of sheet metal and plumber's pipe, got to work creating the laboratory of Raph's dreams. He took as his inspiration turn-of-the-nineteenth-century apothecary cabinets, with their neatly stacked rows of drawers and storage compartments—not an inch was wasted. Working from a napkin drawing, he fashioned the side of a discarded industrial walk-in refrigerator into a countertop and turned a single sheet of metal into a storage locker. He found an old sink in a salvage yard, then made some legs for it and fitted it with an aluminum gray-water holding tank to store the dirty wastewater that goes down the sink. Off-the-shelf wood crates from a hardware store were individually stained and scraped by hand with a rusted mixture Mark made by soaking steel wool in three different types of vinegar. They were then stenciled with the brand's logo. A wood countertop was given a Martha Stewart–like treatment with the negative imprints of lace doilies left behind after a coat of white paint. Behind all this craftsmanship and attention to detail is the nuts and bolts: a solar power system, an instant hot water heater, plumbing, air-conditioning, and a dehumidification system needed to help the soaps cure. The laboratory is also fully insulated, heated (by the kind of furnace used on yachts), and weatherproofed—a necessity when living and working in Canada.

With the trailer built, Mark and Raph replaced their delivery van with a 220-square-foot 1967 Canadian-built MCI Challenger bus.

"It is considered the hot rod of buses—car fanatics drool when they hear about it. It has a really big engine that was also used in World War II tanks and ran on peanut oil. We use diesel fuel now," says Mark. It's a vehicle most people would probably find intimidating to own, but not Mark, who picked up his first car, a broken-down Chevy Nova, at the age of fifteen. "Buying a used vehicle, even if it's as big and old as this bus, is not a risk for me like it would be for most people, because I'm super-confident I can find a way to make it run."

For now, Mark is the only one who can drive the bus. Raph has started practicing by driving it on side roads, but she has yet to switch lanes or gears. "It's a manual and has only four speeds. I've seen firsthand what it requires, and you definitely need to know what you're doing," says Raph.

With only one year of foraging throughout the remote boreal forests of Western Canada in their new rig under their belts, they're still testing out the possibilities and limits of their enterprise. This past summer, they yo-yoed between festivals, craft shows, farmers' markets, folk music fairs, and big events like the Calgary Stampede selling their wares. One weekend they would find themselves on the west coast in Victoria, British Columbia, and the next in the tourist town of Banff, Alberta—a destination more than five hundred miles away. In between vending, they would forage for wild goods and spend evenings formulating products. Running a business with no fixed address has required some out-of-the-box thinking, like receiving supply shipments in public places like Walmart parking lots.

The life Raph and Mark have created for themselves has proven successful. "We have no debt," says Mark. "We were able to build a business and make it pay itself off very quickly by living humbly." Looking around the bus, it's easy to see that the pair doesn't own much. There are few knickknacks or fancy pillows. "We've got nothing, and that feels good," says Raph. For Mark, a skilled mechanic and gearhead, and Raph, a born nomad who remembers stories of her father hitchhiking through the States in the '70s, the partnership is a good one. "We love it out here. For us it's about the lifestyle—this is our adventure-mobile. The fact that this bus can take us out into the wild and that we're comfortable living out there for extended periods of time is what it's all about," says Raph.

> COPPER STILL

Recently, Raph and Mark have started experimenting with distillation, the process whereby they make essential oils from the wild plants and herbs they forage. "Right now I'm really fascinated with the alchemy of plants," says Raph. "We stayed out in the prairies this summer, in the middle of nowhere, and wild sage and mint were growing next to a pond. We ended up distilling both."

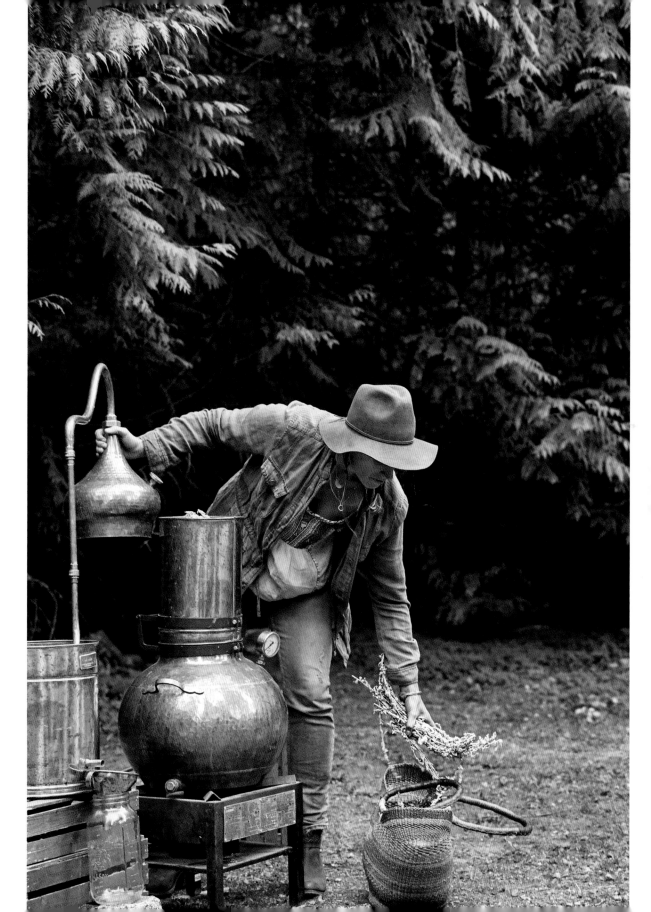

Following the Trail of the Buffalo

Meandering through her Airstream, surveying the vintage copper coffeepot on the stove and the patinated copper vent hood above, Sunny Cooper straightens a slender oil painting on the wall. Continuing into the bedroom, she places her hat on the pillow of her bed and then—with a quick flick of her wrist—smooths out the linen sheets on the matching bed to the left (which belongs to her thirteen-year-old son, Cole) and heaves a sigh of relief. This is Sunny's first day back in her newly renovated trailer after a devastating fire blew through the front end, shattering the window and leaving a trail of smoke damage and debris. Satisfied that everything is as it should be, she walks back through the Airstream and sits down on the corner of the banquette, exhausted.

"Other than the seat cushions, which we're still waiting on, almost everything is back in place after the fire," she says, taking off her poppy-red glasses to rub her eyes. "The adventure has already started for us, just not in the way I expected it would."

Sunny is a believer in signs. She sees them everywhere she goes, and they guide her in her day-to-day life. Ask her about the significance of the color blue (which features

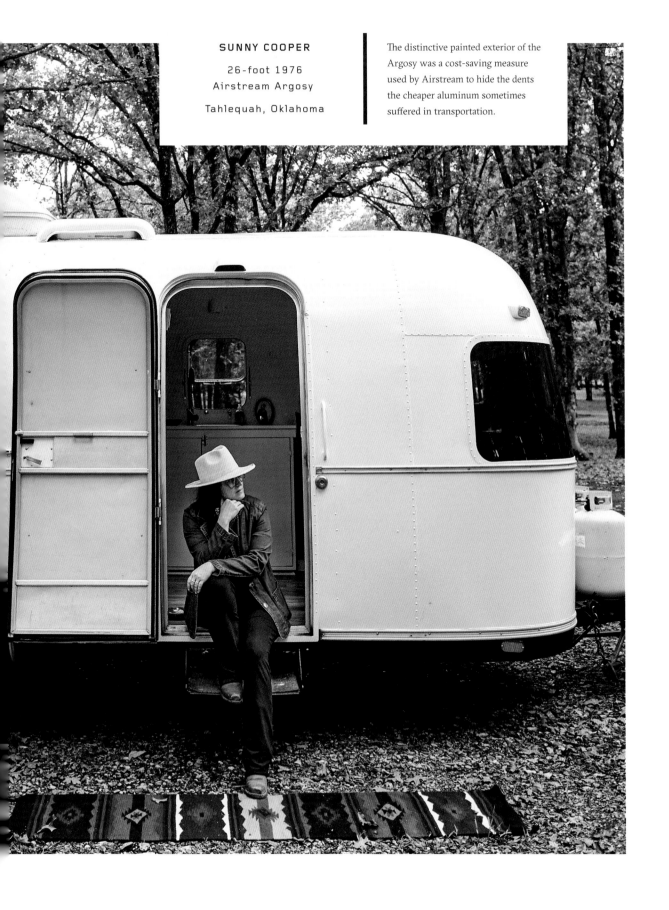

SUNNY COOPER

26-foot 1976
Airstream Argosy

Tahlequah, Oklahoma

The distinctive painted exterior of the Argosy was a cost-saving measure used by Airstream to hide the dents the cheaper aluminum sometimes suffered in transportation.

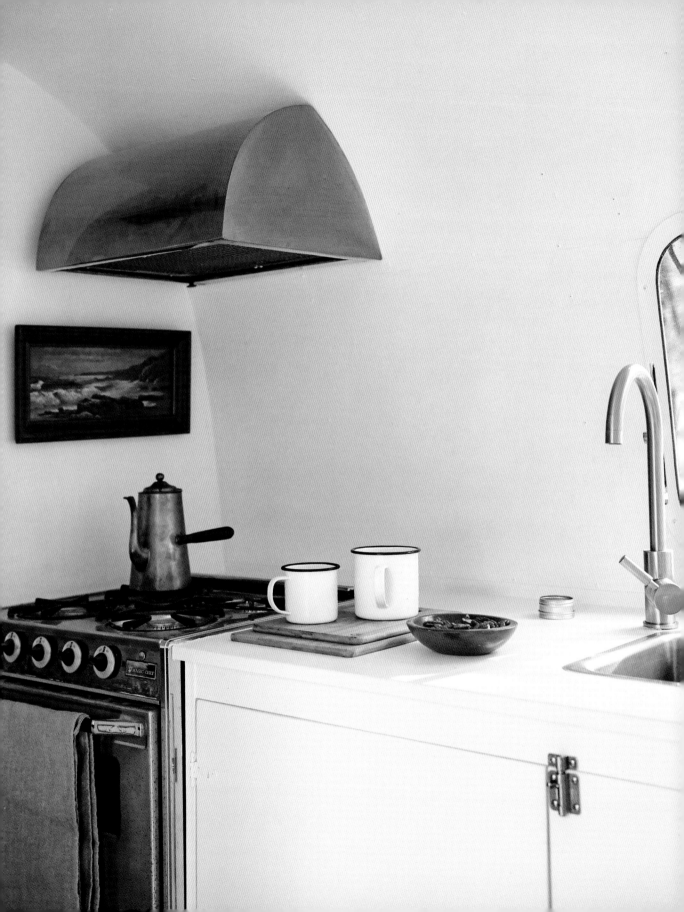

"I've found only one other single mother who is doing something remotely like what I am doing. That part feels a little bit daunting because I don't really have anyone I can connect with. On the other hand, I've found a way. I can be with my son, and I have work that is meaningful, that brings abundance to us and to others. There are a lot of women who will hopefully be encouraged to see somebody else doing this," says Sunny.

< COPPER ACCENTS

This corner of the kitchen holds a collection of Sunny's favorite things: a custom-designed copper range hood made by her builder, a copper coffeepot picked up in Tahlequah, and an oil painting of the ocean found in California. "Gotta have my ocean," laughs Sunny. "It was a thrift-store find, but it has a light to it that I've always liked." The range is by Magic Chef.

prominently in the trailer's design scheme) and she will recall countless moments when it has played a distinctive role in her life—the stain of the doors in a motel she and Cole stayed in after the fire, the shade of the piece of glass she removed from the mouth of a rattlesnake she killed, the hue of the flower from one of her favorite pieces of writing.

So it comes as no surprise that the idea to trade in a typical, settled life as a single mother with a young son for uncharted, nomadic living in an Airstream came to her first via a photograph. Sunny, a writer and writing consultant, was living in her hometown of Tahlequah, Oklahoma, when it happened. She was writing into the late hours, on a "dark night of the soul," as she describes it.

"My young son was sleeping right beside me. I was in a hard place in my life, struggling to think beyond tomorrow, let alone a year ahead. When I saw a picture of these glowing tepees underneath the dancing northern lights, I knew in a moment that it was everything I wanted to feel and show to my son. That's life—I didn't want to miss life," says Sunny, a member of the Cherokee Nation. "I wanted to be in a place like that, with humanity humming right outside our door."

As Sunny slowly emerged from her cocoon, she held on to the vision of the tepees as her guiding light. She had no idea how—or when—she would make the journey happen, but it propelled her forward and gave her hope. It wasn't until Sunny and Cole moved to California and

she began to notice Airstream trailers everywhere that the nebula of those glowing tepees began to crystallize for her into the idea of a life with her son on the road, traveling north toward her vision. "When I saw those Airstreams, I knew this was how I could do it," says Sunny.

For the next ten years or so, Sunny split her time between Tahlequah and California, working toward her goal while asking the pertinent questions: How much would it cost? How was she going to educate her son? How could she protect herself and her child? Would she be able to put food on the table? How would she provide a sense of stability and home?

With little outdoors experience, Sunny reached out to a close friend and asked her to take her and Cole on camping trips. The friend taught them how to cook over an open flame, to check in with the local rangers, and to plan overnight spots. Solo trips exposed them to sleeping in their car, carrying their own water, and relying on flashlights. As a single woman camping with her young child, Sunny learned how to practice smart habits like safety-pinning her car keys to her pocket and letting family or friends know her exact location. Free time would be spent with Cole looking through Craigslist ads and Airstream forums, educating themselves on the different styles of trailers and their approximate costs.

Sunny fortified herself by reading inspirational fiction by single women like Cheryl Strayed, who wrote about her solo expedition over the Pacific Crest Trail. ("I think about her

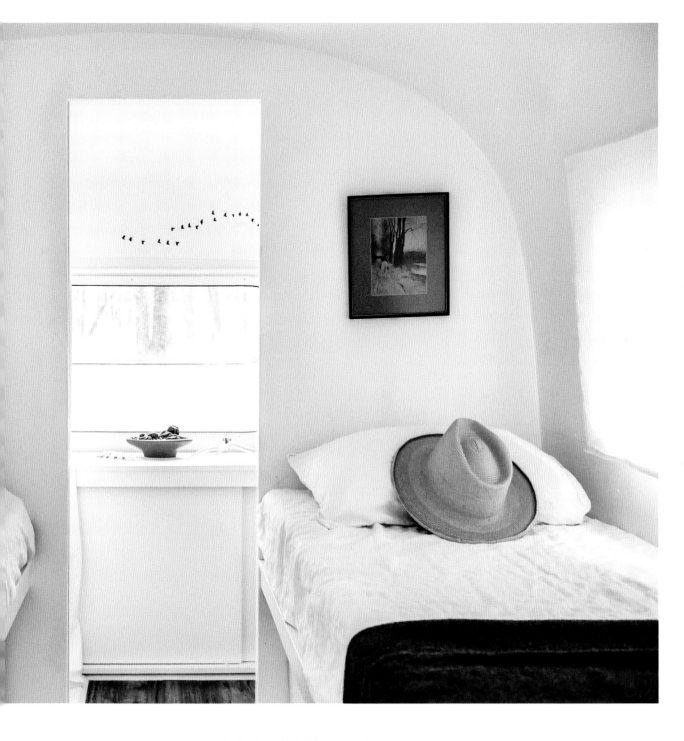

⌃ A PLACE TO LAY YOUR HAT

The Yakima Pendleton blankets at the foot of each bed are journey-warming gifts from Sunny's mother and aunt. "Aside from the practicality of these pure wool throws, I love the history of the Indian trading blankets," says Sunny. Beyond the doorway is the bathroom, where a cloud of blackbirds, painted by Sunny's sister, take flight across the back wall.

with her monstrous backpack; she wasn't prepared, and she did it anyway," laughs Sunny.) The final revelation came from the Cherokee Village Museum in Tahlequah. It was there that Sunny saw the reconstructed cabin of Samantha Bain Lucas—a Cherokee woman and single mother who participated in the 1889 Land Run on the Unassigned Lands in Oklahoma. The twenty-three-year-old woman claimed her own property, raised two children, and supported them as a rancher. "That was the last piece of the puzzle for me," says Sunny. "The Land Run was not an easy affair—it was a dusty, sweaty, brutal, courageous undertaking. I saw the adaptability in Lucas. She just figured it out and did it."

Very shortly after that visit in October 2015, the Airstream Sunny was looking for—a 26-foot Argosy with a twin-bed layout and a rear bathroom, perfect for mother and ten-year-old son—came up on Craigslist. Sunny purchased the vehicle sight unseen and had it towed from Ohio to Tahlequah.

The dated trailer needed lots of work, and it had to be outfitted with all the tools and supplies required to take it off the grid. With no prior Airstream knowledge and very little construction experience, Sunny knew she needed a thoughtful expert who would not only fulfill her eco-conscious requests but also respect her aesthetic vision. Finding that someone in Oklahoma proved to be a challenge.

"That was a long, arduous process for me and, truthfully, harder because I'm a single woman," says Sunny. It was her mom who

∧ THE POWER TO GO

Sunny spent two months meticulously researching composting toilets until she found the one she wanted for her and her son; the Nature's Head loo is self-contained, lightweight, compact, and odorless. "I want to do a lot of camping and be able to do it for as long as we like without being tethered to hookups," says Sunny. "Plus, I had some serious issues with the idea of dump stations. I don't want to mess with black water, neither my own nor that of a thousand strangers. Nope, no way, no thank you. This toilet is our ticket to freedom." (For more on bathrooms, turn to page 264.) Near the window is Sunny's collection of rose rocks, a reddish-brown mineral that forms in the shape of a bloom and is found mainly in Oklahoma, along with some found hawk feathers and an antler.

finally recalled that the kid across the street, Evan Walker, had been building an eco-friendly home in Belize. Sunny met with him and knew immediately that he was a kindred spirit. With the right person on the job, Sunny homed in on her vision.

"I wanted a sense of place, like Georgia O'Keeffe's Ghost Ranch, blended with my own Cherokee and French history," says Sunny. "It needed to have the warmth of old cabins but also the simplicity of a fresh, clean hotel room." To get that look, she started by giving herself a blank canvas to work from, removing all the cheap, fake-wood cabinetry, tearing out the floor, and getting rid of the retro brown polyester upholstery. With the stained beige walls painted a pure white and a new dark laminate floor, the Airstream started developing the character she desired.

For the banquette cushions, she chose a blue-and-white ticking stripe that reminded her of cabins and the French side of her family tree. In the bathroom, the black-water tank was removed and replaced with a composting toilet. (The icky shag carpet went at the same time.) Solar panels were added to the roof to charge laptops, phones, and lights. Once almost everything was in place, Sunny invited her sister, an artist, into the trailer and asked her to paint migrating blackbirds on the back bathroom wall.

After almost a year of renovation at a cost of $12,500, the Argosy, which Sunny refers to as her rugged white pony, was ready to hit the road. Her first trips were to local parking lots

to get a feel for driving the trailer. "I found a stretch of road and I just practiced the heck out of it until I was comfortable," says Sunny. Next, she and Cole worked on the hand signs she taught him to help her back into parking spots. When they thought they were ready, they took the trailer into Tahlequah and parallel parked in front of the local cinema—the Dream Theatre— a sign not lost on Sunny. As their confidence increased, so did the length of their journeys. There were challenges along the way—broken hitches, flat tires, blown fuses, and propane tanks incorrectly installed after fill-ups—but mother and son were unfurling their wings and almost ready to take flight.

Then, while they were away on vacation in California, disaster struck. The Airstream, which had been parked at Sunny's parents' house in Tahlequah, was the victim of an electrical fire that started inside the house and exploded, blowing off the garage door. A beloved pet died. Two cars were destroyed. And Sunny and Cole's home and hard-won dream— their Argosy—suffered significant damage.

Airstream trailers from 1976 are not worth much to insurance adjusters. Most are written off as a total loss in a case like this one, but to Sunny and Cole, this trailer was so much more than a dated recreational vehicle—it was their home and a conduit to their future. After many letters, phone calls, and conversations, they received the money from the insurance agency to move the trailer to Paradise, Texas, where it could be properly repaired. And during those months while

they waited for the work to be completed, Sunny and Cole had some long, heartfelt conversations. "We talked through all those questions that were hanging in the air. Why not a stationary house? Why are we doing this? And in reminding him, I reminded myself," says Sunny. "This isn't our home; we are each other's home. This isn't the dream; this is our passage to the dream. It may be breaking us down, but it's also building us back up together, in a new way."

With the resuscitated Argosy back in their possession and a new miniature Australian shepherd pup, Pax, at their side, Sunny is now thinking about their journey ahead. "We're going to make our way toward California, following indigenous boundaries rather than state boundaries. There's a lot of wild land I want to see, a lot of reservations and ranches that are indigenous owned and public land with horses on it," she says. "Then we'll slowly head up to Whitehorse in the Yukon to see the northern lights. That's where we're supposed to go— that's my touchstone. Really, truly, after all we have been through, I expect a miracle because we've received that along our journey."

︿ FOLLOW THE BUFFALO

Buffalo are an integral part of Sunny's Cherokee heritage and her own mythology, so she asked her sister to paint some on the side of her trailer. For thousands of years, indigenous peoples roamed across the vast plains of North America following the migration of the buffalo. They led a nomadic existence, lived in portable homes, and took only what they could carry with them. Sunny has adopted the idea of a Buffalo Culture in both her life and her work. "Following the buffalo means following our vision. We travel light, dust doesn't gather on our things, and we're ready to go when we see our buffalo," says Sunny.

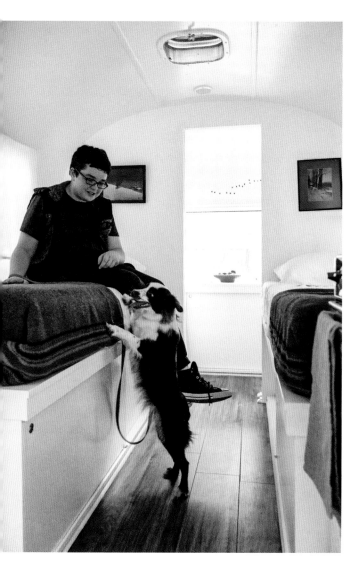

∧ INTO THE UNKNOWN

"It's not easy traveling with children. Most days I feel like Gandalf with Bilbo. 'You *will* go on this adventure and you *will* love it!'" laughs Sunny, referencing one of her and Cole's favorite books, *The Hobbit*. "I'll be the first to tell you that the unknown is really daunting," says Sunny. "But I did not want comfort zones to shape my son. He is very resilient—there's adventurousness and courage there—but I have to pull those things out, and if I'm letting him be comfortable all the time, then those things aren't going to bud and flourish," she says.

≪ LOVE NOTES

These two precious pieces survived the fire: a commissioned drawing by Melanie Knox of a Ghigau—a Cherokee war woman—and a handmade heart by Cole.

∧ LITTLE REMINDERS

Inside the trailer door are two pieces of art with special meaning for Sunny. The top one is a crumpled piece of aluminum in the shape of a rough-hewn wing, found in the rubble after the fire. Beneath it is a piece passed on to Sunny by her mother.

Dare, Dream, Do

It is just as Wim Robbertsen predicted. At around 2:00 p.m., the clouds start to part over the lush flatlands surrounding the village of Baarn in the Netherlands, revealing an endless blue sky. Opening up his preferred weather app, Windfinder, Wim double-checks the forecast, turns to his wife, Anneke, in the wood-lined wheelhouse of their canal boat, and declares, "See, it's always right."

Wim is attuned to the weather—you could say it's his job. He's the director of projects and services for one of the Netherlands' largest wind turbine companies, and his team is on call twenty-four hours a day, around the world. A self-described nomad and workaholic, he left his large Dutch Reformist family at the age of nineteen to become a truck driver. He traveled as far south as the Sahara, and when the company asked for volunteers to drive up to icy Hammerfest, Norway, where not even trees dot the landscape, he was the first to raise his hand.

In those early years, back home between truck routes, he met a young woman named Anneke, who had grown up in the same conservative village that he had. They celebrated their twentieth birthdays together, got married, and had two children. Eventually Wim gave up truck driving and found work advising on wind turbine locations in many far-flung places—Russia, China, Alaska.

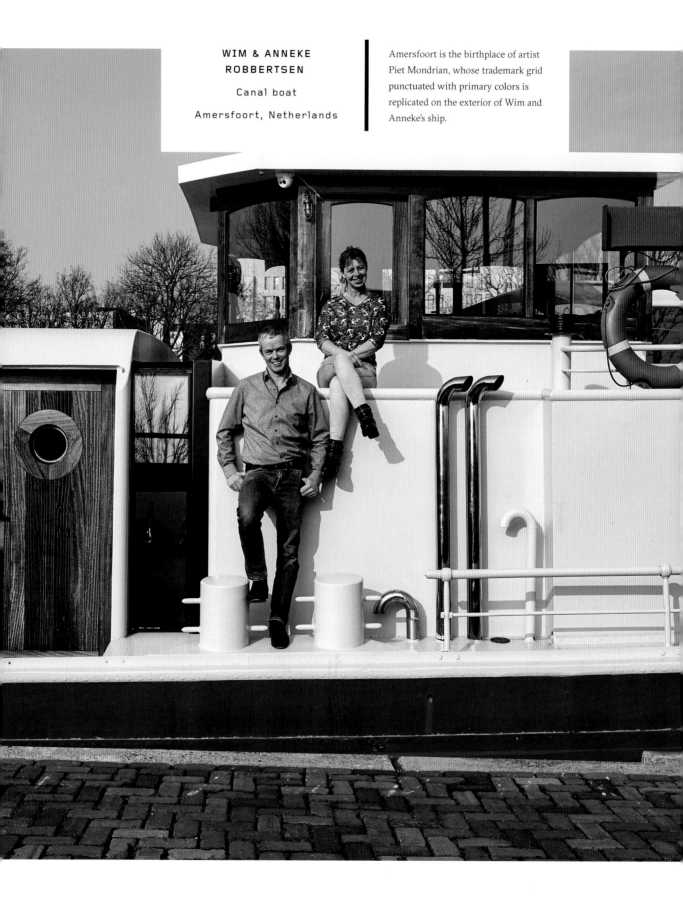

WIM & ANNEKE ROBBERTSEN

Canal boat

Amersfoort, Netherlands

Amersfoort is the birthplace of artist Piet Mondrian, whose trademark grid punctuated with primary colors is replicated on the exterior of Wim and Anneke's ship.

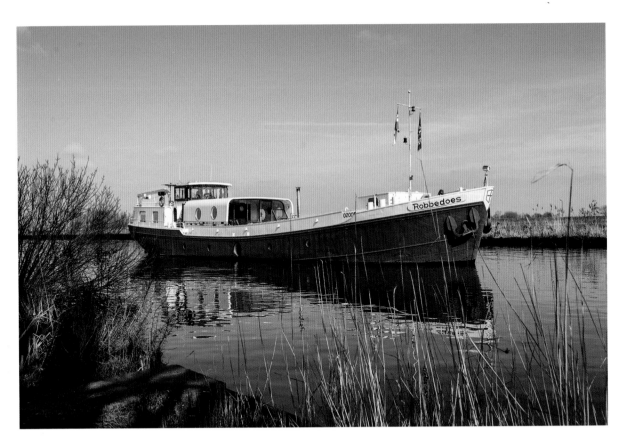

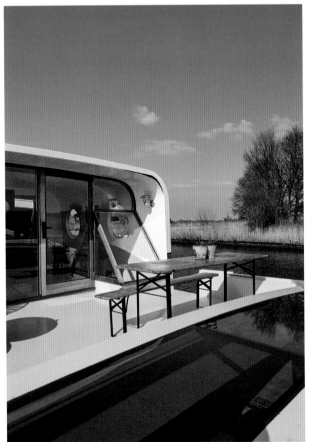

⌃ CHRISTENING THE SHIP

Wim came up with the idea to call the boat *Robbedoes*, the name of a mischievous cartoon character in Holland. "He is adventurous and a little bit naughty," says Anneke. "So it fits with what we are doing." Copies of the old comics can be found in the skipper's saloon.

❮ ALONG THOSE LINES

Wim and Anneke were very concerned about maintaining the original profile of the ship and went out of their way to find skilled craftsmen who would work with them to round edges for the glass windows and produce quality woodwork.

While Wim traveled, Anneke stayed at home and looked after the household.

"We weren't always as happy as we are now," says Anneke. "His work and frequent trips caused a lot of misery."

"I hardly saw our children until they were ten years old," says Wim remorsefully, steering the boat through a narrow canal.

The story of Wim and Anneke—their evolution from disconnected, fly-by-night partners to united, adventure-seeking liveaboards—begins a week before their twenty-fifth wedding anniversary on a bench overlooking the canal in Amersfoort, a storybook-perfect gated town about forty minutes southeast of Amsterdam. The couple had just taken a look at the venue for their party and were enjoying a warm Sunday afternoon watching the boats go by. A year earlier, both of their children had left home to attend university and Anneke's little dog, Snoopy, her constant companion, had passed away. "The nest was very empty," says Anneke. They were at a turning point—a midlife crisis of sorts—and wondering what to do for their second act.

They had both long outgrown the town of twelve thousand people they had been raised in and thought now was their opportunity to reimagine their lives. They decided to sell their house and look for a new place, preferably with a view of the water.

Wim found some houses for them to look at, but Anneke wasn't impressed. The thought of moving occupied her mind day and night, and during a routine cleaning of the house after Wim had gone to work, the idea of living on a boat bubbled to the surface. Knowing Wim's propensity for adventure and his unquenchable wanderlust, Anneke kept the idea to herself, certain that the moment it escaped her lips there would be no turning back. "About two weeks later, when I was convinced in my own head that it was what I wanted to do, I told him, and that was that," says Anneke.

"There was no way back," exclaims Wim with a smile.

That same night, they told their children of their plans but decided to keep it a secret from everyone else in their close-knit community, sensing that others would try to talk them out of it. For the next two years, they schemed and plotted how to make the transition from fifty-year-old empty nesters to seafaring canal boat owners.

"Canal boat slips are hard to find," says Wim. "It's very rare for spots to come up." After some searching, a 52-foot berth became available just outside of Amersfoort, the town where it had all started. Unfortunately, it was in the industrial part of town, bordered by anonymous-looking warehouses and deserted streets. It wasn't what Anneke had originally imagined—she pictured herself closer to the beauty and bustle of the city—but with some convincing, she conceded. Unique to the property was a sizable side lot with shipping containers, a shed, and space for a small garden. Also left behind was a 1929 tugboat loaded

with flotsam and jetsam that hadn't run in twelve years. "It was all or nothing," says Wim. "And we really wanted the spot."

With a space secured, they set off in search of a vessel. They used a ship broker who took them to see various boats around the Randstand. "We knew the dimensions of what we were looking for based on the size of our slip, and we had ideas about what we wanted it to look like," says Anneke. One of the boats their broker took them to see was a working commercial ship—used for transporting soy for livestock—that the current owners were selling due to retirement.

"It was love at first sight," says Wim. "The boat had been built by a well-known shipyard that is recognized for its fine craftsmanship. It

⌐ EARLY ITERATIONS

Wim, with no formal training in architecture, redesigned the entire ship by first sketching his ideas out on graph paper.

∧ STREET PRESENCE

The roadside front door to the lot where Wim and Anneke moor their ship is decorated with a nameplate and some vintage items they found aboard the original boat. "We have a street address, so receiving mail and packages is very easy," says Anneke.

❭ CIRCLE AROUND

In the sun-filled dining room, a built-in banquette is nestled around a table that Anneke made from the base of a drafting table. The couple enlarged the portholes throughout the ship to bring in more light.

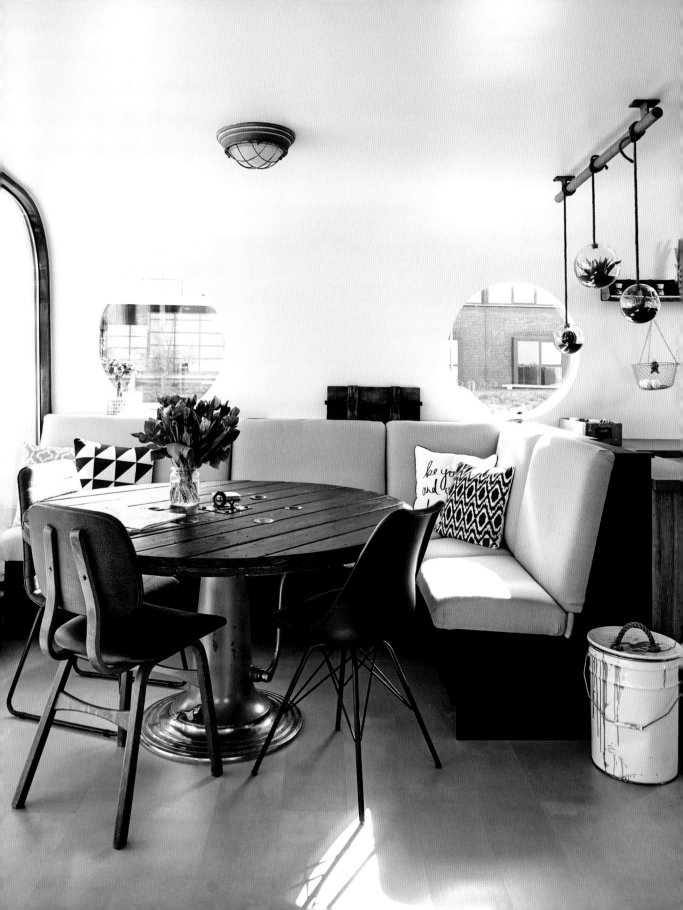

⌃ THE GREAT DIVIDE

The wood-burning stove comes in handy when the couple
is sailing and not connected to natural gas. For fuel, they
use wood from the discarded shipping pallets found in their
neighborhood. The room divider is part of the portion of the
hull that was removed when the vessel was made smaller.
The tar-based paint used to prevent marine-boring organisms
and rust from taking hold has been protected with a coat
of varnish.

⌐ THE PAST IS PRESENT

Anneke and Wim chose a clean, streamlined design for the
kitchen but added their own rustic touches, like the wall-
mounted shelf and blue file drawer (which hides their licorice
stash) repurposed from the original vessel. "We have a respect
for the history of the ship—we like to include things that tell
a story of its past," says Anneke.

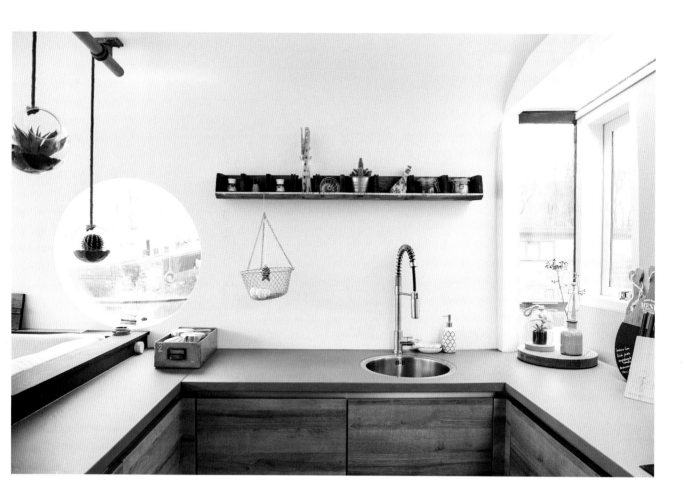

had rounded corners and curved windows that you don't see on most ships."

There was only one problem: It was too long—by almost 69 feet.

But Wim, with his can-do attitude, found a place that would cut the excess metal out of the middle of the ship and weld the ship back together—effectively shrinking it to size. With their house sold and longtime neighbors brought up to speed, they moved into a construction trailer on their lot and began the work of emptying out the old tugboat and renovating their newly shrunken home.

First on graph paper and then later in AutoCAD (computer-aided drafting software), Wim plotted out the new living quarters for the ship, converting it from a working vessel to a home for two. He left the original mate's cabin and the captain's lounge untouched and concentrated his efforts on the spacious below-deck holding area and a small portion of the upper deck where the kitchen would be located. The integrity of the ship's lines was always respected, and considerable work went into making sure the exterior profile didn't stray too far from the original. Afraid that the boat would feel dark

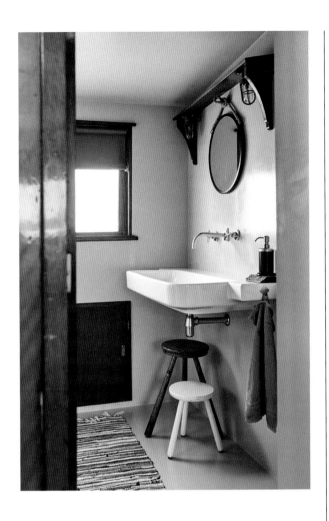

⌃ REPURPOSED SPACE

This bathroom, with its original teak finishes, was the captain's master bedroom. "It had a bed that measured less than four feet across," says Wim incredulously. "I like to say that children were made and born in this room."

⌐ INSIDE TRACK

Originally, this hallway was exposed to the elements, but Wim decided to close it in so he and Anneke could walk from their living quarters to the wheelhouse without having to go outside. The porthole opens to the engine room below and is a handy way of communicating if one of them is down there.

and cramped, the couple decided on a clean, modern look with concrete floors throughout, bright white walls, and a Mondrian-influenced color scheme with reds, blues, and yellows dominating. Wherever they could, they inserted skylights, slashing the deck of the ship into ribbons to bring light into the hull below.

Anneke, inspired by the vintage naval parts left behind on the tugboat, refashioned items into whatever they needed: she made discarded engine tools into a pendant light and the ship's old gangplank into a low console table in the living room.

The amenities on board are not much different from those in their former home—flushing toilets, a washer and dryer, and a dishwasher—and all function normally thanks to hookups that connect them to Amersfoort's water, sewage, and natural gas systems. When the couple is sailing, which they currently do about every five weeks, they switch over to a diesel-powered system, which works almost as well. In the future, they hope to install solar panels to supply some of the electricity they need.

For a couple that was for so long pulled in different directions, the turnaround has been transformational. "We told each other last week that we couldn't live this way without each other. We make each other stronger. I can't imagine ever going back to a brick house now," says Anneke. "We have to be free—always free." Wim, naturally, is in complete agreement. Anneke has continued to document their journey on their Facebook page, discovering a

love for writing and photography and exposing the couple to a new community of people, many of whom are interested in taking on their own life-changing adventures. "I discovered myself because of the ship. 'Dare, dream, do' has become my new motto," says Anneke, with an ear-to-ear smile. "Wim and I have the same hobby now, the same passion—all because of my crazy idea. Now we see each other as we really are, and that is nice. We're happy. We're soul mates. And finally, we are doing something together."

❮ BE OUR GUEST

Pictured here is one of two breadbox-size bedrooms in the unrenovated part of the ship. Each one has a single mattress, a closet, and a generous window. The vintage postcards mounted to the wall were found in a suitcase under one of the beds.

❯ STEP BACK IN TIME

The captain's lounge has been kept as it was originally designed in the 1960s. On the book-matched teak wall, achieved by turning over alternating leaves of wood so that the panels mirror each other, are photographs of the three iterations of the ship, from the previous owners. Wim and Anneke are planning on renting out this section of the ship, which has its own bathroom and two small separate bedrooms, to curious canal ship enthusiasts.

Opportunity Knocks

Climbing up through the hills of the Santa Rosa Valley, just south of Ventura, California, it's easy to miss the turnoff for Ashley and Dino Petrone's building lot. Surrounded by well-kept Spanish-style homes and sprawling California ranches with meticulously landscaped lawns, their 2003 Keystone Cougar trailer parked on a dirt patch is a blip that hardly registers.

"Did my mom tell you the story of how Dino and I met?" asks Ashley, hanging out of the doorway in a breezy pin-striped jumpsuit that epitomizes her laid-back, Cali-girl style. "She and Dino's mom just love telling it."

The story of Ashley and Dino begins with a cow. When Ashley was in fourth grade, her family, native Californians, took a trip up to Lynden, Washington, a rural town on the border of Canada, to visit some family friends. They attended the county fair, fell in love with a cow, and bought it. The purchase prompted the buying of 20 acres, a little farmhouse, and some chickens in the town of Lynden. For four years, the family lived in the Pacific Northwest village, and during this time, Ashley's parents became good friends with the Petrones. Eventually, both families went their separate ways—Ashley's back to California and Dino's to Nevada—but the moms stayed in touch. Years later, when Ashley was fresh out of high school and unhappy in her long-term relationship, she agreed to go on a trip her mom had set up

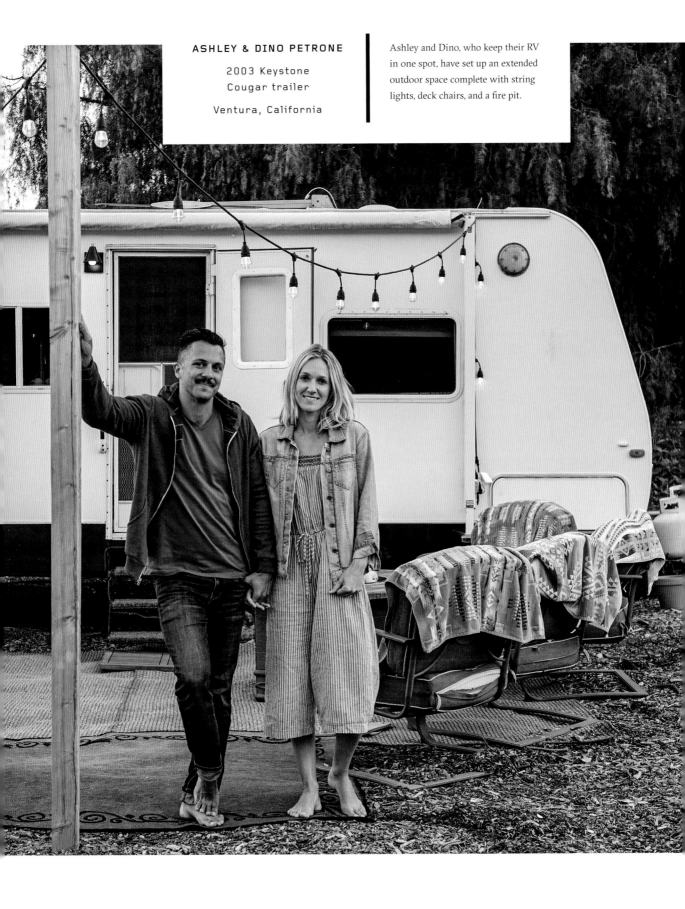

ASHLEY & DINO PETRONE

2003 Keystone
Cougar trailer

Ventura, California

Ashley and Dino, who keep their RV in one spot, have set up an extended outdoor space complete with string lights, deck chairs, and a fire pit.

to visit the Petrones in Las Vegas. Unbeknownst to her, the moms had plotted for Dino to be there as well. The rest, as they say, is history—the pair hit it off and were engaged three weeks later.

What followed was a whirlwind romance, three kids, and a spacious 2,800-square-foot, five-bedroom house. With a grand circular staircase in the entry and a white kitchen with Shaker-style cabinets, it was a jaw-dropping first home, but Ashley wanted a place she could put her own stamp on. She was looking for that elusive "ugliest home on the nicest street that she could get for a song" kind of house. To her surprise one morning, an underpriced 2.2-acre lot with a view popped up in a desirable SoCal community. A drive by later that evening confirmed it—this was the one, the property where she and Dino would build their own house from the ground up. In quick succession, they purchased the lot, prepped their house for sale, and put it on the market; within weeks, it was sold.

With nowhere to live during the build, the couple considered renting an apartment or a small house, but it seemed silly when they had their own land. What if they purchased a trailer and parked it at the foot of their property? It

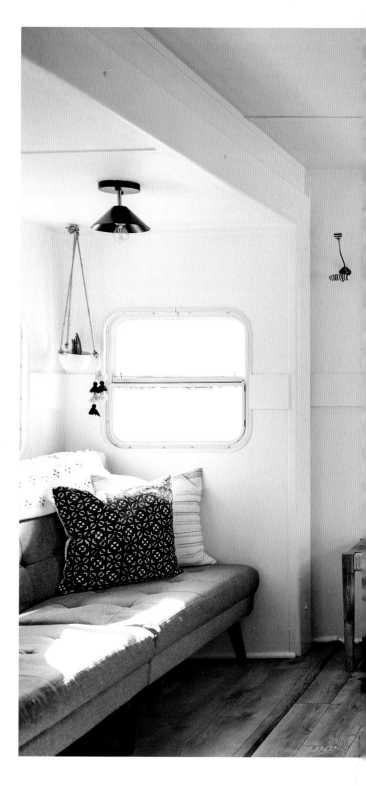

❭ LIGHT AND BRIGHT

Other than painting the walls and laying the laminate floor, which they paid someone to help them with, Ashley and Dino did all the conversion work themselves. "I think the average person could do this pretty easily. An RV is very much like a regular house since it has straight lines."

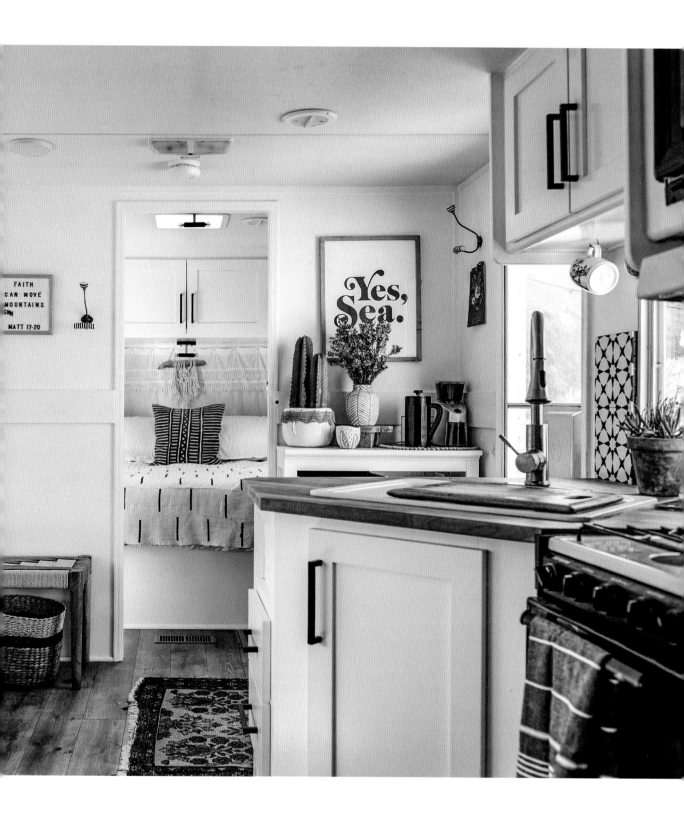

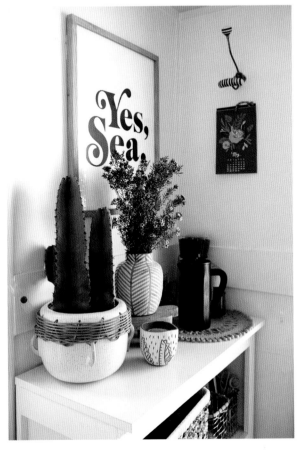

⌃ KICK IT UP A NOTCH

Set up in the RV's slide-out (a section that extends outward when the trailer is parked to give it more room), this hangout space feels airy and spacious. The area underneath the sofa is used to store extra pantry items, like bottles of seltzer water.

❮ CORNER CAFÉ

In order to save room on the kitchen countertops, Ashley set up a coffee bar on a console unit. The Yes, Sea poster, made by local artist Daniella Manini, reminds her of summery goodness and hanging out in the ocean.

⌐ CLUTTER CONTROL

A cutting board placed over the sink provides extra prep space, while hooks underneath the cabinets allow mugs to be easily stored. "I don't fill my cupboards," says Ashley. "If things start getting even a little bit too much, I pare them down. When you live this tiny, you have to." With the exception of a dishwasher, the family has all the major appliances they had in their old home, including a microwave.

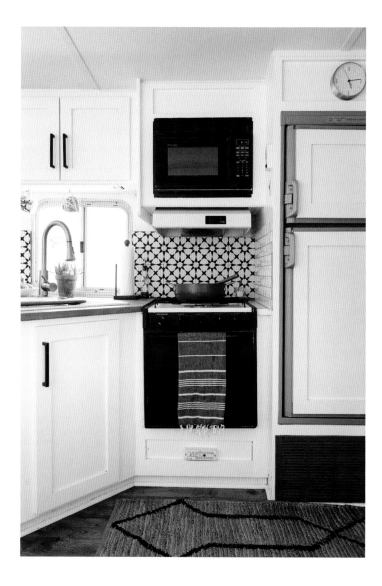

would allow them to supervise the build and save money in the process. They found a tired-looking 31-foot trailer for eight thousand dollars, and Ashley, who has a knack for decorating on a budget, got to work transforming the place to make it livable for the family for the few months they would be there.

She and Dino began by ripping out everything they hated—the dusty-blue wall-to-wall carpeting, dated brass light fixtures, built-in chintz-covered furniture, and oppressive, space-sucking upper cabinets. Ashley decided on an overall West Coast vibe with a punchy black-and-white color palette sprinkled with boho prints and beachy accessories like woven mats and potted succulents. She ordered new door fronts for the kitchen cabinets and began patching and priming the trailer so it would be ready

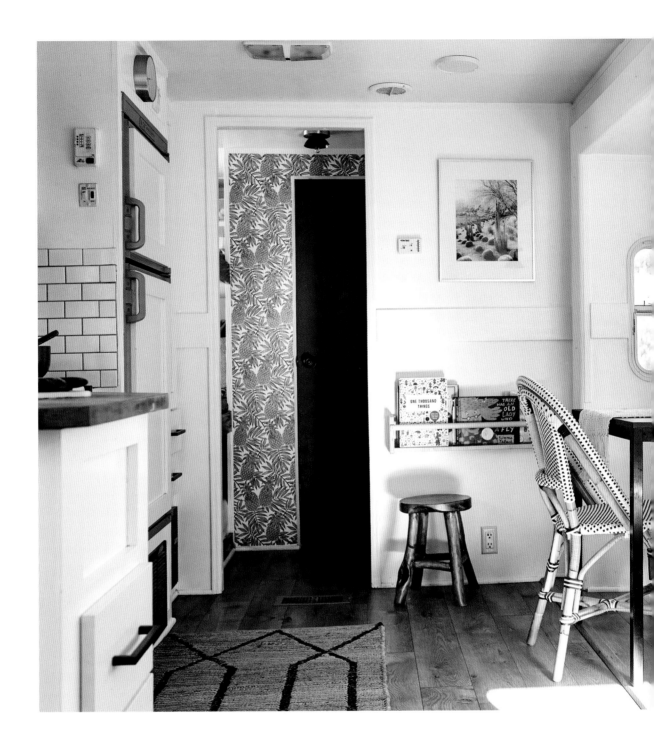

∧ MIXING OLD AND NEW

The dining room, located in the RV's slide-out, is a good example of Ashley's laid-back California style. The Serena & Lily rattan bistro chair at the end of the Ikea table is from a set in the couple's former house. Ashley was determined to keep at least one, "because they are perfection." The lighting throughout the trailer is by Lucent Lightshop, which has a line that runs on DC power specifically for RVs and campers.

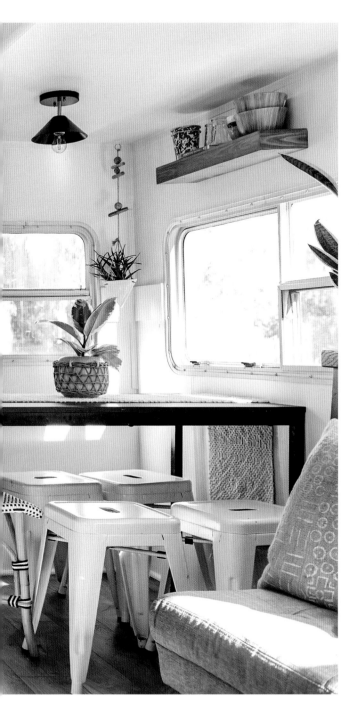

for painting. Some friends gave her a couple of boxes of leftover graphic cement tile from the Cement Tile Shop, which Ashley and her mom installed in the kitchen; a similar tile treatment went up in the bathroom. With the new white kitchen-cabinet fronts installed, accented with streamlined black hardware from Amazon, the existing black appliances jumped into focus and looked as if they had been chosen on purpose.

Three bunk beds, stacked one on top of the other, were squeezed into a shoebox-size space beside the bathroom to function as the kids' room; a separate, light-filled bedroom on the other end of the trailer gave Ashley and Dino their own space. Savvy shopping at online and big-box retailers netted dozens of stylish finds, from black and brass pendant lights to woven storage baskets and space-saving hooks. Wanting to start fresh in their new house, the couple sold the majority of their possessions in three colossal garage sales, dropped off four carloads of goods to charity shops, and moved whatever wouldn't fit into a storage locker (which they subsequently pared down to five boxes six months later). Each kid was given one tote-size bin to hold all their clothes, and toys were strictly limited. "They have one stuffed animal each, some books, and a shared craft bin—that's it," remarks Ashley. "At Christmastime, we give each other experiences, not things."

The 2003 trailer originally sported multiple cougar decals and multicolored stripes. Ashley decided that she couldn't have the outside looking dated when the interior looked so nice.

After sanding off the decals, she primed and then painted the trailer with Rust-Oleum High Performance Enamel in White Gloss, then added black accents. The entire process took about four days. "Nobody wants the decals," says Ashley. "The RV executives still think their market is the retired person, but it's shifting."

Three weeks later, having spent just under three thousand dollars, they were ready to move in. Big adjustments had to be made—there was no washing machine, dishwasher, or garbage pickup, only a teensy shower, and less than 180 square feet to hang out in. But this was temporary, and they had a brand-new house to look forward to. "We thought, 'Oh, it'll be fun, we'll live in this trailer for a couple of months and then we'll move into the house.' Wrong! We've been here for over a year and counting," says Ashley.

What happened after Ashley and Dino moved into the trailer took everyone by surprise. Ashley had a blog and Instagram feed, Arrows and Bow, that featured her mix of tell-it-like-it-is vulnerability, aspirational biblical quotes, and outrageous, lip-sync dance routines; it had already built up a loyal group of followers who turned to her for budget fashion tips and bargain decor finds. She was reluctant to share images of the renovation of her RV with her fans, certain that many people would stop following her, but she was proud of what she had done and ultimately decided to post a few pics. "I thought I was going to lose everybody," Ashley says. Instead, people started reposting photos of her breezy, boho trailer, astonished at how an

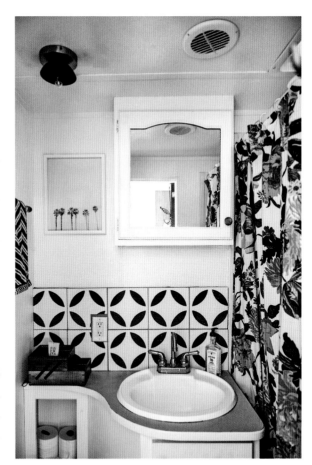

∧ PATTERN PLAY

What the modest bathroom lacks in size, it makes up for in style. Cement tiles in black and white pair beautifully with an oversize-floral-printed shower curtain picked up at Anthropologie. The water pressure is unreliable—strong one day and only dribbling the next—so Ashley tends to plan her workouts at her local gym around when she wants to wash her hair.

⟩ SHOEBOX SLEEPING QUARTERS

One—two—three! Stacked bunk beds are an efficient use of space in the kids' sleeping nook. When they first moved in, the couple was worried that the kids would keep one another awake, but miraculously, most nights everyone falls asleep. The inexpensive peel-and-stick pineapple wallpaper is from Target. It's the second wallpaper Ashley has used in this space, as she finds that the kids tend to put their dirty feet all over it. The first one was a bold black-and-white buffalo check, which gave the space a completely different look and feel.

RV (a space they associated with drab design and humdrum retirees) could suddenly be so hip. Soon the major design blogs came knocking, asking for multiphoto features. As her popularity grew, so did the offers; all-expenses paid vacations, shoe commercials, and even talk of the family appearing on their own HGTV show.

"This whole thing has been a total surprise to us and a total gift. We were not looking to monetize this. We weren't looking for any of this stuff, so as it comes, it's an experience and an adventure," says Ashley.

With so many opportunities presenting themselves every day, and a newfound comfort in living small, Ashley and Dino are unsure about starting construction on their new house. "Living this way has shifted how we want to build and even made us question *whether* we

want to build," says Ashley. "We've definitely realized that you don't need that much, which is very cool. We also know we don't want to move into a house and be house poor. We love how free our life is right now. It's so amazing. Who knows where we'll end up?"

⌄ ALL ABOUT THE ACCESSORIES

Creativity is the key to Ashley's small-space challenges, whether it comes to clothes or decor. Her entire wardrobe fits into the cabinet beside her bed. "I cycle through a lot of the same clothes and just add belts, scarves, hats, whatever," she says. She's also a master at swapping and switching out pillows and throws to create a whole new look whenever she has the urge. The room feels open and airy thanks to the bright-white cabinetry and bed linens.

❭ ROUND THE CAMPFIRE

A wood-burning fire pit and overhead string lights give a warm ambience to the area immediately outside the trailer, where the couple hangs out while their kids fall asleep.

Tiny House Entrepreneurs

Walking through the Hollywood RV Park in Van Nuys, California, where two-story-high murals of Marilyn Monroe and the star-spangled banner loom over the lots, the first thing you notice about Devin Groody and Catrin Skaperdas's home is that it is completely different from all the rest. Surrounded by tent trailers, Airstreams, and full-blown motor homes, their compact tiny house on wheels draws constant attention from the other park residents.

"We wanted that wow factor," says Devin, a lean-muscled, yoga-practicing twenty-seven-year-old. "It's a great conversation starter, and really good for our business." It would be an understatement to say that Devin is a self-starter. At fifteen, he labored at an apple orchard near his hometown in Connecticut and quickly learned that he didn't like working for an hourly wage. In his sophomore year at the University of Connecticut, where he studied finance, he and his roommate started a line-striping company after reading in *Forbes* magazine of a similar start-up that was "one to watch." "It was great for us because we were in school during the day and the only time you can paint a parking lot is at nighttime, so while everybody else was out partying, we would be painting lines," he says. In his downtime, he was running his own

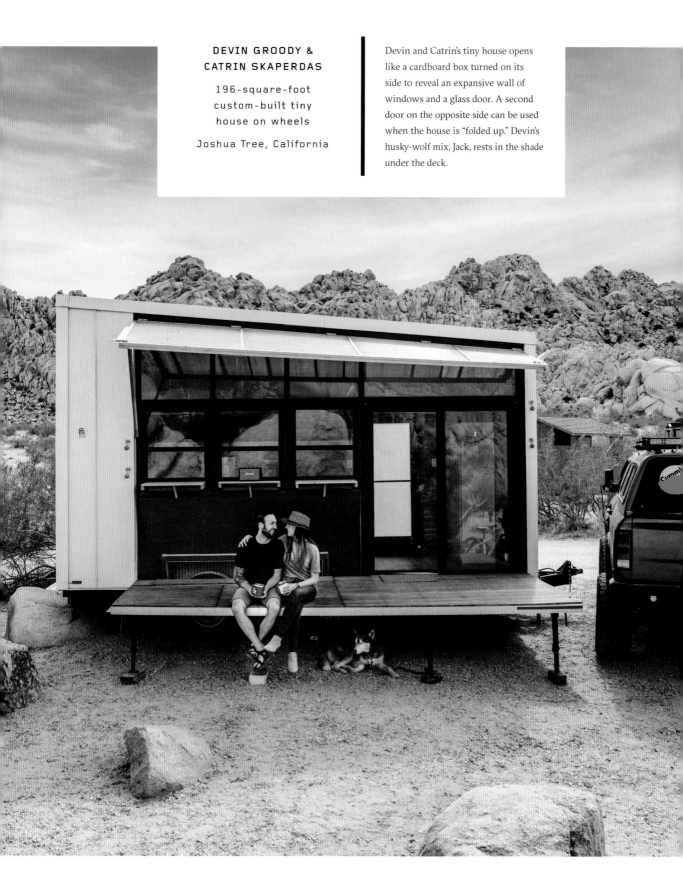

**DEVIN GROODY &
CATRIN SKAPERDAS**

196-square-foot
custom-built tiny
house on wheels

Joshua Tree, California

Devin and Catrin's tiny house opens
like a cardboard box turned on its
side to reveal an expansive wall of
windows and a glass door. A second
door on the opposite side can be used
when the house is "folded up." Devin's
husky-wolf mix, Jack, rests in the shade
under the deck.

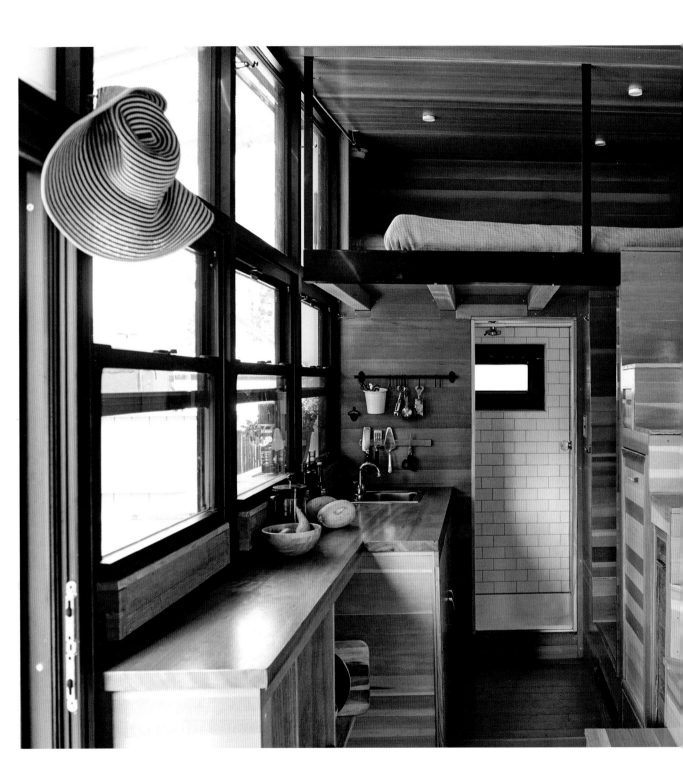

eBay company buying products in bulk from China and selling them for a profit. When Devin eventually graduated, he put his business degree to work and got a corporate job as a financial adviser. He hated it and soon left. From there he bounced around, working at a tech firm as a job recruiter and later for Apple doing remote support. During this stint, one of his friend's moms who worked in real estate needed some photos taken of a house she was listing and asked Devin, who she knew was a talented amateur photographer, to help her out.

"Basically, I ended up taking a ten-day vacation and just tried real estate photography. I made a bunch of brochures, went to almost every real estate brokerage in the state, and tried to shake hands with the most important person there. I said, 'This is what I charge, but I'll do your first shoot for half off.' I crushed it," says Devin emphatically. "No matter how hard I worked on those other jobs, you're always on a time frame—you have to be here for eighteen months and then you're eligible for a promotion. I don't work like that. Everything I've ever done, I've wanted to excel. My goal forever has been to have multiple streams of income so I

⌐ SLEEPING LOFT/GYM

The bedroom is suspended over the kitchen and bathroom by a sturdy metal strut that doubles as a pull-up bar for Devin. "I break out my yoga mat and do a little flow on the floor, then pull-ups below the loft, and finally some push-ups out on the deck."

can make money while I sleep. I've always said that when I can make seven figures passively, then I'll stop."

Devin concentrated his real estate photography business in Greenwich, Connecticut, where he could charge top dollar, and filled his weekends with wedding and engagement photography. It was on the way back from a wedding in the summer of 2017 that Devin, tired of being stuck in traffic and paying way too much money for rent on Long Island, approached his girlfriend, Catrin, a social media manager, with the idea of buying a tiny house. "We had been talking about it," says Catrin. "I was always entering us into tiny house giveaways, and Devin was constantly looking at eco-friendly tiny house websites, and we decided then and there to start making strides toward it." For the next year, Devin built up his photography team so he could work remotely, determined to hang on to his flourishing business, while Catrin started to build her own brand as a travel blogger and establish herself as a remote social media strategist.

Pouring cold-brewed coffee into a Yeti Rambler, Devin apologizes for their current living situation—at present they are plunked in the middle of a massive metropolis with no views in sight. "We were up in Joshua Tree a couple of weeks ago, about an hour north of here. It's beautiful, but there's no service. We both run online companies, so we had to get down into the mix."

Walking into the home, which measures 8 feet across, you're struck by the rich wall-to-wall solid-wood paneling that covers the floor, ceiling, kitchen cabinets, and countertops. It's a clean, minimalist look, and with few personal belongings on display save an acoustic guitar (also wood), it has a warm, soothing effect. The notable exceptions are the expansive, black-framed windows and sliding doors that stretch the full 13-foot height of the interior and cover one side of the house.

"We decided to buy something that was ready to go because we didn't have a place to convert or build our own. We were renting, and my parents live in a gated community that doesn't allow RVs, so we needed something we could just move into. But then everything broke."

The story of Devin and Catrin's tiny home is a bit of a cautionary tale. Devin committed himself to the search for a dwelling like he does to his work—with absolute gusto. He quickly acquainted himself with the vagaries of the market and was impressed one day by the unique look of a compact house that was being sold by an architectural firm out of Colorado. He guessed the home would be in the $100,000 range and was surprised when he found out it was listed for only $55,000. He contacted the sellers immediately and when to his surprise they agreed to $43,000, a contract was written up.

What followed was a lot of hoopla when the company received a full-price offer a few

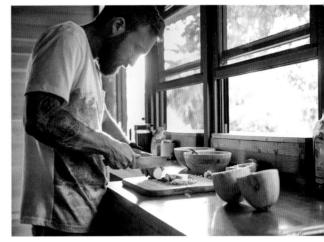

⌃ OUTDOOR ENTERTAINMENT

Takeout-style tray tables fold up in front of the windows, creating an extra spot to sit and drink coffee or eat dinner when the weather is good. Devin also uses one as a standing desk. A portable radio that runs on batteries adds to the mood.

⌐ COOKING LESSONS

On a recent trip, Catrin and Devin listened to an audiobook that has had a big impact on how they approach living in their tiny home on wheels. "It was about how a chef arranges his mise en place before service. It changed my approach to everything; how I put things back after I use them, how everything should have a home, how things should be done in as efficient an order as possible. It was the most life-changing book I've ever listened to," says Devin. Because the tiny house doesn't have a cooktop, all the cooking takes place outside on a Camp Chef camp stove.

❯ HANG IT ON THE WALL

A wall-mounted bar with hooks and a magnetic knife strip provide a place to store cutlery and kitchen utensils.

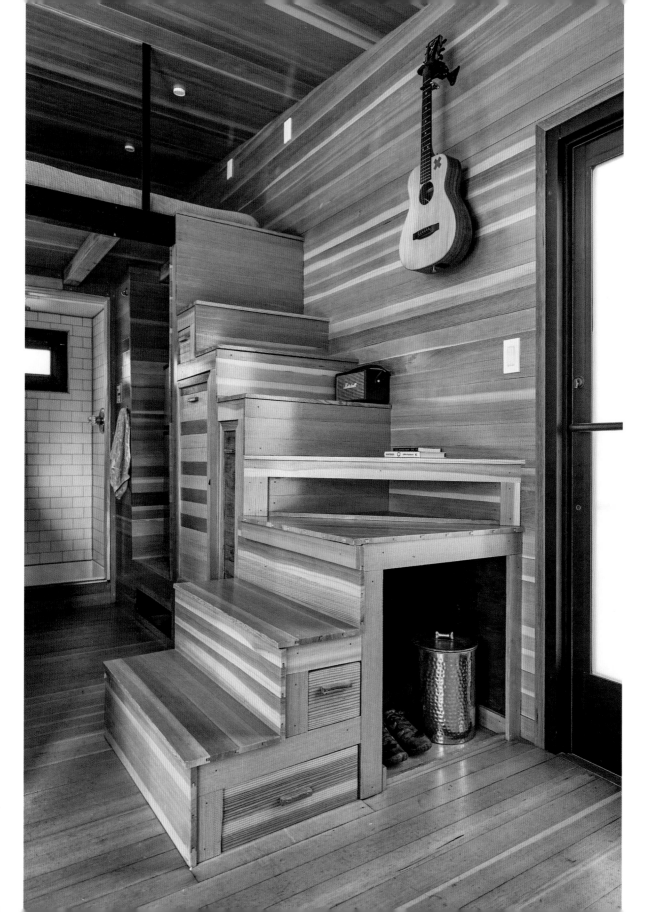

weeks later and tried to back out of the deal. In the end, Devin and Catrin got the house, but the exchange was very cursory. "They sold it to us, but they literally just gave us the keys. They didn't tell us anything about it—the plumbing, the electric, the solar. Nothing," says Devin.

The architects, who built the home as a prototype for a popular television show, never intended it to be used as a traveling tiny house, crossing hundreds of miles over rugged terrain. "It was made with rigid PVC piping, so when we took it from Boulder, Colorado, to our first stop in Arizona, everything was broken. The black-water tank was leaking—it was a mess," says Devin. For the next month, holed up at a friend's horse ranch, he and Catrin rebuilt most of the tiny house's operating systems. Then they replaced the rotting and leaking stainless-steel shower unit with new white subway tiles. "There's still a lot we want to do, but we spent so much time just getting it functioning that we need to stop doing projects for a while," says Devin.

Once everything was roadworthy, the couple set out again. They are among the very few who actually tow a tiny house. Most owners of this form of dwelling choose to live semi-nomadic or stationary lives. However, Devin and Catrin have never been ones to follow expectations. He still manages the day-to-day schedule of his photography team back in Greenwich while establishing himself as an outdoor and lifestyle photographer, and Catrin continues to expand her travel-blogging brand. They are pursuing what makes them truly happy and living on their own terms. "Too often, people stay in jobs that they complain about every day or remain in places while dreaming about living somewhere else," says Catrin. "I challenge people to live life on their own terms, not by what is scripted by their environment, society, or anyone else."

As for that goal to make a million dollars while he's sleeping, Devin has a business plan for his latest tiny home venture: "We're going to travel full-time and every two years try to acquire a piece of property," he says, cutting up a spaghetti squash for his dinner. "We'll park this tiny house on the land permanently, rent it out to make some passive income, and then acquire a new tiny house. I believe this place is only going to appreciate in value over time, like a normal home would. An RV is like a car—it depreciates; it rots—but this should just increase in value. I'd love to gut an Airstream or a school bus next, something that is very custom. That curved roof with wood looks so good."

❮ IN THE DETAILS

The fine craftsmanship of the house is evident in the tongue-and-groove solid-wood flooring that folds over the stairs. (Each step, no matter how small, has its own drawer—see page 282 for a closer look.) All this solid wood means the house weighs more than eleven thousand pounds empty, which can affect gas mileage. "We chug through gas. We get like ten miles per gallon, tops. We get about eighteen miles per gallon when we're not towing the tiny house," says Devin, who drives a heavy-duty pickup truck.

Nomadic Renovators

On a breezy late-spring morning, up a country driveway shaded by an avenue of Texas red oaks dripping with ball moss, Kate Oliver climbs through the skeleton of a gutted Airstream with her young daughter, Adelaide, not far behind. Her wife, Ellen Prasse, wipes the sweat from under her hat and calls out for Kate to come and help her remove the final section of subfloor. Passing a hand drill back and forth, they unscrew the last few fasteners holding the water-damaged board in place. With a few almighty tugs it finally releases, allowing Kate to drag it back through the trailer and heave it out through the front door.

Kate and Ellen, two women in their thirties, single-handedly renovate Airstream trailers while also home-schooling their daughter and living on the road. "We have only four and half months to complete this reno," says Kate, swinging open the screen door of their own converted Airstream trailer, a short 500-yard walk away. "We already have our next renovation lined up in Arizona. The work doesn't stop when you start living on the road, and if anybody believes it does, then they haven't lived it."

The warm, soulful interior of Kate and Ellen's trailer is layered with rich wood, earthy textiles, woven baskets, and pretty tile, all set against a modern white backdrop. Kate has two go-to paint colors—Simply White (a bright, basic white) and Dune White (a warmer, creamy white),

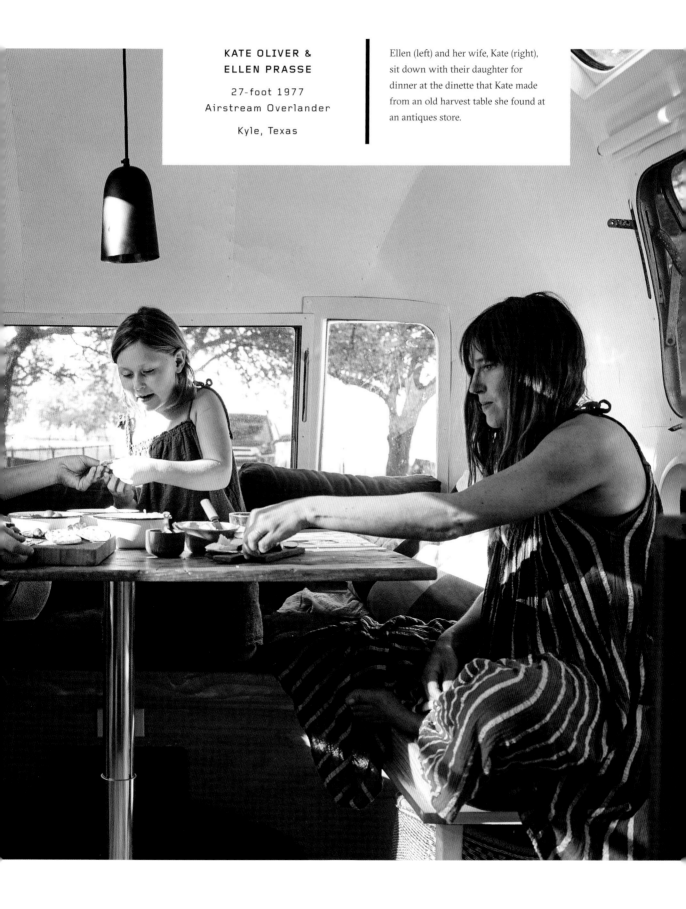

**KATE OLIVER &
ELLEN PRASSE**

27-foot 1977
Airstream Overlander

Kyle, Texas

Ellen (left) and her wife, Kate (right), sit down with their daughter for dinner at the dinette that Kate made from an old harvest table she found at an antiques store.

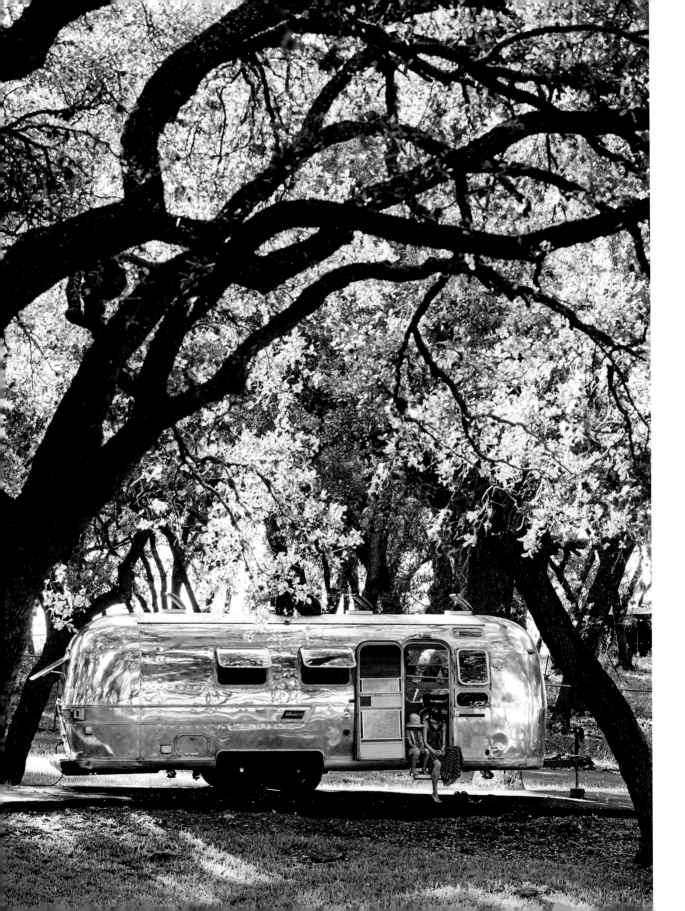

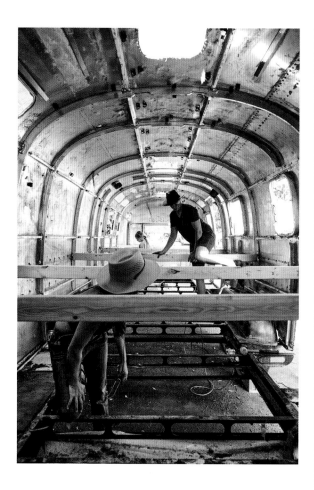

both by Benjamin Moore—that she uses in all their renovations. Their trailer serves as a calling card, just one of the many ways they've reimagined the possibilities for these "silver bullets," turning the geriatric interiors of vintage Airstreams into light-filled "vessels for transformative living" that people can't wait to get their hands on. They're fully booked for this year and the next two years after that. Moving from building site to building site across the United States, this family of three sets up shop on their clients' property, sleeping a few feet away in their own converted home on wheels for the duration of the renovation.

Kate and Ellen met at the University of Evansville in Indiana. They were the closest of friends—inseparable—but when Kate transferred schools after a year, they lost touch. Kate ended up getting married a year later, had Adelaide, and soon found herself a de facto single mother when the marriage didn't work out. Through the magic of Facebook, Kate and Ellen reunited, and Kate found herself "creeping" Ellen's photos more often than she'd like to admit. "It didn't register that I was attracted to her. I knew, but I didn't," says Kate. They started a conversation, which soon led to midnight Skype calls. After many of these talks, they set up a twenty-four-hour date halfway between their two homes. "We just knew. She kissed me right away in the parking lot," says Kate. "From that point on, we did long distance for nine months and then, when that became too hard, we bought a house together in Kentucky."

︿ WOMEN AT WORK

Ellen's mother has an associate's degree in electrical engineering (she was referred to as the "fix-it lady" in their home), and her father built houses for a living, which is where she picked up a lot of her knowledge. "Plus a lot of Google searching and trial and error," she laughs. Kate's creative eye for detail comes into play later in the process, but she's also an integral part of the heavy lifting that happens in the early stages of each reno.

❮ PARK AND GO

Kate and Ellen love the versatility an Airstream gives them. They can unhitch the trailer at a campsite or their temporary home base and then use their vehicle to run into town to pick up supplies or groceries.

The couple settled into their new life, filling their 1,600-square-foot home with stuff and pursuing their careers—Ellen as an art teacher and Kate as a wedding photographer and part-time nanny. Their life might have looked perfect from the outside, but it wasn't. "Ellen was commuting almost three hours a day, we spent more time working in the yard than actually enjoying it, and people were not kind to us—we felt like our house was this island we couldn't escape from," says Kate. Furthermore, funds were tight.

"I think we both started to question what we were doing," says Ellen. "Is this the life we want? What are we doing here? This isn't what we signed up for."

One morning after Ellen went to work, Kate came across some photographs by a musician who was documenting his life on a tour bus. "There was this kid on board, and it hit me: We could do that. That could be us," says Kate. "I sent Ellen a text and said, 'What if we sold everything, bought a bus, and traveled around?' And she said yes. Just one word. 'Yes.'"

Many nights of research followed, and after looking into the safety records of buses and RVs, they decided on an Airstream trailer, which would allow them to strap Adelaide into a car seat. Buying something new was out of their reach, so they focused their search on a vintage trailer. They found a 1957 Overlander and christened her Louise. For a year and a half, they renovated her, swapping out rusted and moldy fixtures for basic plywood cabinetry, white walls,

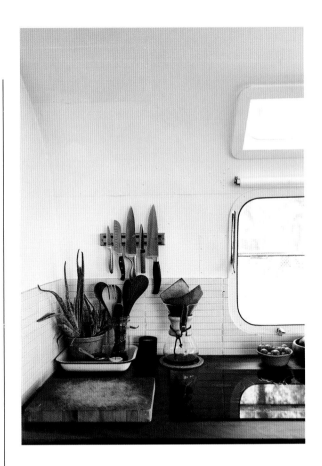

⌃ WORKING AROUND THE CURVES

The sleek induction cooktop by Furrion works on electromagnetic energy, which means the couple doesn't need to carry propane tanks on board. The curved walls of the Airstream can be tricky. The magnetic knife holder works fine as long as the knives are put in the exact right position (otherwise they tend to fall off). The coffeemaker is by Chemex.

❯ LUMBER CONSIDERATIONS

All the cabinetry in the Airstreams they remodel is bespoke—Kate designs it, Ellen figures out how to build it, and then the pair constructs and installs it together. "Airstreams or RVs in general are known for retaining humidity, so we have to be mindful of the materials we use," says Kate. For their kitchen, they used softwood pine for the door fronts, plywood for the framework, and laminate for the floors. The backsplash is by Fireclay Tile, while the granite-composite sink is by Alfi.

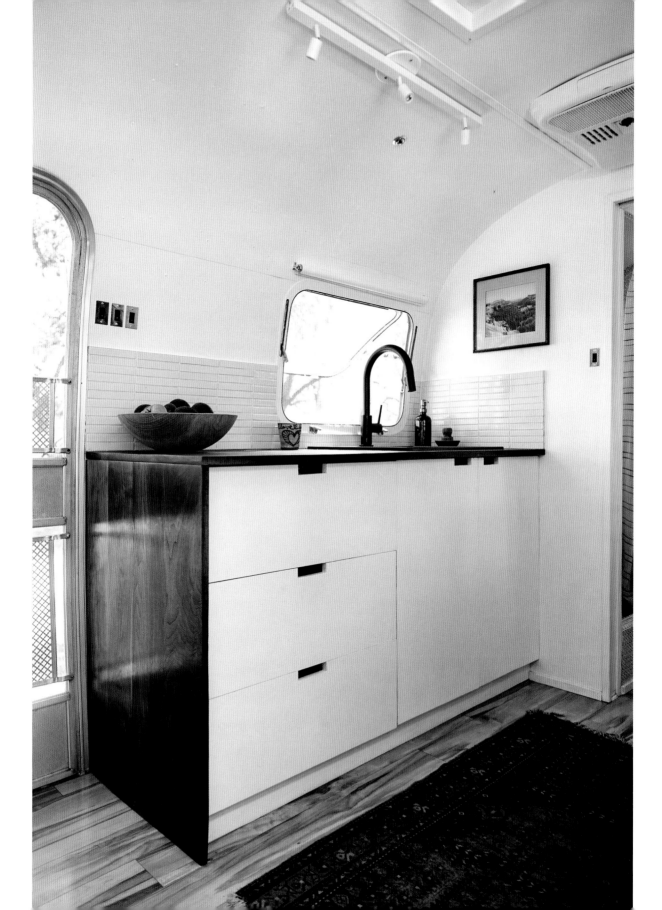

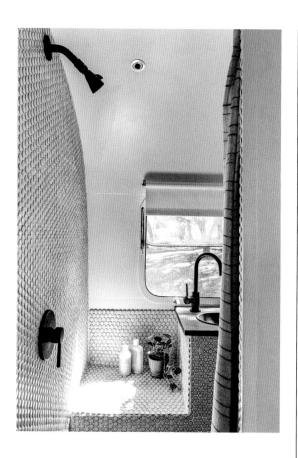

THE RIGHT PROPORTION

The 12-foot-square wet room includes a composting toilet, a stand-up shower with a tiled seat, and a copper sink with a Delta Trinsic single-handle bar faucet. Kate always specifies a bar-size gooseneck faucet for the Airstream bathrooms she designs as their diminutive size is well suited to the space, and the elevated spout allows you to wash your face. To keep the tile on the walls from cracking, the couple uses a special adhesive made for RVs called MusselBound.

INTENTIONAL LIVING

A simple ritual such as making dinner is a conscious act. "Every time I turn on the water, I think about the fact that I will have to dump all the dirty water that goes down the sink later," says Ellen. "There's more thought and more action with everything you do. It's daily work."

textured fabrics, and brass light fixtures. In order to put money into the trailer and preserve the small nest egg they had saved up for their trip, they budgeted twenty-five dollars a week for food and picked up extra jobs wherever they could. "We poured our hearts into it," says Kate. It was 2014, and they were about to hit the road for the first time as permanent travelers.

What followed was a six-month trek up to Alaska and then back down to the lower forty-eight. They felt free, unburdened by all the stuff that had been weighing them down. It was the break they needed to refocus their priorities. Then, on a trek across the country to visit Ellen's parents in Kentucky, they got a phone call that would end their journey abruptly. A family matter required them to return to Indiana for an indeterminate amount of time. They sold Louise and begrudgingly rooted themselves in a duplex. "I would just stare out of the back window of the house at this dilapidated garage with peeling paint and think, 'Well, that's not a national park,'" says Ellen. The couple felt trapped. They were mad at each other, mad at their circumstances, mad at everyone around them.

"One night, Ellen just broke down. I realized that we needed to do something about our situation. We had worked so hard for our freedom, and in a second, it had been taken away. We had lost the dream," says Kate. The couple started looking for a new Airstream. Within four months, they found it: a 1977 Overlander they named June.

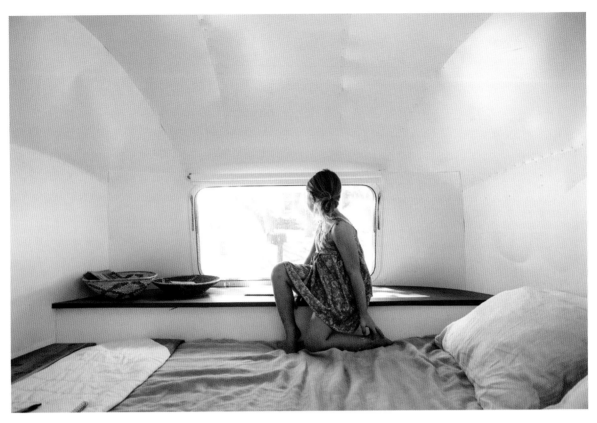

∧ BEDROOM IN THE BACK

Adelaide hides out in Kate and Ellen's bedroom, where a few favorite things rest on built-in walnut-topped shelving that surrounds the queen-size bed. "Everything we have in here has a story," says Kate. "We don't have room for anything that doesn't."

❯ MADE TO MEASURE

Kate and Ellen have learned to live simply after having pared down a few times. "At the beginning of the process it was hard, but there's not much in here I'd be really upset about losing," says Ellen. "It's not the things that matter. Once you kind of wrap your mind around that, it's all okay." A simple bulldog clip holds photographs above the custom full-size dresser she and Kate built.

The number of hours that go into the renovation of an almost forty-year-old Airstream cannot be overstated. While the space may be small, the curved lines require every fixture to be customized, and vintage replacement parts can be hard to track down. Working through rain, snow, and sweltering summer days, Kate and Ellen stripped their new trailer down to the skeleton and painstakingly put it back together piece by piece. A weekend to-do list might read: finish subfloor removal, take out vacuum reservoir and AC unit, repair old steps, strip off blue striping from outside, grind rust off chassis, get rid of broken propane lines, take out belly pan. Dirty, tired, and covered in blisters, the couple would roll into bed each night dreaming of the moment when they could put the aluminum walls back on and start working on the interior design. When that moment came, they riffed on their modern earthy style.

In the kitchen, flat-front drawers with handle cutouts are topped with a walnut countertop that Kate ripped on a table saw and then glued together and secured in place. A matte black sink with matching gooseneck faucet was added, along with a sleek under-counter fridge and an induction cooktop. In the living area (which triples as a dining area and Adelaide's bedroom), generous navy-blue linen cushions topped with a mélange of graphic printed pillows make the front of the Overlander a comfortable place to hang out in. Farther back, Kate chose a milky white penny tile and ran it over the curves of the walls in an uninterrupted pattern to create

an appealing wet room. A platform bed dressed with neutral linen sheets is nestled into the back curve, and a custom dresser made to match the kitchen cabinets gives the couple ample space to store their clothes. Throughout, DC-powered recessed ceiling lights by Acegoo provide light even when the vehicle is off the grid.

While the renovation was under way, Kate documented it on her and Ellen's personal Instagram account, as she had with their first Airstream overhaul. The couple had fantasized about starting their own renovation business right after they completed Louise, but with only one reno under their belts, they felt it was a bit premature. With Airstream number two complete (a year to the day after they started renovating it), Kate suggested they take some baby steps toward that goal by creating a website. The idea was to slowly turn what had been a behind-the-scenes account, the Modern Caravan, into a fledgling business. Kate got to work right away, putting up photos of their projects and giving a short description of her and Ellen's history. At the last minute, she decided to add a "services" tab to the website, hoping one day in the future to expand this section. "By the end of the second week," she says, "I had signed our first contract and had three other people waiting in the wings."

With no land of their own to do the builds on and in no position financially to purchase property, Kate suggested they travel to each of their clients. It would get them back on the road doing the work they loved best.

"I'd say it's ninety-seven percent hard work—gross, dirty, crappy work—and three percent dreamy. Not just to get here, but to stay here," says Kate. "There's very little sitting around and just being." A normal day begins with one of them working with Adelaide on her schoolwork while the other gets busy with their current project. Kate keeps regular office hours so she can take care of their bookkeeping, marketing, client contracts, design work, and supply ordering. In the afternoon, Adelaide fills notebooks with stories and drawings, plays outside, or helps her parents.

With their calendar fully booked, Kate and Ellen are a design force to be reckoned with—or in Kate's words, "two badass women getting it done." But for them to expand their business, they know they're going to have to be stationary at least part of the year. Plus, Adelaide's needs will change as she gets older. They're hoping that with continued success, they'll be able to buy some property and hire a few extra hands to help them out.

"We didn't sign up for this life because we thought it would be easy," adds Ellen. "It means so much to us to be here, to be creative, to work for ourselves," says Kate. "We really faced the impossible, and we overcame it because we worked hard and did not give up."

∧ UNDERFOOT

Sofie (left) and Memphis (right) retreat to their usual corners. "We went into a pet store to get dog food one day and walked out with Memphis," says Ellen.

❯ STOLEN MOMENTS

Kate and Ellen's current renovation is located on a farm just outside of Austin, Texas. The family often takes walks down to the small pond on the edge of the rural property at the end of the day.

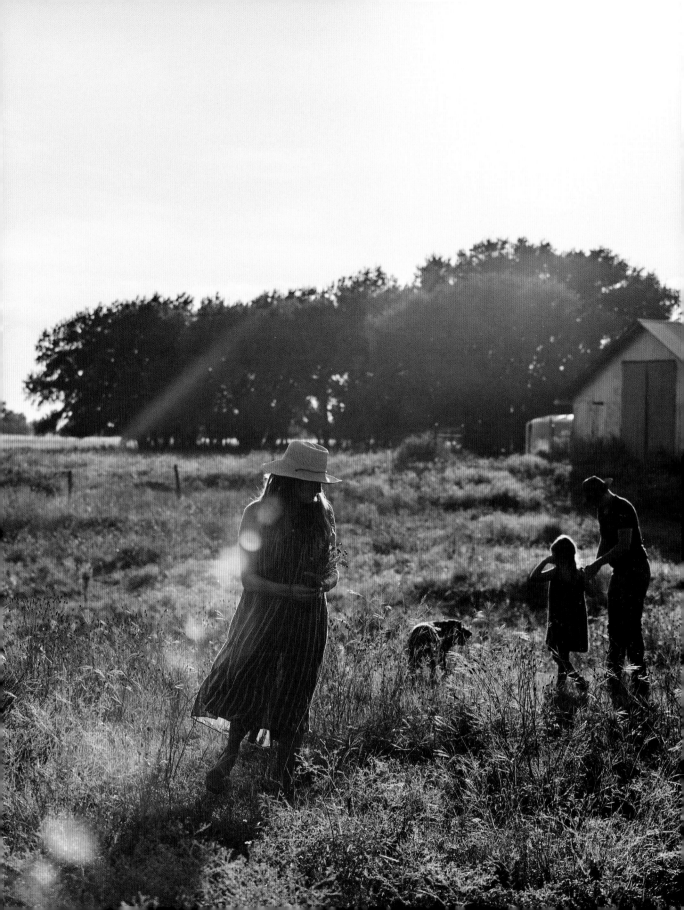

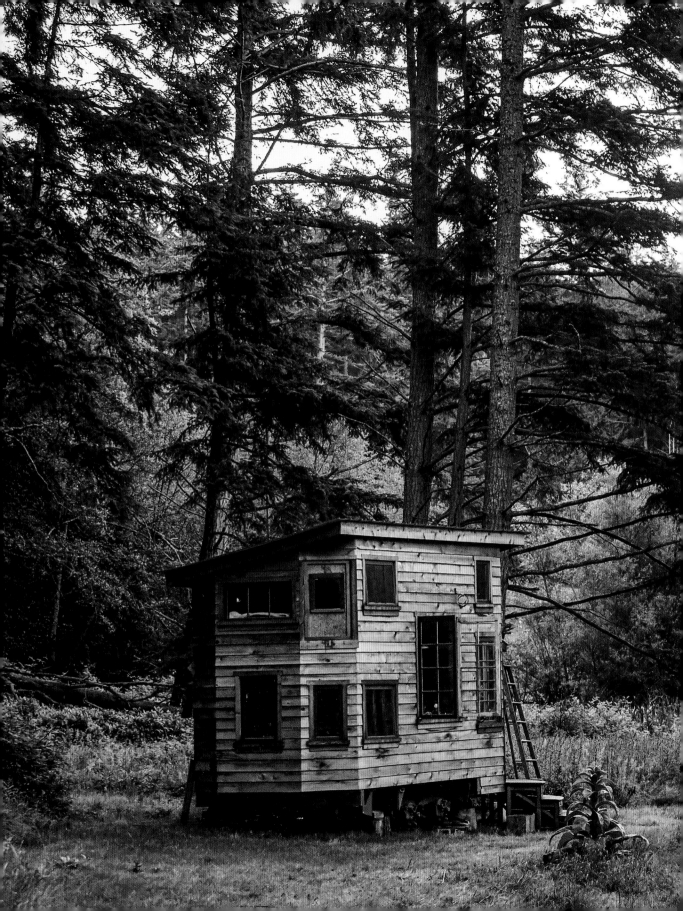

3
—
The
Minimalists

SEEKING A SIMPLER EXISTENCE THAT
PRIORITIZES EXPERIENCES OVER THINGS

Living Off the Land

"It's funny where you end up—you really never know," Brooke Budner muses, looking through the open window of her cedar-lined tiny house on horseshoe-shaped Orcas Island, located just miles from the Canadian border. "I had never heard of this place; I didn't even know it existed," she says as she surveys the idyllic pond and old-growth forest that she calls home. She then heads out the door of her house to grab some raw cow's milk for her coffee from an outdoor mini fridge that she has propped up on a wood stump.

Not fifteen minutes later, Brooke—with a woven basket in hand—starts her day walking the short stretch of mowed-down wild grasses to the deer-proofed garden she works on with her partner, Emmett Adam (though he has temporarily relocated to Alaska for a couple of months to make some money fishing). As she passes buzzing beehives, she gets to work pinching leaves off tomato plants, removing dead flowers, and harvesting garlic scapes. Stalks of heirloom corn that will be made into polenta and tortillas

❮ IN THE CLEARING

The house is built on an 8½-foot-wide flatbed trailer and measures 14 feet tall—the maximum width and height allowed to keep it road legal. Brooke and Emmett remove the wheels while they are parked, as the sun tends to degrade them. The tiny house was recently moved to this clearing beside a small pond. A cedar-lined outdoor bath is located at the water's edge.

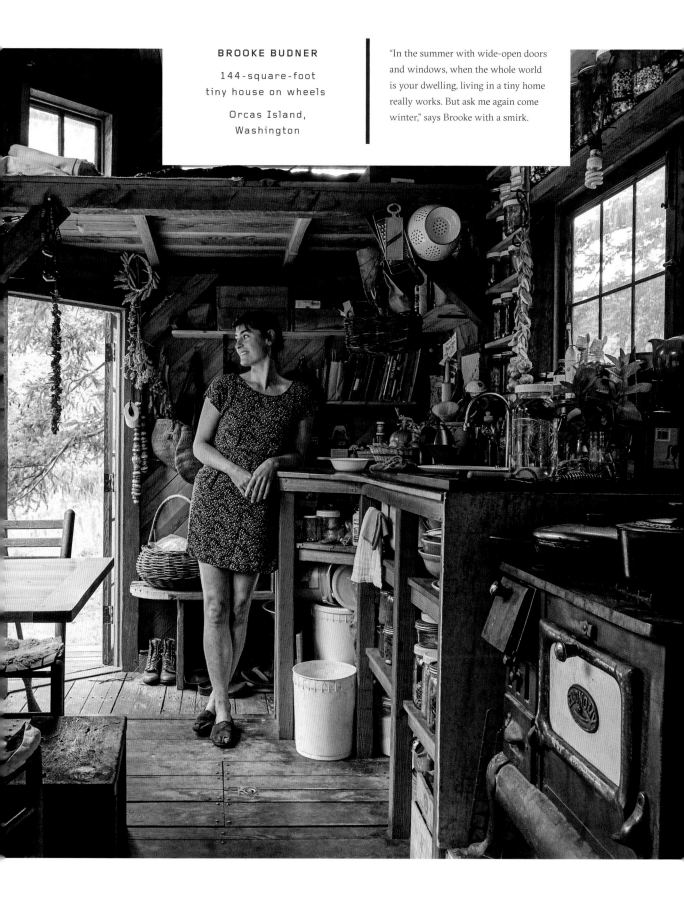

BROOKE BUDNER

144-square-foot
tiny house on wheels

Orcas Island,
Washington

"In the summer with wide-open doors and windows, when the whole world is your dwelling, living in a tiny home really works. But ask me again come winter," says Brooke with a smirk.

mingle with eggplants, potatoes, fava beans, snap peas, onions, leeks, parsnips, carrots, and squashes, and staples like wheat, millet, and quinoa. Sweet berries, figs, and a new planting of orchard trees provide fresh fruit. She can't resist nibbling and looks more goat-like than human as she munches her way through the garden. This plot—supplemented by a few store-bought dairy products and meat from local deer, which the couple hunt and slaughter themselves—will provide enough food for Brooke and Emmett to live off for an entire year.

To understand just how Brooke reached this degree of self-sufficiency, it helps to know where she came from. A trained painter and mixed-media artist, she began working on commercial farms in between semesters while she attended the Rhode Island School of Design, light-years away from her suburban upbringing in sprawling Dallas, Texas. "When I went to college, I started to explore different things and get politicized. I wanted to take ownership over something physical in my life and be less dependent—have more skills to take care of myself," says Brooke. After graduating, she headed west to California and started working at the Occidental Arts and Ecology Center, where she learned the fundamentals of permaculture farming. It was the tools she acquired at OAEC that led her and a friend, Caitlyn Galloway, to turn a blighted lot in the middle of downtown San Francisco into a CSA-approved production farm supplying restaurants and consumers with fresh produce.

Their farm, named Little City Gardens, flourished for seven years, during which time the pair came up against many civil and corporate challenges. "It was kind of crazy and really contentious," says Brooke. "We had to work with the city to try to change zoning codes in order to make it legal." The sale of the family-owned land to a developer during their tenure also made things difficult. The new owner was determined to make money, and their garden wasn't part of his vision. "Coming up against wealth can feel really hard when you're in a field that's important but has no money in it, especially when there's money in things that aren't as needed," laments Brooke. "To be honest, I was kind of pooped by the end of it."

Mixing a bowl of peppery salad greens with names like ruby streaks and golden frill, she reflects on what a relief it is to be able to grow food only for oneself. If something fails, it's no big deal, because there is always something else. "To grow enough that you have abundant food to eat is easy, but to grow enough that you can actually break even is really hard."

During her time in San Francisco, Brooke met Emmett, who was living aboard his sailboat with some friends at the Berkeley Marina. In the winter of 2012, the couple, who were both

> LOOKOUT OVER THE POND

"There's always something happening right outside my window," says Brooke. "Every season has its magic. First, there are the wild roses, and after that the irises. It just keeps going. We're never without something popping up or fading away."

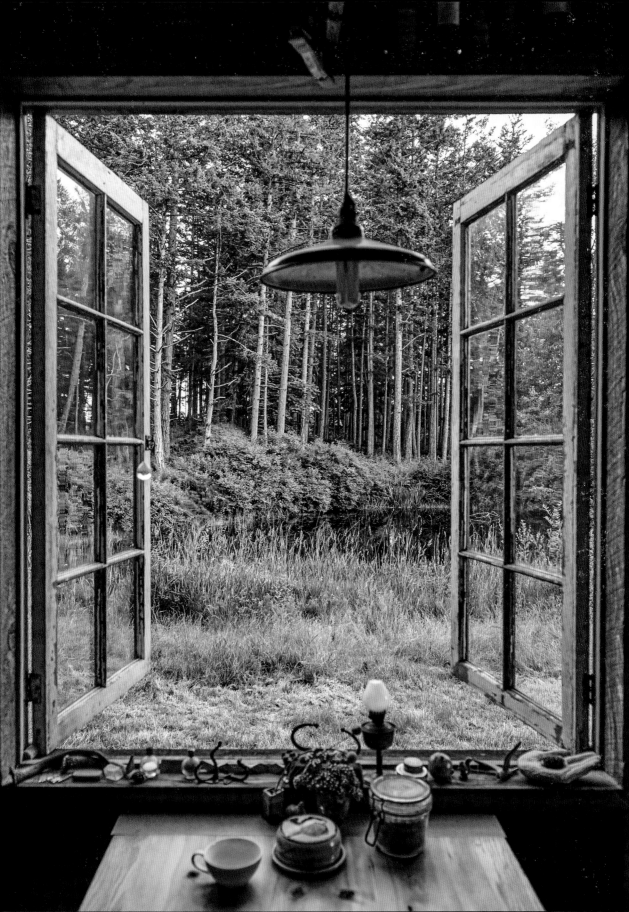

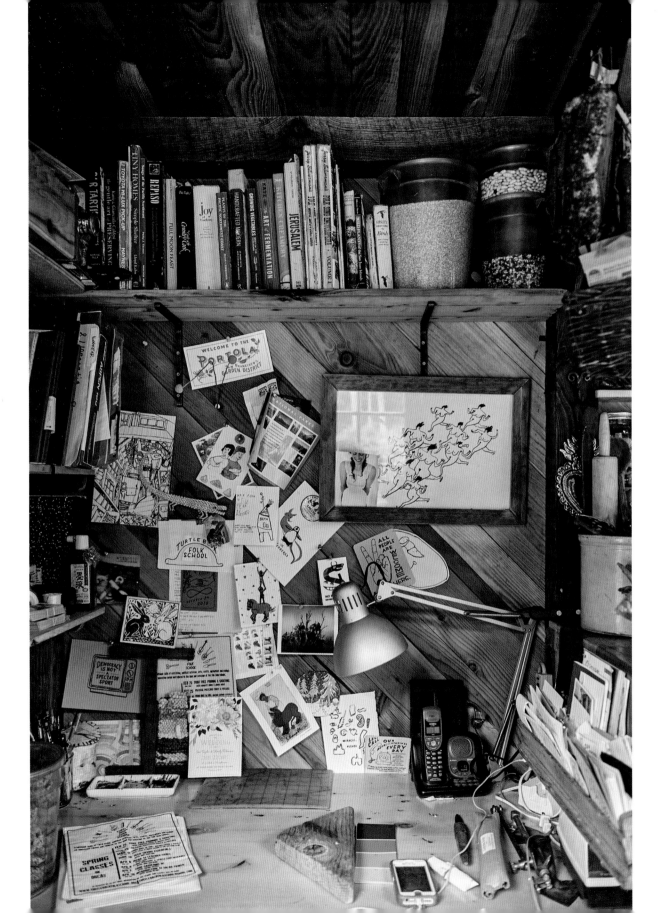

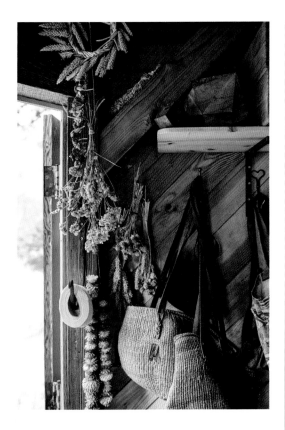

↑ **HOOKS FOR EVERYTHING**

Beside the front door, high-mounted shelves and lots of hooks get items like market bags off the floor. A roll of toilet paper is at the ready for anyone having to visit the outdoor thunder box (see page 272).

‹ **STAYING IN TOUCH**

Brooke divides her time among her three passions: graphic design, permaculture farming, and her new business producing and distributing a seasoning blend called gomasio. "Even though graphic design is arguably the most lucrative, I can't stand to be sitting and working on the computer all day. I try to keep it at healthy thirds." The house is connected to grid power and has a Wi-Fi signal. "In the past, I think moving to a rural location meant a strong commitment away from urbanity. Now you can kind of have a bit of both," says Brooke.

eager for change, was offered a house-sitting opportunity for two months on Orcas Island. It was during that stay that Brooke realized that Orcas was a place where she could settle down. Still committed to Little City Gardens, she returned to San Francisco for the spring and wrapped up her duties. By the summer, she was back on Orcas, living in a rent-free yurt with Emmett, getting to know the locals, and homing in on a new way to make a living.

She picked up some assignments as a graphic designer, a profession that lends itself to working remotely. As her community on the island deepened, she heard about a woman in her sixties interested in finding some young people to help her build a homesteading farm on her land. Brooke and Emmett, with their considerable knowledge of permaculture farming, began helping her out. As they started to settle into their life on the island, they decided that it was time to upgrade their accommodations to something more permanent.

Inspired by a tiny house she had seen in a friend's backyard in Oakland, Brooke and Emmett began to draw up plans for a small, movable structure they could park on the land where they farmed. A nearby property happened to have a small sawmill, and they approached the owner about taking off-cuts or discarded pieces of wood. Using a free 3-D modeling program, they mapped out the design of the house just to wrap their heads around it. Then they winged it. "We're not experts. I think the typical way of doing a timber frame is that you get all the

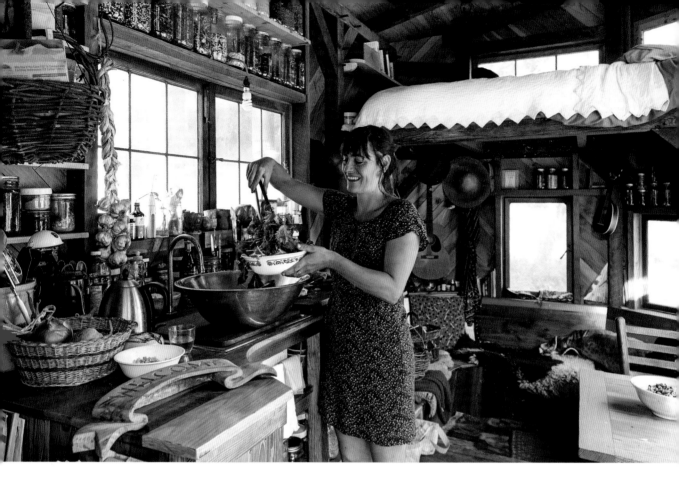

pieces cut perfectly and then you can erect the house all in one day—like the old barn-raising thing," says Brooke. "Unfortunately, our measurements weren't impeccable, and we tried to put up things piece by piece instead of getting everything done at once." The entire cost of the house was just two thousand dollars, but it took them about a year to complete it. "We learned a lot," says Brooke with a sigh.

The majority of their 144-square-foot house is given over to storage for the foodstuffs they need to survive year-round; mason jars line the walls, homemade prosciutto hangs from a beam in the office, and a bundle of chilies is tied by a string near the heavy cast-iron hunting stove.

The most noticeable decorations are strands of dried strawflowers and chrysanthemums that dangle from the ceiling, moving with the wind.

The central portion of the house is raised about 10 inches; a design necessity to accommodate the home's wheel well, it gives the space three distinct zones: a lower entryway with built-in office space, an elevated cooking and eating area, and a sunken living room. This simple gesture of stepping up or down as you travel through the space gives the feeling of entering different rooms. On either end of the house, above both the living room and the office, are platform beds just tall enough to sit up in that can be reached by a ladder. Ample windows

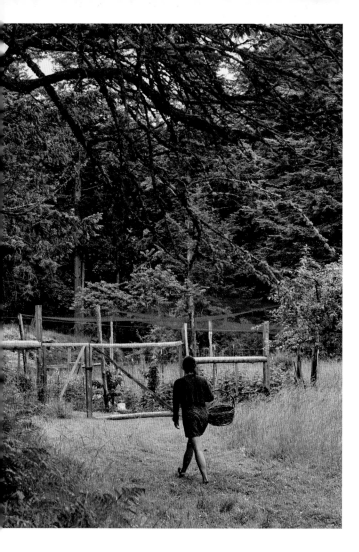

STOCKED PANTRY

Row upon row of neatly arranged jars speak to the hard physical labor of feeding oneself year-round. Come harvesttime, the garden's bounty is dried, milled, pickled, canned, and fermented so that the couple has food throughout the winter months. The couple's loft bedroom is perched above a U-shaped sunken seating area lined with sheepskins and decorated with musical instruments.

⌃ WALKING TO WORK

Brooke's daily commute takes less than a minute. Deer-proof fencing and netting protects the garden plot from hungry critters. A beehive within the enclosure provides the couple with fresh honey.

⌄ ON DISPLAY

Brooke opted for open storage everywhere, turning her everyday necessities like mason jars and mugs into their own kind of decoration. "In another universe, I would have walls of books," she says.

⌃ A MINIATURE CELLAR

A mere 6-inch gap was left between the floorboards and the underside of Brooke's tiny home, but it was space she wasn't going to let go to waste. A trapdoor in the floorboards allows easy access to fruit preserves, empty mason jars, and the odd onion or two.

make the home feel light and airy, yet the wood-lined walls keep things cozy—a necessity for rainy West Coast winters. In order to shower or go to the bathroom, Brooke and Emmett have to head outside. A thunder box (a raised outhouse-style toilet—see page 272) is located in a wooded area behind the house; a few times a year, the couple will dig a new hole. For bathing, they can head down to their hot tub–like bath located beside a pond on the property or behind the house to a propane-heated shower (see pages 266 and 267). On warmer days, even the pond makes a good place for a quick rinse.

At thirty-six years old, Brooke knows that the time to start a family is now. Between her graphic design work, farming, and a new business producing and distributing gomasio (a sesame, kelp, and nettle seasoning blend), finding the right moment is tough. Then there is the question of space. "I'd like to build a bigger house at some point," says Brooke. She can't imagine living in anything enormous after her experience in a tiny house, but she looks forward to creating something with enough space for kids. "This house, which I built with my own hands, is the thing I'm most proud of in my life," says Brooke. "I'd like to build my own place again."

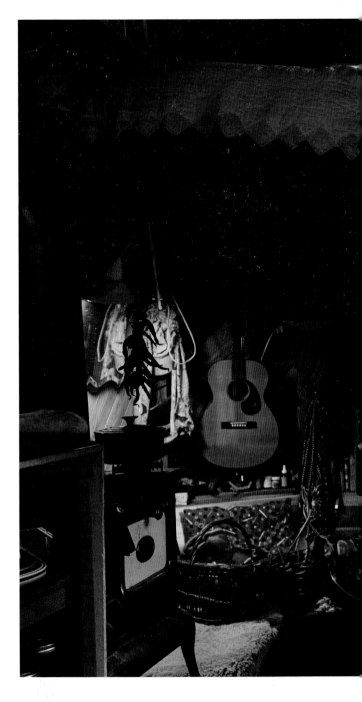

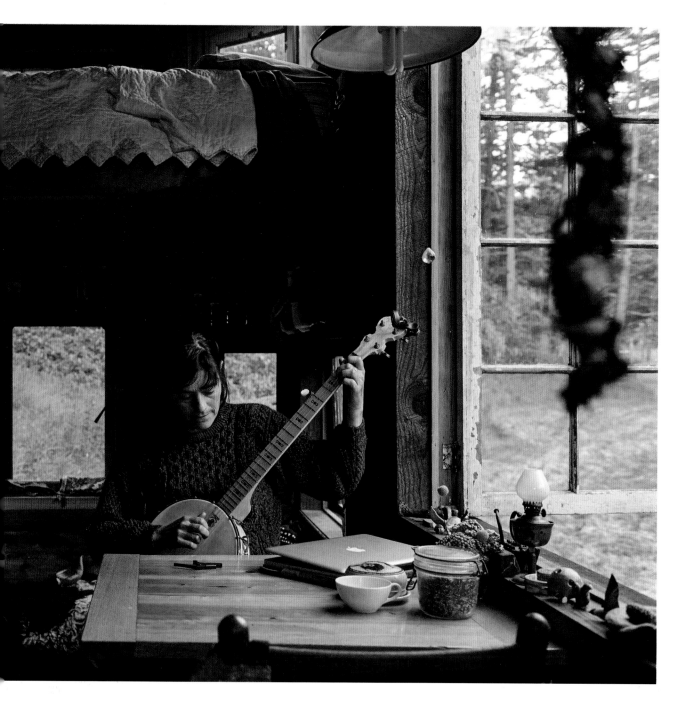

⌃ NIGHTLY ENTERTAINMENT

"Emmett plays just about everything—accordion, guitar, ukulele," says Brooke, as evidenced by the instruments strung up around the house. She, meanwhile, has taught herself to play banjo. The single-pane windows can make for some tough winters, especially this far north. The couple keeps the wood-burning stove going all day to ensure that the place stays warm and cozy. Any future builds they do would incorporate double-pane windows.

Choosing Simple

Driving down a leafy neighborhood street in downtown east Austin, you'd be forgiven for motoring right past native Texan Ashlee Newman's blinding silver Airstream. Camouflaged by cactus, cypress, and pecan trees and sandwiched between a friend's one-story house and a corrugated metal fence, Dottie (as Ashlee affectionately calls her trailer) is conspicuously out of sight.

"I feel confident backing it in here. It's not that big of a deal," Ashlee, a thirty-four-year-old freelance lifestyle photographer, says in her singsong drawl, referring to the narrow concrete pad her Airstream is parked on. "I grew up on a ranch and used to haul horse trailers for my brothers and sister when they did rodeo. Maybe that's it," she says.

With her hair still wet, Ashlee, in a coral pink spaghetti-strap sundress and mud-encrusted cowboy boots, is at once entirely feminine and tough as nails. When she tells me she has no problem hitching Dottie up to her old Toyota 4Runner and taking off on solitary camping trips, I believe her.

This is Ashlee's third tiny living dwelling—not counting the weeks she spent sleeping in her car when she abandoned her corporate job as a marketing executive, steady boyfriend, and beautiful condo with leather sofas and a big-screen TV in Houston, Texas, a decade ago. "I didn't have a

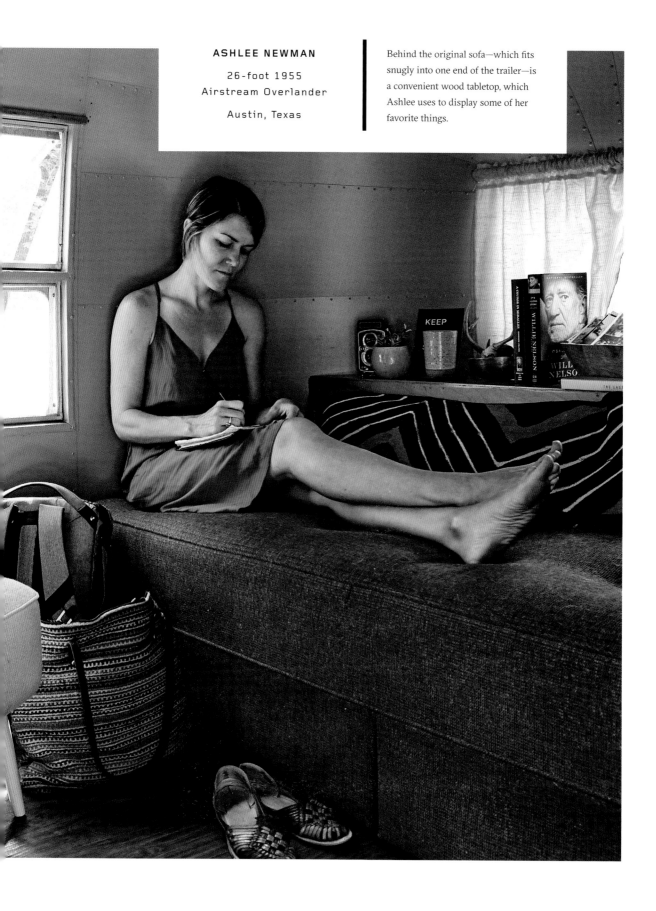

ASHLEE NEWMAN

26-foot 1955
Airstream Overlander

Austin, Texas

Behind the original sofa—which fits
snugly into one end of the trailer—is
a convenient wood tabletop, which
Ashlee uses to display some of her
favorite things.

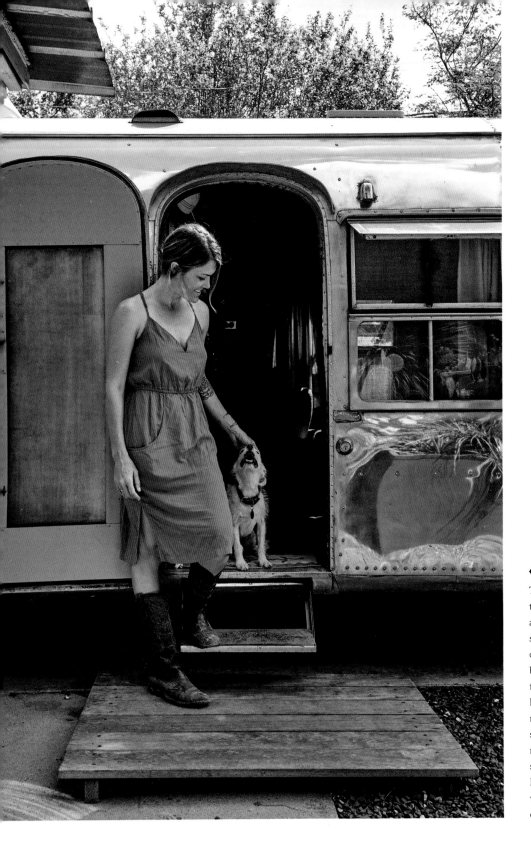

❮ FREE TO GO

The trailer weighs only thirty-five hundred pounds and can be hauled by a small SUV. Ashlee takes it on trips a few times a year but otherwise parks it on a friend's property. "I haven't had a lease in eight, maybe nine years, and the idea of signing anything makes me want to hyperventilate," says Ashlee. "Even though I don't take the trailer out very often, the thought that I could if I wanted to is nice."

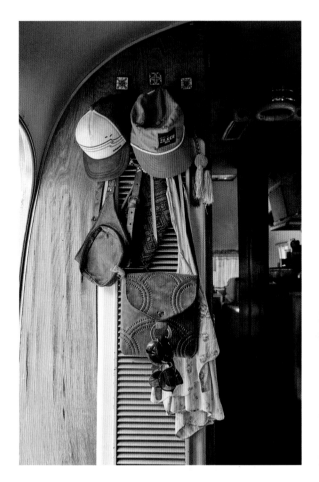

reason to complain. Everything was taken care of," says Ashlee. But night after night, she would find herself crying in her walk-in closet. "I was incredibly unhappy, like something huge was missing. I tried filling it with my job, or going out and buying more things, and then finally one night I just left," she says.

After a short sojourn at her parents' house, she found herself living out of her car in breathtaking Moab, Utah, an outdoor enthusiast's Disneyland, at the invitation of a friend. At the local grocery store, she wrote down the number of an organic farm that was looking for help picking weeds—no experience necessary. "I worked for ten dollars an hour that summer, and I saw just how little I needed to be happy," says Ashlee. "For the first time, I was genuinely calm and content—wearing the same clothes every day and just working with my hands."

During that time, she met a fellow Utah transplant who lived in an Airstream trailer. They fell in love, moved in together, and eventually got married. Over time, they started to crave

⌐ **LOVE PATCH**

"I think the ex-husband of the woman I bought Dottie from put this heart on there," says Ashlee. "It's sweet." When Ashlee takes Dottie out on the road, she keeps her at a steady fifty-five miles an hour. "I'm mostly scared of other people hitting me, 'cause she's like my baby and I don't want her to get hurt. But it's also a bit terrifying to think about fishtailing or getting hit by a gust of wind," she says.

⌃ **CONSCIOUS CONSUMPTION**

A small wall to the left of the entry is a catchall for some of Ashlee's most prized possessions—hats, bags, and sunglasses. "Everything I bring into my home is chosen with intention," says Ashlee. "The fact that I have no space to store anything makes me think about every single purchase."

a bit more space and traded in their Airstream for a school bus. After about a year and a half, the marriage fizzled, and rather than deciding which of them would take over the deed to the converted school bus, they sold it. "Man, I wanted to keep it," says Ashlee, "but it just didn't work out. It was better for everybody that way."

Ashlee's evolution from a pencil skirt-wearing executive to a freelancing Airstream dweller living a simpler life was a conscious decision. She is the oldest of five kids; her three parents (her mom, stepdad, and biological father) all had their own businesses. Chasing the American dream, they were in constant pursuit of new job opportunities and better schools for their kids. "We moved every three to four years, which I think fed that wanderlust inside me. I learned at a young age not to get too attached to homes or places," says Ashlee. Successful in their work, they were accustomed to life's small luxuries. "I grew up in a house where money just burned a hole in your pocket," says Ashlee. "My parents were suffocated by the amount of things they owned, and I started to see that in myself. I knew I had to check those natural tendencies in me to consume.

"This," she says, waving her arm around her Airstream, "is forced pattern changing."

In 2015, with her divorce finalized and a strong vision for the kind of life she wanted to pursue, Ashlee decided to purchase her own Airstream. On her mind was an unrefurbished 1955 whale-tail Airstream Overlander like the one she had first lived in—a tall order to fill. A three-year search and a kismet-like connection with an Overlander owner she had met a few years earlier paid off. "She knew I was looking for one, so when she was ready to sell hers, she tracked me down on Facebook," explains Ashlee. "She said, 'If you're going to live in it, you can have it.'"

The interior of Dottie is almost entirely original, right down to the white propane stove, twin beds, and upholstered sofa with skirt. There are not many trailers like this left in the world, and Ashlee feels a certain responsibility to preserve its history. However, the trailer is also her home, and there are certain changes that would make her day-to-day existence—not to mention her dating life—more comfortable. "The single beds are a bit tricky," she laughs. "It's already hard enough having to explain to a new date the reason I choose to live this way." But any changes Ashlee makes to her trailer will be ones she can easily undo. "I would make sure that it could be turned back. If I save all the pieces, like handles or the beds, I can always return it to its original condition," says Ashlee. For now, the only major alterations she has made are the additions of a peel-and-stick vinyl floor, a new fridge, and a composting toilet.

Ashlee's stamp can be seen, however, in the small decorating gestures she has made throughout her home, from the inspirational sayings she's posted around the trailer ("Keep It Simple"; "Food: Don't Waste It") to the peaceful landscape photos she's taped onto the shelves in her office. Global patterns and textures pop

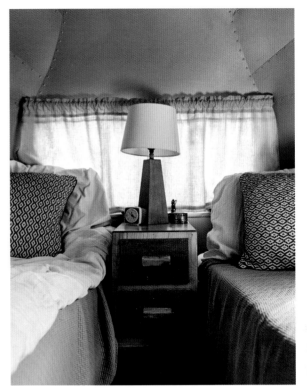

⌃ UNPACKED FOR A WHILE

Ashlee pulls an animal spirit card every day as part of her morning ritual. A dolphin card, for example, indicates that a blessing is on the way, while a peacock symbolizes inner beauty and self-acceptance. For Ashlee, the biggest challenge of living seminomadically is the undoing and resetting of her home each time she moves. "I've been parked a few months now without moving, and it's nice that everything has a space and just stays there."

⌐ SLEEPING OPTIONS

"I switch back and forth between the two beds—a week in one and then a week in the other one. It stops my back from getting all jacked up," says Ashlee. The nightstand and table lamp between the two beds are original to the trailer. Ashlee has a couple of pieces of furniture and some art stored at a friend's house. "But it's okay if they go away and I never see them again," she says.

❯ SHELF SHIFTER

A flip-down shelf, part of the original trailer design, becomes a small desk. Ashlee simply rotates the lounge chair in her living room to create a mini work space. "It's just big enough for my laptop and a little bit of journaling space," says Ashlee. "I don't know why they ever did open shelving on a trailer. It drives me insane."

up in the mudcloth that covers her midcentury-modern sofa and the pom-pom tassels and woven bag that hang from hooks on her wall. Then there is her collection of hats and sunglasses (a weakness, she confesses), which hang from hooks, curtain rods, and even over light fixtures. Ashlee has turned fashion necessities in hot, sunny Texas into decorative accessories.

Walking over to the sofa with a cup of coffee in hand and her rescue dog, Lucy, nipping at her heels, Ashlee sits down in her favorite spot on the sofa to start her day. For the past three years, she has followed the same routine: "I get up, make my coffee, light a candle, pull an animal spirit card, and write in my gratitude journal," she says. "It's my ritual." It's the kind of morning that would have been impossible in her busy nine-to-five life back in Houston. That's not to say that her current days are all laid-back and carefree. "It's hustle, hustle, hustle," says Ashlee. During the spring and fall months, her days are filled with shooting weddings and events throughout Texas, and when the weather gets too warm and the wedding season trails off, she works on photo partnerships with outdoor brands like Yeti. "It's humbling to look back on my life in Houston because I never would have thought I would be doing this. I started paying attention to intuition and signs and saying yes to things instead of falling into a mold that didn't feel right. I followed what was exciting, and it has made me so happy."

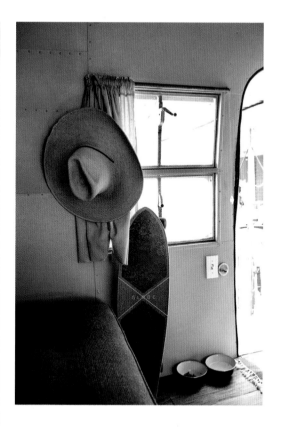

⌃ GET OUTSIDE

Ashlee hasn't owned a TV in eight years. "I don't miss it. It's not fulfilling." Instead, she is more likely to be found outside, pursuing activities like skateboarding, fly-fishing, wakeboarding, camping, or hiking. "Turning off the TV leads to a richer and more satisfying life," she says.

❯ DISTINCT CURVES

These riveted end panels, known as a whale tail, are found on a select group of Airstreams that were produced in California. "Somewhere along the line, I got attached to the idea of having one. I think because such a small club of people have them," says Ashlee. The aluminum used on Airstreams back in the 1950s and '60s was aircraft grade, which accounts for its super-reflective mirror-like finish.

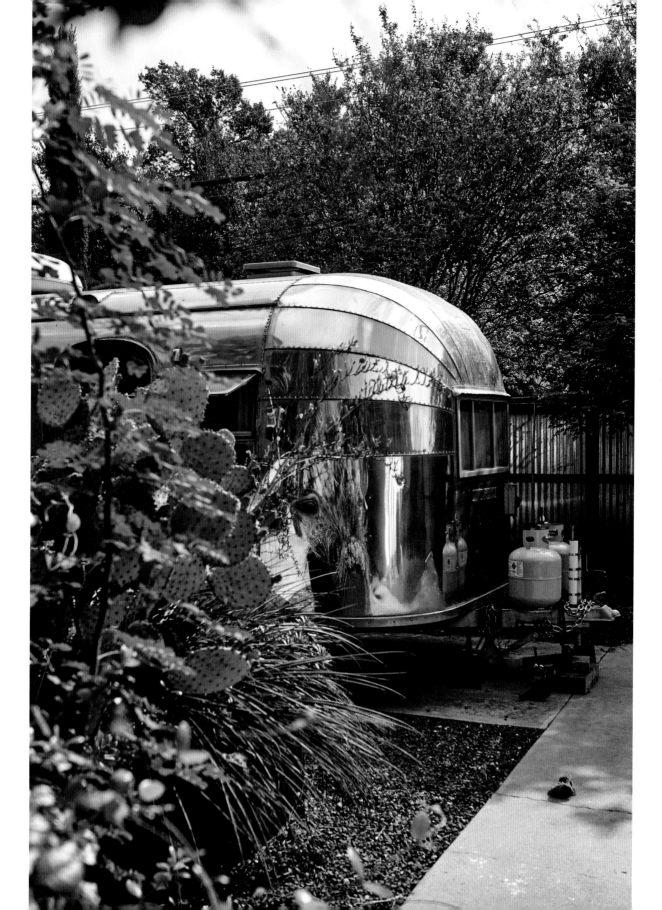

Mini Minimalism

Robert Garlow shakes his head and laughs in disbelief when he thinks about the moment that led him and his wife, Samantha, to pack up their lives in Buffalo, New York, and move across the country to the little-known town of Yakima, Washington, for a nursing job Samantha was considering.

"It was this two-hour conversation we had with a stranger named Brian who we met through couchsurfing .com," says Robert. "We didn't need a place to stay—we just wanted to talk to a local who could give us the real rundown on the place, and we thought this would be a good way to do it." Brian, a Yakima transplant himself, invited them to his place and over homemade soup told them about Thursday-night beer-making sessions, monthly "idea jams" in a local warehouse, rock-climbing parties, and camping weekends in the nearby mountains. It all sounded pretty good to this outdoorsy, adventure-loving couple, so they took a chance.

Robert and Samantha arrived in Yakima ready to start their careers. Both had received their master's degrees from state universities in New York (Robert studied architecture, while Samantha has a degree in nursing), and after some epic trips—backpacking through Patagonia, sleeping on train cars in Europe, and even living out of their pint-size Honda Civic hatchback while traversing the United States—they were ready to settle down. They had plans to

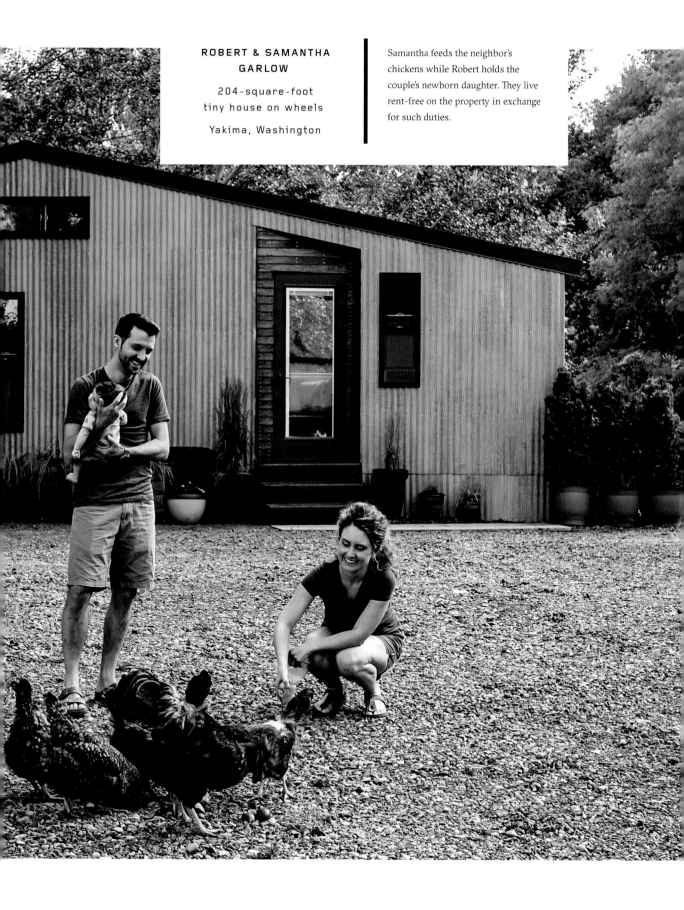

ROBERT & SAMANTHA GARLOW

204-square-foot
tiny house on wheels

Yakima, Washington

Samantha feeds the neighbor's chickens while Robert holds the couple's newborn daughter. They live rent-free on the property in exchange for such duties.

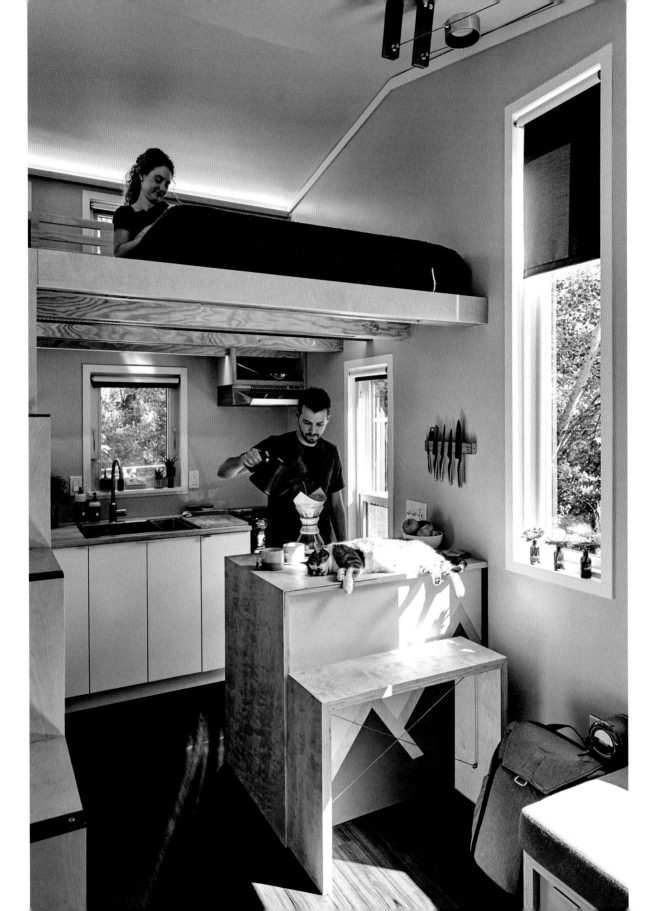

⌃ THE BIG LITTLE KITCHEN

Robert and Samantha didn't want to compromise on their
kitchen. They carved out space for their stand mixer and
purchased a Summit Professional 20-inch gas range, which
runs on propane and is large enough to accommodate a
full cookie sheet. They also paid particular attention to the
exhaust fan they installed. "When you cook onions in a tiny
house, your upholstery and bedding can smell for weeks,"
laments Robert. The refrigerator is an apartment-size unit
by Avanti; the sink and faucet are by Ikea.

❮ WORKING ON ALL LEVELS

Every inch of Robert and Samantha's home was
thoughtfully conceived. Inexpensive building materials
like Baltic birch plywood and Ikea cabinetry were used
throughout. The sleeping attic, accessed by a set of deep
stairs that double as storage (see page 282), has two operable
windows that allow hot air to escape, creating a constant
flow of fresh air. The couple's cat, Tobermory, always seems
to find a sunny spot.

have children one day and maybe even own a
house, but after accumulating sizable student
loan debts, they wondered how they would
ever do it. Throwing their money away on
costly rental apartments each month certainly
wasn't helping.

"Then one night, I brought it up. 'What about
one of those tiny house things?' I knew we
could live in a small space and it would probably
be cheaper," says Robert. The more the couple
looked into the idea, the more it seemed to make
sense. "We could build it ourselves, learn from
it, save a lot of money, and reduce our environ-
mental footprint," he says. "Plus it would be a
big adventure as well—it would be cool."

With Robert's architectural know-how, they
started digging into the specifics. The first thing

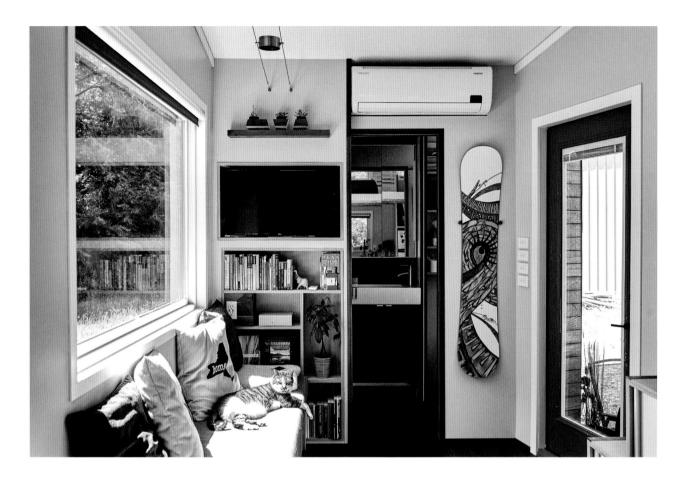

they needed was a foundation, which for a tiny home on wheels is a flatbed trailer. For six months, they hemmed and hawed and trolled Craigslist hoping to find a used one for about a thousand dollars. "It just wasn't going anywhere," says Robert. So the couple changed their search parameters and looked at buying something new. They found a place in Portland called Iron Eagle Trailers that has been making tiny house–specific trailers for almost a decade. "We were confronted with a thirty-five-hundred-dollar price tag—a lot of money for

∧ LIGHT-FILLED LIVING SPACE

Avid snowboarders, the couple won this custom-designed board in a scavenger hunt at their local ski hill back in Buffalo, New York. It is one of the few things that has hung in all their homes. A pair of built-ins neatly holds a television, some books (mostly mountain and hiking manuals, local field guides, and architecture books), and a plant. A Pioneer Ductless Mini-Split heater and air conditioner above the doorway keeps the house cool in the extremely hot summers and warm in the very cold winters.

a DIY venture that we weren't a hundred percent committed to," says Samantha. Before dropping the cash, the couple reached out to a veteran of the tiny house movement, Macy Miller, and asked her advice. She suggested the pair attend a tiny house meetup taking place in Boise, Idaho, where they could talk to dozens of homeowners. That weekend would seal the deal—within twenty-four hours of returning to Yakima, they had ordered their brand-new, 24-foot-long, 8½-foot-wide trailer. There was no looking back now.

Standing in the living room, reviewing the stop-motion video of the making of their house, Robert marvels at their naïveté. "When we started, we didn't have a place to construct it. We didn't have a truck to transport it with after it was built. We didn't even have a piece of land to park it on," says Robert, laughing at their bush-league plans.

Confident that their community would help them out, they started to spread the word about their new venture. Responses started trickling in. A friend with some old barns offered up one of his massive outbuildings for the construction of the house. Another friend, who had recently closed on a 7-acre property just outside of Yakima, liked the idea of sharing his land with them in exchange for their looking after his dogs and chickens when he was away on business trips.

Robert put his architecture degree to work and began by assessing his and Samantha's personal wants and needs. He decided that the house should have two distinct sides: the one facing the road would be more closed off and offer them privacy, and the back side, with expansive, operable windows, would visually make the house seem bigger and let them take advantage of the view. The big window would mean sacrificing storage space, but the two were prepared to cull their belongings to only the necessities. The layout would place the bathroom and kitchen at either ends of the trailer with a living space in between. Robert paid special attention to the layout of the bathroom. "It was important to make the center portion of the bathroom look beautiful so if the door was left open—which we knew would be often, to visually expand the space—it would look good," he says. To that end, he positioned the vanity in the middle of the doorway and ran walnut paneling behind the medicine cabinet and up over the ceiling.

Knowing that lighting can make or break the mood of a home, Robert opted for LED lights in the kitchen, loft, and main living space and put them all on dimmer switches. A cable system made by Tech Lighting called K-Corum, which allows multiple units to be positioned along a wire and flipped to create either direct or indirect lighting, was chosen for the central portion of the house. "My number one piece of design advice for tiny home dwellers is to illuminate the ceiling instead of the floor," says Robert. "It makes the space feel bigger and brighter."

A set of deep stairs that double as closets would rise to a sleeping nook that was just big

enough for Robert and Samantha to sit up in without bumping their heads. "If you're over six foot four, you're not going to want to live in our house," laughs Robert. "It's based on our heights and was made to work for us." In terms of furniture, they decided that everything (with the exception of a multipurpose bench/table— see page 277) would be built in.

On the exterior of the house, a punched-in doorway with a cherry-red glass door provides the home with a focal point. Extra corrugated metal was purchased to cover up the wheels of the trailer, to make it appear more like a permanent structure. A normal extension cord runs between the tiny house and an outbuilding on the property, providing all the electricity the couple requires for their lights, the refrigerator, the exhaust fan, and any heating or cooling needs, plus a hair dryer.

After fourteen months spent searching the internet for hard-to-find supplies, several icy drives back and forth to Portland to grab Ikea flat-packed kitchen cabinets, and many trips to Home Depot in their Honda Civic hatchback to pick up lumber, their 204-square-foot tiny house—which they affectionately refer to as Shed (a play on words at once connoting a simple structure as well as the act of ridding oneself of unwanted things)—was ready. The total cost was thirty thousand dollars. All of Robert's careful calculations had worked out, with the exception of one small oversight—the house was too tall to make it out through the barn doors. A quick thinker, he hoped that if they

let the air out of the tires on the flatbed trailer, they might be able to squeeze out the extra few inches they needed to make it through. The plan worked. They were soon hauling their handmade home down backcountry roads to their new landing spot.

Now that they've settled in, they've adopted a very minimal approach to decorating, with just a couple of snowboards on display, and have pared down their belongings to only what they need—two coffee mugs, four wineglasses, and four plates. Every single object has a specific place where it belongs; as a result, the home looks neat and orderly. For those few things that might get left out, like shoes, the couple has a set of established rules: "Only one pair of shoes can be left by the door—everything else has to get put away," says Samantha. One exception to this less-is-more credo is their 24-square-foot gear room, which is accessed by its own door on the outside of the house. "This is our pride and joy," says Robert. "If the house is the very simplified, no-clutter side of our personalities, then the gear room is our ready-for-anything room." With everything from paddleboards to hiking crampons, tents, helmets, and a "Have Beer, Need Lift" cardboard hitchhiker sign, it's obvious that the couple has a big love for adventure.

"We've been really happy with the tiny house—it's way easier to live in than I would have imagined. We preach as architects that if a space is custom-designed around your needs and the way you live your life, then it should

feel pretty effortless. We really put that to the test in this small space, but it's everything that we need and nothing that we don't, which is an incredibly liberating feeling," says Robert. "We live normal lives—we've got two cars, we've got careers—we just come home to a slightly different setting than most people."

Last year, Robert and Samantha added one more thing to their tiny house—a daughter, Aubrin Sage. When they were drawing up plans for the home, they knew they wanted to have kids but pragmatically decided against designing for a family in case those dreams didn't come true. For now, Aubrin sleeps beside her parents in a co-sleeper designed by Robert. In time and with more kids, the couple knows they will have to move on. "The tiny house, while maybe not our forever home, is so important at this stage in our lives because of the debt we are trying to pay off," says Samantha. "We won't sell it, though. It will stay in the family and possibly be used as a studio or guesthouse, or we could rent it on Airbnb."

"Or it could be an off-the-grid getaway up in the mountains," Robert chimes in, his face lighting up at the prospect of having a place from which to navigate more adventures.

> ### NOOKS AND CRANNIES

A custom-designed snowboard divides the open shelving in the kitchen. Wineglasses, bottles, and mugs slot into a narrow space on the left, while pots and pans and everyday tableware fill the larger portion to the right. The cat's litter box, at the bottom of the closet, has a specially carved-out opening.

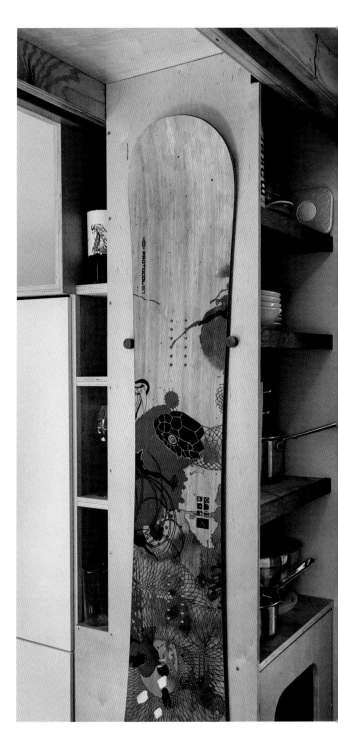

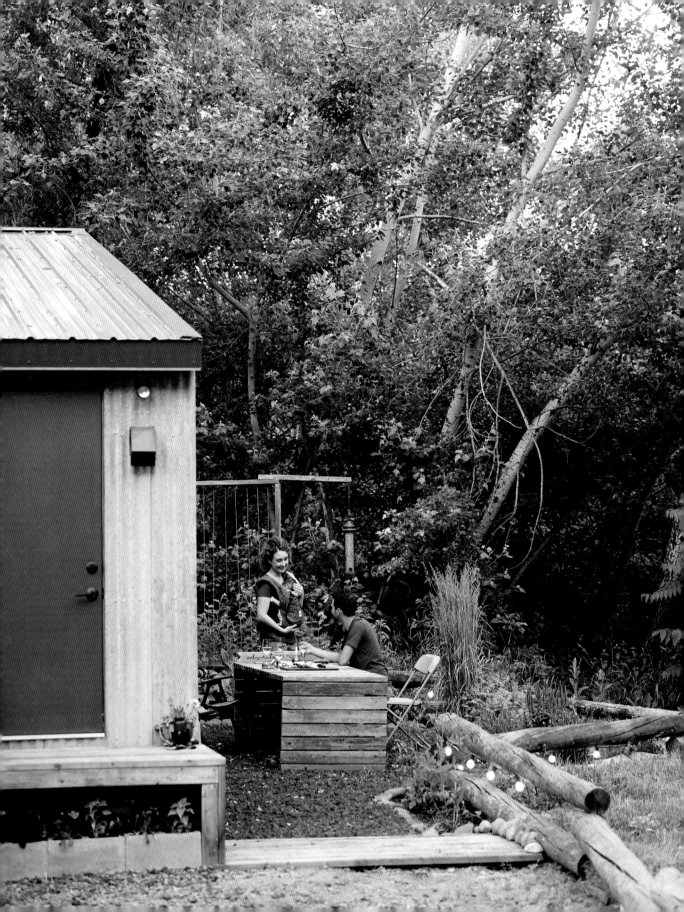

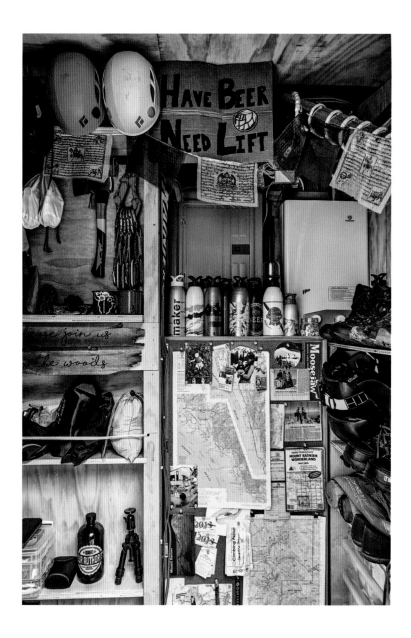

❮ GARDEN IN THE BACK

A DIY table and a small vegetable garden at the rear of the tiny house provide the family with an outdoor space to hang out in. The gear room is located at the side of the house and has its own entrance. The corrugated-metal exterior cladding is from an old apple bin canopy from an orchard up the road. "Usually, corrugated metal is shiny crap, but this piece has had eighty years of sun on it and it's got that nice dull patina," says Robert.

^ PACKED TO THE RAFTERS

The tiny gear room, which is no bigger than a standard closet, holds an inflatable canoe and paddles, four snowboards and four pairs of boots, four helmets, four backpacks, two skateboards, two sleeping bags, two inflatable mattresses, two water bladders, two life vests, two shovels, a tent, a camp stove, various water bottles, ropes, pickaxes, maps, Tibetan prayer flags, and more. It also hides many of the mechanical systems for the house.

Family School Bus

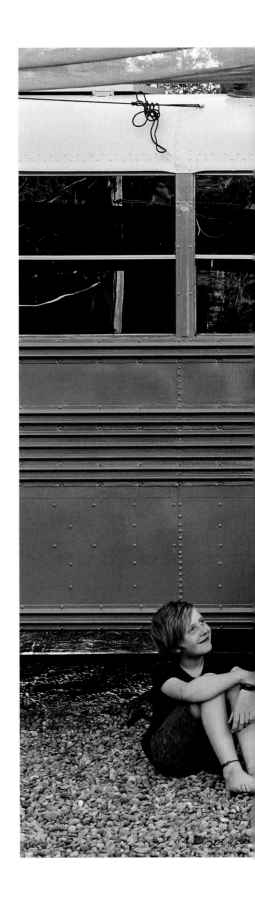

On a breezy early-summer evening just outside of Albuquerque, New Mexico, Ashley Trebitowski, dressed in a pair of black Converse sneakers, black jeans with holes in the knees, and a Tupac Shakur T-shirt, runs her hand through her multihued, curled hair. "I used to cut hair for a living," she says, opening the door of the converted Bluebird skoolie she calls home. "I'm thinking of sharing more beauty tips on our Instagram feed. Can you imagine? 'Here are my three favorite products, because nothing else fits in my closet.'"

"Tiny hair tips!" pipes up her husband, Brandon, who, with his buzz cut, clearly doesn't need them.

"There's a community of us bus wives, and we've all trained our hair so we don't have to wash it more than once a week," continues Ashley. "But my best tip for bus beauty is eyelash extensions. I never have to do my makeup."

With only one mirror on the bus, three children under the age of nine, and a full-time job homeschooling those kids, Ashley has an impressive talent for appearing pulled together. Her ability to wield a curling iron is matched only by the deftness with which she handles a circular saw. She won't take credit for it, but Ashley is responsible for almost all the woodwork in the family's converted school bus. "Don't let her sell herself short," says Brandon, a successful tech entrepreneur who now runs

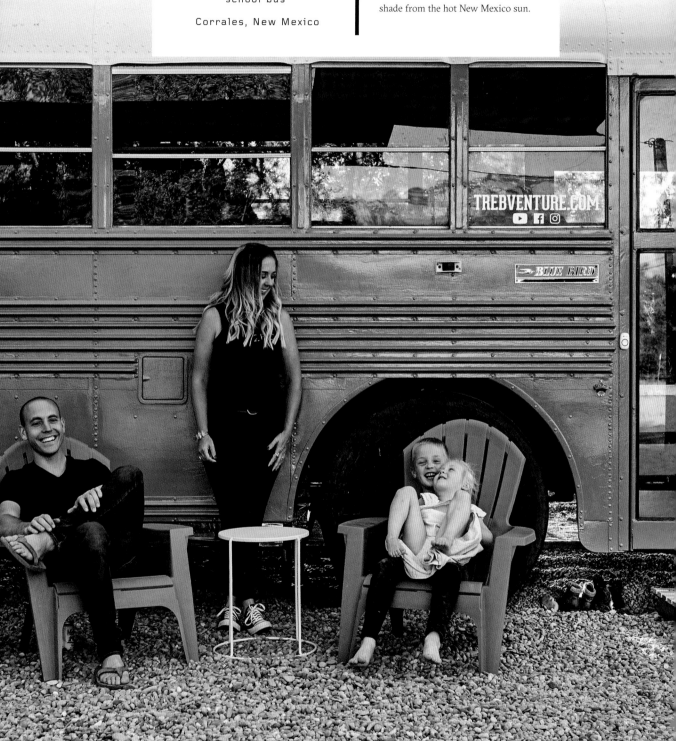

ASHLEY & BRANDON TREBITOWSKI

39-foot 1999 Bluebird school bus

Corrales, New Mexico

Brandon and Ashley recently purchased the lot their bus is parked on. Sunshades attached to the top of the bus and surrounding trees provide shade from the hot New Mexico sun.

TREBVENTURE.COM

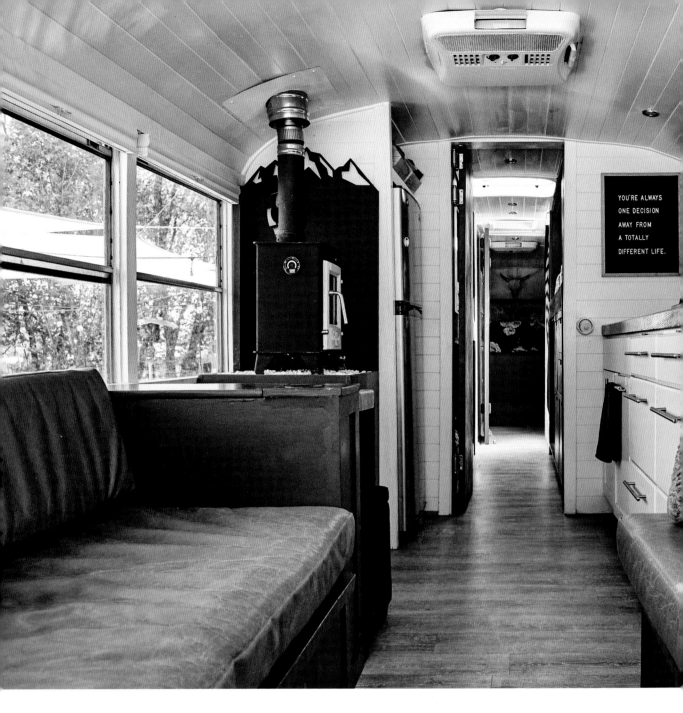

∧ SCANDI SCHOOL BUS

The warm caramel faux-leather upholstery not only mimics the color of the butcher-block countertops, creating a seamless palette for the main living space, but also stands up to the demands of three children. But it still takes a lot of abuse. "In another year, we'll need to reupholster them. I get the whole cushion redone. It costs me three hundred dollars, so it's an investment, but it's not that big of a deal." The letter board, made by Letterfolk, was the first thing the family put up on their walls.

a seven-figure app company out of the bus. "She built most of the wood structures in here single-handedly."

Ashley and Brandon met when they were in sixth grade in Rio Rancho, New Mexico, a community not far from their current home. By senior year, they were dating; college, a 2,100-square-foot house, three kids—Caydon, Jackson, and Reagan—and financed cars soon followed. In the spring of 2015, the couple purchased a tow-behind travel trailer, in part because Ashley hated tent camping and the family wanted to get out and see more of the country. When Ashley's childhood friend and constant sidekick, Vanessa Miller, heard about their plans, she started looking for her own recreational vehicle, dreaming of the day the two families could go on camping trips together. They were all shocked by what her husband, Denver Miller, came back with: an old yellow school bus. "We thought he was insane," says Brandon. But the two families began working together on converting the bus. Ashley fell in love, and soon she and Brandon were selling the trailer and finding a bus of their own.

Looking down the length of the skoolie at the white shiplapped walls and ceiling and modern rustic kitchen, it's hard to imagine this cozy pad as the school bus it once was. The first order of business was removing all signs of its former life—out came the rusted-in seats stuck with bubble gum, followed by the thousands of metal rivets that held up the walls. With the skeleton of the bus exposed, Ashley and

Brandon shored up the insulation, laid down a new subfloor, and then started taping out the floor plan. Structurally, the biggest change they made to the bus was removing the original, drafty two-pane glass windows from the back of the bus. In their place they added new oblong RV windows purchased on eBay.

On the whole, Ashley has taken a very minimal approach to decorating, relying on a black-and-white color scheme accented with bold geometric prints—a look that would be equally at home in a mod Scandi apartment.

⌃ MINI SPACE HEATER

The family installed a wood-burning stove to keep the bus warm. Wood can be neatly stacked in the container underneath, while the metal plate with the custom mountain cutout is a fire regulation. Their Dwarf Small Wood Stove is from TinyWoodStove.com.

⌐ SCHOOL ON THE BUS

Ashley homeschools all three of her children. It's this decision in part that lets the family take off for extended trips across the country. "Throughout the year, we do a lot of local field trips," says Ashley. "We also have a huge homeschool friend group—the kids are super socialized." A small desk behind the sofa is set up as a homework spot, with a built-in pencil/cup holder.

❯ SHELF AWARENESS

When Ashley and Brandon first built the bus kitchen, it didn't have any shelves, but small appliances, fruit, and vegetables were taking up precious counter space. First the couple added the pop-up wood bracket behind the cooktop and moved all their coffee supplies to the ledge, and then months later they added another shelf above the windows, primarily for fresh produce.

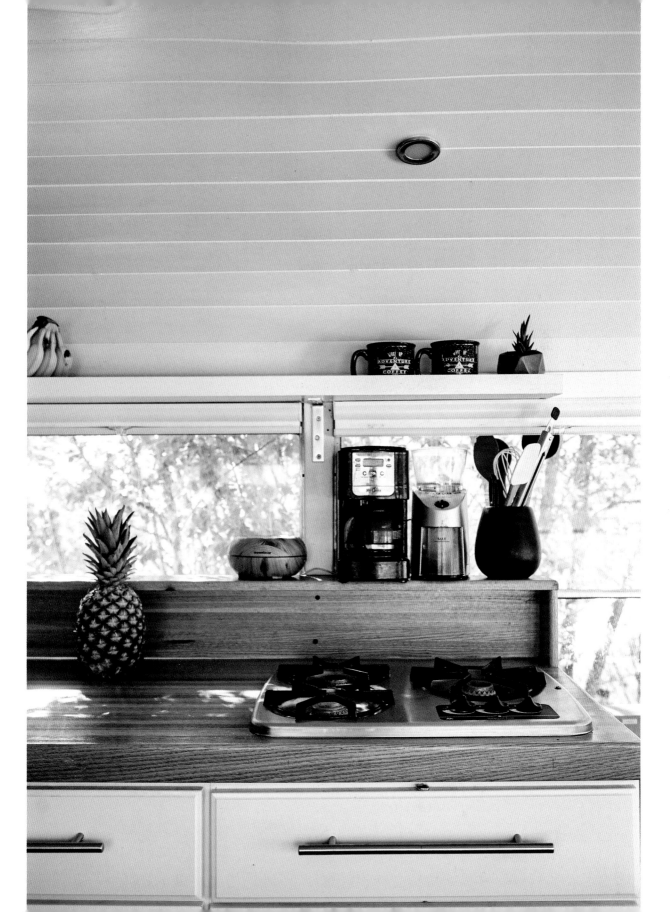

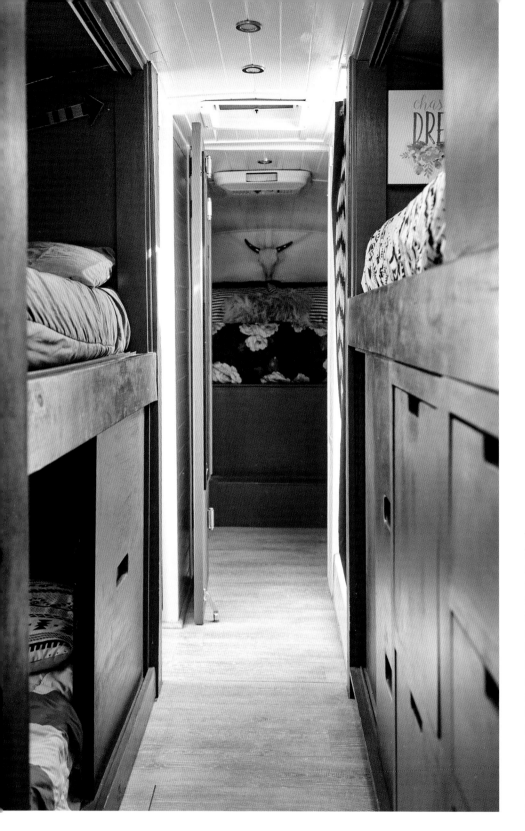

❮ KIDS' ZONE

The very first thing Ashley constructed on the bus was the kids' bunk beds, which line either side of the hallway. Painted in charcoal gray, each bunk has its own sliding door that the kids close at night. At the end of the hall is Ashley and Brandon's bedroom. A pair of one-pound NAPA Auto Parts struts were installed under their king-size bed so they can tilt it up to access the electrical components and a hundred-gallon water tank.

The wood frames for the sofa benches off the front door and the kids' stacked bunk beds—each of which has its own sliding door to allow them some private space—were constructed by Ashley, but she left the kitchen cabinets to the pros, purchasing them from Lowe's. ("Drawers are a whole other ball game," says Ashley.) The black-and-white color scheme is repeated in the bathroom, which is separated into two parts—a sink and toilet on one side and a spacious, sunlight-filled shower (thanks to an overhead skylight) in white subway tile on the other. Behind the bathroom is the master bedroom, which consists of a raised-platform, king-size bed with storage underneath.

⌃ LIGHT FROM ABOVE

Brandon and Ashley quickly grew tired of the bus's original, too-tiny shower and added a 14-inch lift that popped the shower ceiling above the curve of the bus's rooftop. They finished the room in glossy white subway tiles and added a custom-made skylight. "It's now our very own spa shower," says Ashley.

⌐ CRAFTY COMPARTMENTS

The closet has a dedicated spot for every item. Shoes are stashed on an angle in trugs, hats live in a see-through wire basket, and outerwear goes in a soft knitted bin. Ashley's everyday essentials like her jewelry, hairbrush, and perfume are stored in the upper drawer. The pull-out table is a standing desk.

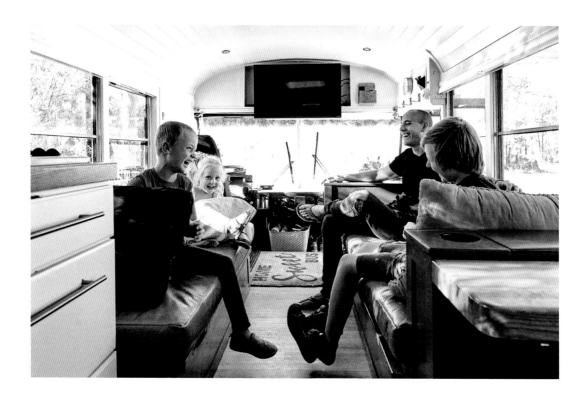

When it came time to take the converted bus out on its inaugural trip, the family headed north to a wedding in Roseville, California. "We had to learn everything," says Ashley. "It took us a while to get used to parking and navigating through gas stations, for sure." Once home in New Mexico, they looked around their sprawling home and realized that they didn't need most of what they owned. Their friends the Millers had recently moved onto their bus full-time, and Ashley and Brandon were impressed with the minimalist and debt-free lifestyle they had adopted. They knew that if they did the same, it would free up a lot of their finances to grow Brandon's company without the added pressure of keeping the family afloat, and also allow them the flexibility to travel extensively and spend quality time with their children, then aged seven, five, and two. "It just seemed so much more

important to spend our time with our kids than to pay bills, fix things, and put stuff away all the time," says Ashley. Within two months, the Trebitowskis had put their house on the market, sold the majority of their possessions in a garage sale, and moved onto their bus full-time.

Going from 2,100 square feet to 200 has required a few compromises. "We don't have a dining room table," says Ashley. "That's the one thing I wish we had . . . and a porcelain toilet. I just miss the ease of a regular toilet, plus the composting ones only come in ugly colors." However, living with less has become easier and easier. "When we had the house, it would take me all day to organize the kids' clothes. Now it takes about a half hour once a week to put away our whole family's wardrobe." The family stashes their dirty clothes in the fourth, unused bunk bed, which was initially conceived of as

a guest bed. "Dirty clothes are one of the challenges with living small, and when we decided to repurpose that space, I was determined to put a clothes hamper in that spot. That way the kids can put their clothes in there, and if it overflows, it messes up that area rather than being out in the walkway. Any bit of clutter in a small space can make you crazy." She's also become savvy about things like books and toys for the kids. "For reading, we turn to a Kindle, and each kid is allowed one drawer to fill with toys—no more."

Brandon and Ashley find that parking the bus can be challenging. Their preferred spots are on public lands under the Bureau of Land Management that can be camped on free of charge and RV parks, although many RV parks do not allow converted school buses. When they are in a pinch, they will park at a Walmart, Cabela's, or Ikea.

The school bus is currently parked on land that Brandon and Ashley recently purchased in Corrales, New Mexico. They've been dividing their time between this strip and the wider United States since 2015, and while they hope one day to build a house, the prospect worries Ashley. "It scares me. Since we moved onto the bus, we've rented for a month here and there for Brandon's work and I hate it. When you live small, it's easy to clean, it's easy to pick up after the kids, all those things." However long it takes the family to make the transition, the experience of going small has changed them forever.

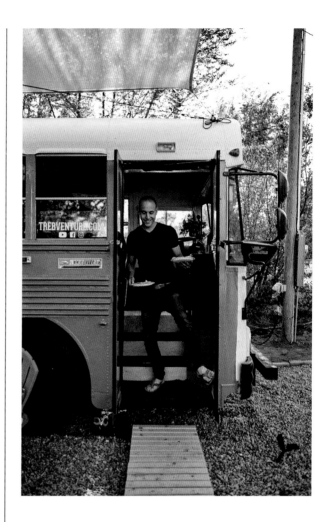

˄ FOOD DELIVERY

Brandon kicks open the double doorway of the bus balancing two plates of dinner.

˥ HANGOUT SPACE

This is the family's main gathering spot, whether they're watching TV (which is mounted over the front windshield), playing cards (Uno is a favorite), or sharing a meal.

Tin-Can Campers

Getting to the spot where Michigan natives Alexandra Keeling and Winston Shull park their battered aluminum teardrop camper on the public lands managed by the Bureau of Land Management outside of Moab, Utah, is no easy feat. Fine sandy roads, pockmarked with potholes big enough to swallow a car, require slow, focused driving—not to mention a vehicle with good clearance and a decent set of shock absorbers. Off the main thoroughfare, about ten minutes down a barely visible artery, a small cul-de-sac of vehicles and tents forms a mini community of full-timers and weekend warriors. Between two stunted trees not much taller than the camper itself, the pint-size trailer, surrounded by camping accoutrements, gleams in the midday sun.

"We need to come up with a better story of how we met so we don't have to keep telling people we met on Tinder," laughs Alex, poking her head out of the hobbit-shaped door (prompting her dog, Rocko, a sad-faced pit bull, to jump up from his shady spot). The pair went on a few dates when they first met in 2015 but quickly realized that their mutual passions for photography and travel would be better served through a friendship. This might seem hard to believe now, given that the puny trailer measures a mere 9 feet by 5 feet and has only one queen-size mattress (which they also share with Rocko), but the intimate confines don't seem to faze the good friends.

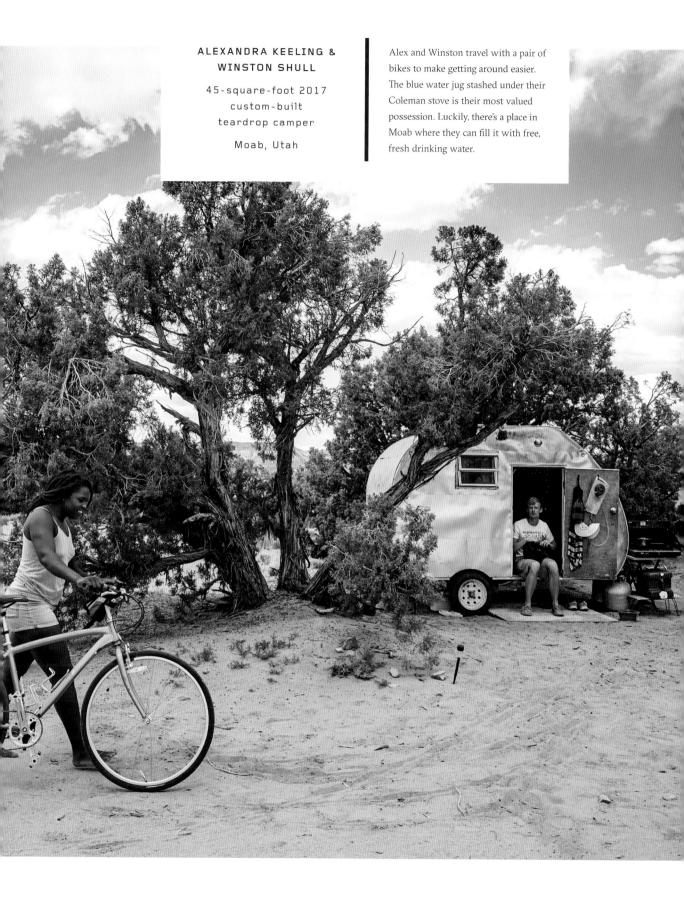

ALEXANDRA KEELING & WINSTON SHULL

45-square-foot 2017 custom-built teardrop camper

Moab, Utah

Alex and Winston travel with a pair of bikes to make getting around easier. The blue water jug stashed under their Coleman stove is their most valued possession. Luckily, there's a place in Moab where they can fill it with free, fresh drinking water.

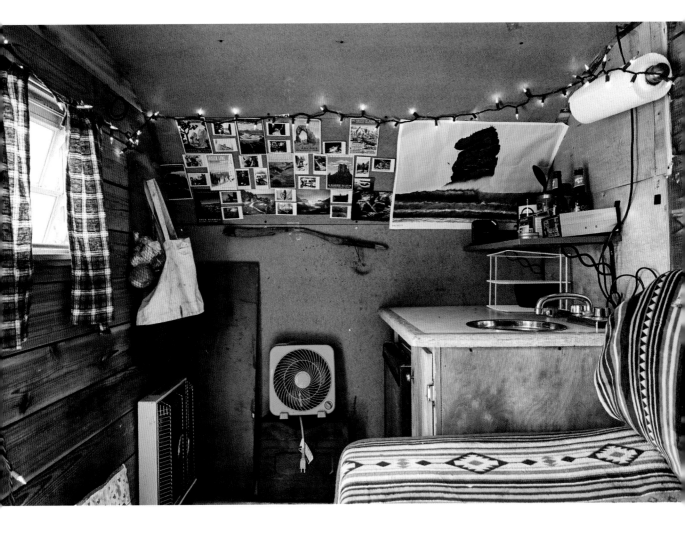

∧ LILLIPUTIAN LIVING

The kitchen consists of a tiny sink and a fridge, which the pair doesn't use very often. Almost all their cooking is done outside on a camp stove or over an open fire. Postcards and photos, including a shot of their inaugural day out on the road in their RV, are taped to one of the curved walls in the teardrop to document some of the places the pair has already traveled to.

❯ CABIN CHIC

The sofa folds down to create a queen-size bed that fills the width of the camper. Storage is at a minimum, but luckily, the duo has an SUV that they can fill with most of their gear. When they are stationed for longer periods of time, they will set up a tent beside the camper and use it as storage. It also prevents any weekend warriors from making camp right next to them, which they find can be loud and annoying, especially when they have to get up at 7:00 a.m. to head to work the next morning.

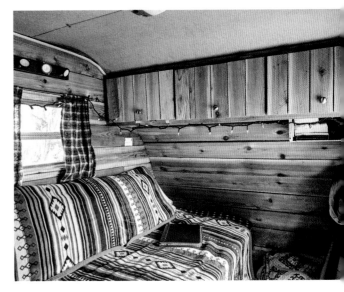

"I was employed at Dow Chemical in Midland, Michigan, as a graphic designer," says Winston, a lanky strawberry blond with a smattering of freckles. "I had a full-time job, I was renting a house, I had my own car—'all the things,' so to speak—but I found myself not even looking forward to the weekends anymore." With Saturdays dedicated to doing laundry, buying groceries, and preparing meals for the week, his days off began to feel like work as well.

Alex agrees. "We were in our late twenties and getting burned out and we thought, 'How are we going to make it to sixty?'"

A few years earlier, Alex had been on a solo photography trip through the Midwest, sleeping in her Kia Forte sedan night after night, and she was itching to get back on the road. She suggested to Winston that they quit their jobs, pack up their camera gear, and live nomadically for a while. They picked out a 1987 Itasca Phasar—Winnebago's answer to the fuel crises of the 1970s that saw gas-guzzling RV sales rapidly decline. The company partnered with Renault to create a compact RV based on a small European drivetrain unit. The pair didn't spend much on the RV itself, but they ran it through maintenance checks, did some minor repairs, and updated the interior to make it more comfortable.

With a loose itinerary in hand, they set out from Midland. When Alex's mom asked for details, Alex responded, "The plan is, there is no plan. I might come home, I might not." Two days into the trip and a mile from the closest gas station, she and Winston noticed that their coolant gauge wasn't working. Seconds later, they were on the side of the road with steam pouring out of the hood of the RV. "A mechanic came and towed us to his garage. He looked at the RV for about a week, but he couldn't do anything for us. Fixing the French-made engine would have cost us as much as we paid for the whole RV," says Winston glumly.

"At that moment, we had to accept the fact that the plan we'd made was not going to happen," says Alex.

The twosome stayed in a hunting lodge nearby while they debated their future; they could quit, or they could find an affordable solution that would keep them on the road. Determined to carry on, they decided to head back to Michigan and pick up Alex's Nissan Xterra SUV, a vehicle they had camped out of before.

"At first, we tried sleeping outdoors in tents, but most of the time we found it was too cold," says Winston. They headed to a hardware store and had a piece of plywood cut to fit into the back of the SUV so they would have a flat surface to lay their sleeping bags on. "It was a headache," says Alex. "Every night, we would have to take everything out of the trunk and then reload it the next morning." When an invitation to stay with some friends in Colorado arrived two months into their travels, they jumped at the chance for a break from their claustrophobic living quarters.

It was during their stay in Colorado that the pair found their camper, which was listed

on Facebook Marketplace. "The guy we bought it from in Grand Junction built it about a year ago for solo camping trips, but then he got married and his wife was like, 'There's no way I'm fitting in that,' so he decided to sell it. It's the only one he ever made," says Alex.

It takes a moment for your eyes to adjust inside the dark trailer. There's just enough room for two people to stand up inside, although moving about requires a shuffle-like dance. Alex can stand up straight, but Winston, who's taller, must crouch. A pull-out sofa covered in a fleece Navajo-style blanket cozies up to wood-lined walls, and the postage stamp–size windows are covered in cabin-like flannel curtains. The remaining space is made up of a single kitchen cabinet that houses a fridge and a sink. On the counter-top is a package of baby wipes—the do-it-all necessity they can't live without. "We use them for a quick bath, to clean dishes, anything we can think of," says Alexandra. "Water is such a precious commodity that we don't waste it on things we don't need to." Hooks hold everything from recently purchased groceries to sun hats and hoodies. Stashed away in the SUV are the duo's big-screen TV and Xbox—which they refused to leave home without. A battery pack allows them to play it in the camper. Also stashed away in their car is a portable outdoor shower hose, which they can hook up to a bucket of water for very quick rinse-offs, although they prefer to hit up a Planet Fitness if there is one in town. "We

definitely need our own space, especially with how tight it is right now, but we're perfectly fine being able to say that to each other. We're not dating, so I don't have to be nice to him," jokes Alex.

The pair has big plans for the teardrop, including updating the sleeping arrangements to two separate bunk beds and adding a pop-top so Winston can stand upright. To cover those renovations and pay down some of the debt they incurred when their plans went off track, Alex and Winston have decided to put down roots in Moab for a few months and pick up some part-time restaurant jobs before they head down to Louisiana. Being employed in this outdoorsy outpost has opened their eyes to a new way of thinking about employment. "Before, I was working to afford stuff, not for anything I really enjoyed or cared about," says Alex. "Here, people are doing shifts at the restaurant so they can afford to do twenty more skydiving flights or take a week off to go climbing. Their attitudes and mind-sets are just different from those of people who are working only to pay down their mortgages. It's crazy; I actually enjoy work a lot more now."

Winston nods his head in agreement and says, "When we picked up the teardrop camper, we knew things were going to be uncomfortable for a little while and that we would be living in close quarters, but I have no regrets. We've made sacrifices, but at the end of the day we get to travel and pursue our photography— we get to do what we love doing."

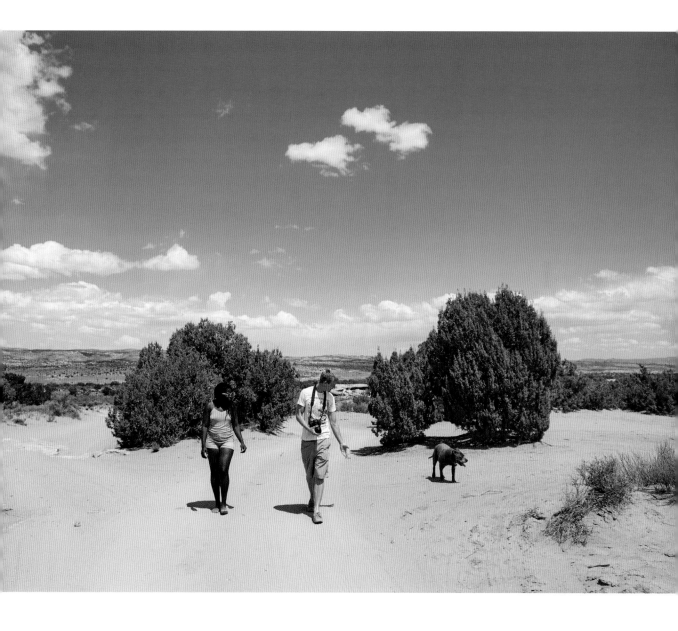

∧ MEETING NEW PEOPLE

There is a huge online community of full-time travelers on Instagram. Alex and Winston use the app to reach out to others who might be in the same vicinity. "It seems like our generation prefers non-face-to-face communication first. So usually I'll message someone and go from there," says Winston. Taking Rocko for a walk is also a great icebreaker.

Taking a Different Path

"It's magical," says Yoav Elkayam, pouring coffee into a well-loved wood mug with cracks running so deep through the surface that you expect the hot liquid to come pouring out on all sides. "When you fill it up, it expands and doesn't leak. You just have to think about a cup in a different way," he explains.

It's midday, and the sun is high in the sky on a patch of land close to the town of Alcanena, Portugal. Perching himself on the back of his blue Luton delivery van customized with an abstract pattern of wood shingles and a quaint white-framed window that looks like it could have been stolen from an English seaside cottage, Yoav grabs a dog-eared copy of Jack Kerouac's *The Dharma Bums* and places his coffee on the rear bumper. "I usually take a couple of hours off from working when it is this hot and do some reading—Portugal time," he says, laughing.

Yoav was born in Israel, and when he turned eighteen, he dodged compulsory army conscription ("I told them I was crazy," he says) and moved to Tel Aviv. His skipping military service was fine by his parents, but they expected him to support himself and find a job. His first love was music, specifically percussion, but he knew that he wouldn't be able to pay the rent doing that alone, so he got a job as a dishwasher. From the start, it didn't make much sense to him. "You work so hard and then you give all your

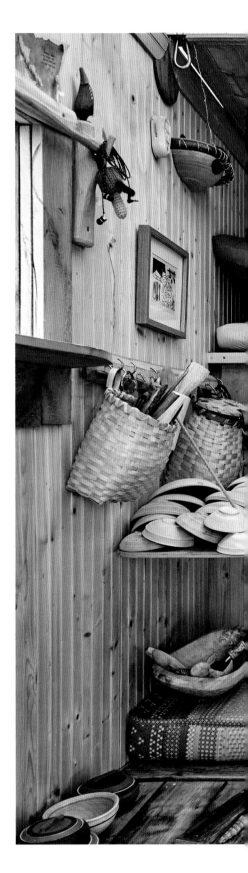

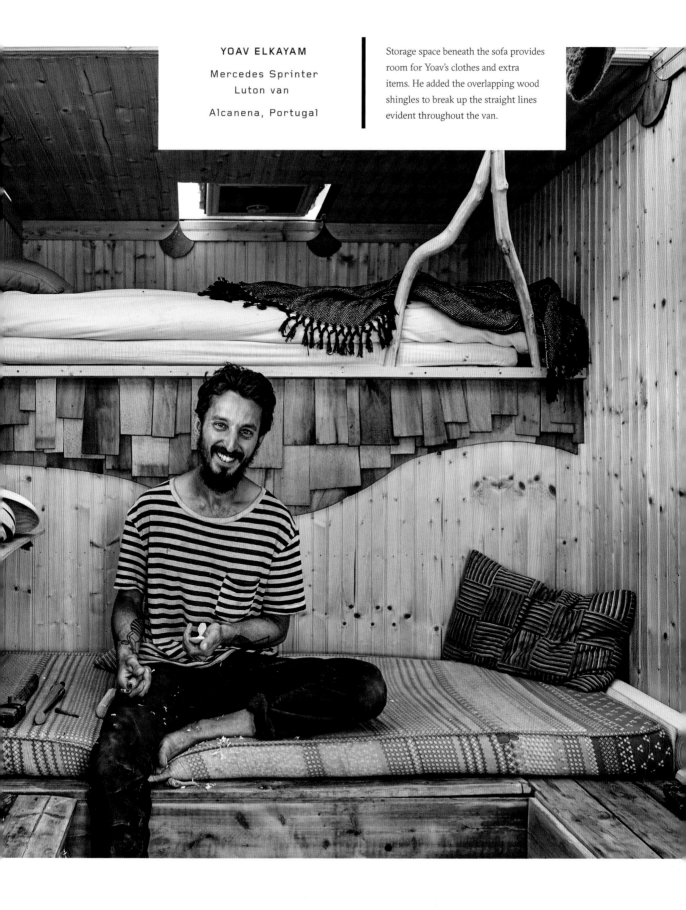

Storage space beneath the sofa provides room for Yoav's clothes and extra items. He added the overlapping wood shingles to break up the straight lines evident throughout the van.

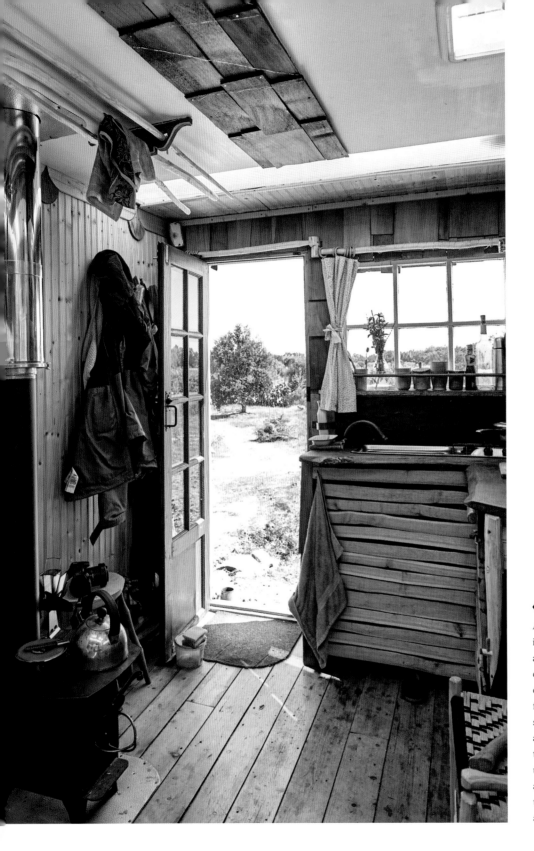

〈 PUMP IT UP

A sink with a low spout
is located directly below
a window that looks out
over the landscape. Wells
on the property provide
fresh drinking water; Yoav
simply fills jugs with water
and then hooks them up
to a pump system located
underneath the sink. Using
a foot pedal, he can suction
the water up through tubes
and out the spout.

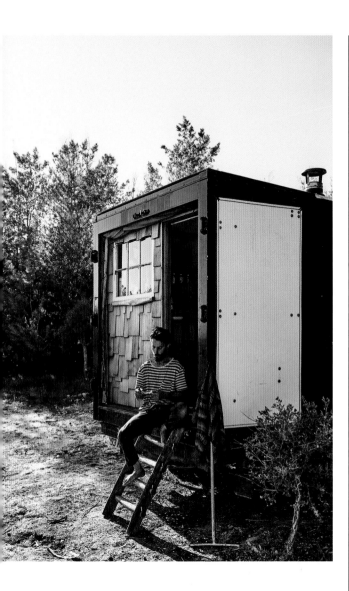

At first, Yoav thought he would make the van look really nice on the outside, but then he had second thoughts. "Why should I draw attention to it?" he says. Even the shingled panel on the back with the painted window and door is concealed by two large exterior van doors. "That way if I end up in a not very magical place, I can stop anywhere and just look like a regular transport van."

money away, and then you go back to work to make more money and then you hand it all over again," he says. After a year and a half, he figured that there had to be another way. "I was working as a dishwasher because it paid more than playing gigs, but what I loved most was music and I wasn't doing that at all, so I decided to make a change," he says. "I thought, 'I'm a musician. I can earn this much a month. How can I live on that? How can I make it last?'"

He moved out of the city and into a tiny barn in the countryside. He dedicated himself to his music and started playing gigs wherever he could. Soon he was playing with a traveling band called the Turbans, a world beat collective featuring musicians from Turkey, Bulgaria, Iran, Greece, and England. As their popularity grew, they began touring Europe, playing festivals all over the continent with the seven or more band members sleeping like sardines in a Volkswagen T3 van or in tents. "It was happy days and lots of laughs," says Yoav. During one of his stopovers in England, he helped a friend build a yurt and decided that it made sense for him to do the same back in Israel. "I realized, right, why pay rent for that small place in a barn when I could live for free? So I built my own yurt in that village," says Yoav.

Amid touring with the band, Yoav learned about green woodworking, a type of carpentry that uses unseasoned or recently felled wood. He started hanging out with people who were carving their own spoons and making items like bowls on pole lathes—a foot-powered mechanism

that uses hand-forged tools to shape the wood. "I found it very, very satisfying to make something," says Yoav. Soon he was attending events like Spoonfest and taking workshops with leaders of the movement like Sharif Adams. He had found a new passion and wanted to open himself up to learning more. "I decided to sell the yurt and with the proceeds buy a van," says Yoav. This would give him the opportunity to move more freely around Europe and immerse himself in the green woodworking culture. It didn't happen right away, though. For a year, he traveled living out of only a backpack, always with an eye out for the perfect van. Then, with only one month remaining on his visa, he found it: a Mercedes Sprinter with a Luton box (an enclosed box body that extends over the driver's cab) that had previously been used to transport pianos.

Having already lived in a smaller VW, he had three requirements for his new home: for him to be able to stand up inside the van; to have a permanent bed that didn't require setting up and tearing down each morning; and, with a bit of skillful space planning, to have enough room for him to roll out a yoga mat. As luck would have it, some friends nearby were building a full-scale, low-impact house with trees they'd cut down and milled on their land. In addition, they had gathered a ramshackle collection of doors, windows, and trim. What they didn't use—their "spare bits and goodies"— were up for grabs.

Yoav laid the foundation for his new home by putting down a reclaimed wood floor; he then moved on to the kitchen, where he installed an L-shaped set of cabinet frames finished with wavy, unevenly cut lumber strip doors. In an ode to his favorite material, he continued adding wood in the form of beadboard walls topped with overlapping shingles, mounted carpenter-like toolboxes filled with wood cups and canisters, handmade wood chairs, trunks covered in shingles, and two notched-out wall racks displaying dozens of hand-carved spoons made by his friends and mentors. Even with the addition of a loft bed and sofa, there was still enough room to roll out a yoga mat. The entire build cost him about six hundred British pounds.

Yoav drove the van back to Israel and eventually racked up more than five thousand miles

﹁ IN TUNE WITH THE SEASONS

Yoav sees the sunrise most mornings. "I wake up and it's grayish blue, and then you see this golden light emerge. I see the moon rise as well," he says. "I think one of the reasons I was really attracted to this way of living was because you are reliant on nature—there's a direct connection to how warm or cold or light or dark it is, and those are your limitations. You need to play within those borders and decide what to do."

❯ STAYING PUT

"Traveling costs a lot of money, so I try to be as static as possible," says Yoav. "If I'm driving a long way, I'll try to do it in a few days and then park for at least a month. That way, I can put my pole lathe up and turn wood, and it doesn't cost me any money. I find it tiring to move all the time."

❯❯ HOMEMADE DRYING RACK

A rack of recently carved bowls dries on a cantilevered shelf hovering over the sofa. As the green bowls dry, they begin to warp and take on their own characteristic shapes. A bowl holds partially carved spoons awaiting further whittling.

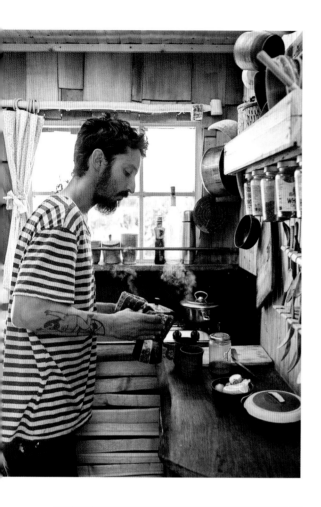

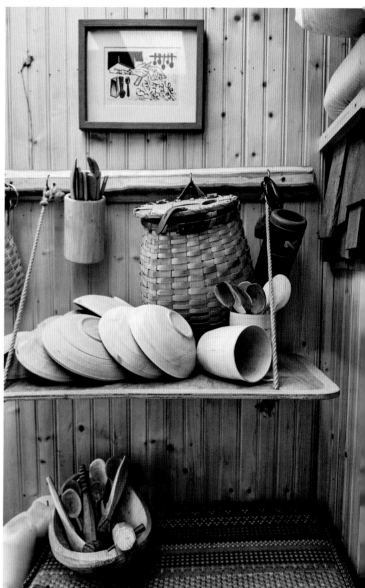

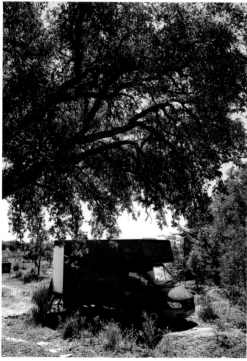

driving back and forth to England. He had been on the go, living a seminomadic existence, since his band days, and he was yearning to slow down, set up his pole lathe, and be self-sufficient for a while. Through a friend, he heard that property in Portugal was relatively inexpensive, so he set off in his van and had a look. He liked what he saw, but he didn't have enough money to buy a property by himself. So he put out the word to his friends and acquaintances, and two of them decided to go in on the purchase of the land with him.

Hidden away down a nondescript road, the property seems as though it is from another time. Crooked mature orange trees heave with sweet fruit, while overgrown grape vines are just starting to bud. There is a languorous mood to the place, made all the more obvious by the slow, diligent way Yoav walks barefoot through the property. You get the feeling that he has found his own paradise and doesn't want to do anything to disturb it. With the beginnings of a vegetable garden planted and his pole lathe set up in a shady clearing of mimosa bushes, Yoav spends his days turning greenwood bowls and cups and working toward his goal of becoming completely self-sufficient.

Yoav proved to himself a long time ago that chasing his own dream was always the best decision. As he washes out his coffee cup, the one that miraculously seems to hold in the liquid, he says, "There's always an alternative in life. You just have to open your mind to the possibilities."

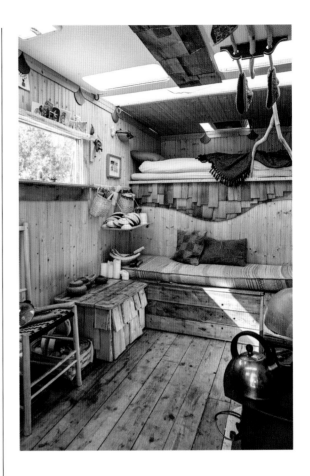

⌃ HEAD-TO-TOE TIMBER

Wrapped in wood and outfitted with an upholstered bench, throw pillows, and blankets, Yoav's van is a cozy place to hang out. A wood-burning stove was added to the van after the initial conversion. Overhead, Yoav installed a simple clothesline made of three stripped-down branches to help dry wet clothes and outerwear. "I got the idea from the laundry pulley racks you see in England, which are often found in kitchens over the range," he says.

❯ A TROPHY WALL

Everyday cooking items—including canisters, bowls, and cups turned by Yoav—are mounted within arm's reach on the van wall. The spoons on display were picked up through trades and exchanges with other woodworkers. Yoav has so many, he recently had to build a second display rack.

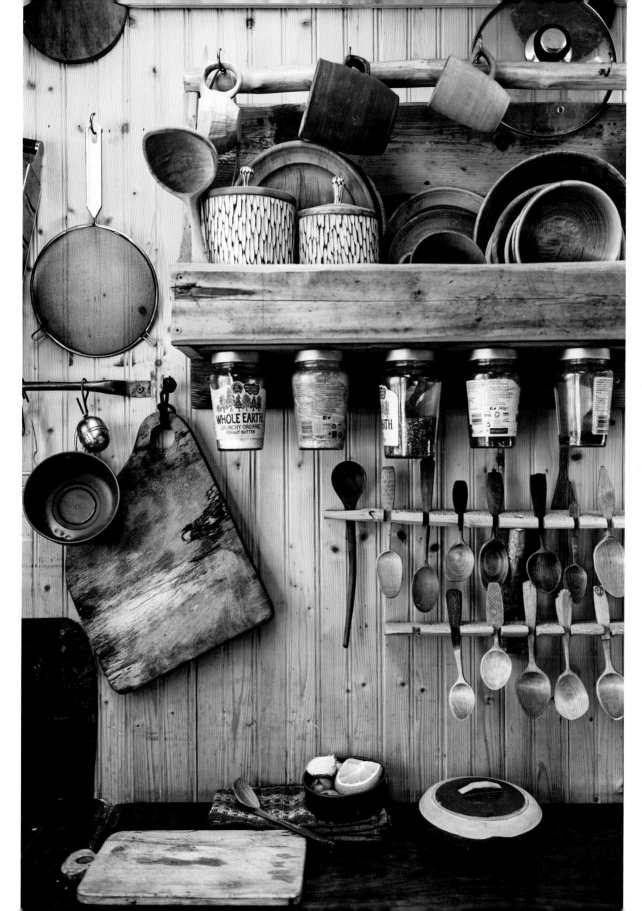

⌃ MADE BY HAND

Yoav begins the work of carving a bowl. Each artisan forges
his own hand tools to carve the wood. It gives each object a
distinctive character.

⌐ PEDAL POWERED

Yoav pumps a wood plank balanced on a tree stump, which
moves a tensioned string up and down, causing the piece of
wood he is working on to rotate. He then applies pressure
with his hand tools, gently coaxing a bowl into shape.

❯ CARVING STATION

Yoav takes his lathe with him wherever he goes. The wood
he uses comes from recently felled trees and is relatively fresh
and supple, making it easier to work with. A grove of mimosa
bushes provides some welcome shade.

4
—

The
Escapists

IN PURSUIT OF A NEW KIND OF FREEDOM,
REMOVED FROM A CONVENTIONAL
NINE-TO-FIVE LIFE

Dodging the Daily Grind

Stretching out his long frame, Carsten Konsen rubs his hands vigorously over his arms and legs and surveys his parking job. Pulled over on a dusty road bordered by a dense mat of succulent plants and sagebrush on one side and the Atlantic Ocean on the other, he calls out to his longtime girlfriend, Sina Schubert, who is still sitting in the passenger seat, and tells her he's going to turn the van ninety degrees so the brisk wind doesn't blow through their sliding door all night. With everything settled, the pair gets to work making their dinner before the sun dips below the horizon.

"One of our rules is always to find a parking spot before it gets dark," says Carsten, a sweet giant of a man with floppy hair. Opening up the back door of the van and pulling out a pair of wood storage boxes on drawer slides, he creates a table of sorts. Sina walks around the other side, hands him a cutting board, and starts grabbing veggies from a hanging basket inside their van. As the piles of cut vegetables—butternut squash, zucchini, red pepper, cauliflower, shiitake mushrooms—accumulate, Carsten heads back inside their contemporary-style van and adds them to the pot of Thai red curry that is simmering on top of the spotless propane camp stove positioned beside the sliding doors.

❮ MAGIC HOUR

The sun sets on the southern tip of Portugal while Sina and Carsten prepare their van for the night.

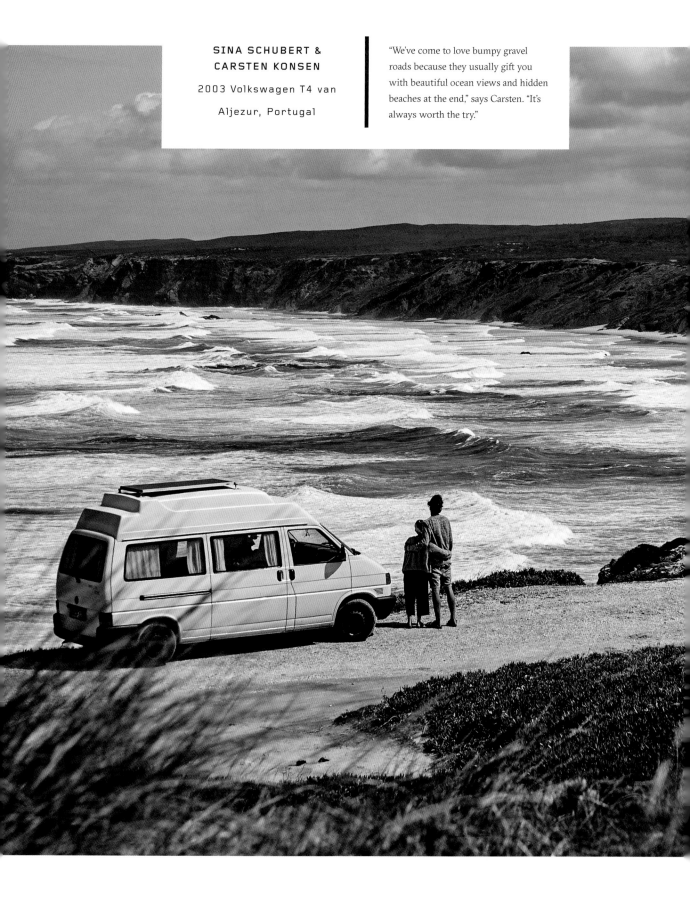

**SINA SCHUBERT &
CARSTEN KONSEN**

2003 Volkswagen T4 van

Aljezur, Portugal

"We've come to love bumpy gravel roads because they usually gift you with beautiful ocean views and hidden beaches at the end," says Carsten. "It's always worth the try."

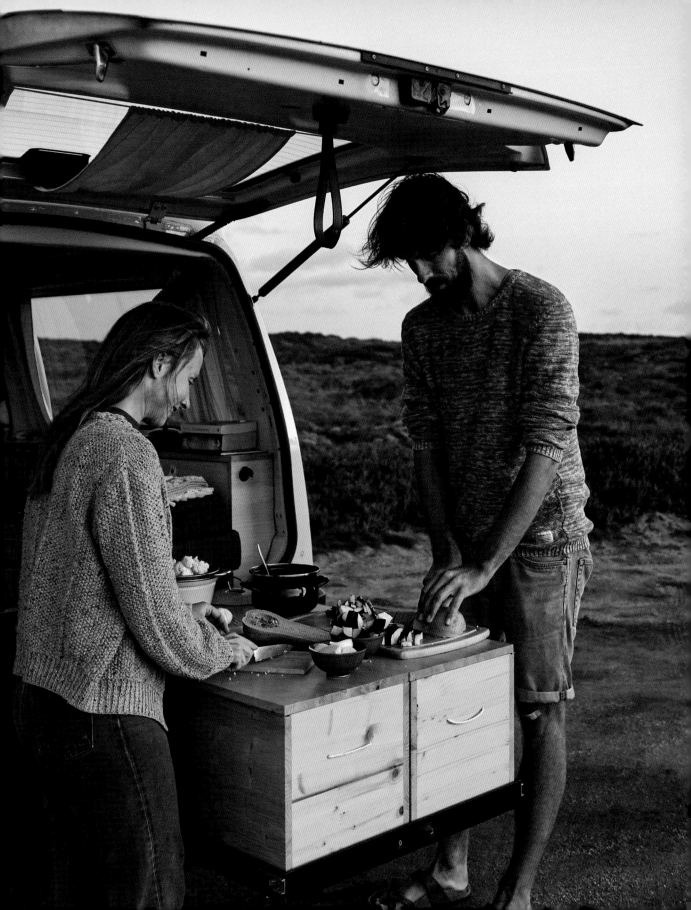

WAKE-UP CALL

Sina and Carsten tend to rise with the sun. "We only have thin curtains, so the sun comes right through them. It's super nice, but it also forces you to get up," says Sina. The bed is just a bit smaller than a queen-size mattress. Sina doesn't consider herself a hard-core surfer but thought having her board along would force her to get out into the waves more often.

EXTENDABLE SPACE

A pair of boxes with simple rope handles can be pulled out of the back of the van on a sturdy drawer slide. This smart solution not only turns the dead space under their bed into extra storage, it also gives the couple a large work surface for prepping meals or drying dishes. The open van door even provides a canopy of sorts, offering some protection from the elements.

"I didn't sleep very well last night," says Sina, a petite blonde with an elfin face, as she stashes all the cutting boards and dirty utensils in a marine yellow waterproof bag, to be washed in the morning when they have more daylight. "We were going to stay in our spot down in the Algarve a little bit longer, but then we realized that we were out of water, so we had to pack up. I hate having to pack everything up just to get water—it's the worst. But that's van life."

Sina and Carsten, both twenty-nine years old, met before they were even teenagers. The two lived in the same small neighborhood in Germany, and their first encounter was in the back of a car, when Sina's father agreed to take some of the local kids down to the soccer stadium to watch a match. Sina only had eyes for her football heroes that day, but all that changed when she turned sixteen, and she and Carsten started dating. Despite a significant break when both pursued other relationships, they eventually found themselves back together.

Carsten, at the urging of his father, started working in a bank directly out of high school before pursuing a business administration degree. In his senior year, he was required to do a six-month internship to complete his thesis, and he chose to work at Bitburger, one of Germany's biggest beer breweries. "It felt like a really good fit. It was a company I was interested in, and I could really see myself working for them," says Carsten. "I had great colleagues who let me work on big projects, and everyone treated me with respect—I wasn't fetching

coffee. But after three months, I wasn't that motivated. I stayed for fifteen months, but in the end it was . . ." Carsten sighs and gives the thumbs-down sign. Sina, though initially interested in business administration as well, ultimately graduated with a master's in interior design in early 2017, after completing an internship at Ghislaine Viñas's studio in New York City.

With their studies completed and the prospect of a lifetime of work looming, the couple put on the brakes and took stock of their situation. "We didn't really have an exact plan besides the feeling that we couldn't imagine working from nine to five with only short weekends in between," says Sina. They had talked in the past about moving into a van and traveling throughout Europe, and they figured that now was the time to do it. Without wasting another minute, the pair purchased a slightly used 2003 VW Transporter van with 196,000 km on it from the German government (it had previously been used to carry prisoners).

Before any design work could begin, they needed to remove all evidence of the van's former life. The jail bars were removed, and all the tiny holes they left behind were filled in and sanded. As Carsten worked on fitting the van with a new pop top complete with solar panels and on insulating and painting the interior, Sina built a virtual 3-D model of the van and began designing individual modules with multiple functions that could be jigsawed together into the tight space. You would think having an

interior designer on board would help with the process, but in the beginning, it only hampered it. "Her studies made her a perfectionist," teases Carsten. "The simple act of drilling in a screw would take half an hour: 'Is this the best spot?' 'Could we build it another way?' 'Are you doing it right?' So that had to stop."

Sina laughs and nods. "It's true. We had to find a balance of how to work on this project together."

Using a superlight, inexpensive solid-wood material called paulownia, they constructed the various modules that Sina designed. Each one either flips open, folds down, pulls apart, or slides forward to create all the components the couple needs: an L-shaped sectional, a 55-by-75-inch bed, and lots of useful storage space. A compact row of minimalist cabinets runs across the front of the van to form a streamlined kitchen, complete with a compact refrigerator, a small sink, and a two-burner propane stove with storage underneath for the tanks.

The cold, hard walls of the van are softened with natural linen curtains, whitewashed wood, an eco-friendly laminate floor in a white oak finish, and indigo-blue cushions topped with plush sheepskins. An open shelving unit protected by a zigzagged bungee cord system is both a delight to look at and a smart solution for keeping things in place (see page 276).

Seven months after they started the conversion of the van (four months later than they anticipated), Carsten and Sina were ready to hit the road. Like most European van-dwellers,

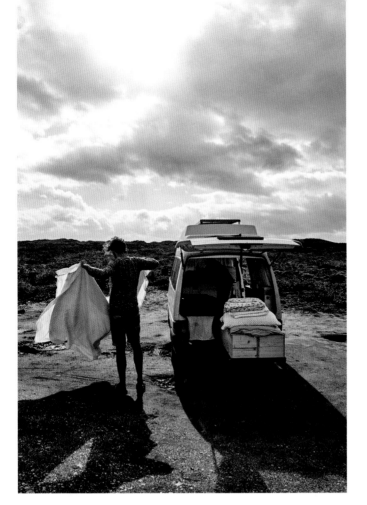

❮ DAILY CHORES

Carsten folds up the sheets from the night before while Sina converts the interior back into their everyday living space. The couple has a rule that you have to finish a task completely before you start something new, to keep the van from getting too messy.

❯ SPICK-AND-SPAN

The streamlined kitchen occupies the space directly behind the driver's cab; the two areas are separated by pocket curtains. Whitewashed paulownia wood cabinets with canvas pull tabs, designed by Sina, are topped with a butcher-block countertop. An extra piece of wood flips upward to protect the linen curtains from catching on fire when the propane stove is in use. Everyday cleaning essentials and even a roll of toilet paper are suspended on a white dowel above the sink, freeing up precious counter space.

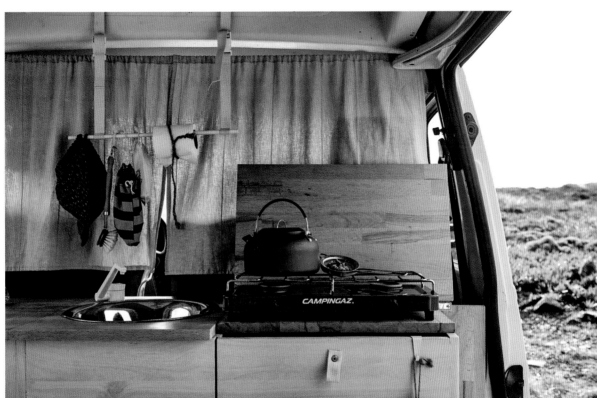

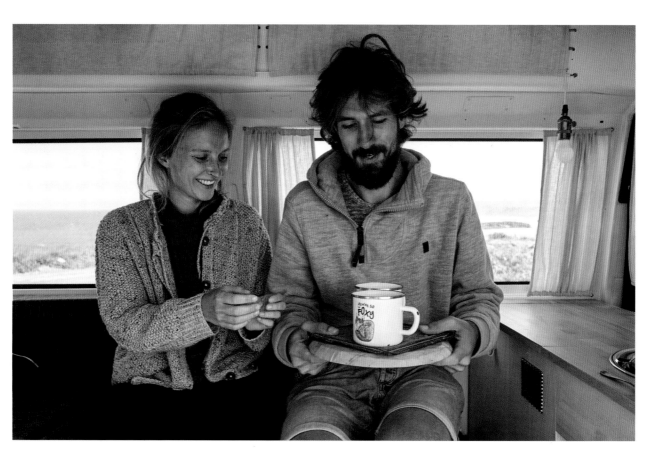

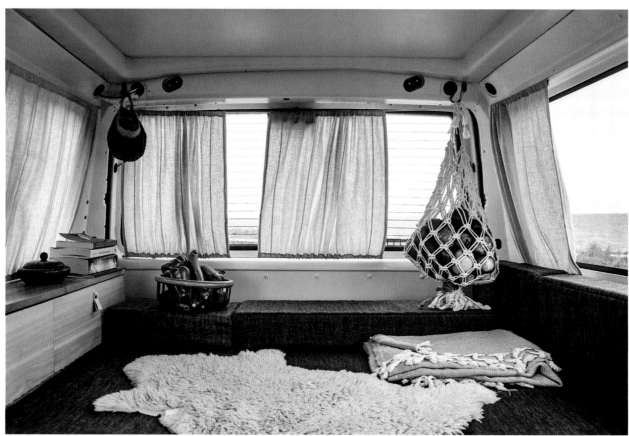

they headed south to the warmth of Spain and Portugal, taking advantage of the countries' more accessible overnight wild camping spots and locations. "Being in Europe is pretty cool because you can drive twelve hours and be in a totally different culture—Italy, Poland, Spain . . . ," says Carsten.

"Wild camping, which is basically parking for the night in an unauthorized spot, is tolerated to different degrees throughout Europe. In some places, if you roll out a rug or put down levelers, you could be at risk of having a policeman come by and ask you to move on," he continues. "But if you're not breaking any of the rules and only 'parking,' then most of the time you're okay." He and Sina agree that reading up in advance on the particular country's rules is the best way to stay out of trouble, especially during the busier summer season.

The couple is currently pouring all their design knowledge into an e-book that they plan to sell through their website, WanderHorizons .com, which currently documents their travels and some of their tips and tricks for living in a van. "We want to put all the information in one place to make it easy," says Carsten. "It took us six weeks of research all over the internet before we could even start the conversion of our van." They're banking on the sales of this book to keep them on the road indefinitely. Neither of them is too keen on going back to a conventional job.

As the windows of the van fog up with the condensation of the simmering curry, Sina confesses, "I talked to my mom the other day on the phone and told her we were concerned about our money running out. She is very supportive of us. She thinks we should do this and just go for as long as we can."

"My mother, on the other hand," says Carsten, laughing, "likes to remind us that we need to save for our retirement."

"Right now we have money for the next four or five months. But we would like to keep on going," says Sina. "I can't imagine going back to a job."

"Me neither," says Carsten. As they add their dirty dishes to the waterproof bag and get ready to make their bed for the night, they decide that tomorrow will be a workday; they are determined to get their e-book finished so they can stay on the road as long as possible.

⌐ IN GOOD ORDER

Sina adopted the same simple technique she used for the window treatments to cover up these overhead storage bins—a pocket curtain panel made of linen. The fabric keeps the clutter of van life hidden away and goes a long way toward making the space feel neat and organized. A simple bare bulb with a beautiful brass socket lights up the space in the corner. The countertop beneath the bulb flips open to reveal the couple's refrigerator, hence the vent panel in the cabinet front.

❮ ONE SPACE, MULTIPLE USES

The modular van design, conceived by Sina, allows the couple to lounge, eat, and sleep in the same small space with just a few easy adjustments. The seat cushions are Tetrised together at the end of the day to make a generous-size mattress. Sina crocheted the hanging fruit basket and is thinking of selling similar ones on the couple's website. "I'd like to make things that are handy for people in vans," she says.

Road
Therapy

"It's a little game we like to play—pick out the serial killer in town," jests Kieran Morrissey, a laid-back Australian with a shock of dirty-blond hair and a bit of Elvis Presley swagger.

"We spend so much time by ourselves listening to these murder mystery podcasts that by the time we pull into these tiny towns, we're suspicious of everybody," jokes Pauline, his travel companion and wife of five years.

Dangling from the plastic dashboard of their desert-pink, wicker-filled 1994 motor home, temporarily parked in a leafy national park just outside of Austin, Texas, are two sets of noise-canceling headphones and two USB jacks. When you've been on the road for almost six months in a space no bigger than a college dorm room, escaping into another world, even a horrific one, is a way to make the long drives easier.

"The RV makes a lot of noise, especially with all the things we put in it, so we tend to have our headphones on all the time. Podcasts have been a godsend," says Kieran.

This is the second time he and Pauline have packed up their lives and hit the road to travel across America in a secondhand RV. Five years ago, the couple capped off a twelve-month adventure in England with a ninety-day trip zigzagging across the States as a final cheerio to their fun-loving college days before they settled into their working lives in Sydney, Australia. They bought a used RV and

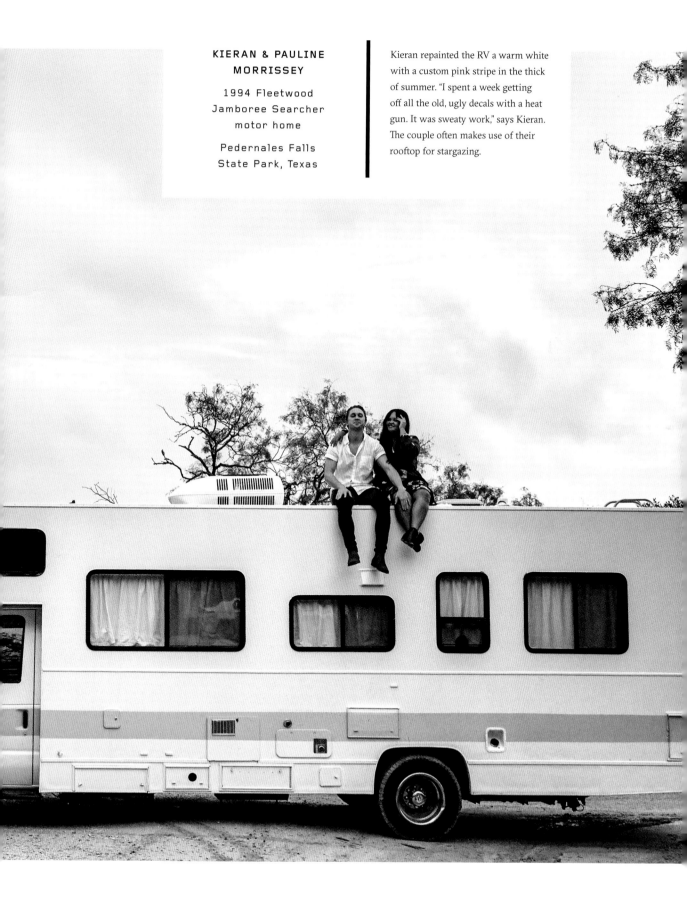

**KIERAN & PAULINE
MORRISSEY**

1994 Fleetwood
Jamboree Searcher
motor home

Pedernales Falls
State Park, Texas

Kieran repainted the RV a warm white with a custom pink stripe in the thick of summer. "I spent a week getting off all the old, ugly decals with a heat gun. It was sweaty work," says Kieran. The couple often makes use of their rooftop for stargazing.

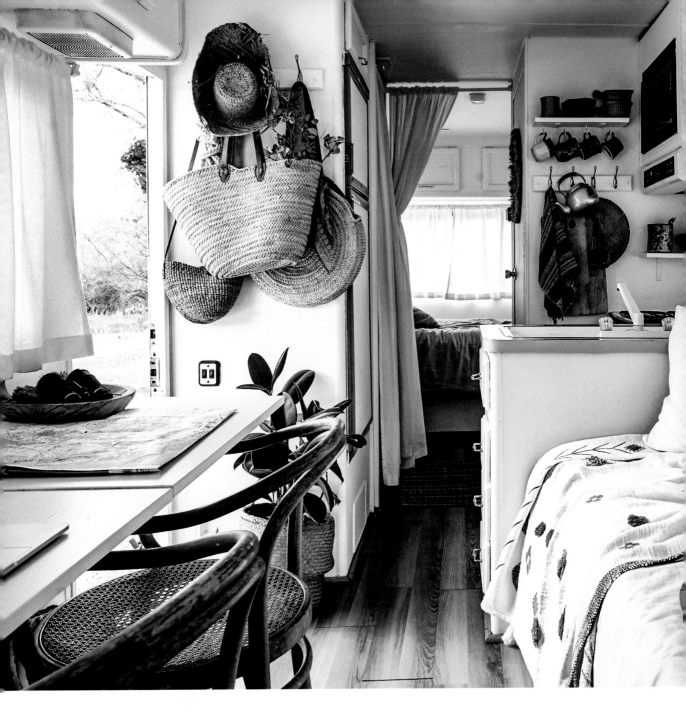

∧ PAINT IT WHITE

The old adage that there isn't anything a coat of white paint can't fix is certainly true in this renovated RV, which almost glows from within. The light linen curtains, while beautiful, have their drawbacks. "We've had to sleep in Walmart parking lots on a few occasions, and it's so brightly lit, it's like daylight," says Kieran. "We don't have blackout curtains, so it's hard to make this place sleepable sometimes."

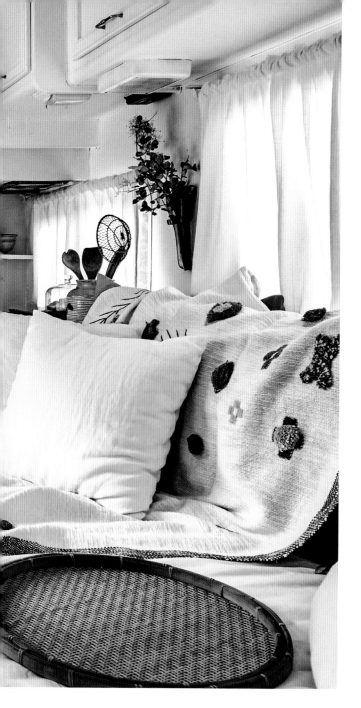

some paper maps (these were the days before talking smartphone assistants) and meandered from place to place, crossing popular tourist destinations and major cities off their must-see list. At the end of the three months, they sold the RV and headed back down under.

After the trip, Pauline and Kieran started their careers: Kieran as a contract manager for Sydney's major water authority, Sydney Water, and Pauline as a writer and social media producer for Domain, an addictive online real estate site similar to Zillow. "The housing market is crazy in Australia," says Pauline. "Real estate news is basically an economy unto itself. I was working about sixty hours a week because there was this voracious appetite for anything about the market."

A self-described workaholic, Pauline tried to keep pace with her burgeoning career, but as her job got bigger and bigger and the demands more intense, her internal life started spinning out of control. Panic would descend upon her each morning as she contemplated the day's to-do list. She started eating less and found herself awake at night more often. Running into traffic jams on the way out of Sydney to visit her family would bring on intense anxiety to the point where she had to stop going. Soon, she was afraid to leave the house—and when she did, she mapped out the route to the nearest hospital in case a panic attack came on. "I found that the better my career was getting, the more mentally ill I was becoming," says Pauline.

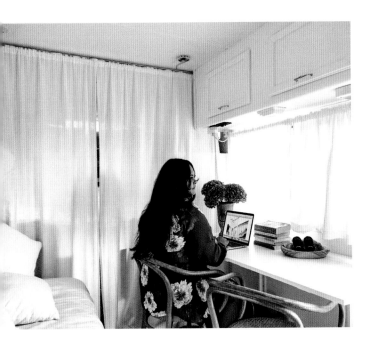

Eventually, day-to-day life became impossible, and she was diagnosed with anxiety and panic disorder. "When I was twenty-one, I lost my dad very abruptly to cancer," says Pauline. "I took on the responsibility of my mom and sister, and I pushed my grief down. I never dealt with it. Then when my work took off and the stress got to be too much, I think it triggered some underlying anxiety." She and Kieran agreed that something had to shift. "I remember Kieran asking me if a drastic change would help," says Pauline. "He asked me to recall a time in my life when I felt most safe and free. My answer—traveling in our RV back in 2012."

It seemed like a good solution, but Pauline had some reservations. Having a space of her own where she could go and decompress, away from everyone, including her own husband, had become integral to her survival. Furthermore,

⌐ DON'T BE A STRANGER

Pauline, who describes herself as an introvert, says traveling has made her much more outgoing. "After a few weeks of being on the road, seeing nobody and being inside your head all the time, I'll say hi to anybody. It's a relief to just be in the now."

∧ CREATIVE THINKING

Pauline found this gun holster in a market near Redwood, California. She thought it would make the perfect vase for dried flowers.

she needed it to feel comfortable—a cocoon she could escape to. She shared these thoughts with Kieran, and they decided that if they found an RV with a separate back bedroom—something their former vehicle lacked—and they allowed for a few weeks to renovate, they could create a home away from home for Pauline.

Before they even left Sydney, Pauline made some Pinterest boards with inspiration for their RV and a list of destinations she wanted to visit. Next, she and Kieran loosely mapped out a route, knowing that they wanted to start their road trip in California, as it's one of only a handful of states where a foreigner can buy and register a vehicle without a permanent address or social security number. Finally, they knew from their previous experience that they would have to find a place to renovate their rig before they left. Since many RV parks enforce what is known as the "ten-year rule" (code for the prohibition of weathered, worn, or cruddy-looking vehicles more than a decade old on the property), finding a site isn't always easy. After numerous phone calls, they found a place in Palm Springs.

With everything lined up, they waited out the end of their lease, sold off most of their possessions, and flew out to Los Angeles, where they found a 26-foot, twenty-three-year-old RV on Craigslist for five thousand dollars. They parked for two weeks, during which time they got to work making over the interior: stripping out the dirty navy-blue carpet, altering the dinette, and taking down the dated curtain valances.

"We wanted it to have a beachy, coastal feeling," says Pauline. To that end, they installed wide-plank red oak–looking vinyl floors, slapped on coats of white paint, and decorated with loads of natural textiles like straw baskets and hats, woven throw rugs, and even a stunning pair of Thonet bentwood chairs with cane seats that they found at a secondhand store. To give themselves a comfortable spot to hang out in, they layered white linen pillows and a boho knitted throw over a simple double mattress that they placed where the dinette had been. In the kitchen, open shelving and hooks replaced bulky overhead cabinets and were soon filled with flea-market finds like ceramic mugs, wood cutting boards, and a brass teapot. The finishing touch was a couple of tropical plants and some dried flower arrangements.

After a long day on the road, Pauline will often head back to the bedroom, pull the drape across the door, and have some quiet time. She and Kieran have discovered that there are actually many "rooms" throughout the RV, with enough space for each of them. "There's the bedroom, the sofa, the kitchen, the office," says Kieran. "A few weeks into our trip, Pauline noticed a lever under the arm of the captain's chairs up front and went flying backward," says Kieran.

"It was a game changer! I was like, 'Another room!'" laughs Pauline.

Most mornings, they head up to the driver's cab, sit in the captain's chairs, and enjoy their first cup of coffee. "Usually, when we pull into a spot at night, without even noticing it, we've

positioned ourselves to get the best view out the front windshield," says Kieran.

Sitting on the daybed surrounded by plump pillows, drinking a Diet Coke while a warm rain finds its way in through the open window, Pauline looks relaxed and happy. Before she left, she negotiated a twelve-hour-a-week contract with her employer. That very morning, she had received an email from her boss letting her know that they had recently brought on someone to help out with the role, but they were hoping Pauline could pick up a few more hours because she was faster and more efficient than the new hire. "I said no. But I never would have said that five months ago. Being away has really been life-changing for me," says Pauline. "It's allowed me to strip everything back—to be in the moment. It's like pushing a pause button."

After ten months of living on the road, Pauline and Kieran know they will probably return to Australia soon. There are days when they don't want their adventure to end. They take inspiration from people they have met along the way—often people with children and pets—who are making it work, and wonder if they could do the same.

"What if this calls us back because we miss it so incredibly? The thing I comfort myself with is this: whatever we decide to do, it will be my choice. It had stopped feeling like my choice for a long time. This trip has made me aware that I'm making my own decisions every day. It feels good to take the wheel," says Pauline, laughing at her own pun.

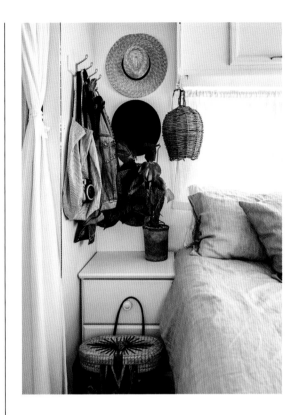

⌃ PICKED UP ALONG THE WAY

The bedroom at the rear of the RV is a good example of Pauline's laid-back, beachy aesthetic. She has a knack for finding good wicker pieces, as evidenced by this hanging light and basket she picked up on her travels. A lineup of hats and some pretty but useful everyday items like a pin-striped tote and her camera are the only decoration the room needs.

❯ OFFICE ON THE GO

When the dinette table was removed to create a comfortable lounge spot, Pauline and Kieran installed these two drop-leaf tables from Ikea so they would have somewhere to eat and work from their laptops. "We've got a Wi-Fi hotspot device, and that's been good pretty much all over the States," says Pauline. "I'll do my work right here while Kieran's motoring along." The woven rug helps the two wicker chairs stay in place even when the RV is in motion.

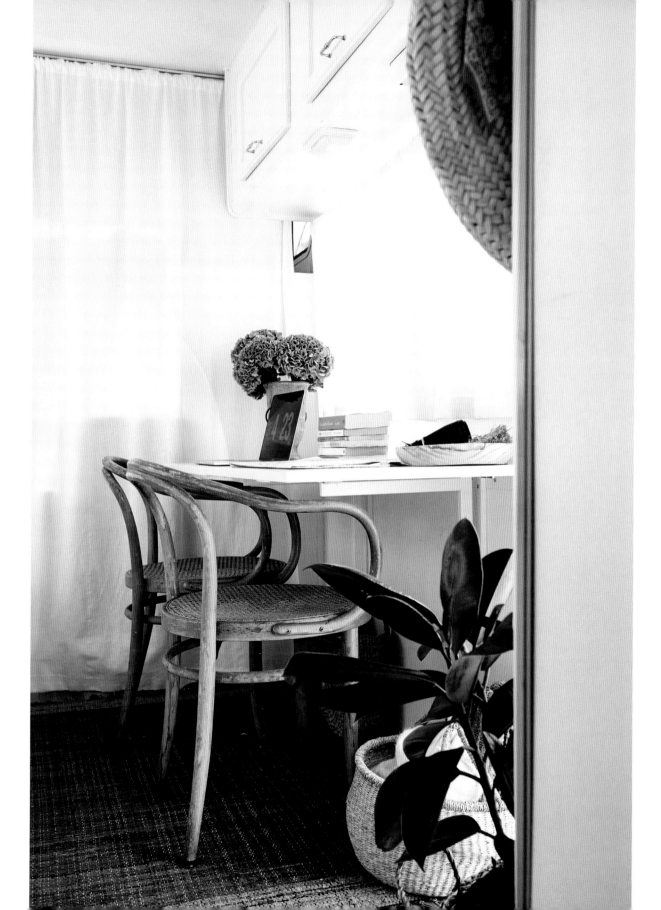

Liveaboard Life

With the sultry acoustic rhythms of Buena Vista Social Club filling the air and just enough of a breeze to keep the sailboat moving swiftly toward the Golden Gate Bridge, Audrey Ruhland emerges from the helm carrying a cheeseboard, while her husband, Garrett, deftly maneuvers their 1979 Rafiki sailboat through Richardson Bay near Sausalito, California.

"We can't tell you the new name of the boat," apologizes Audrey. "Not until we have the naming ceremony."

"It's sailboat lore," adds Garrett, unconsciously touching the anchor pendant he wears around his neck. "To change the name, you have to remove any traces of the original one, then you have to write that name on a piece of paper and cast it into the ocean, and finally, once it's changed, you can never say it again. To christen the boat, there's a ceremony that basically involves pouring and drinking a whole bunch of booze. With the first boat I bought in college, we didn't do the ceremony, and it was a lemon. So now I'm like, whatever I have to do. I will pour all the booze," he says emphatically.

Garrett's initial boat, purchased for three thousand dollars when he was a student at Michigan State University, was sort of like a starter marriage; it prepared him for the future but ultimately proved to be 95 percent work and only 5 percent fun. When his first job after college took

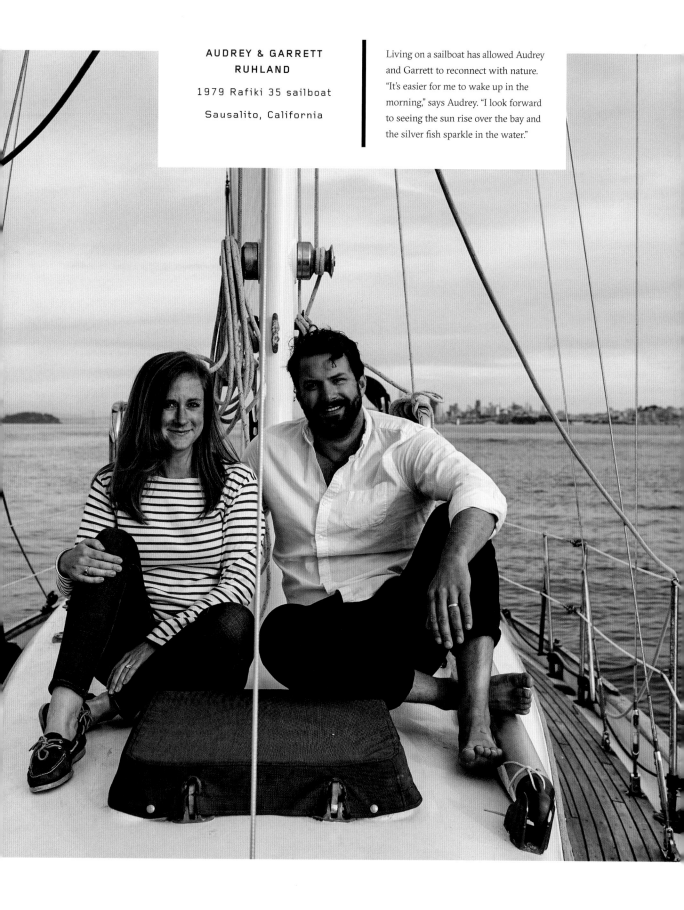

AUDREY & GARRETT RUHLAND

1979 Rafiki 35 sailboat

Sausalito, California

Living on a sailboat has allowed Audrey and Garrett to reconnect with nature. "It's easier for me to wake up in the morning," says Audrey. "I look forward to seeing the sun rise over the bay and the silver fish sparkle in the water."

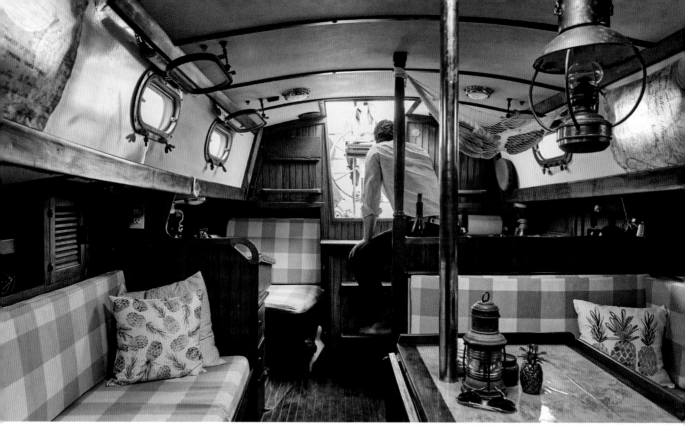

him and Audrey (his college sweetheart) to landlocked Arizona, he sold the boat and gave up his sailing dreams temporarily. But two years later, another job promotion uprooted them to San Francisco, and Garrett found himself drawn to the water once again.

"We didn't know anybody in the city, so I'd find myself every Saturday morning getting on the Golden Gate ferry heading to Sausalito. For ten dollars, I could have my very own little cruise. I'd grab a cup of coffee and ferry back again," says Garrett. At the same time, they started asking new acquaintances in the city if they knew of any sailors hoping to log a few hours out in the harbor. One person led to another, and soon Garrett was spending his weekends on friends' boats, putting his

⌃ A MATTER OF TIME

"On a boat, anything that you think is going to take one hour to fix is going to take four," says Garrett. He found a tiny leak on the boat before they moved on board, which resulted in the entire ceiling having to be removed. Keeping the windows open and burning scented candles helps keep the boat smelling fresh.

⟨ CLOSE RANKS

There's a whole classification system for people who live on boats. "There are the liveaboards, who have approval from the marina—that's us," says Garrett. "Then there are sneakaboards, people who don't have liveaboard status but live on their boats anyway. Then there are anchor-outs, who drop anchor out in the bay but never move. You can usually spot them by the plants they have on board, which they would never have if they were sailing full-time. They aren't paying anyone and have a bad reputation. Finally, there are the cruisers, who go from port to port."

considerable strength to work and picking up valuable skills along the way. "There are so many people, especially older people, who have beautiful boats and sailing knowledge but maybe not the strength to do this, so I was getting on amazing boats and racing and sailing a lot," he says.

It's no surprise that Garrett's coworkers in the tech industry tease him about being a bit of a pirate. His preppy white button-down shirt can't hide the anchor tattoo on the inside of his left arm. Then there are the Top-Siders and beaded bracelets, and the aforementioned anchor necklace. He says his fascination with boats stems from a childhood spent on Lake Huron in Bay City, Michigan, but his passion seems to come from somewhere much deeper. Down in the galley, books on boats and nothing else line the shelves. "I've read books about living on a boat, buying a boat, how to sail a boat, how to live aboard a boat, how to find the perfect boat, and on and on," he says. When he wasn't reading about sailboats, he was cruising message boards and magazine classifieds looking for his next vessel.

Then one day at work, he came across an ad on Craigslist for a Grand Banks yacht, a well-known, highly sought after cruiser with a distinctive style, for an unbelievably low price. "It was listed at fifteen thousand dollars, which is like ten percent of what it should be, and I called the broker to tell him he had missed a zero on the website," says Garrett. It turns out the bank was foreclosing on the boat and it was still available for the listed price. "I called

∧ A SHIP'S DETAILS

Audrey found the flat-bottomed coffee cup, perfect for rough seas, when she was cleaning out the boat. "Garrett suggested that since he was the captain, it naturally belonged to him," says Audrey jokingly. "I ended up finding another one for us on Etsy, and then months later, when we moved onto the boat, we found a third."

❯ COOKING WITH GAS

The galley's stove runs on compressed natural gas, which was popular in the 1970s but is more or less out of use these days. "Propane is heavier than air, so it has the potential to leak into your bilge, and if you light a match—*boom*—you blow up. Not ideal," says Garrett. "Compressed natural gas is lighter than air and much safer, but it never took off. Luckily, I found two huge tanks, which should last us a while." Cutout notches ensure that everyday items stay put when the boat is in motion.

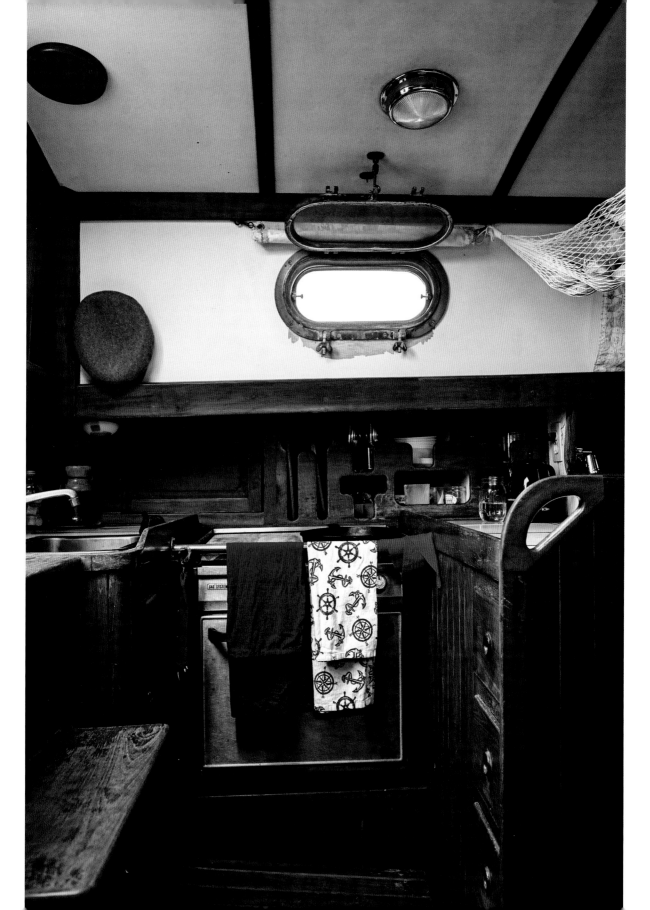

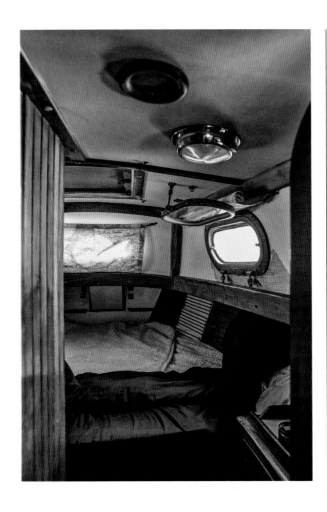

˄ TUCKED INTO THE BOW

Garrett and Audrey's bedroom occupies the pie-shaped quarters at the front of the boat. Audrey was adamant about making the room as comfortable as possible, so they invested in a new cushion mattress and covered the bed in soft fleece blankets.

˥ HELLO, NEIGHBOR

Harbor seals sun themselves on wood pilings just outside of the Sausalito marina.

Audrey immediately and told her we could buy this boat and sell it for double tomorrow, plus it was bigger than our apartment." It dawned on him in that moment that he could be living out his dream of sailing full-time while saving money as well. "I said, 'Let's do this. Let's move onto a boat,'" he recalls.

San Francisco has always been an expensive city to live in, but when the tech industries of the early aughts moved in, the cost of living jumped to astronomical levels. Even with steady, well-paying jobs in tech, Audrey and Garrett could afford only a 380-square-foot studio apartment with no patio and a loft-style bed that Garrett built himself. Frustrated with their inability to save money, they decided that moving onto a boat didn't seem that crazy. "I agreed to Garrett's idea, but I told him that if we made the leap, I wanted to work toward sailing full-time one day and not just anchoring in one spot," says Audrey. Garrett was on board. They settled on a plan to continue to live and work in San Francisco for two years to prepare themselves financially, with the goal of eventually setting sail for Mexico, down the Panama Canal, up to the Caribbean, and beyond. Unlike road travel, the sailing season is very dependent on the weather. "October is the best time to leave," says Garrett, since hurricane season starts in June in the tropics. Because of their ambitious travel plans, the motor-powered, gas-guzzling Grand Banks was out of contention, but it opened the doors to finding the perfect sailboat for their new adventure.

With Garrett's extensive knowledge and previous sailing experience, it didn't take them long to find a boat. "I think we looked at about twenty boats before we bought this one," he says. They both knew they wanted a vessel that they wouldn't have to do a ton of work on, so when they came across a 1979 Rafiki 35 sailboat that had been lovingly maintained by a couple who took it out mainly on weekend cruises, they knew they had found their new home.

To bring the boat into the twenty-first century, the couple made a few cosmetic changes to the interior. "It was very dark and masculine," says Garrett, "with chocolate-brown pleather seat cushions, '70s-era green curtains, and a dinette table with a black leather insert." Playing up the sailing theme, Garrett started by sewing new light-aqua-blue-and-white buffalo-check covers for the cushions around the banquette and updating the dinette table with an inset vintage mariner's map covered in a layer of epoxy. Then, to bring light into the wood-lined hull, he swapped out all the sun-blocking curtains for lightweight printed cotton ones with images of maps.

There was no navigation system on board when Audrey and Garrett bought the boat. Now they have an iPad, which is all they need. "People spend tens of thousands of dollars on high-tech stuff, and my computer is way smarter. I use three different apps: Navionics, iNavX, PredictWind. I tell them I want to go to San Diego, and they come back with three different time frames, how fast I'll get there, what

sort of ride it will be, what route I should take. It's like Google Maps for sailing," says Garrett.

While he and Audrey were renovating, they put their names on a list at the marina to receive liveaboard status. Without the go-ahead from the harbormaster, they were stuck in their money-draining apartment. "In Sausalito, they limit the amount of liveaboards," says Garrett. "Only ten percent of each marina can be occupied by people who live on their boats because otherwise it would be overrun."

"We pursued it aggressively, calling and emailing when we were a hundred percent certain the boat was ready to move onto," says Audrey. "Finally, I went straight to the harbormaster. Once I got through to her, after a few follow-ups, she responded that a boat was being sold and a slip was opening up. I think the process took us about a year and a half in total from when we first bought the boat."

With their liveaboard status secured, they gave thirty days' notice on their apartment and made the transition from land to sea. "That period was hard for me, being between two places," confesses Audrey. "I was excited to be on the boat for this new chapter but also sad about leaving the city where we had been for four and a half years. Once that period was over, though, I was fine. I think we were really prepared for boat living, having stayed in such a small space in San Francisco."

Since moving on board their sailboat, Garrett and Audrey have cut their living costs almost in half. They pay twelve hundred dollars a month in slip fees, as well as a small rental charge on a nearby storage unit. With nowhere on board to hang the business casual clothes their senior-level jobs require, they use the storage unit like a walk-in closet, visiting it a couple of times a week to exchange outfits. When they are docked, they use the marina's shower facilities, packing a toiletry bag each morning. "I liken it to camping," says Audrey. "When we leave the boat for the day to head into the city for work, we bring our shower caddies, towels, clothes, wallets, and anything else we might need. I guess when you leave any type of home, you have a checklist of belongings that you have to bring with you, but our checklist has definitely grown since we moved on board."

For now, their kitchen has only an icebox, so the way they buy and make food has changed. Perishable items need to be purchased on a daily basis—but luckily for them, there is a grocery store located just outside the marina. "I still make a smoothie every morning for breakfast," says Audrey. "But I need to be sure I get through the almond milk in a few days." For all these inconveniences, the pair is still happy they made the change. "I was starting to feel really disconnected living in the city," says Audrey. "There's an app for everything. If you run out of cheese, there are like five different apps just for cheese delivery!"

"We've definitely become more hippie—more conscious of our carbon footprint," says Garrett.

With the boat back in its slip for the night and the Buena Vista Social Club still playing on repeat, Garrett asks Audrey if she remembered to sign them up for the Baja Ha-Ha, a sailing rally in the early fall that goes from San Diego to Cabo San Lucas. "All our friends are trying to get Coachella tickets, but for us it's the Baja Ha-Ha," laughs Garrett, clearly pleased with the new life on the water he has created for himself.

❯ ANCHORS AWEIGH

Garrett compares racing sailboats to running. "It's not hard—anyone can do it—but to be good at it, you have to do it a lot."

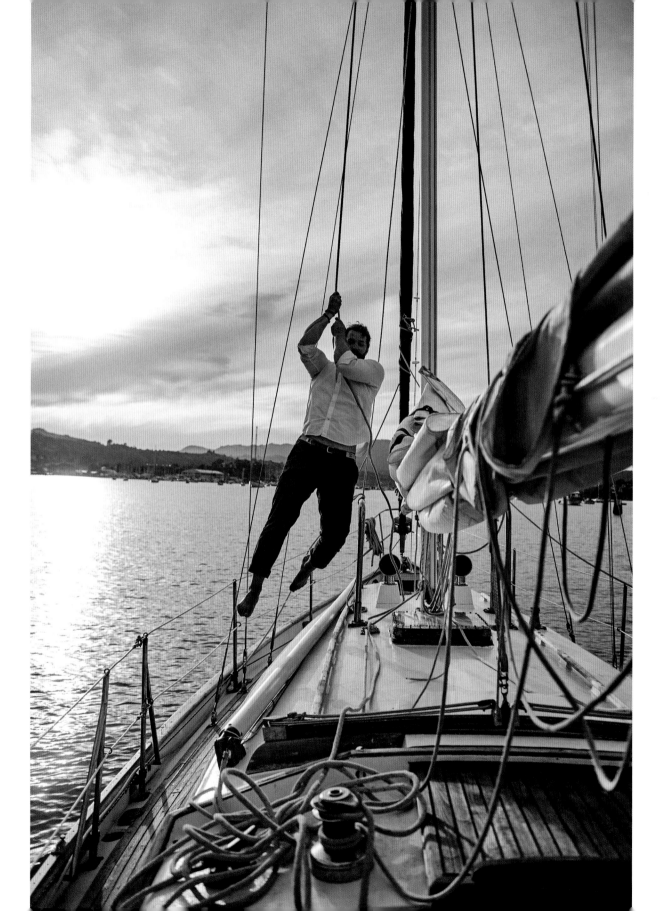

Woodland Retreat

Dressed in a quilted army-green Patagonia jacket and a hat from Cabela's, Brett Colvin pulls open the door of his 2002 Airstream and steps inside. Taking off his transition glasses while they adjust to the light, he looks around his rustic wood-paneled home layered with Navajo-style rugs, Pendleton blankets, and worn leather furniture and smirks.

"I thought I could probably do something with an Airstream that no one has ever done before—that's just the way I am," says Brett. "I like to look at what's out there and then put my own stamp on it. Sometimes I might go a little overboard."

Sitting down at his canvas-covered desk, which occupies the entire front curve of the trailer and looks out onto a view of Flathead Lake, Brett pulls out a pile of notebooks filled with his sketches. Inside are simple, well-executed drawings of flags inscribed with everything from brand names like Thompson Dry Goods to sayings such as "Life Is Better in the Mountains" and "Be Here Now." At the top corner of each page is the name of the customer who commissioned the flag and the date it was ordered. Folded neatly to his right are stacks of cotton canvas cloth, piles of metal rivets, squeeze bottles of paint, and dozens of lead pencils. These are the supplies that Brett uses to make the limited-edition and custom flags he sells on his website, PointerAndPine.co. Most days his only companion is his dog, Monte, but he likes it

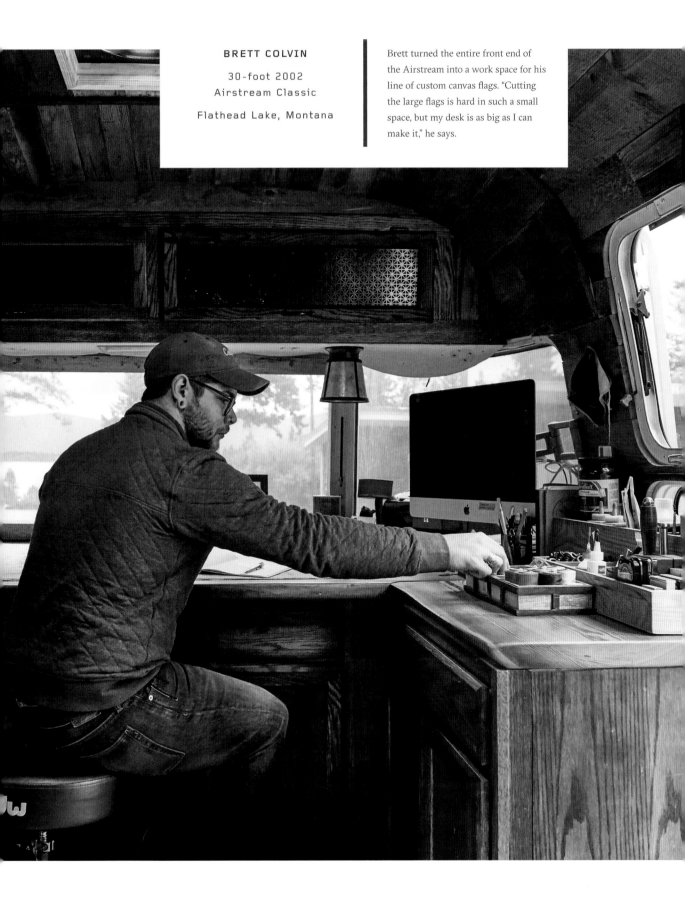

BRETT COLVIN

30-foot 2002
Airstream Classic

Flathead Lake, Montana

Brett turned the entire front end of
the Airstream into a work space for his
line of custom canvas flags. "Cutting
the large flags is hard in such a small
space, but my desk is as big as I can
make it," he says.

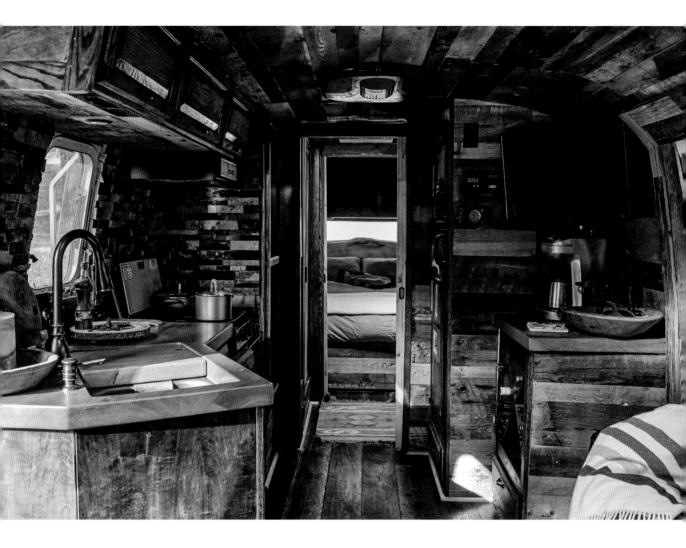

⌃ WRAPPED IN WOOD

The cozy Airstream has all the conveniences of a regular home, including two TVs (the second one is in the master bedroom), a full-size fridge, a coffeemaker, and surround-sound speakers wired in. Brett plans to remove the under-counter wine rack, which rarely gets used, and replace it with a half-size dishwasher he has found. "I'll probably hide it and make it look like a cabinet," he says.

^ FRAME UP THE FRIDGE

Brett replaced the inlays on his fridge and freezer doors
to match the cabinetry in the Airstream. Since they don't
hold magnets, Brett made his own frames to show off his
collection of vintage postcards of Glacier National Park that
he found in Whitefish, Montana. The red Swiss cross flag is
a miniature version of the canvas flags he makes.

Monte, but he likes it that way. "I have a routine,"
says Brett. "I've tried relationships, but right now
I need to focus on my company while it grows."

Brett didn't always prefer a solitary exis-
tence. At sixteen years old, he was the drummer
in a band called Porcelain Smile that found an
audience among fans of alternative rock. Cross-
country tours and out-of-state shows soon
replaced algebra classes and science labs, a trade-
off Brett was only too happy to make. For a kid
who always struggled at school, it was a way
out of a system in which he saw no future. His
parents thought otherwise, but an unlikely
advocate, his high school principal, came to his
defense and convinced Brett's parents that he'd
never have an opportunity like this again. He
did three circuits across the United States, even
making an appearance at the Vans Warped Tour,
and lived the kind of rock-and-roll life most
kids can only dream of. Then, like most young
bands, the group split up, and Brett moved
home to Virginia.

His time there wasn't easy. His mother,
who was living on her own, required constant
support—medical, financial, and emotional—
and it started to take its toll on Brett, who was
ill-equipped to attend to her needs. A long-
term romantic relationship fizzled. Then he had
a stroke, brought on by all the stress. "It took
me out for a year. I couldn't talk, walk, or even
really think for three months," says Brett.

During his recovery, Brett made plans to
leave Virginia and head west to the waterfront
lake house in Montana that his grandparents

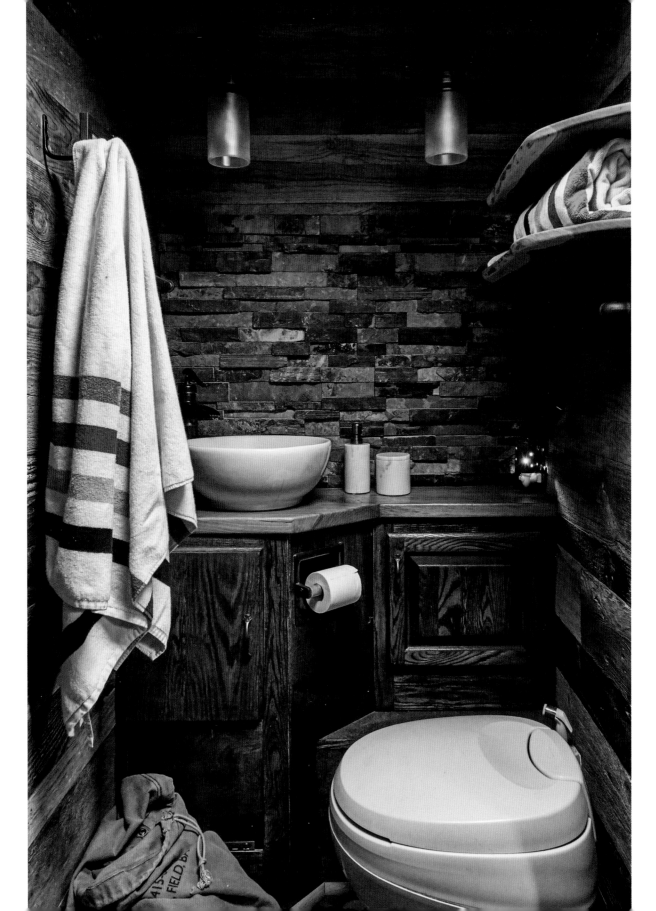

⌃ OLD-SCHOOL SKETCHING

"I don't know how to do anything designwise on the computer," says Brett. "I have a bunch of notebooks with all the preliminary sketches and the person's name and the date. Then I hand draw everything onto the canvas flags." Each flag has to be cut and sewn to size, embellished with grommets and a label, hand-painted with a design, washed and dried, dip-dyed in coffee, and then dried again. After that, Brett sends the flags out all over the world.

⌐ DEDICATED DESK SPACE

A self-described neat freak, Brett created individual wood bins for all his flag supplies—grommets, glue, pencils, thread, labels, and paint. "Living in a small space, you have to be very organized. Plus, I like walking in here and knowing where everything is," he says.

❬ RUSTIC RESTROOM

Brett's mountain cabin aesthetic continues into the bathroom, where dark wood cabinets and a stone backsplash snug up to reclaimed wood walls. The original layout had wall cabinets above the sink; Brett removed them to create more headroom. He's thinking of switching out the white sink for one in hammered copper. The lighting is from Lowe's.

owned and where he had spent every summer vacation as a kid. After a tumultuous few years, it was a touchstone for him—a place with happy childhood memories; remote, rugged wilderness; and some much-needed peace. As he got back on his feet, he took inspiration from his grandfather, a successful self-starter and entrepreneur, and decided to branch out on his own. He began illustrating custom drum sets for friends and musicians he'd met during his stint on the road. Around the same time, he made a few flags when he couldn't find anything he liked to put up in his own room. However, when a musician friend came calling with a business venture down in Salt Lake City, making products for a start-up leather goods company, Brett jumped at the opportunity to be part of something bigger.

Not sure how long he would be in Salt Lake City, and perhaps wanting to bring some of the familiarity and security of Montana

with him, Brett chose to fully overhaul a 2002 30-foot Airstream trailer, which he purchased for about thirty thousand dollars, instead of rent a place. With the goal of creating a log-cabin vibe, he covered every available surface in strips of solid, reclaimed barn wood—seven pallets' worth from a supplier in Kalispell, Montana. At first, he tried lining the bottom half of the walls with a log cabin siding, but after experimenting with it in the slide-out, he determined that using only reclaimed wood siding throughout would look better.

As a single guy, he knew he didn't need much, but an expansive office space was a necessity. "I wanted where I worked to be inspirational, so I found this company that hauls trees from the bottom of Flathead Lake and makes them into slabs," says Brett. He made a wraparound desktop out of the preserved wood, dedicating the entire front portion of the trailer to a spacious work zone. "No matter what, if I sell this Airstream, the desk comes with me," he says.

His rugged, outdoorsy aesthetic is visible throughout the trailer, from the 72-inch aged-leather Restoration Hardware sofa tucked into the slide-out (a rarity for an Airstream) to the flat-weave rugs in earthy colors that cover his rustic wood floors. In the kitchen, Brett installed a stone backsplash three times. His first attempt was a disaster—the whole thing was too heavy, fell down, and shattered. He next tried a lighter faux-rock surface but after living with it for two weeks decided that he hated it and tore it down. Finally, he went back to the original stone surface, but this time he installed it using a product called HardieBacker, a fiber cement backer board, to keep it in place, which was a success. Rough-hewn-log cutting boards and carved-out wood bowls line the countertop and corral everything from scented candles (one of Brett's favorite things) to dog leashes. Brett did all the work himself, and when he didn't know how to do something, he watched YouTube tutorials and figured it out. "I didn't go to college, but you don't need to these days. Why would I pay fifty thousand dollars when I can learn everything I need to know from a Google search?" The Airstream is also outfitted with solar panels (although Brett is typically hooked up to services where he is parked), satellite TV, and air-conditioning.

If all this sounds pretty luxurious, it is. "This was the heaviest trailer Airstream ever made, and I've only added to the weight of it. It's probably the heaviest Airstream out there," confesses Brett, shaking his head. "I'd never done this before—I didn't know!" At over ten thousand pounds, it takes serious horsepower to haul it around. Luckily for Brett, his dad has a heavy-duty work truck, and he was willing to haul the Airstream for him. After eighteen months in Salt Lake City, Brett returned to Flathead Lake to concentrate on his flag business, which proved to be the most successful of his creative endeavors. There his Airstream has more or less stayed put. "I really don't care for trips," says Brett. "After traveling all over this country, I really like just staying up here."

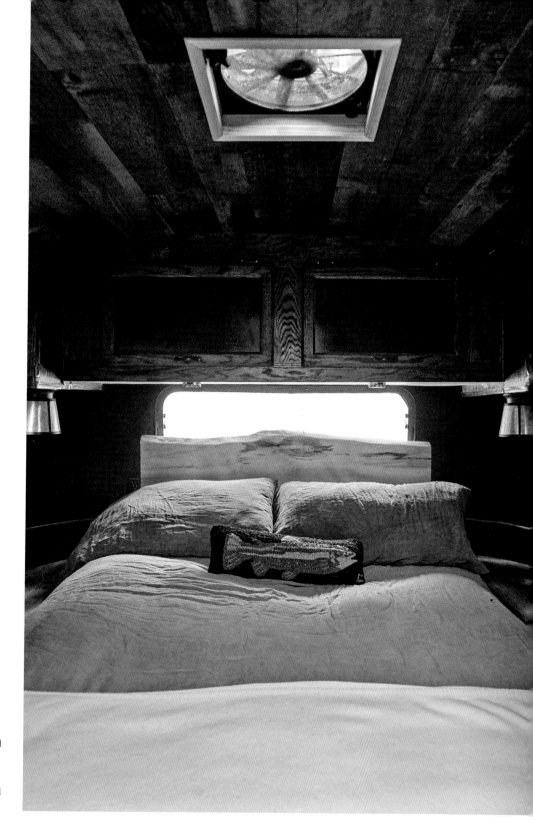

❯ CURVES AHEAD

Airstream designed the bedroom mattress with rounded corners to facilitate circulation in the small space. However, Brett, who likes things to be neat and orderly, hates the fact that regular sheet sets do not pull taut. Brett found a live-edge piece of wood to use as his headboard. The hand-hooked pillow is by Pendleton.

Wherever, Forever

Kyla Trethewey, hand on her hip, is standing over the stove in her recently renovated tugboat kitchen, impatiently waiting for the hot water to trickle down through her chic pour-over coffeemaker. "I only pull this out when I have people over," she says sheepishly. "I actually use a twenty-dollar Black and Decker coffeemaker most of the time. I used this Chemex for the first month I had the boat because I was obsessed; I was like, 'My cutlery is going to be brass, my colander will be copper, and everything is going to be beautiful.' But after about four weeks, I was so sick of making slow coffee every morning, I went out and bought a coffeemaker with a timer on it so the coffee is ready for me when I wake up."

You can't fault Kyla for wanting everything in her new home to be just so. She spent the past five years roaming the US interstate system in a Spartan tow-behind trailer with her best friend, Jill Mann, and space constraints (and the simple fact that the camper had to be packed away before each drive) meant that personal possessions were kept to an absolute minimum. Recently, the pair returned to British Columbia, Canada, where they both grew up, to take a breather from the constant travel and to come to terms with turning thirty. "Part of me wants to live on the road forever, but lately I've had these maternal pangs and think I want to have kids this year," confesses Jill, a straight

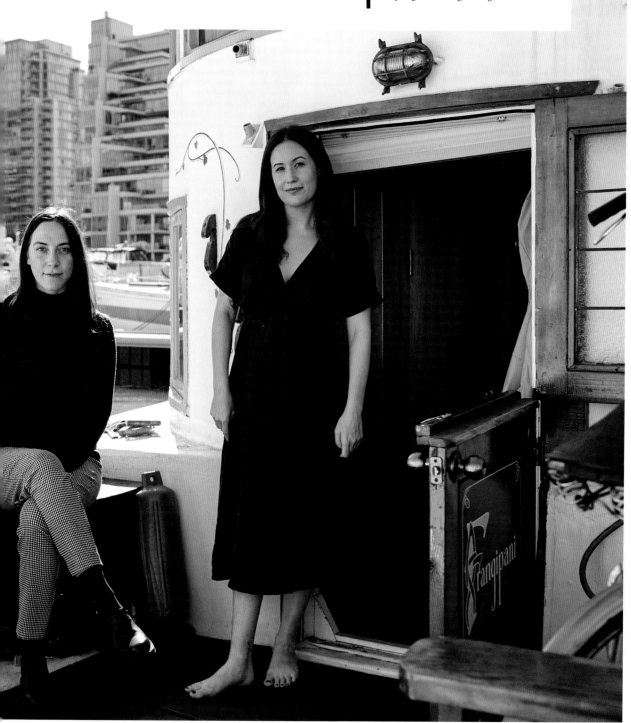

KYLA TRETHEWEY

425-square-foot 1982 Salish
Coastal Sea Home tugboat

British Columbia, Canada

Tugboat owner Kyla (right) spent five years traversing the United States in a tow-behind trailer with best friend Jill Mann (left) at her side. The pair parked their trailer last winter and spent the spring renovating the tugboat.

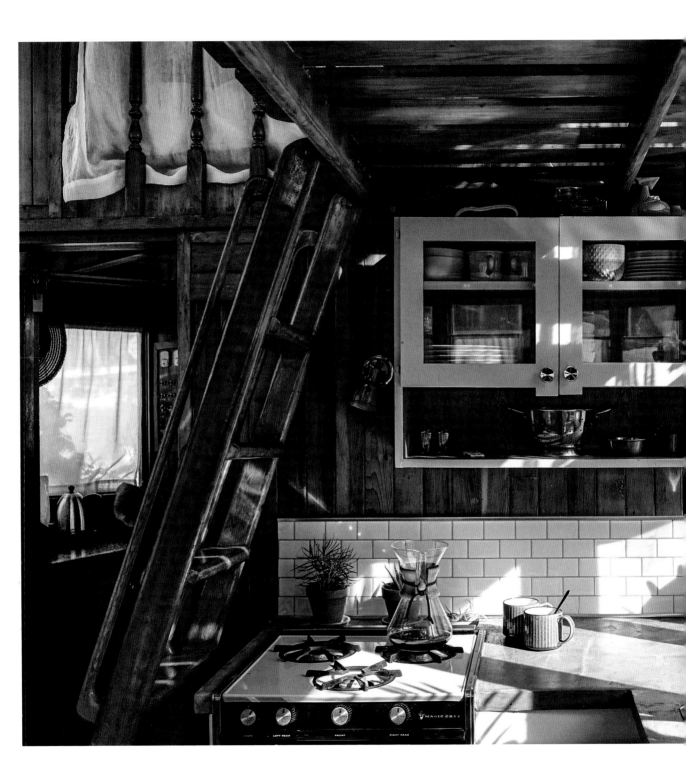

talker with a dry sense of humor. "I need to start putting things in place. I didn't even think about having kids throughout my twenties and then all of a sudden I was like, 'Oh God.'" After years of living side by side, she and Kyla decided to get their own places—not an easy task in the lower mainland of British Columbia, an area well known for its lack of affordable housing. Jill found a studio apartment, while Kyla contemplated moving into a two-bedroom suite with a married couple. When her dad called to say that a liveaboard boat was coming up for sale in the marina where he anchors his own sailboat, Kyla explained that she would never live on a boat—unless, of course, it was the tiny hippie tugboat overflowing with plants and hand-painted with flowers that has been a permanent fixture in the marina since she was a child. As luck would have it, it was. Within twenty-four hours, she had bought it. "One day I didn't know what I was doing with my life, and the next day I was buying a tugboat," she says.

If all this sounds a little spontaneous, it isn't such a surprise when you consider Kyla's

❮ CAST IN CONCRETE

The stove, kitchen cabinets, and lights over the sink are all original to the tugboat. Jill made the new concrete-looking countertop in the kitchen. "Kyla and I ripped the original Formica countertop off until only the plywood base remained," explains Jill. "Then I applied a thin coat of concrete putty—the kind of stuff you use for patching cracks. It's a bit more flexible than regular concrete. Finally, I added a lip to the counter so it looks like it's a solid top, but the whole thing added only a couple of extra pounds."

⌃ SMALL FRIDGE SACRIFICES

The stove, kitchen cabinets, and lights over the sink are all original to the tugboat. Kyla leans on a bar-size refrigerator hidden behind the solid panel cupboard door. "I don't have a freezer," she laments. "If I get ice cream, I have to eat it all at once. The worst thing, though, about having a small fridge is that I have to go to the grocery store often and I have to eat what I've bought, not necessarily what I want."

❯ DOUBLE-HEIGHT DWELLING

The two-story-high interior space, connected by ladders and open-planked gangways, makes the floating home feel spacious and airy. For now, Kyla doesn't have any intentions of taking the boat into open water. "Finding an affordable place to live is such a win that I don't want to risk sinking it," she says of the old boat. "That's why none of the furniture is strapped down and I have so many plants."

past. When she was seventeen, her dad made a small gesture that ended up setting the course for the next decade or so of her life. "He had a company that sold polyurethane truck-bed liners, and one morning, when I was on my way to high school, he lent me one of his company gas cards to fill up my car. I ended up leaving town for two and a half months with the card in my pocket. I'm a big Bruce Springsteen fan, and I had spent a lot of time fantasizing about what it would be like to live down in the United States," she says. She traveled as far south as Tijuana, Mexico, east to Colorado, and then up the West Coast until she arrived back in Canada. "I could only eat at Chevron gas stations, and I slept in my car, but I finally got to see all these places I had dreamed about." Her dad finally canceled the card and the adventure ended—but not before Kyla had developed a deep love for life on the road. Upon her return, she finished high school and tried college, but she ultimately dropped out and ended up working as a property manager for a high-end rental company. "I remember eating dinner with my dad and complaining endlessly about my job, and he asked me, 'What do you want to do?' I told him, 'I just want to drive across the United States with my friends,'" says Kyla with a laugh. "But who was going to pay me to do that?"

Around the same time, Jill—who had graduated from a photography program at a local art college—was dabbling in fashion photography while working in the service industry to pay her bills. She and Kyla met through their boyfriends,

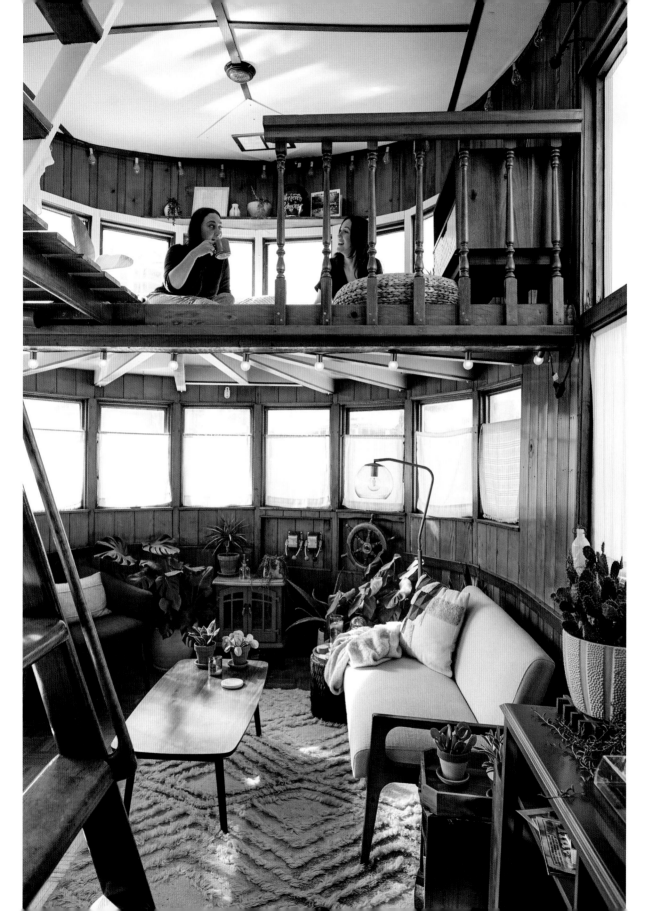

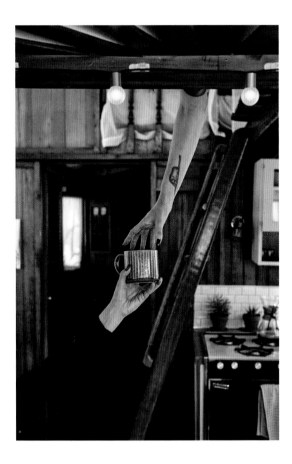

▲ EQUAL PARTNERS

"Kyla and I pooled all our money and split everything for
the first three years we lived together in the trailer," says
Jill. "We had only one bank account between us. If I went
shopping and spent a hundred dollars, then Kyla would
get to spend a hundred dollars. Everything was equal—the
earnings and the expenses—so it made sense."

‹ TOP OF THE LADDER

There are two ladders in the tugboat: the first one takes you
up to the second floor, where the two bedrooms are located.
The second ladder leads to the roof. "I love it on the second
floor," says Kyla. "Jill will sleep over sometimes and we'll be
in our rooms on opposite sides of the boat and it's like being
back in the trailer."

who were best friends. The women would often
see each other in social settings, but they hardly
ever spoke. Then, after four years of being in
committed relationships, they both found them-
selves single over Valentine's Day weekend in
2013. "I asked a mutual friend for Kyla's phone
number and reached out to her for the first
time ever. I didn't even have a way of contact-
ing her up to that point," says Jill. Over a couple
of bottles of wine, the two discovered that they
had both grown up in isolated Canadian com-
munities and had the same dream to road trip
through the United States. The next morning,
Kyla woke up in her newly empty apartment and
found a small jar of salt she had scooped from
the Bonneville Salt Flats outside of Salt Lake
City, Utah, on her first road trip across America.
She and Jill had planned to go for a walk that
afternoon, but Kyla suddenly had another idea.
"I texted Jill and asked her if she wanted to go
to Salt Lake City instead. I told her, 'If we leave
now, we can watch the sunrise on the salt flats.' I
pleaded with her to say yes," says Kyla. "She did."

Their first trip together was a short one, but
it gave them a glimpse of what life could be like
if they traveled together. "In those four days, I
had more fun than I could remember having
in the past four years. It was this incredibly
reckless, wild experience," says Jill. On the way
home, they set about making a plan to take an
extended trip.

Over the next five years, they would traverse
the United States in a tiny vintage camper they
christened Bobby Jean (after the Springsteen

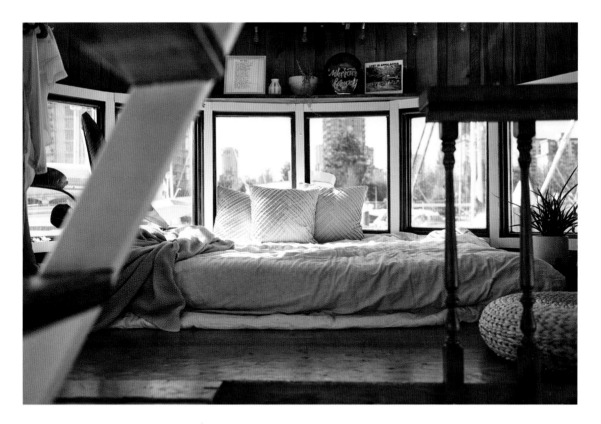

∧ BEDROOM HIDEAWAY

The foam mattress in Kyla's bedroom was cut into a curved form so it could fit directly underneath the windows. A shelf holds a few of Kyla's favorite things, including the song lyrics to "Half Broke" by Justin Peter Kinkel-Schuster (the first line of the song is "Strange how far you'll travel hoping to belong"), a motorcycle helmet, and the photo book *Lost in Appalachia* by Jerimiah Smith, a trailer-living friend.

‹ HOMEMADE CLOTHING RACK

Kyla has slowly been rebuilding her wardrobe since her days on the road, when she and Jill shared all their clothing. She made the clothes rack herself out of copper piping and plastic tubing. Metal wire storage baskets stuffed with T-shirts and accessories are lined up along a wood shelf.

song), documenting their carefree, live-in-the-moment existence through thousands of photographs that they shared on their newly designed blog and Instagram feed, Our Wild Abandon. "We were in a different place every day, seeing things I had never seen before, and more than that, I was watching my friend experience these places for the first time," says Jill. The pair faced some sobering setbacks along the way: a four-thousand-dollar engine repair ninety days into their trip—which they financed by selling postcards of their work online while holed up in a scrapyard in Moab, Utah—and later a serious rollover accident in California that left them trapped in their flipped-over SUV with their totaled trailer behind them. "That would have been a *really* good time for us to quit," says Jill. "We didn't have a lot of money. We were shaken from the accident. Literally everything we owned was destroyed. But we contemplated our future for a few days and we agreed that this wasn't the way it was going to end for us. So we dusted ourselves off and bought a second well-loved trailer." The best friends traveled with their new mobile home, nicknamed Billy the Kit, from June 2016 until the beginning of 2018, when they finally returned home to Canada to take stock of all they had accomplished. In the years they had been away, they had gone from unhappy office and service workers to popular amateur photographers with a strong social media following to professional photographers with agents in New York City.

"I love how your wardrobe matches the color scheme of your boat," banters Jill, declining the coffee that Kyla has laboriously made and requesting an herbal tea instead. "It kills me every time."

"That's from when I was temporarily insane and wanted everything to look perfect," admits Kyla. While only Kyla lives on the new tugboat, her best friend has been there every step of the way, dedicating her time to the renovation of the space.

The tugboat is one of only five Salish Coastal Sea Homes, which were built on Vancouver Island in the early 1980s. "Most of them have been renovated multiple times. This one has not," says Kyla. Loving its earthy, West Coast–hippie vibe, Kyla looked to improve on the existing decor rather than start from scratch. She didn't want to touch any of the original wood paneling on the boat, but she and Jill painted every remaining surface with a coat of Behr Almond Milk paint. The one exception was the bathroom. "It felt like a cave in there, so we broke my rule and painted the woodwork. We also added some copper shelving," says Kyla.

The kitchen received the biggest makeover, with new concrete-looking countertops and a fresh backsplash of peel-and-stick subway tiles mounted to boards and finished off with real tile edging to give it a more substantial, authentic look.

The tug is hooked up to the city water supply, and a new propane water heater means

that hot showers are easy to come by. Plans for a composting toilet are next, as Kyla currently has to walk over to her dad's boat to use his. "Right now, my toilet drains out into the marina, so I have to find somewhere else to go," says Kyla.

Despite these trade-offs, the tugboat has proved to be a lucky find in an area where affordable housing is a big issue. "A lot of our friends are in their thirties and thinking about having kids and buying a home, but the question is, where?" says Jill. "None of us wants to leave the city, but we can't afford to stay here and buy property or raise families."

While Kyla and Jill navigate their own separate lives and settle into a more stationary day-to-day, they haven't totally given up on their dream of living on the road. "The trailer is parked on some family land about an hour away from here," says Kyla. "I think we'll go on a one- to three-month road trip in the spring."

"Yes," says Jill emphatically, echoing the simple refrain that kicked off their wild adventure.

⌃ WHAT'S IN A NAME?

Kyla has not yet officially changed the name of the tugboat; for now, she refers to it as Franny. Like most boat owners, she is well aware of the superstitions that surround the renaming of a sea vessel and wants to make sure she goes through the proper name-changing rituals lest she bring bad luck aboard.

❯ CHILDHOOD FANTASY

Kyla has had a soft spot for this tugboat since she was a kid. She remembers passing by it on the way to her father's boat, which is moored in the same downtown marina. "The original owner of the tugboat was a set painter for films," she says. "He did all the illustrations on the outside of the boat. They're well done but not my style. I plan on repainting the tug."

The Vanlifers

Whispers started circulating through the van meetup before they'd even arrived.

"I hear they've slaughtered rabbits."

"They're kind of outlaws. They just do their own thing."

"They've changed their names."

By the time the slightly battered orange 1976 VW Kombi belonging to Kit Whistler and J. R. Switchgrass rolled into the campsite, a day after the vanlife gathering of about a hundred people had officially started, expectations were high. Not only did the couple have a massive following on their Instagram account, which was well known to all the participants at this Colorado meetup, but they were also veterans of the movement, having been on the road since 2012. To most of these people, they were bona fide heroes—they had lived the life that these newbies were only just getting a handle on. As they emerged from their camper, J.R. in a button-down shirt that matched the color of the van and Kit in a pair of creamy-white linen overalls with a rabbit-fur headband holding back her long hair, it was safe to say that expectations were met. When the open side door of the van revealed a pair of antlers and a draped fox fur stole attached to the passenger seat, their outlaw status was confirmed.

Long before "vanlife" became a hashtag, Kit and J.R. were on the road. The pair met in high school, and after

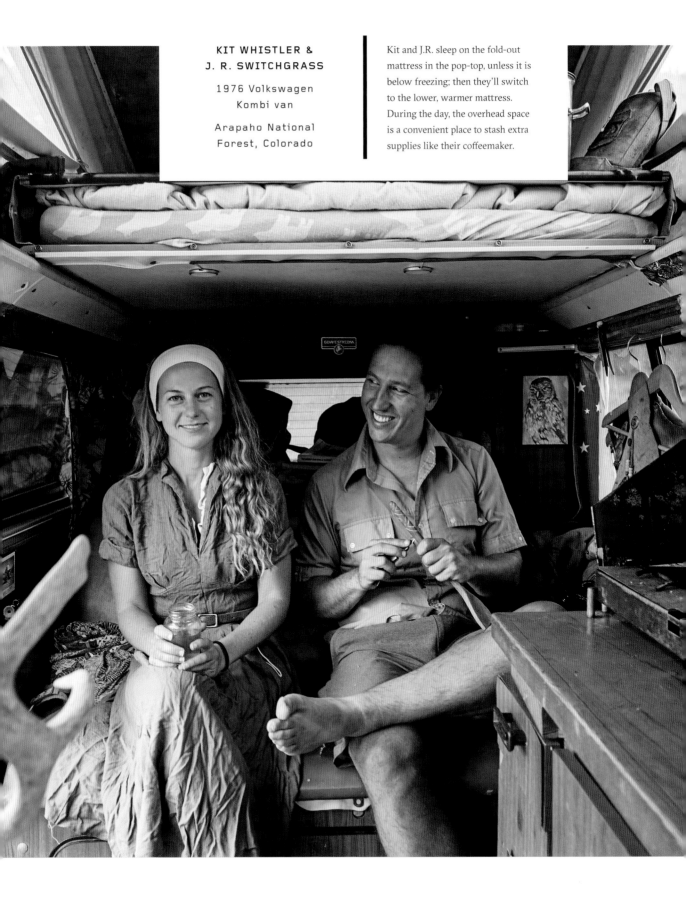

KIT WHISTLER & J. R. SWITCHGRASS

1976 Volkswagen Kombi van

Arapaho National Forest, Colorado

Kit and J.R. sleep on the fold-out mattress in the pop-top, unless it is below freezing; then they'll switch to the lower, warmer mattress. During the day, the overhead space is a convenient place to stash extra supplies like their coffeemaker.

graduating from college—Kit with a degree in English and J.R. with one in filmmaking—the couple decided to take a year off and travel in their van, which they had purchased on a whim from a Kmart parking lot. "We were products of the recession," says Kit. "I was going to head to grad school, but with the loan situation, I thought, 'I'm not going into debt for this,' so we hit the road." The couple wandered far and wide, exploring the United States before returning to California.

Back in Los Angeles, J.R. put his film degree to work and started to make videos for a surf culture website called Korduroy. He was soon making films with Foster Huntington and Cyrus Sutton, two of the people many credit with kicking off the current vanlife movement. "We had a lot of van culture things going on that summer. We went on a few trips with them through Big Sur and around the San Francisco area. Then I did Foster Huntington's short video *How to Van Camp*," says J.R. Inspired by others who were fully committed to the lifestyle and not finding much happiness in conventional day-to-day life, J.R. and Kit quit their jobs, gave away most of their possessions, and hit the road once again.

With no particular plan or urgency, the couple began meandering across the country. From the outset, they were determined to bring some balance into their lives, which they felt were too heavily weighted toward work and prioritized the use of their minds over that of their hands. They wanted to infuse their days with both leisure and idle time, which they defined

∧ STAYING HYDRATED

Fresh water that is used for drinking, cooking, and cleaning and two jars of homemade kombucha sit side by side in the back of the van. The jars of kombucha travel pretty well. "We've had only one casualty," says J.R. Tucked behind the water jug is the green-handled sanitation shovel that is used for digging holes when nature calls.

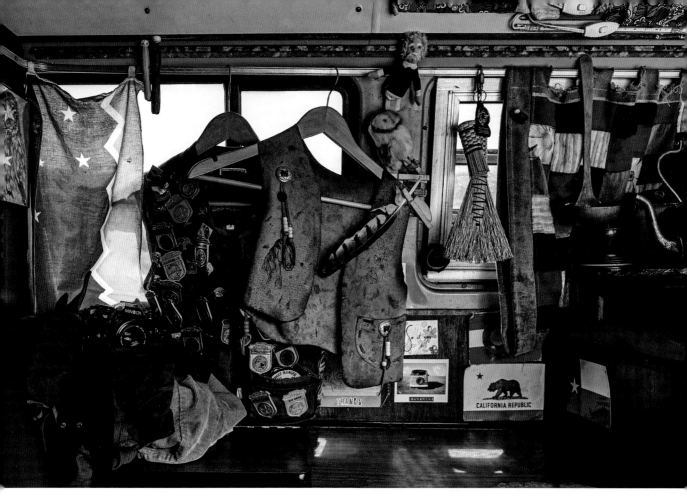

⌃ PRIZED POSSESSIONS

Everything in the van is as Kit and J.R. found it. "It's cool when you look in other people's vans and they've done a bunch of stuff, but we're minimalists at heart," says Kit. The small hand broom hanging in front of the window is from a woman in northern Georgia. The couple finds it too beautiful to use and clean with a store-bought nylon one instead. The two vests belong to Kit—one has all the pins she earned from completing the Junior Rangers courses at National Parks across America.

⟩ TEATIME

Kit prepares tea on the two-burner stove inside the van she has called home since 2012. "It's nice to have your own space when you're always in a different location," she says. "It's a comfort zone you can retreat to."

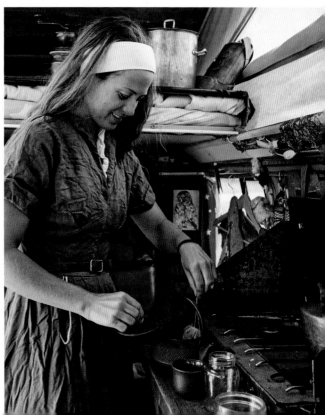

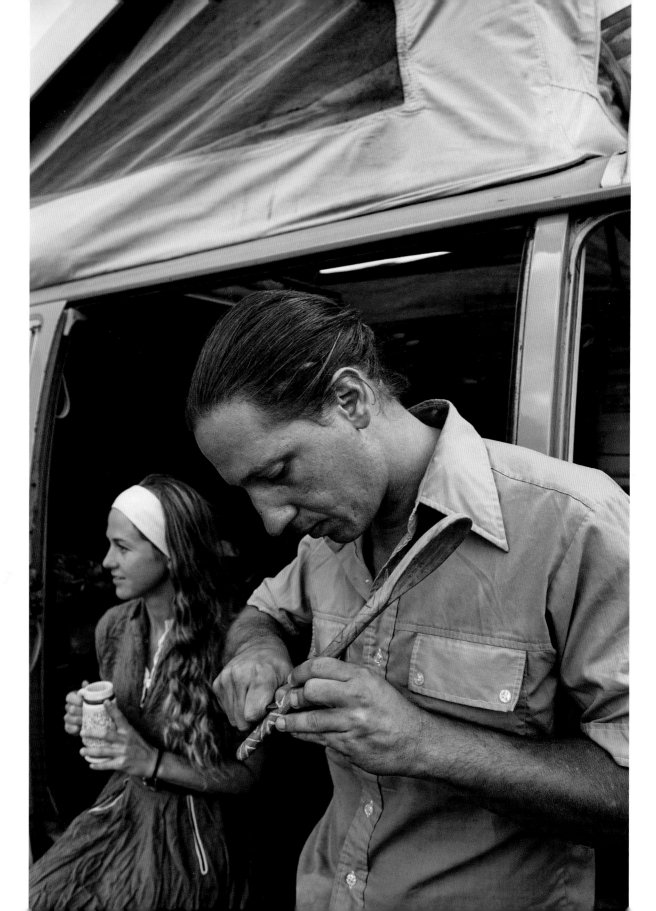

as moments spent pursuing passions as well as bouts of doing nothing at all. To achieve this, they supplemented their more cerebral creative work—shooting photography and making films (J.R.) and writing (Kit)—with migratory farm labor, and took the opportunity as soon as they had made enough money to just be present in the company of nature.

Kit and J.R. did not spend any time updating Sunshine, as their bus is affectionately known. "It's definitely a sparse vehicle," says Kit. However, it suits the two of them just fine, and it's loaded with character. Everything in their van has a story; most was either given to them by someone they met on the road or picked up in a small-town thrift store. Take the antlers and the fox stole, for example; the antlers came from a fisherman in Arkansas who was impressed with the couple's tenacity in handling the swaths of local mosquitos ("He thought we were badass," laughs Kit), and the stole—an unfortunate by-product of roadkill—came from a rancher in Wyoming.

Underneath the avocado-green vinyl seat in the back is Kit's closet—she loves clothes and

∧ A GOOD SIGN

A wood chain carved by J.R. and feathers collected by him and Kit line the dashboard. "Kit has this thing with owls. Whenever she hears or sees them, we know we're in the right place, doing the right thing," says J.R.

⟨ RESOURCEFUL CRAFTERS

J.R. busies himself with the final decorative touches on a spoon he has been carving. He and Kit are pretty enterprising and will try their hands at making things out of stuff they find in nature. "I made moccasins out of some rabbits we butchered," says J.R. "I also made Kit a collar out of rabbit fur."

isn't afraid to admit it. She picks up things at vintage stores wherever she and J.R. go and is constantly cycling them out at the end of the season. The couple is religious about keeping their possessions to a minimum. "Once a month we have a day where we're like, 'Okay, what haven't we touched recently?'" says Kit. "We're sticklers about going through things. If we're not using it every day, it's really hard for us to justify keeping it." Kit's biggest extravagance and a thorn in J.R.'s side is a drawerful of books, mainly field guides on the flora and fauna of specific regions in the United States that she refers to constantly.

Lined in a '70s-era teakwood laminate—with the original hippie-flower fabric still visible in a few places—most of the van is given over to a small kitchen with a two-burner propane stove. Water is hauled in large plastic jugs that are lined up on the floor beside pickle jars full of homemade kombucha in various stages of fermentation. There is no toilet on board—only a green-handled sanitation shovel. The couple prefers to bathe outdoors, jumping into lakes, rivers, or creeks to stay clean. "In the winter, we'll head to campgrounds where we can pay for a hot shower, or we'll ask the truckers when we stop at rest stations if they have any extra shower coupons, because they sometimes get them for free when they fill up," says Kit.

The increased interest in van living is perplexing to the couple. "This has just started in the past two years," says Kit. "Everyone says it's a movement."

"When we started doing what we're doing, I never would have envisioned this," adds J.R., looking around the campground with its groupings of circled vans scattered throughout. Both he and Kit admit that keeping friendships going has been hard. "Holding on to friends has been a little tough. Some of them don't understand," says J.R. "We don't have traditional friends, which is fine," adds Kit, her voice betraying her a bit. "Instead we hang out with a lot of friendly strangers."

The couple recently self-published a book, *Orange Is Optimism*, about their adventures on the road. It's proven to be a fairly successful venture, with more than seven hundred copies sold before it was even released, netting the pair a healthy sum. However, the couple remains committed to their goal of trading in a conventional nine-to-five work life for an equal mix of leisure time, which they spend pursuing their passions; work; and time spent doing nothing. Like modern-day millennial evangelists, they travel the country spreading the word of reduced consumption, no debt, and making time to appreciate the natural world. "If we all could shake our addictions to owning stuff and defining ourselves only through our work, then we would be better, more well rounded individuals," says Kit. "We enjoy van living—that's why we do it," says J.R. "But you don't have to do something so radical. It's not about living in a van; it's about changing your mind-set."

When it came time to register their book with the Library of Congress, the couple took

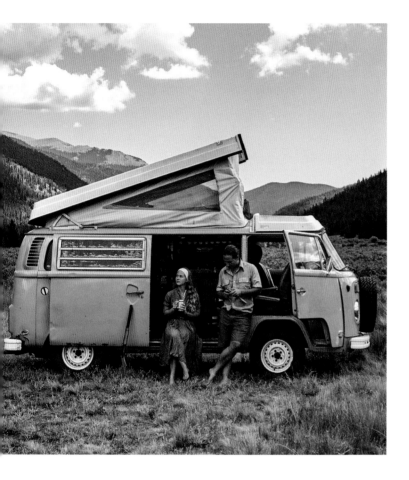

the opportunity to officially change their names to Kit and J.R. There's a history of choosing a trail name when you hike long distances like the Pacific Crest Trail, which the couple has done part of, and so they riffed on those names; they felt that they were more suited to the people they had become over seven years of constant travel. "Your birth name carries a lot of weight and a lot of baggage," says Kit. "I feel like I'm a different person than who I was. Changing my name has given me the space to be this person that I finally feel like I really am."

YOU CAN ALWAYS GO HOME

When Kit and J.R. first moved into Sunshine, they didn't tell anyone they lived in a van. "It wasn't cool. We lied to everyone because it was embarrassing to tell people we were living out of our car," says Kit.

EVERYTHING THEY OWN

All J.R.'s and Kit's possessions fit in the van, and they are proud to have only a single key to their name.

5
—

In
Detail

A CLOSE-UP LOOK AT BATHROOMS
AND STORAGE

Bathrooms

When it comes to bathrooms in small and
often mobile spaces, the answer can be as simple
as a sanitation shovel and a dip in a river, or as
luxurious as a composting toilet in a subway-tiled
wet room with matte black fixtures. Here's a closer
look at a range of different solutions, and how
the homeowners make them work.

SUBWAY-TILED SHOWER

For the shower on his school bus conversion, Michael Fuehrer chose to install mini subway tiles—bigger tiles would be more likely to crack with the constant movement. The wet room features a full-size shower pan and is outfitted with a lightweight faucet and showerhead with a trickle-valve switch (specifically made for RVs by Dura) that reduces water flow to a thin stream at the touch of a button. This switch can be activated when full water flow is not needed—during shampooing, shaving, or lathering—to help conserve water. However, Michael is lucky to have a couple of water tanks stored under the bus, which, in combination with a portable tankless water heater, provide a constant stream of hot water, making the use of this switch necessary only when he is boondocking in the wilderness for a few days at a time. The composting toilet, positioned one step up, is by Nature's Head. *See the rest of Michael's home on pages 22–31.*

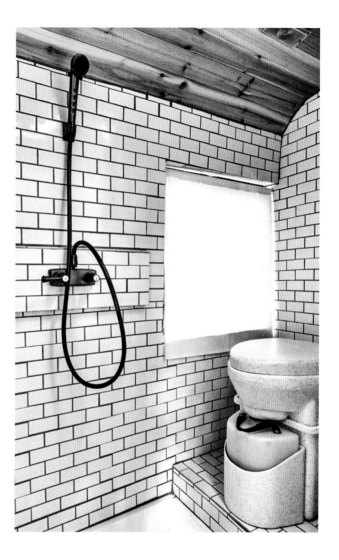

OUTDOOR BATHTUB

"It's more of a hot tub than a bathtub," explains tiny house owner Brooke Budner of her outdoor bath setup. "The black solar panel on the ground heats up black tubes of water, and the system works on a thermal cycle. The hot water is lighter and wants to rise, which in turn sucks the cold water down." Brooke and her partner, Emmett Adam, made the tub out of a simple galvanized metal feeding trough that they enclosed in a cedarwood box. On days when there isn't enough sun to power the solar panels, they hook up a barrel beside the tub that is outfitted with a long metal coil and a pair of flexible tubes that are plumbed directly into the tub. Once the bathtub is filled with water and the hoses are connected, a fire is lit within the barrel. As the fire heats up the water in the coils, the warm water moves up into the bath, which in turn sucks the cold water out of the tub and back into the coils. Surrounded by old-growth cedar trees, the outdoor bathtub is the perfect place to bathe under the stars on a summer night. *See Brooke's shower opposite, and the rest of her home on pages 152–161.*

TANKLESS HOT-WATER SHOWER ———————

Connected to the backside of Brooke Budner's tiny home is a hot-water shower that is heated by an on-demand hot-water heater. The unit uses water supplied from a simple garden hose and heats it using liquid propane gas, meaning the water that comes out of the showerhead is instantaneously hot and the supply is unlimited. The lightweight unit is portable and can be moved anywhere. This in combination with her hot tub (opposite) means that Brooke has a couple of options for bathing, albeit both outdoors. *See the rest of Brooke's home on pages 152–161.*

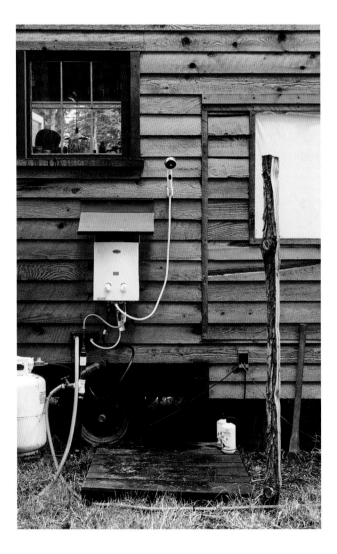

ONE VAN, TWO SHOWERS —————

Vanlifers Jace and Giddi Carmichael have not one but two showers, which allows them to camp off the grid for longer periods of time and have five to six showers each before the tanks require refilling. The first setup, made by Road Shower, uses the heat of the sun to warm up a slender five-gallon tank that is located on the left side of their roof. A 12-volt compressor can be hooked up to the hose to deliver a high-pressure spray. The second one, made by Eccotemp, is a tankless hot-water heater located on the inside of the van in a pint-size white box that works off liquid propane. "You just flip the switch on the water pump, it ignites, and out comes hot water. It has controls so you can adjust the flow of the water and have a really conservative shower if need be. We tend to turn it off when we shampoo or lather up," says Jace.

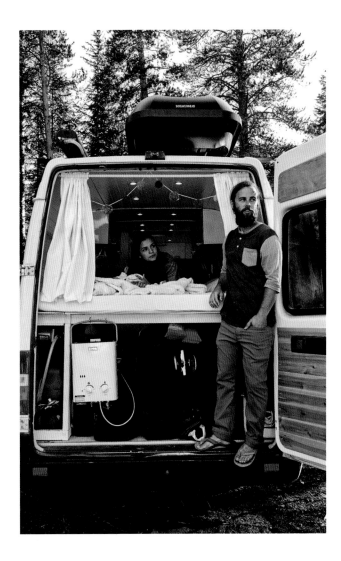

ROLL-AWAY COMPOSTING TOILET ⸺

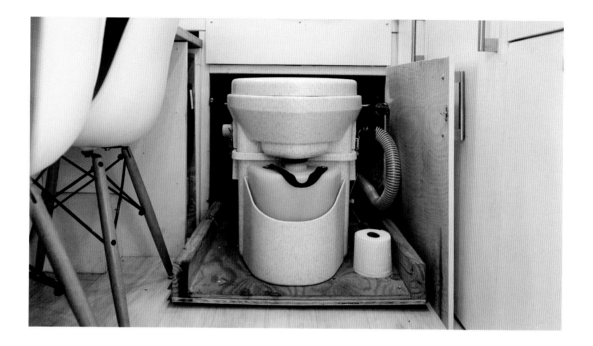

The Nature's Head composting toilet in Jace and Giddi Carmichael's Sprinter van is tucked away under the queen-size bed and rolls out on a five-hundred-pound drawer slide, a unique feature custom-designed by Jace that maximizes the vertical square footage available in the van while preserving precious floor space. The key to composting toilets, which are all approximately the same size, is the separation of the liquids from the solids. The toilet is designed so that the urine is diverted to a separate transparent container mounted on the front of the unit. The waste vessel is located underneath the seat. Each will need to be dumped separately, depending on frequency of use. For this family of three, the urine is dumped once a day, while the composted waste is dumped once or twice a month. The urine can be emptied into a conventional toilet or onto mature trees, or diluted for use on plants (the nitrogen, potassium, and phosphorus found in urine work as a great fertilizer). Sphagnum moss or organic coco coir within the waste tank breaks down the solids and makes them nontoxic so they can be dumped into a compost pile or simply thrown in the garbage. "A very quiet fan runs all the time to help compost the solids," says Jace. "There is little to no smell."

DIY PEAT-MOSS TOILET

Betsy Sohmer and Chris Patterson made their own composting toilet in their Airstream. "If you open up the lid, there's a lined five-gallon bucket in there. We fill it with different layers of organic material like the wood shavings they use for pet bedding or coconut coir and then cover it with some peat moss," says Chris. When the bucket reaches its limit, they seal the bag carefully and then take turns throwing it away in a Dumpster. Legally, this falls into the same category as throwing out soiled diapers or disposing of dog poop. However, the waste cannot be mixed with liquid, must be securely bagged, and must be in small quantities (around five gallons). Regardless, the actual throwing-away process can be a bit risky. "It's a bit of a covert mission," says Chris.

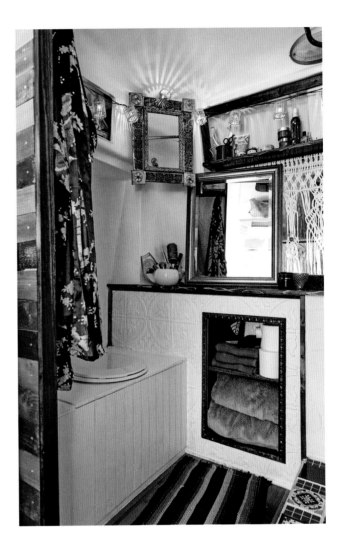

BLACK-WATER-TANK TOILET

Many RVs, like Danielle Boucek and Tommy Krawczewicz's, have toilets where waste is collected in a black-water tank. (The size of the tank will vary depending on the RV.) These toilets look the same as ones you would find in a regular home but require a two-step flush: a foot pedal must be pushed to release water into the tank before you sit down and then pressed again once you are finished to transfer the waste (solids and liquids) to the black-water holding tank. Depending on the number of people on board, the tank will need to be emptied every few days to once a week. Many gas stations provide a place where you can dump your tanks. "It's a process," says Tommy. "I usually rinse the tank a few times afterward." *See the rest of Danielle and Tommy's home on pages 50–57.*

OUTDOOR TOILET

For those with a more fixed location, an outdoor bathroom can be a space-saving solution—but it's not without its drawbacks. "If it's pouring outside, you just have to go in the rain," says Brooke Budner of her plein air toilet located about 750 feet away from her home up a wooded path. The rudimentary setup, known as a thunder box, consists of nothing more than a raised box and toilet seat positioned over a big pit that Brooke digs (a roll of toilet paper and a flashlight are kept on a hook near the front door of her tiny house). When it fills up, she covers the hole and digs a new one. *See Brooke's tub on page 266, her shower on page 267, and the rest of her home on pages 152–161.*

THE SIMPLEST APPROACH _____

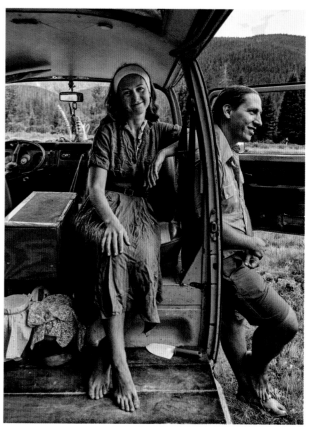

No fancy equipment is needed for these bare-bones setups: a bucket filled with collected rainwater (above left) makes a basic shower on the property where Yoav Elkayam's Luton van is parked. The chair is there to keep the towel dry and off the ground. And when it comes to most van-dwellers' bathroom needs, the preferred tool is the sanitation shovel (as shown above right) in Kit Whistler and J. R.

Switchgrass's van). The only guidelines: get as far away from camps and other water sources as possible; the hole should be dug as deep as your hand; and any toilet paper used should be deposited in a bag, hiked out of nature, and disposed of properly. *See the rest of Yoav's home on pages 196–205; see the rest of Kit and J.R.'s home on pages 254–261.*

Storage

Super-small spaces—especially those that are subject to sudden movements—require outside-the-box thinking when it comes to storage. With little room to spare, you have to either find an attractive way to display your stuff or a tidy way to stow the things that you need most. Following are nine ingenious ways of putting every inch to work.

1. USE BOTH SIDES OF A SHELF ——————

Maximize your storage space by using the bottom of a floating shelf. In Danielle Boucek and Tommy Krawczewicz's RV, construction adhesive keeps mason jar lids in place on the bottom of the shelf (above left), allowing the glass jars to be easily screwed off and on when needed. A roll bar stops mugs from flying off the top of the shelf when the vehicle is in motion. Using the same logic, in Robert and Samantha Garlow's tiny home, a simple mitered box with a bottom slit (above right) allows wineglasses to rest upside down securely while not taking up precious cupboard space.

2. ADAPT YOUR OPEN SHELVING ————

Wanting some open storage in the van she shares with her boyfriend, Carsten Konsen, but not sure how to keep things from falling off the shelves, Sina Schubert designed this stylish looped elastic cord system. Basic screw eyes are mounted on both the top and bottom of the shelf, and a single length of bungee cord is woven through them. "I love design that has a real purpose, and I can testify that nothing has ever fallen out!" she says. Decanting staples into matching glass jars and hiding other necessities in knitted storage bins makes the shelf visually appealing and keeps clutter to a minimum— essential in a tight space.

3. CHOOSE DOUBLE-DUTY PRODUCTS

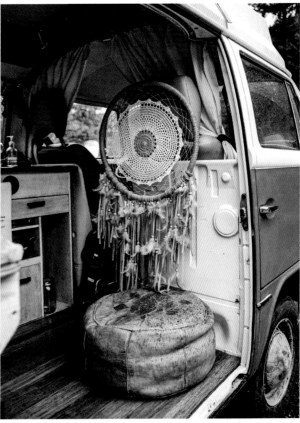

In a small space, having items with more than one use is paramount. The aptly named "drifter table" in Robert and Samantha Garlow's tiny house (above left) moves throughout their space according to their needs. It works triple duty as a seat in front of their kitchen peninsula, a workstation for their laptops when pulled up to the upholstered built-in bench, and a makeshift coffee table. The Moroccan leather pouf in Nash and Kim Finley's VW (above right) provides a seat for guests and can be used as extra storage: the couple stuffs it with out-of-season clothes.

4. HANG EVERYTHING _____

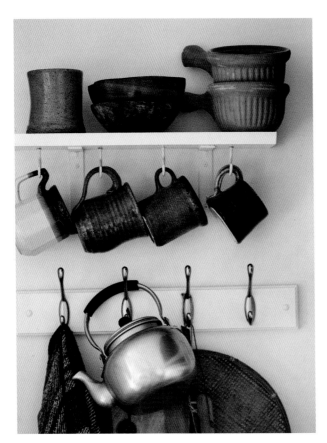

When storage is at a premium, consider hanging your stuff. In Pauline and Kieran Morrissey's RV, hardware-store hooks were screwed into the bottom of a shelf and hung above a row of coat hooks (above left) to create a compact storage space for kitchen supplies, including coffee mugs, a teakettle, and even a cutting board. A simple white dowel looped through canvas straps (above right) hangs above the sink in Sina Schubert and Carsten Konsen's van and keeps all their cleaning supplies within arm's reach. Instead of buying disposable sponges and paper towels, the pair spent a bit more money on environmentally friendly, pleasingly elegant products they can use over and over again. In Nash and Kim Finley's VW (opposite), bulldog clips are used to hold heavier items like felt hats while simple paper clips do the job for favorite snapshots.

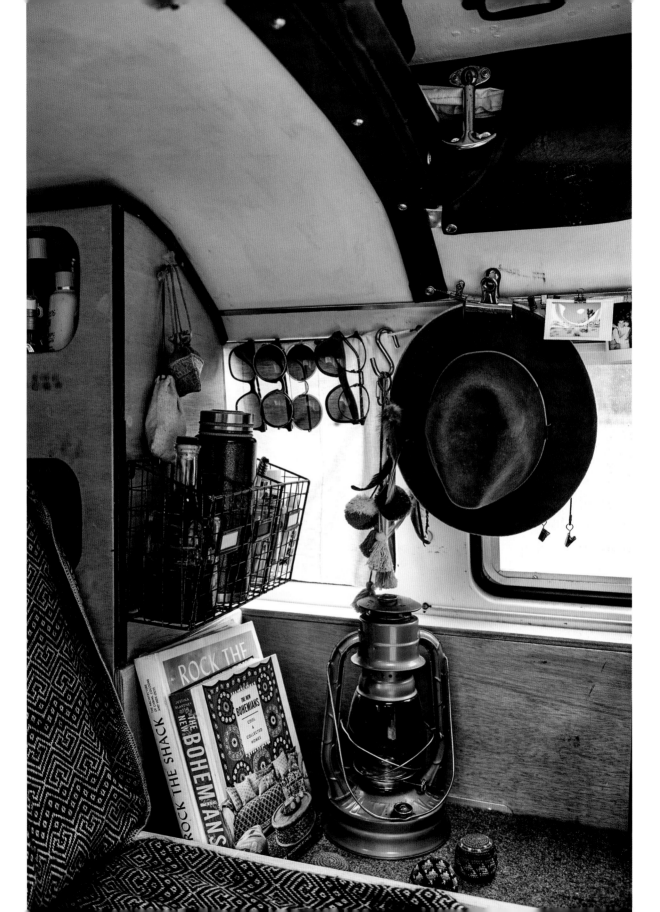

5. MAKE ROOM FOR BOOKS ──────────

Every inch is worth using in a small space, whether it's found in nooks and crannies or added to existing walls. An awkward but still useful triangular compartment in Tommy Krawczewicz and Danielle Boucek's RV (above left) was made into a book cabinet.

Whereas in Ashley and Dino Petrone's RV (above right), a shelf from Ikea was mounted on the dining room wall within easy reach of children. Its thin design is perfect for small-space living, and the added bar makes it ideal for those on the move.

6. USE THE SPACE UNDER THE BED ———

 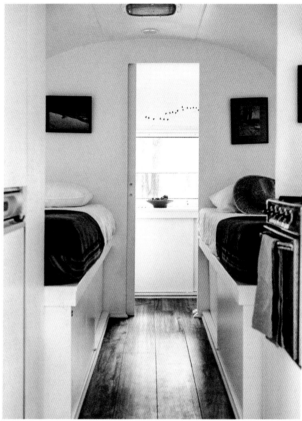

If you find yourself with a raised mattress, as Kate Oliver and Ellen Prasse did in their Airstream (above left), consider storing clothes in the 12- to 18-inch space underneath the bed. Handled baskets or containers, like these versions, are easy to pull out. If you're building from scratch, consider installing sliding doors or roll-out drawers under the bed for extra storage, as Sunny Cooper has in her Airstream (above right). These spaces will quickly fill up with clothes, bed linens, and towels.

7. TURN STAIRS INTO A CLOSET _____

 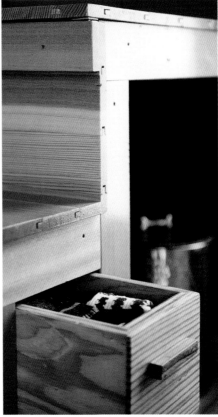

You're probably used to hanging your clothes across a horizontal bar in a regular closet, but small spaces require out-of-the-box thinking. In Devin Groody and Catrin Skaperdas's tiny house, the spaces beneath the stairs (above) pull out to reveal deep closets with room for clothes to be hung front to back. The lower stairs, although pocket-size, provide just enough room to stash pairs of socks. A similar method is used in Robert and Samantha Garlow's tiny house, where a simple staircase to a sleeping loft doubles as clothes storage (opposite).

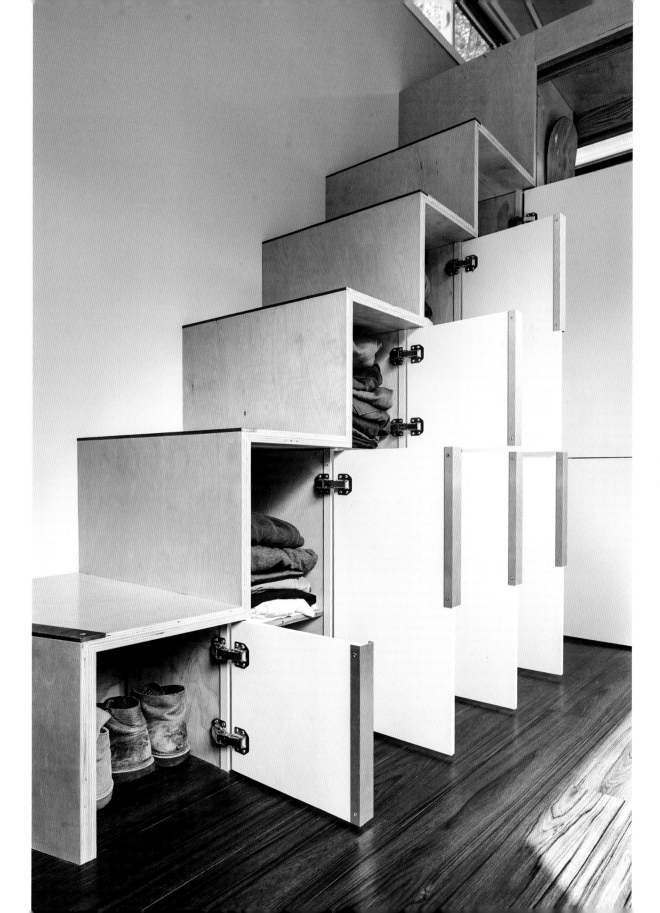

8. STASH THE TRASH

Aside from being unattractive, garbage bins also take up a lot of valuable floor space. Planning for each and every object, including something as mundane as a trash can, makes a big difference when it comes to living in a small space full-time. Stashing those things away, as seen in the pantry of Kate Oliver and Ellen Prasse's Airstream (above left), is a smart solution: they stay put when the trailer is on the move.

Saving space was at the top of Mark Coelho's mind when he designed this sawed-in-half garbage can (above right). The lid, mounted to the side door of the trailer, lifts up on hinges for easy accessibility and can be held open by attaching the chain to a nail on the door.

9. CORRAL THE PET STUFF

Figuring out where to put a cat's litter box can be tricky in any home. John Ellis and Laura Preston had the brilliant idea to use the space beneath the banquette in their Airstream (above right) for their cat's box—keeping it out of the way and out of sight. A cat door allows easy access for Papa to get in and out, and a small fan that vents outside wafts smelly odors away. The couple also has two dogs, whose leashes are hung on a simple S-hook suspended from their Airstream's screen door (above left).

Road Map to Freedom

A NUTS-AND-BOLTS GUIDE TO NOMADIC LIVING

Before You Begin

There will no doubt be a long list of firsts in your journey to a nomadic or seminomadic lifestyle (first time pulling a trailer, first time dumping your tanks, first time charging your onboard batteries), so having a little knowledge beforehand can go a long way. Ask yourself these questions up front, so you'll be more informed when it comes time to put your plan into action.

Why am I doing this?

Before you can decide what version of this lifestyle is right for you, you need to figure out your motivations. If your goal is to search out the best waves, then a VW bus or van that can make it down sandy roads might be a better choice than an RV (which is more suited to pavement). If you're looking to reduce your environmental footprint, a tiny off-the-grid house with a garden might be a better fit than a vehicle that is always on the go.

How will I support myself?

Thankfully, the ubiquity of the internet and increasing job flexibility mean that many people can work from anywhere, whether as a freelancer or for an employer comfortable with a mobile workforce. If you're interested in going this route, be sure to think about what kind of amenities your work will require. Will you need an office? Internet access? Storage for shipping supplies?

You can physically work while on the road, too, of course. Perhaps you'll pick up seasonal farmwork, in which case you may want to plan your route based on when and where certain crops need to be harvested. Or you could stay put and work as a barista, a graphic designer, or a handyman while you replenish your resources and gear up for the next trip.

If you have a location-based job you love, consider opting for a vehicle like an Airstream or a boat, which you can park and live in during the week and travel with on weekends or during vacation time.

What do I need to live comfortably?

Figuring out your living priorities *before* you buy a vehicle or tiny house can save you a lot of heartache down the road. If the thought of having only a bed to hang out in makes you feel sluggish, consider a home with enough room for a sofa. If heading outside to go to the bathroom in the rain is a deal breaker, you'll need to get a place that can accommodate a toilet.

Am I going off the grid?

If you intend to spend most of your time in places without running water or power, you'll need to outfit your home accordingly; check out the section on living off the grid on page 295.

What climate(s) will I encounter?

Insulation will keep you warm in cold climates and cool in hot ones. Skimping on this was a common regret I heard from homeowners. To improve air ventilation in hot climates, opt for windows that are operable. (Air conditioners are huge energy users and often won't work if you're running on a DC system.) If you plan on traveling or living in a temperate or cool climate—keeping in mind that even the desert sees huge temperature drops at nighttime—consider adding a heat source like a space-saving marine heater or a tiny woodstove. (See page 310 for sources.)

What about my pets?

Some animals are better suited to nomadic living than others. Most people know in advance whether their animal is a good traveler, but keep in mind that if your pet is likely to dart after a squirrel and take off into the wilderness, then you may not want to risk losing it. If you've decided to bring a pet on board, think about the following: Where will it sleep? Where will you store its food? Where will you put its litter box? If the pets are going to be coming in from outside after muddy walks or rolling in the sand, choose upholstery that can be easily wiped down, like vinyl, or at the very least a dirt-disguising fabric—patterns are best. For dogs or cats that shed a lot, you may want to consider bringing along a handheld vacuum.

Once you hit the road, says Danielle Boucek (see page 50), "make sure the outside temperatures are safe for the pets inside—open vents and turn on fans, fill up their water containers, and close off access to the driver's cab." For those times when you do have to leave pets alone, consider investing in a security camera whose feed can be viewed by a phone app (see page 303). Finally, keep in mind that most national parks in the United States prohibit pets from hiking on trails and being in the backcountry. However, there is usually land adjacent to these parks—often part of the Bureau of Land Management (BLM)—where pets will be more welcome.

What if something doesn't work out?

Living on the road or off the grid can present a lot of challenges, and being adaptable is paramount to your happiness. For road emergencies, consider joining an organization like AAA or similar roadside assistance clubs in other countries. Reach out to other people living the same lifestyle (Instagram is a great connector) and build a support network. More often than not, these folks will have been through similar challenges and will have helpful suggestions. Consider having a slush fund for medical emergencies, major car repairs, even flights back home in case of a crisis.

Finally, before you begin this journey, you may want to think about how much of your former life you want to shed. If, ultimately, you find that this lifestyle isn't for you, what do you want to come back to? Research storage-locker fees, and weigh the pros and cons of holding on to some possessions if that makes you feel more comfortable. Also, if you own a home or an apartment, you can consider subletting it rather than selling it. (This option may also provide you with some income while you are on the road.)

Still not 100 percent sure? Try staying in a tiny house hotel or an Airbnb Airstream rental for a few nights, or rent a VW camper van for the summer. (See page 310 for some suggestions.)

Finding Your Home

Unlike when buying a traditional house, there are no Realtors to work with when you go to purchase a bus, Airstream, sailboat, or RV—you're on your own. (In certain markets, you might be able to find a broker to help you find a tiny home.) Before you make your first deposit, do your research. The more questions you ask, the more knowledgeable you'll become. Here are a few places to get you started on your search.

Direct-to-consumer suppliers

It is possible to buy some nomadic homes brand-new. RVs are readily available for sale both online (try RV.CampingWorld.com) and in most major cities; visit Airstream.com for the latest models of their trailers. Many tiny home builders offer custom and ready-made models. Minim Micro Homes (MinimHomes.com) can have an on- or off-the-grid model ready for you in just twelve weeks. Tumbleweed Tiny House Company (TumbleweedHouses.com) is the largest manufacturer of tiny houses in North America, with homes ranging from $63,000 to $73,000. Other tiny home suppliers include New Frontier Tiny Homes (NewFrontierTinyHomes.com), which designed Bela and Spencer's home on page 68, and Wheelhaus (Wheelhaus.com).

Online classifieds

Craigslist.org, eBay.com, Autotrader.com, and RVTrader.com are a few of the most popular places to find cars, vans, RVs, and Airstreams in North America. You can also try SearchTempest.com, which will search all of Craigslist and eBay for you. In Europe, Mobile.de, AutoScout24.com, and AAAauto.eu offer similar services.

Facebook groups

Become a member of a Facebook group like Airstream Addicts or Sprinter Vans Unlimited. Individuals will often post private ads to the group before they try to sell their wares on a bigger website like Craigslist.org. Also, check out Facebook Marketplace, which will give you information on tiny home, boat, and vehicle sales within a specified radius.

Online forums

Hang out in online forums. Some will have sections dedicated to buying and selling vehicles. Here are a few popular options: AirForums.com (for Airstreams), Skoolie.net (for school buses), LoveMyBus.com (for VWs), RVForum.net (for RVs), TinyHomeForums.com (for tiny houses), and CruisersForum.com (for sailboats).

Government auctions

Surplus and confiscated vehicles of all kinds, from school buses to hauling vehicles like SUVs and trucks, can be found through live and online auction sites. Throughout the United States, there are several government agencies that sell forfeited or seized goods as well as vehicles or equipment that an agency no longer needs. There are four large national auction sites in the United States: GSAAuctions .gov, GovSales.gov, Treasury .gov, and USMarshals.gov. Individual states may also have their own auction sites. The general rule for auctions is that the highest bid wins, and you can't cancel your bid once you've made it. Read up in advance on payment and cancellation policies for each auction before participating.

Shipbrokers

Canal boats and sailboats are sometimes sold by shipbrokers who specialize in the selling of boats. Nautical trade magazines like *Latitude 38* also include classifieds that deal directly with boats.

Tiny home festivals and trade shows

Festivals and trade shows are becoming increasingly popular with builders and suppliers who will answer your questions and potentially even sell you a prefab tiny home. In addition, most festivals invite guest speakers and current small-space dwellers who will give you a firsthand account of the lifestyle. Visit TinyLiving.com/festivals for an up-to-date, comprehensive list of festivals happening throughout North America and beyond. *Note: Most tiny home festivals are not limited to tiny houses—they're worth checking out no matter what type of home or vehicle you are thinking of purchasing.*

Tiny home real estate websites

With more and more tiny homes being bought and sold, a small real estate market has started to emerge where new and secondhand homes can be purchased. Check out TinyHouseListings.com for a selection of homes for sale or rent.

Renovation 101

Chances are that whatever you buy—whether it's a van, sailboat, tiny home, or Airstream—you will want to make changes. Perhaps you're building from the ground up (or trailer up), or stripping a vessel down to its shell and rebuilding it from the inside out.

If your home is on the move, every pound affects your gas mileage, so lightweight materials are key, and the constant vibrations from the road require everything to be securely attached yet flexible. Often, parts will need to be modified, custom-made, or specially ordered to work within the confines of a vehicle. Following are some points to consider before starting your conversion.

Establishing a Realistic Budget

When determining your overall budget, you'll need to consider the initial cost of the home; if it's going to be mobile, what it will cost to get it travel ready; and finally, how much you want to spend on remodeling. Here are ten tips to help you get to the right number.

❶ Don't be afraid to negotiate. Recreational vehicles and boats often sit on the market for long periods of time, and sellers will be happy to off-load them for a lower price.

❷ Make your first stop a mechanic. If your home is going to be mobile, before you focus on more superficial renovations, you need to be sure it is capable of traveling safely. If you've purchased a secondhand vehicle, you'll need to see a mechanic or other qualified individual to assess the costs to make it road- or seaworthy.

❸ Determine the scope of your project. Decide early on what kind of conversion you want or are capable of doing. Some mobile homes, like RVs, VW vans, and even sailboats, may need only face-lifts, while others, like tiny homes or school bus conversions, will require building everything from scratch.

❹ Consider how handy you are. Once you know the scope of your project, be honest about how much of the conversion you are capable of doing. And unless you already have a garage stocked with tools, don't forget that if you're doing the work

yourself, you'll need to add the cost of the tools you'll need to your budget. If you plan on hiring someone else to do your conversion, speak with them early on in the process. While more and more services are becoming available for vehicle conversions and tiny home builds, finding a contractor may take some work. Do research within the community (see page 290 for a list of online forums), and ask around for suggestions.

5 **Factor in the cost of a towing vehicle.** If your new home requires hauling, don't forget to add in the cost of a vehicle that is powerful enough to hitch it to.

6 **Research material costs.** Investigate solar systems, plumbing fixtures, decorative finishes like tile or countertops, appliances, foam mattresses, and anything else you think you might need if you plan on making over the space.

7 **Plan your journey.** If places with extreme temperatures (cold or hot) are in your future travel plans, you may want to replace the insulation and/or add new heating and cooling devices. Putting these in after the fact is always more costly and inconvenient.

8 **Be prepared to pay double.** Factor in the cost of paying for two places while you build or convert your new home.

9 **Think about the payoff.** Many beautifully converted vehicles can be sold for a tidy profit. Investing in quality, durable repairs and finishes up front could pay off in the long run.

10 **Set aside some extra money.** No matter how well you plan, there will always be some unforeseen expenses. Budget an extra 20 percent for any contingencies.

Finding a Renovation Site

If you plan on converting or renovating your new home, you will need to find a place to build it out. In major cities, where parking is hard to come by, this is often a bigger challenge than many people anticipate. Even in rural locations, there are certain amenities you will want close by. Consider sites with access to the following conveniences.

Space to maneuver. Not only will you need a spot large enough to park your vehicle, but you'll need an area close by to set up a table saw and other tools, lay out

materials, and construct interior fixtures like bed frames and kitchen cabinets.

A nearby bathroom. Having to drive home or find the nearest convenience store eats into valuable daylight.

Access to power. Most construction tools will need to be connected to a power source, or will require it for charging.

A secure site. You have a lot invested in your conversion. Having a place where you can lock up your tools and store building materials is imperative.

Protection from the weather. Regardless of your location, a spot where you can store building materials out of the rain, sun, or snow will come in handy. If you have a long renovation ahead of you, you may also consider a building site like a warehouse or an old barn where you, too, can stay out of the elements.

Conveniently located renovation centers or hardware stores. Having easy access to building materials will make the job go more quickly.

Timeline

Six to eight months seems to be the average conversion period, but this can vary widely depending on the scope of the work required, your skill set, and how many hours you have to dedicate to the project each day. Tiny homes that need to be built from the trailer up may take as long as a year. Professional Airstream renovator Kate Oliver (see page 138) also suggests at least a year for a full gut renovation of an Airstream if you are working on it only on the weekends. Even with that seemingly generous timeline, she cautions that you will still need to put in ten- to twelve-hour days to get all the work done on schedule. No matter the project, first-time converters tend to underestimate the amount of hours it is going to take, so it may be wise to tack on an extra four weeks or so.

And be sure to research lead times for products: many of the items you might want to use will be special order or custom-made, so account for long delivery times. Often, finding out how to do something and getting all the materials in hand can take as long as, if not longer than, actually doing it.

A Quick Overview of Mobile Utilities

Getting yourself acquainted with the water and electrical systems on a vehicle or boat can make you wish you had paid more attention during sophomore science class. Below are some basics to get you started.

WATER

Recreational vehicles typically contain three types of tanks: freshwater, gray water, and black water.

As the name suggests, a **freshwater tank** holds clean water. This is the water that comes out of the tap.

A **gray-water tank** holds the dirty water from your kitchen sink and shower. This tank needs to be emptied out at a dumping station when it becomes full.

The **black-water tank** holds the wastewater or sewage from the toilet. It also needs to be emptied at a dumping station. The size of the tank, number of people on board, and how often it is used will determine how many visits you'll need to make to a dumping station.

AC/DC POWER

Most off-the-grid homes have two electrical systems: an alternating current system (AC) and a direct current system (DC).

With an **AC system**, you plug your dwelling into an external AC power source (like an electrical grid or shore power). The AC system provides all the comforts of home: it can power big appliances like air-conditioning units and microwaves, as well as electrical outlets.

The **DC system** works off a battery and can be used to power more basic necessities—lights, water pump, fans, TV, and radio—while you're off the grid.

The AC and DC power systems in most vehicles are connected. If the vehicle is hooked up to AC power, it will charge the batteries for the DC system using a device called a converter. A device that turns DC power into AC power is called an inverter.

Going Off the Grid

If you want to take off into the wilderness for weeks at a time, free from hookups, you'll want to make sure your rig is set up to go off the grid. Here's what you'll need.

A source of power. You'll require electricity to turn on your lights, charge your phone, and possibly run your fridge. A generator is one way to do this, but generators tend to be noisy, and they run on fuel, which you'll have to purchase. Portable power stations like the Yeti by Goal Zero are another solution. They will need to be recharged once they are depleted, but this can easily be done with solar panels. Solar panels can be permanently attached to the roof of your vehicle, tiny home, or sailboat, or you can use portable units that you set up in the direction of the sun when you are parked. Smaller devices like a phone can be charged using a 12-volt socket.

An inverter. For all those small appliances you can't charge with a 12-volt socket, you will need an inverter. Inverters take the power from your battery bank and turn it into AC power. (See opposite.)

A composting toilet. These work by separating the liquid waste from the solid waste into two different compartments. The urine will need to be disposed of every few days, but the feces can remain in the tank for upward of a month. In fact, the longer the waste has to sit, the better it composts. RVs tend to have toilets with gray- and black-water tanks, which, depending on the size, will last up to two weeks. Of course, you could also just use a sanitation shovel. (See more on bathrooms beginning on page 264.)

Something to cook on. This could be a propane-powered cooktop or an oven. It could also be as simple as a camp stove or an open fire. (Check fire bans in your vicinity before proceeding.)

Twelve-volt appliances can run off your batteries and solar panels.

A way to get clean. If you're stationed by a lake or a river, then go ahead and jump in, but for all those other times, you may want to add a portable shower station like the Road Shower (see page 309).

A method of staying warm. Tiny woodstoves produce enough heat to warm a van, Airstream, tiny home, or school bus if you're heading for colder climates. (See page 310 for sources.)

How Much Will You Pay?

	INITIAL COSTS	RENOVATION COSTS	ADDITIONAL COSTS
VW VANS	From $2,500 for a vintage VW bus. To buy a model with a restored interior, expect to pay $25,000 or more.	Older buses may require complete engine and transmission rebuilds. Put aside a minimum of $10,000 to get the vehicle road ready. Any money you save should be allocated for future repairs. On the positive side, these vehicles often need only minor cosmetic repairs to make them livable.	Upgrading appliances or adding a secondary battery or solar panels can be expensive. Research these costs ahead of time. Also budget approximately $3,000 for vehicle registration, insurance, and an emissions test (depending on where you live).
SPRINTER VANS	$45,000 or more for a new, off-the-lot Sprinter Van shell. Older models (dating from the early 2000s) can be found for around $12,000.	Expect to pay between $5,000 and $15,000 (or more) to convert a Sprinter van. These costs will vary depending on your desired materials and whether you do the work yourself.	Budget approximately $3,000 for vehicle registration, insurance, and an emissions test (depending on where you live).
AIRSTREAMS	Approximately $5,000 for a vintage model; $150,000 or more for a new 31-foot Classic Airstream.	A cosmetic face-lift may start at around $2,500, while a full gut renovation begins at around $12,000 and goes up from there.	Airstreams' curved walls require patience. Traditional measurements don't always work, and custom fabrication is necessary. Plan in advance to spend time and money on finding solutions.
SCHOOL BUSES	$3,000 to $6,000 for a vintage model, including all the old seats.	School bus shells require all the amenities for daily life to be added, so budget at least $30,000. You can reduce this amount slightly by putting in lots of sweat equity and getting creative with building-material choices.	Registering and getting insurance for your bus may take a bit of ingenuity since many institutions and businesses do not know how to classify these vehicles once they become homes. Expect to spend extra time—and, potentially, money—on this part of the process.

	INITIAL COSTS	RENOVATION COSTS	ADDITIONAL COSTS
RVS	Depending on the size, year, and mileage, these can cost anywhere from approximately $2,500 to $400,000.	Cosmetic changes can be handled for as little as $2,000, while a complete overhaul will start at around $15,000 and go up from there.	Since most RVs tend to be on the larger side and have been built for comfort, replacing or maintaining the fixtures and appliances can cost more money. (A full-size RV fridge, for example, will cost more to update than a smaller under-the-counter model in a Sprinter van.)
TINY HOUSES	If you are starting from scratch, expect to spend between $12,000 and $35,000. For a luxury dwelling with everything included, prices upward of $150,000 are not uncommon.	Unless you are buying a secondhand tiny house and renovating it to your liking, the estimated cost of a tiny house typically includes the price of interior furnishings and fixtures.	If you plan to park your tiny house semipermanently or permanently, you'll need to factor in the price of buying or leasing a piece of land.
BOATS	Prices range widely depending on the size, style (power vs. sail), and age of the boat. Expect to pay from $2,000 to $200,000 or more.	Again, prices will vary depending on the age of the boat and the scale of your project.	Moorage costs vary between $300 and $1,500 per month, depending on the location of the marina and the amenities it provides. If you're buying a used boat, you will need to have it surveyed to get insurance. Budget $3 to $5 per foot for the survey. Put aside some extra cash for maintenance, including applying bottom paint (to prevent the growth of barnacles), once a year.

Finishing Touches

Once your renovation is complete, it's time to make your space into a home. What do you need to surround yourself with to be happy? Maybe you gravitate toward a handcrafted aesthetic with lots of warm wood and organic textures, or perhaps you're aiming for something more contemporary with clean lines and minimal color. Don't know where to begin? Here are ten things to consider.

1 Choose lightweight materials. Opt for things like peel-and-stick tile and laminate wood flooring to keep your vehicle's weight down.

2 Invest in durable upholstery materials. Vinyl and wool are easy to clean and can stand up to dirt and constant use.

3 Stick with one color scheme. Having too many colors in a small space can make it appear busy. When in doubt, paint it white. A coat of white paint can make a small space seem bright and spacious.

4 Add some texture. Up the cozy factor with woven blankets, nubby throw pillows, and soft sheepskins.

5 Find hidden space. Under beds, on the wall, hung from the ceiling: every surface is a place where a hook, shelf, or basket could live.

6 Install drawers instead of cabinets. Drawers allow you to easily access everything and don't require you to get down on your knees in a tight space and rummage in a back corner.

7 Create rooms. If you have only one big space, divide it into zones for different tasks—sleeping, eating, working, lounging, etc.

8 Take only the minimum. When it comes to everything from dishware to clothing, less is more. If you bring it along, you'll use it, which only means more dishes to clean, more laundry to do, and more places you'll need to store it all.

9 Embrace multitaskers. Choose furniture that can do double duty—see page 277 for examples.

10 Have a place for everything. This will keep your home looking neat and organized. (For clever storage ideas, see pages 274–285.)

Home-to-Go Essentials

Here's a roundup of indispensable products that are relatively indestructible, compact, and often multifunctional—and look good to boot.

AEROPRESS COFFEEMAKER

Available at amazon.com

This single-cup brewing system makes café-worthy coffee, is light as a feather, and can be tucked away in a drawer.

PORLEX STAINLESS-STEEL MINI HAND GRINDER

Available at clivecoffee.com

With settings ranging from Turkish brew to French press, this grinder is made for coffee enthusiasts.

FALCON ENAMELWARE

Available at unisonhome.com

Campers have used enamelware for decades because it is lightweight and indestructible. It's a favorite of nomadic travelers for the same reasons.

MAGNETIC KNIFE HOLDER

Available at bedbathandbeyond.com

Everyday items like knives and other gadgets can be kept close at hand on a wall-mounted magnetic knife holder. Bonus: These bars grip so well that utensils will stay safely put when the vehicle is in motion.

PRODYNE HH-360 FRUIT AND VEGETABLE HAMMOCK

Available at amazon.com

Free up counter space and keep your fruit lasting longer with a net hammock. The open-weave design permits complete air circulation, which allows fruit to breathe.

5-SPEED KITCHENAID PRO LINE CORDLESS HAND BLENDER

Available at kitchenaid.com

You can use this surprisingly versatile, compact tool to puree soup, make smoothies, blend pancake batter, or even whip cream. Bonus: This one runs on a 12-volt rechargeable lithium-ion battery.

PLASTIC-FREE DISH-WASHING BRUSH

Available at lifewithoutplastic.com

This all-natural brush can be used countless times before the head needs to be replaced. At the end of its life, the head can be composted.

TUNDRA 45

Available at yeti.com

Built with outdoor living in mind, these coolers are tough and made to last. Available in a variety of sizes.

YAKIMA CAMP BLANKET

Available at pendleton-usa.com

Rugged and durable, this medium-weight throw will
look good on your bed or couch and can be used as a picnic
blanket or to wrap around your shoulders on cold nights.

BOLGA BASKET

Available at connectedgoods.com

Made from elephant grass, these multipurpose baskets can
be taken to a farmers' market and loaded with veggies,
filled with throws, or hung on a hook to hold extra clothes.

CARRY-ALL FOLDER

Available at presentandcorrect.com

Store an entire office in one file folder. This box is made to
carry pens, pencils, scissors, notebooks, a stapler, and tape and
can easily be put away on a shelf.

BULLDOG CLIPS

Available at kikki-k.com

These can be used to hold up rolled fabric blinds or to display
your latest photographs. They are ridiculously inexpensive and
will come in handy in an infinite number of ways.

CANARY ALL-IN-ONE

Available at canary.is

Get intelligent alerts and stream video from inside
your rig through an app on your phone. Canary alarms
include cameras with night vision, motion-activated
recording, and air-quality sensors.

BANG & OLUFSEN BEOPLAY A1 SPEAKER

Available at bang-olufsen.com

With a play time of up to twenty-four hours and
a splash- and dust-resistant shell, this small but powerful
Bluetooth speaker can tag along on all your adventures.

DYSON V11 TORQUE DRIVE

Available at dyson.com

With smart attachments able to get into the smallest
crevices and the ability to clean both hard and soft
surfaces, this cord-free vacuum is able to display
the life of the battery down to the second.

NOMADIX TOWEL

Available at nomadix.co

Made from recycled plastic bottles, this quick-drying,
superabsorbent towel is the only one you'll need. Use it on
the beach, at campgrounds, and even as a yoga mat. As a
bonus, the National Parks Collection Grand Canyon design,
pictured here, won't show dirt.

On the Road

So you're ready to hit the road or set sail. It should be easy from here on out, right? Think again! Many travelers agree that the first few weeks on the road are among the toughest. Here is some information that will hopefully make those early days (and the ones that follow) a little easier.

Where to Park

While everyone admits that they've slept in a Walmart parking lot or behind a gas station, most prefer to boondock (camp off the grid) in the wilderness or on public land and save those less glamorous locales for times when they're making a beeline to get somewhere fast.

Be aware that a degree of localism exists among road dwellers, just as it does among surfers. Many natural spots are cherished, and as the popularity of living on the road rises and public spaces become crowded, people become more secretive about the locations where they park. It is not uncommon for newbies to be lambasted on social media for geotagging or revealing a coveted site.

That said, there are many community-based platforms where people share their favorite places. Some of the most popular ones are FreeCampsites .net, Campendium.com, and iOverlander.com, all of which are available as apps, as well as the Trucker Path app.

Here are a few suggestions and guidelines for finding your own beautiful spots. And remember, half the fun of living on the road is going down that unknown dirt path and discovering what's at the end of it!

GOVERNMENT-OWNED LAND

National parks can provide some of the most picturesque camping in any country, but be sure to book in advance (sometimes upward of six months), and expect to pay for the privilege. If you plan to stay at several US national parks on your journey, purchase an annual park pass. The eighty-dollar pass covers entrance fees as well as day-use fees. If you are a member of the military, the pass is free, and there are discounts for seniors, fourth graders, and volunteers. Note: Dogs and other pets are not allowed on backcountry trails in US national parks. If you're traveling with your pets, you may prefer to stay on BLM land (see below), which can often be found adjacent to the parks.

The Bureau of Land Management (BLM.gov) is an agency within the US Department of the Interior that looks after more than 247 million acres of land, much of which is available to camp on free of charge, on a first-come-first-serve basis. Maps of the sites are available online. This land is usually completely unserviced, meaning you will need to bring your own water, garbage bags, etc. Some of these places are also quite remote, so don't expect cell-phone service.

Crown Land in Canada is similar to BLM land. The rules for camping on Crown Land vary from province to province, but it is generally allowed for up

to twenty-one days in any one site in one calendar year. Check with each province for specific regulations and required permits.

WILD CAMPING OR BOONDOCKING

Wild camping or boondocking (also called free or dry camping) refers to camping off the grid or without hookups, usually out in the wilderness. There are different levels of tolerance for this type of camping throughout the world, with each country having its own rules. Read up in advance on the area you plan on staying in or speak to locals. There are lots of guidebooks and internet sites that explain the customs of different regions. In most cases, if you set up shop for the night in an area where you are not allowed, you will simply get moved along by the authorities, but in some places you could be ticketed or fined.

LONG-TERM PARKING

If you plan to stay in one spot for longer than a month, consider long-term parking. RV parks are one solution, especially in cities where space is at a premium. If that doesn't appeal, Craigslist and other classified sites can be used to request spots such as driveways or rural land for a fee.

FARM AND VINEYARD EXPERIENCES

The World Wide Opportunities on Organic Farms (WWOOF) and Harvest Hosts provide two different experiences of farm life. In exchange for free food and board (if needed) WWOOF provides hands-on farm experiences, from caring for crops to working with livestock. Harvest Hosts provides overnight stays to qualified RV vehicles on participating farms and vineyards across North America and works on a yearly membership basis.

SISTERS ON THE FLY

This members-only support group is for women looking to explore the great outdoors without prejudice or fear. Since its inception in 1999, more than 12,000 women have joined the organization throughout the United States and Canada. A registry called Sisters on the Curb allows members to park for free on other sisters' properties when they are passing through town.

MARINAS AND CRUISING

Living aboard a sailboat has its own rules and regulations. If you are going to be permanently anchored in a marina, you will need to apply for liveaboard status and pay for a slip. Once you've become a member of a marina, most other clubs offer reciprocal agreements, allowing you to dock your boat short-term at their facilities. Cruisers who go from port to port also have the option of anchoring out in the open water if it is safe to do so. If you opt for this method, be sure to invest in good-quality anchor lights so that other boats will see you from both far away and close up. If you plan on anchoring out a lot, consider investing in a reliable dinghy to get you to shore.

Expenses

Here's a quick rundown of the things you'll be spending money on once you hit the road, with tips for how to stretch your budget.

Gas. This is by far the biggest expense when living on the road. Some credit cards offer great gas rewards. There are also a few apps that will find the cheapest gas stations near you—try Gas Buddy or Waze. If money is really tight, plan out longer stops between drives or limit yourself to one tank of gas a month and get better acquainted with a particular community.

Food and water. Preparing your own food will always be cheaper than eating out. Take advantage of roadside fruit and vegetable stands, farmers'

markets, and signs for free eggs. Tip: Some Laundromats will have a sink. Take the opportunity to fill up your water bottles while you're doing your laundry.

Maintenance. Don't neglect oil changes and other regular maintenance. If you don't know how to do basic car repair, learn. You don't want to have to take your vehicle to a mechanic every time something goes wrong. That said, try to have a slush fund at the ready for bigger repairs.

Camping fees. Every now and then, you'll probably need to pay for somewhere to park. A typical campsite costs twenty to forty dollars per night. Preparing your rig to go off the grid (see page 295) will give you more free parking options once you're on the road.

Gym membership. While you might use the facilities to work out, the real benefit of having a membership is the hot showers. You can join Planet Fitness for approximately twenty dollars a month, and one pass allows two people access.

Hard Days Ahead

Not every day is going to be epic. It takes work to live an alternative lifestyle, and some things we take for granted in conventional, everyday life will suddenly become much more challenging. Here's

some insight into the more common difficulties, along with suggestions for how to work through them.

The weather. When the world is your living room, the effects of the weather become much more noticeable. Depending on your disposition, cold rainy days might really get you down, while for others, it can be the unrelenting heat. Take weather patterns into consideration when you plan your journey. You might want to visit the Pacific Northwest in the summer and head down to Texas for the winter.

Loneliness. While you will inevitably meet hundreds of interesting people on your journeys, few of them will become close friends. For some, the isolation can be a challenge. Consider making trips back home for special celebrations or having friends periodically join you on the road. Also, reach out to others within your new nomadic circle and plan meetups.

The absence of a safety net. When times get tough, you really only have yourself to rely upon. If your vehicle breaks down, you'll have to figure out how to get it fixed and back on the road. Practice the idea of paying it forward. Be the stranger who stops to help others when they're stranded on the side of the road, in the hopes that the favor will be returned. By

participating in the community, you make it better. In the end, any adversity will only make you stronger and more adaptable.

Lack of a routine. Not having a place to go each morning can throw some people for a loop. If you need something to get you going each day, develop a new set of habits more in tune with your mobile lifestyle: start every day with a walk, or by planning your upcoming route. You might also want to develop a checklist of things you have to do before you can get moving, whether it's checking the air in your tires or making sure everything is put away and securely stowed.

Resources

Airstream Parts

SILVER TRAILER SUPPLY
airstreamsupply.com
This company carries parts for all types of Airstream trailers, from vintage models to modern ones. They stock door parts, axles, beds, brakes, windows, and even Airstream-branded pet accessories.

VINTAGE TRAILER SUPPLY
vintagetrailersupply.com
For more than fifteen years, Vintage Trailer Supply has been a source for both vintage replacement parts for old Airstream trailers and authentic reproduction parts. Their product includes appliances, awnings, plumbing fixtures, and exterior lights.

Appliances and Camp Equipment

CAMP CHEF
campchef.com
A good source for well-designed camping grills and other tools for outdoor cooking. The website also has a treasure trove of recipes that can be cooked outdoors.

SUMMIT APPLIANCE
summitappliance.com
This manufacturer and distributor of kitchen appliances carries a large selection of small-scale products, including under-counter fridges and two-burner gas cooktops well suited to tiny spaces.

VITRIFRIGO
vitrifrigo.com
This well-established Italian company specializes in fridges and freezers for campers, boats, trucks, and other automotive vehicles.

YETI
yeti.com
Known for its hard and soft coolers and drink mugs, Yeti is an industry leader in the outdoor market, with stylish designs that appeal to the design-savvy traveler.

Fabrics and Textiles

CALICO
calicocorners.com
Offering thousands of designer fabrics (from, for example, DwellStudio and Justina Blakeney) in both regular and upholstery weights, Calico has both an online presence and physical locations.

FABRIC.COM
With a massive selection of affordable and durable upholstery fabrics, this site covers all the basics.

INSTA LINEN
instalinen.com
Insta Linen sells metallic, sheer, upholstery-weight, and cotton-linen fabrics by the yard, dyed in the United States in a range of beautiful colors.

SPOONFLOWER
spoonflower.com
Spoonflower is a fabulous source for chic fabric—you can even upload your own design and have it printed.

TONIC LIVING
tonicliving.com
Featuring a modern, curated selection of fabrics by the yard and ready-made pillows, Tonic Living will also custom-make bench cushions, roman shades, and shower curtains.

Faucets and Fixtures

DURA FAUCET
durafaucet.com

Dura's focus is on kitchen and bathroom faucets for RVs, ranging in style from classic to ultramodern. They also carry a line of showerheads.

ECCOTEMP
eccotemp.com

Recognized as the number one seller of portable tankless water heaters in the world, this family-owned company offers a wide variety of portable instant hot water heaters.

NATURE'S HEAD
natureshead.net

The Nature's Head composting toilet is a popular choice for mobile and tiny home dwellers. The website has a comprehensive overview and a frequently asked questions section on the specifics of this sanitation device.

ROAD SHOWER
roadshower.com

This innovative company produces portable shower systems that use solar energy to heat water stored in a black container mounted on your vehicle's roof. Each system comes with a flexible spray hose or an additional flex neck; a hands-free showerhead can be added.

RVFAUCET
rvfaucet.com

This online store carries a wide selection of kitchen and bathroom faucets, including bar faucets and exterior showers and sprays.

Furnishings and Decorative Accessories

1767
1767designs.com

This Nashville-based design studio sells a small selection of rustic wall art pieces made from wood rescued from homes prior to demolition.

THE CITIZENRY
the-citizenry.com

This online store sources its products from around the world and donates 10 percent of its proceeds directly back into artisan communities through entrepreneur development grants. Find pillows, poufs, rugs, and ceramics here.

CONNECTED GOODS
connectedgoods.com

Featuring a selection of handmade quilts and baskets, Connected Goods sources both American-made items and goods from global artisans who are members of the Fair Trade Federation and World Fair Trade Organization.

ETSY
etsy.com

Etsy is an umbrella site representing artisans and small purveyors. It's an excellent source for finding handcrafted and one-of-a-kind goods.

IKEA
ikea.com

Ikea's affordable and well-designed kitchen systems work as well in a skoolie or tiny home as they do in a conventional house. In addition, their stores (with locations worldwide) are a great place to pick up housewares, bedding, and throw pillows.

LOOM & KILN
loomandkiln.com

Founder Hannah Loumeau Leonard fills her online store with one-of-a-kind Moroccan, Persian, and Turkish rugs that she has chosen personally.

PENDLETON
pendleton-usa.com

Known for its rustic blankets, rugs, and woolen goods, the Pendleton company dates back to 1863.

SACKCLOTH & ASHES

sackclothandashes.com

Founder Bob Dalton was inspired to help the homeless population when his hardworking mother found herself living on the streets in 2013. For every blanket purchased, another blanket is given to a local homeless shelter.

SOCIETY 6

society6.com

This online site represents hundreds of thousands of artists from around the globe, selling everything from affordable artwork to throw blankets and pillows.

STOUT TENT

stouttent.com

The waterproof and mold-resistant canvas bell tents made by Stout are perfect for adding some extra square footage to your space.

General Stores

DOMETIC

dometic.com

This worldwide dealer specializes in all the essential products you need for your mobile lifestyle, including refrigerators, cooktops, ovens, and air conditioners.

RV PARTS ONLINE

rvparts-online.com

This comprehensive online site sells everything from microwaves to portable ovens, washers, and dryers.

TINY LIFE SUPPLY

tinylifesupply.com

As the name suggests, this outfitter provides everything you need to live a tiny life, including solar and wind products, backup generators, gray-water tanks, and even yurts, geodesic domes, and framing kits.

Heating

DICKINSON MARINE

dickinsonmarine.com

Dickinson Marine has manufactured innovative marine cookstoves, barbecues, and heaters for nautical vessels since 1932. However, the use of these items is not limited to boats: the heaters pop up in tiny houses and aboard buses as well.

FOUR DOG STOVE

fourdog.com

Four Dog Stove is a small family-run shop based out of St. Francis, Minnesota, that custom-makes lightweight tent and backpacking stoves, along with titanium pots.

TINY WOOD STOVE

tinywoodstove.com

Founder Nick Peterson and his family work and travel full-time in their Airstream. When they were looking for an off-the-grid heat source, they decided on wood heat but couldn't find anything to suit their needs. And

so Tiny Wood Stove was born, specializing in small wood-burning stoves and accessories.

Home Rentals

ESCAPE CAMPERVANS

escapecampervans.com

This award-winning camper-van rental company, with locations across the United States and Canada, offers more than 450 fully equipped, custom-built camper vans perfect for weekend getaways or epic road trips.

GETAWAY

getaway.house

Getaway offers escapes to simple, beautifully designed tiny cabins hidden away in the wilderness close to the metropolitan areas of New York City, Boston, and Washington, D.C. The secret locations are not revealed until you've made your booking.

HIPCAMP

hipcamp.com

Founded in 2013, Hipcamp is an online travel service designed to help people discover and book camping experiences across the United States on ranches, vineyards, beaches, and land preserves.

WICKED CAMPERS

wickedcampers.ca

With rental locations worldwide, Wicked Campers come loaded

with mattresses, gas stoves, cutlery, crockery, and coolers. The wildly painted camper vans are sure to illicit a few friendly stares.

Lighting

ACEGOO
acegoo.myshopify.com
Acegoo offers RV and boat recessed LED ceiling lights in modern, clean designs.

LUCENT LIGHTSHOP
lucentlightshop.com
Featuring a small but stylish selection of pendant and sconce lighting in black and brass for RVs and campers, Lucent Lightshop is a one-stop shop for chic lighting choices.

Marine Supplies

GO2MARINE
go2marine.com
This comprehensive online store carries everything you need to keep your boat running smoothly, including bulkhead lights, anchor chains, winches, refrigeration units, and boat wheels.

WEST MARINE
westmarine.com
Launched from founder Randy Repass's basement in 1968, West Marine has grown into the largest retailer of boating supplies and accessories in the United States, with over 100,000 products ranging from ropes to marine navigation systems.

Portable Power Solutions

GOAL ZERO
goalzero.com
This company, popular among design-conscious outdoor enthusiasts, specializes in contemporary crafted portable power solutions including solar kits, USB power banks, AC power banks, and a selection of solar lights and lanterns.

HUMLESS RELIABLE POWER SYSTEMS
humless.com
Humless is known for their high-efficiency solar panels, which they pair with advanced lithium batteries to create solar-generating systems.

RENOGY
renogy.com
Providing solar kits, solar panels, charge controllers, inverters, generators, and deep-cycle batteries, Renogy is an award-winning renewable energy company that provides highly efficient products at competitive prices.

Featured Homeowners

DANIELLE BOUCEK &
TOMMY KRAWCZEWICZ
@slowcarfasthome
slowcarfasthome.com

BROOKE BUDNER
@brookebudner
brookebudner.squarespace.com

JACE & GIDDI
CARMICHAEL
@ourhomeonwheels
ourhomeonwheels.com

BRETT COLVIN
@pointerandpine
pointerandpine.co

SUNNY COOPER
@migrationsofsun

YOAV ELKAYAM
@yoav.kafets
yoavkafets.bigcartel.com

JOHN ELLIS &
LAURA PRESTON
@thelonglongairstream
@vacilandoquilting
vacilandoquilting.co

NASH & KIM FINLEY
@thenomadicpeople
bareescape.com

BELA FISHBEYN &
SPENCER WRIGHT
@belafish
tinymigrations.com

MICHAEL FUEHRER
@navigationnowhere
navigationnowhere.com

RAPHAËLLE GAGNON &
MARK COELHO
@borealfolk
borealfolk.ca

ROBERT & SAMANTHA
GARLOW
@shed_tinyhouse
shedsistence.com

MARCELLA GAROFALO &
TANNAZ DARIAN
@lostintrillium

DEVIN GROODY &
CATRIN SKAPERDAS
@devingroody
@finallytiny
@travelingfemale

MATT H-B &
STEPHANIE RHODES
@slownsteadylivin
slownsteadylivin.com

ALEXANDRA KEELING &
WINSTON SHULL
@alexandra_abroad
@winston_wandering

KATHARINA KÖRFGEN
@kathawillsommer
saltysoulexperience.com

KIERAN & PAULINE
MORRISSEY
@kieranmorrissey
@paulinemorrissey
paulinemorrissey.com

ASHLEE NEWMAN
@loveisintheairstream
ashleenewman.com

KATE OLIVER &
ELLEN PRASSE
@themoderncaravan
themoderncaravan.com

ASHLEY & DINO PETRONE
@arrowsandbow
arrowsandbow.com

WIM & ANNEKE
ROBBERTSEN
@woonschip_robbedoes
woonschiprobbedoes.nl

AUDREY & GARRETT
RUHLAND
@thisldu
thisldu.com

SINA SCHUBERT &
CARSTEN KONSEN
@wander.horizons
wanderhorizons.com

ASHLEY & BRANDON
TREBITOWSKI
@trebventure
trebventure.com

KYLA TRETHEWEY
@ourwildabandon
ourwildabandon.com

KIT WHISTLER &
J. R. SWITCHGRASS
@idletheorybus
idletheorybus.com

Acknowledgments

Making a book is a true collaboration. I'm honored to have been surrounded by so many talented and insightful people (most of them women!).

To all the people who opened their trailer doors, invited us aboard their ships, and took us for rides in their school buses, thank you for telling us your stories. I am astounded by your courage and willingness to take on lives of adventure.

To my sister-in-arms and photographer Sian Richards, who was by my side on every leg of this journey, this book is as much yours as it is mine. Your compassionate eye sees things in ways I never could. You brought heart and soul to this book.

My thanks go to all the people at Artisan who made this book possible. From my initial conversation with publisher and editorial director Lia Ronnen and editor Bridget Monroe Itkin, I knew I was in good hands. They were truly engaged from the very first phone call and asked me all the hard questions. A special and very big thanks to Bridget, who continued to ask all the right questions and took meticulous care of this book. Your insight and ceaseless work ethic are an inspiration. To Sibylle Kazeroid, Bella Lemos, and Elise Ramsbottom, thank you for keeping this book on track. I know your work behind the scenes made the process a smooth one. Thanks also to the creative team at Artisan: Michelle Ishay-Cohen, Nina Simoneaux, Jennifer K. Beal Davis, Barbara Peragine, and Hanh Le. You brought a spirit to this book that words and photos couldn't achieve alone. And to Allison McGeehon, Theresa Collier, Amy Michelson, and Patrick Thedinga for getting this book out there. I am fortunate to be in such good hands.

A special thank-you to my agent, Maria Ribas at Stonesong. You took a chance on me and then fought tirelessly to make my dream come true. Your guidance through this process has been invaluable.

To the team at *House & Home* magazine and especially Lynda Reeves, thank you for giving me the time and space to pursue this book. Without your generosity and understanding this book would still not be written.

Two good friends, Murray Whyte and Rose Pereira, were instrumental in getting this book off the ground. I'm grateful for your friendship and editorial insight. Thank you, Murray, for engaging in endless conversations with me and teaching me to trust my own voice. Your writing has been my best teacher and biggest inspiration. And to Rose, whose keen eye I turn to time after time, I don't think I'll ever be able to thank you enough for all the nights and weekends you gave to this project.

To my parents and sisters, my first and favorite travel companions: In some ways this book feels like an ode to the blurred landscapes and shared stories of my childhood. Home for me will always be wherever the five of us are together.

To my children, Henry and Orla, who cheered me on and were generally delighted with all the souvenirs I brought back from my travels, I hope this book gives you the inspiration to follow your own heart when the time comes.

And finally, to my husband, Myles, who not only picked up all the pieces but lent his talented eye to this book, I can't thank you enough.

Index

Emma Reddington is the founder of the Marion House Book, a design site and curation brand that reaches millions of fans. She is also the editor in chief of *House & Home* magazine. Reddington has been featured in or curated for brands such as *Elle Decor*, *Good Housekeeping*, *HGTV Magazine*, West Elm, Etsy, Home Depot, and many others. She lives in Toronto, Canada, and can be found on Instagram @marionhousebook.

Sian Richards is a photographer based in Toronto and Boston. Her work is focused on interiors, design, and lifestyle photography, and her client list includes the *New York Times*, *Good Housekeeping*, *Chatelaine*, *House & Home*, and West Elm. View her work at sianrichards.ca.